MINING THE HOME MOVIE

# Mining the Home Movie

Excavations in Histories and Memories

Edited by
**KAREN L. ISHIZUKA** and
**PATRICIA R. ZIMMERMANN**

UNIVERSITY OF CALIFORNIA PRESS
Berkeley   Los Angeles   London

University of California Press, one of the most distinguished university presses in the United States, enriches lives around the world by advancing scholarship in the humanities, social sciences, and natural sciences. Its activities are supported by the UC Press Foundation and by philanthropic contributions from individuals and institutions. For more information, visit www.ucpress.edu.

University of California Press
Berkeley and Los Angeles, California

University of California Press, Ltd.
London, England

Library of Congress Cataloging-in-Publication Data
  Mining the home movie : excavations in histories and memories / Karen L. Ishizuka and Patricia R. Zimmermann.
    p.  cm.
  Outgrowth of an international symposium at the Getty Center, Los Angeles in 1998, called The past as present: the home movie as cinema of record.
  Includes bibliographical references and index.
  ISBN 978-0-520-23087-3 (cloth : alk. paper)
  ISBN 978-0-520-24807-6 (pbk. : alk. paper)
  1. Amateur films—History and criticism.   2. Film archives.
I. Ishizuka, Karen L.   II. Zimmermann, Patricia Rodden.
PN1995.8.M56   2008
791.43'0222—dc22                                    2006035372

Manufactured in the United States of America

17  16  15  14  13  12  11  10  09  08
10  9  8  7  6  5  4  3  2  1

The paper used in this publication meets the minimum requirements of ANSI/NISO Z39.48–1992 (R 1997) (Permanence of Paper).♾

*To the memories of Kirk T. Ishizuka, George T. Ishizuka, and Maryann Gomes*

*To the movie mining of Alice R. Zimmermann and Sean Zimmermann Auyash*

*To the excavations of Erik Barnouw*

*And to the spirit of home moviemakers around the globe*

# Contents

# Illustrations

# Foreword

KAREN L. ISHIZUKA

This anthology began as an international symposium—which I organized and in which Patricia Zimmermann was a participant—at the Getty Center in Los Angeles during its inaugural year, 1998. Called "The Past as Present: The Home Movie as Cinema of Record," the symposium was a result of my tenure as a visiting scholar at the Getty Research Institute for the Arts and Humanities. The Getty, of course, began as a museum based in Greek and Roman antiquities, eighteenth-century French furniture, and European paintings before becoming a modern-day Edinburgh Castle looming over the cultural landscape of Los Angeles. Bringing an anarchic and unorthodox subject such as home movies into the annals of this refined institution evidenced its capacity to transcend the traditional and break new ground.

At the Getty Scholars Program, the topic of home movies was admittedly greeted with mixed reactions. Most of the scholars—anthropologists, historians, architects, photographers, and writers—had never considered home movies to be a topic for serious, much less academic, consideration. Conventionally the terrain of birthday parties and vacation memories, the home movie was definitely the lowbrow bull in this highbrow china shop of arts and culture. As I got to know the other scholars, most were polite, some were intellectually curious, and a precious few viewed the topic critically enough to genuinely ponder and discuss if and how the study of home movies might fit into the arts, humanities, and social sciences.

All of my colleagues, especially those who were highly skeptical, contributed to a profound intellectual milieu and deepened my conviction regarding the utility and potential of this marginal genre to shed much-needed light on overlooked corners of history and culture. The encounter resurrected my desire—first experienced while attending the conferences of the Association Européene Inédits (European Association Inédits) in 1994

and 1995—to gather together like-minded individuals who had also been mining this lost amateur cinema.

Seizing the Getty moment, I approached Michael Roth, then director of the Scholars Program, about sponsoring a symposium during which the historical and cultural significance of home movies would receive dedicated intellectual attention. In the process I hoped the symposium would strategically help to legitimize the study of home movies and raise the topic out of what Zimmermann has called "the junk heap of private culture."[1] Roth, a true scholar eager to blaze new academic territory, was willing to put the Getty stamp—and resources—on this unestablished topic. He understood and embraced the fact that the symposium would not be standard film scholarship in the sense of analyzing the aesthetics, politics, ideologies, or economies of existing cinemas. Instead, it would be a process of recovering and rethinking practices and products that had heretofore been academically disregarded.

Roth wanted the symposium to focus on the "work" home movies could do rather than be an arena for scholars to present and pontificate, and I wanted to keep the focus on the image, centering and grounding dialogue on and around the home movie itself. Working together, we came up with the following format. Seven presenters from around the world who had direct experience working with the home movie as a cinema of historical and cultural record—rather than as a medium of self-expression and artistic production—would be selected to participate in an intensive two-day workshop. Both work and homework would be required. They were asked to submit an excerpt from a home movie or collection of home movies they actively worked upon and to write an accompanying paper discussing why and how they selected it and its initial origin and provenance, as well as its historical and cultural significance. These were due two months before the actual symposium. The excerpts were then edited onto a single reel, duplicated on VHS, and distributed along with the papers to all the participants. Both the video and the papers were to be thoroughly viewed, read, and digested before the symposium. A commentator was assigned to each presentation and asked to prepare a formal commentary. The two-day symposium itself would consist of the screening of the selected home movies, a brief review of each paper by the presenter, response by the commentator, and discussion by all the participants.

In addition to Zimmermann, the presenters consisted of Hungarian filmmaker Péter Forgács, who recasts home movie collections into cinematic productions; Toronto-based video artist and critic Richard Fung, who has incorporated his mother's home movies of his youth in Trinidad into his own work; Anglo-Indian archivist par excellence Maryann Gomes, who spearheaded the North West Film Archive in Manchester, England, and to whose pioneering

spirit this anthology is dedicated; geographer Heather Norris Nicholson, who holds honorary research positions at the Centre for Mediterranean Studies and in the School of Geography, University of Leeds, and at the Centre for Regional History, Manchester Metropolitan University; Los Angeles–based filmmaker Robert A. Nakamura, who, independently of but simultaneous to Forgács, recrafted home movies into hybrid documentaries to unearth unknown histories of everyday people; Roger Odin, who created a research group on home movies and amateur productions at the Université de Paris–Sorbonne Nouvelle; and Robert Rosen, dean of the School of Theater, Film and Television, University of California, Los Angeles, who has long understood the meaning of home movies for history and culture.

The discussants were equally stellar and consisted of Robert Dawidoff, Department of History, Claremont Graduate University, Claremont, California; photographer and filmmaker Marlon Fuentes, San Diego, California; Karin Higa, Japanese American National Museum, Los Angeles; David James, School of Cinema and Television, University of Southern California, Los Angeles; Valerie Matsumoto, Department of History, University of California, Los Angeles; and Lesley Stern, School of Theater, Film and Dance, University of New South Wales, Sydney, Australia, as well as Michael Roth, Getty Research Institute. Special guests included David Francis, chief of the Motion Picture, Broadcasting and Recorded Sound Division of the Library of Congress in Washington, D.C., and André Huet, secretary general of the Association Européene Inédits, based in Charleroi, Belgium.

The UCLA Film & Television Archive collaborated by programming an evening of rarely seen home movies from around the world, "Homemade Movies," which I curated. Noted *Los Angeles Times* film critic Kenneth Turan wrote, "'Homemade Movies' is the deceptively simple title for an intriguing, provocative program. . . . It's a fresh examination of the home movie form—and those who think of these efforts as primitive and devoid of interest will have their heads turned in a major way."[2] A standing-room-only crowd relished humorous examples of the social history of home moviemaking; rare reflections of regional, ethnic, racial, and religious diversity in the United States; home movies of Marilyn Monroe and Sigmund Freud; and inside-out views of World War II from the United States, Germany, and Holland. The films were generously loaned from the archives of the Academy of Motion Picture Arts and Sciences, the Japanese American National Museum, the Library of Congress, the Nebraska State Historical Society, Northeast Historic Film, Wales Film and Television, the University of California, Los Angeles, and the University of Mississippi—many of which are represented in this volume.

That the symposium succeeded in doing the work it intended is evidenced by each of the participant's papers in this anthology. They speak eloquently on their own. However, for the participants and for the field, the symposium did much more. Many of us work in relative isolation from one another, and we each have similar experiences of too often having to defend the integrity of the home movie. Thus, the event transcended the typical academic symposium as we greeted one another not with the usual academic formality, but with eager familiarity and camaraderie. The symposium stimulated not only an intellectual combustion, but also personally moving experiences as we brought our shared topic into the light of genuine inquiry with others who had been working underground to extract buried and neglected images. In this very rarified setting high above Los Angeles, Zimmermann analogized our work to the struggles of her immigrant grandfather, who had labored deep in coal mines with fellow miners of various ethnicities and races. Before the time of occupational safety rules, when mines collapsed, deadly, invisible gas would be released. Canaries were brought into mines as a safety warning: if the canary died, miners knew gas had leaked and they needed to escape. Zimmermann recalled her grandfather saying that "when the canary died, we all could die, so it was time to move out—together."

It is from this point of shared passion and connection to many communities of difference that Zimmermann, a Scot-Irish-German from the East Coast, and I, a Japanese American on the West Coast, decided that our collective mining had summoned us to the joint effort of producing this international book about home movies. We solicited articles from other miners in the field and felt strongly about including information on various archival mines that hold and preserve home movies for others to study and enjoy. To honor the work involved in finding home movies and to center the project in an action rather than a removed analysis, we named this anthology *Mining the Home Movie: Excavations in Histories and Memories*. We know that if the canary dies, we all die, and with us, the images. Like the recently emerged miners that we are, from the "junk heap of private culture," we offer you these bits of rubble turned into gold.

## Notes

1. Patricia R. Zimmermann, *Reel Families: A Social History of Amateur Film* (Bloomington and Indianapolis: Indiana University Press, 1995).

2. Kenneth Turan, "The Most Personal Filmmakers," *Los Angeles Times*, December 1, 1998, F1 and F6.

# Acknowledgments

KAREN L. ISHIZUKA AND PATRICIA R. ZIMMERMANN

Many generous hands and minds work together within the covers of this book. Our mining of home movies across ethnicities, nations, races, genders, disciplines, ranks, professional affiliations, and communities continually affirms the necessity of a collaborative historical ethics to produce shared meanings. This collaborative work has taught us that film history is always a dialogical juxtaposition of images, discourses, people, and practices.

We thank our contributors, an international brigade of home movie partisans. They invented new creative and scholarly approaches to home movies during the journey of this book's creation. They graciously accepted our long delays during several deaths in our families: those of each of our fathers, George T. Ishizuka and Byron L. Zimmermann, and Karen's brother, Kirk T. Ishizuka. We especially honor Maryann Gomes, the visionary curator from the North West Film Archive in Manchester, England, who passed away shortly after writing her essay for this anthology.

Eric Smoodin was our first editor at the University of California Press. Without his vision, *Mining the Home Movie* never would have materialized. We are indebted to his moxie. Mary Francis, another editor at the Press, adopted this project in its final stages with patience, astuteness, and equanimity.

Our research assistants Alice Hom, Grace An, and Liz Czach functioned as home movie angels, marshaling all details. Alice rode herd on the contributors' revisions. Grace translated from French into English and gathered biographies. Elizabeth developed the filmography/videography and bibliography. Mayumi Kodani provided invaluable assistance with the illustrations and visual material. For their labor and for their friendship, we thank Rachel Knowles, Jenny Jediny, Kole Ade Odutola, Jerome Ng, Marc Lesser,

Rachel Lewitt, Ashley Ferro-Murray, and Loni Shibuyama, our undergraduate and graduate research assistants.

We also were blessed with a coterie of academic friends who cajoled us to have more intellectual courage. Through calls, e-mails, and food, Robert Dawidoff, John Kuo Wei Tchen, Stephan Gong, Gina Marchetti, Zillah Eisenstein, David E. James, Tim Murray, Amy Villarejo, Ruth Bradley, Scott MacDonald, John Hess, Anna Siomopoulos, Dale Hudson, Lisa Patti, Paula Rabinowitz, Laura Marks, and Tom Shevory became part of this project.

In the archival film realm, Steven Davidson, Stephen Gong, John Homiak, Jan-Christopher Horak, Eddie Richmond, Milt Shefter, Karan Sheldon, Dwight Swanson, Eric Schwartz, and Pamela Wintle shared their vast knowledge of amateur film to keep this book honest and useful. They all insisted that amateur film acquisition, preservation, and access require the most rigorous thinking and action.

A wide and generous variety of research grants from Ithaca College brought this massive project to fruition. We thank former Provost James Malek, current Provost Peter Bardaglio, and Associate Provost Garry Brodhead for their intellectual and financial support.

We also thank colleagues at Ithaca College and the Japanese American National Museum: Robert Dirig, John Esaki, Sandra Herndon, Karin Higa, James Hirabayashi, Lloyd Inui, Akemi Kikumura-Yano, Masaki Miyagawa, Roger Richardson, Tanya Saunders, Traevena Byrd, and Simon Tarr.

The Japanese American National Museum and Ithaca College provided important and sustaining institutional support. *The Moving Image* (the journal of the Association of Moving Image Archivists), the Small Gauge Task Force of the Association of Moving Image Archivists, the National Film Preservation Board, the National Film Preservation Foundation, and the Visible Evidence Conferences on Documentary created a vibrant, passionate community for many explosive yet productive polemics about the relationship between representation and history. Since 1993, these conferences have taken place in a variety of locations, such as Durham, North Carolina; Chicago; Los Angeles; Montreal, Canada; Bristol, England; Marseilles, France; and São Paulo, Brazil.

We also honor our families, who helped to get this book out simply by living with us. Karen thanks Robert A. Nakamura, her partner in life and work, for his insistence and ability to make everything even better; her children and best friends, Thai Binh and Tadashi, for laughs, love, and raison d'être; and her mother, Mary Ishizuka, for proving that love is stronger than death. Patty thanks her partner, Stewart Auyash, for love, sustenance, and inspiration; her son, Sean, for exuberance, spirit, and urgency; and her

mother, Alice Zimmermann, for her home movies, shot in Chicago and across the United States.

We also thank each other for the gifts of collaboration. On the East and West Coasts, from different cinematic milieus, and from different ethnic heritages, we learned concretely that no good work happens alone. The world of home movies is simply too sprawling and too teeming with life and loss for solitary excavations. We formed a home movie workers' union, looking out for and pushing each other on when the work felt too complex and gargantuan. These solidarities helped us through transitions with our children and spouses, the deaths of our fathers, the devastations of September 11, and the horrific prospect of infinite war.

Finally, we thank the home moviemakers and their subjects from all over the globe for allowing us to move their work from private memory to public history. Each home movie image holds glistening fragments of the past. Each home movie contains specters of the dead, smiling ghosts inviting us into the image and its imagined world. Yet these home movie images are not phantoms. They live among us, pressing us to montage together the past, the present, and the future to bear witness. These home movies ask us all to embrace an alliance of people, histories, memories, and images that produces a continually unfolding commons, a dream against amnesia.

Introduction **The Home Movie Movement**

Excavations, Artifacts, Minings

PATRICIA R. ZIMMERMANN

## Why Home Movies?

This innocent query suggests a web of misconceptions and dispossessions. Although the evolution of home movies and amateur film has paralleled the historical trajectory of commercial film since 1895, and despite the pervasive use of home filmmaking technologies since the mid-1920s, home movies too often have been perceived as simply an irrelevant pastime or nostalgic mementos of the past, or dismissed as insignificant byproducts of consumer technology. In the popular imaginary, home movies are often defined by negation: noncommercial, nonprofessional, unnecessary.[1]

*Mining the Home Movie* asks our readers to turn their thinking about cinema inside out, to reverse these popular-culture assumptions about home movies by starting with home movies as a visual practice emerging out of dispersed, localized, and often minoritized cultures, not a practice imposed on them.[2] Amateur film provides a vital access point for academic historiography in its trajectory from official history to the more variegated and multiple practices of popular memory, a concretization of memory into artifacts that can be remobilized, recontextualized, and reanimated.

Contemporary advances in critical historiography, including the Annales School in France, the subaltern historians in India, Foucauldian genealogies, and the new film history in cinema studies, have expanded the range and types of evidence, particularly those considered suppressed or at the margins of official events and practices, as well as promoted new explanatory models of discerning patterns, meaning, and significance within and between disparate events and artifacts.[3] This study of international amateur film as an index, marker, and trace of trauma resonates with these intellectual schools that revise our notion of the historical to include lost and repressed objects,

practices, and discourses as vital and important realms of historical inquiry. The focus of this volume on the recovery of amateur film artifacts parallels similar moves in historiography to interrogate the function of the archive itself as a machine of selection and privileging of discourses that requires expansion into new territories.

## Amateur Film and the Project of Film History

In the last two decades, film history has undergone significant revision through more precise empirical archival work and reformulations of historiographic methodology. However, much of this revisionist history—although massively important to our understanding of the structure of the film industries—has concentrated on areas with ready-made corporate archives, such as the studio system, unions, and various national cinemas. The international movement of scholars, archivists, artists, and collectors dedicated to mining amateur film has contributed to this revisionist movement in film history by shifting away from corporate history toward a different formation of film history from below: home movies. For example, in this volume, Hungarian filmmaker Péter Forgács, who has spent decades collecting amateur films chronicling the hidden everyday history of European wars and occupations in the twentieth century, which he remakes into feature-length documentaries, draws on the ideas of Ludwig Wittgenstein to emphasize home movies as a vernacular narrative imaginary, private histories of private lives. In his essay "Wittgenstein Tractatus," Forgács proposes that home movies permit us to see the unseen to deconstruct and then reconstruct the human through the ephemeral and microhistorical, where the real and the performed exist side by side.

Amateur film and home movies open up a series of questions that the contributors to this book attempt to answer and probe. How are film history and social history intertwined? How can we begin to unravel their historiographic significance in counterdistinction to these other kinds of film histories from above? What kind of history and histories are produced from home movies made by minoritized cultures? What sort of evidence do they yield? How do they function as a counterpoise to public history? How do they construct historical knowledge? How do we understand the visual inscriptions of amateur film, where the public and private are fluid?

*Mining the Home Movie* brings together a diverse group of international scholars, film archivists, and cultural workers (filmmakers and video artists) to explore the promise and problematics of home movies and amateur film

footage as unseen cinemas of public memories and traumatic histories. Our project is directed toward decoding the historical and visual significance of home movies through multiple methodologies and approaches. In his essay "Reflections on the Family Home Movie as Document," Roger Odin, a well-known semiotician of cinema, proposes a semio-pragmatic approach to analyzing home movies that starts with context and then works in toward the text, which he configures as a "festival of Oedipal relations." He argues that different modalities of amateur film not only involve varying affect and interactions during their making and viewing, but also create a double, sometimes contradictory process of remembering that is collective and individual. In my own essay (I am a film historian and theorist), "Morphing History into Histories," I demonstrate how amateur films from Wisconsin, Africa, and Maine travel fluidly among facts, fictions, and fantasies, congealing as nodal points for gendered, racialized, and localized histories that open up layers of historical contradiction. This book is interested in connecting groups that are generally considered separate—scholars, filmmakers, and archivists—to begin the process of mapping the internationalization of the amateur film project.

## Stories from the Listeners

The new social history movement, dubbed "history from below" and exemplified by historians like E. P. Thompson, Eric Hobsbawn, Eric Foner, Natalie Zemon Davis, and Emmanuel Le Roy Ladurie, writing in the 1960s and 1970s, shifted historical inquiry from the top—officials, battles, government—to below, to the experiences of everyday people.[4] As a group, whether writing about the working class, small communities in early modern France, or slave life, the new social historians exhumed and analyzed documents and discourses outside official or governmental sources, such as diaries, songs, memoirs, political manifestos, folk art, examples of resistance, and functions of daily life such as eating, working, and leisure—all examples of incomplete fragments marking the practices and discourses of everyday lived relations that rejected grand narratives for microhistorical analysis.

Jim Sharpe has explained that "those writing history from below have not only provided a body of work which permits us to know more about the past: they have also made it plain there is a great deal more, much of its secret still lurking in unexplored evidence, which could be known. Thus history from below retains its subversive aura."[5] History from below raises questions about the nature of evidence, conceptual models, and methodology. These

questions require moving beyond the traditional historiography of elites into intellectual alliances with social theory, anthropology, psychoanalysis, ethnography, and even science to admit—and find—new source material that tells different stories of those who have been denied a history. Amateur films represent unexplored evidence for film history, a way to create a more complex, richer explanation of how visual culture operates across many levels of practice, from elites to amateurs, as an instance of filmmaking from below.

These amateur film artifacts present a materialization of the abstractions of race, class, gender, and nation as they are lived and as a part of everyday life, much valorized by cultural studies as a site for agency, fissure, and resistance to dominant modalities. Home movies provide vectors into the processes of racialization, race relations, and the imaging of racial difference. In her contribution on significant amateur films in the Academy Film Archive in Los Angeles, Lynne Kirste describes rare footage of the Negro Leagues baseball teams as an example of the racism of American sports. Karen L. Ishizuka shows how an extensive collection of Japanese American films from the 1920s and 1930s, deposited in the Japanese American National Museum, documents the intricacies and details of specific ethnic communities in California, refuting the popularized hegemonic image of Japanese Americans as victims in the World War II concentration camps.

Amateur films and home movies negotiate between private memories and social histories in a variety of forms and iterations; there is never a one-to-one correspondence between the empirical fact and the representation. Consonant with explanatory models of history from below, the history of amateur film discourses and visual practices are always situated in context with more elite, more visible forms of cultural practices, such as Hollywood, national cinemas, and avant-garde movements, as well as other, larger historical, political, and social metanarratives.

Two contributions from England demonstrate how amateur film can illuminate the representation of the working class in industrial communities undergoing significant economic transformation before World War II. In "'As If by Magic,'" geographer Heather Norris Nicholson analyzes films of working-class people shot by individuals with economic, ideological, and social dominance in northwest England during the 1930s and 1940s. The films focus on industrial processes of production rather than people, suggesting a managerial outlook produced by middle-class male hobbyists and used for moral, civic, and religious uplift. Refuting the idea that all amateur films constitute counternarratives, she shows how these films blurred the border between amateur and professional, exhibited with voiceover commentaries

that supported the existing social order. The late Maryann Gomes, an archivist, explains in "Working People, Topical Films, and Home Movies" how the North West Film Archive used the idea of the working class, one of the most salient groups in this part of England, to collect alternative forms of primary evidence from different class perspectives in a specific region. The films span local mill-town topicals, Wakes Week films of tourists meant for public exhibition, middle-class movies of working-class people, newsreels, ads, and quasi-professional work.

The authors included in this volume share an interest in how the home movie can function as a recorder, an interrogator, a deferral, a condensation, and a mediator of historical traumas that extend beyond the self, such as labor, war, race, gender, religion, illness, diaspora, and displacement. They are all interested in the theoretical and practical problematics of home movies as artifacts that require mining, excavation, exhumation, reprocessing, and reconsideration. They mobilize these images into a dialogical relationship with history, moving them out of the realm of inert evidence into a more dynamic relationship to provide historical explanation.

Heterogeneity marks the analytical formations of this volume as a way to insist that the vast, untapped domain of the amateur film and the home movie requires many approaches and tactics in our attempt to move beyond the artifact into historical understanding of the significance of these works and a critical engagement with the forms of knowledge they yield. Robert F. Berkhofer Jr., in his *Beyond the Great Story*, has argued that advances in the philosophy of history—pushed by what has been termed "the linguistic turn" evolving out of poststructuralist literary theory—have figured history as modes of representation and forms of story and argument that are constructed. These discussions have moved history away from a single, metanarrative, and omniscient viewpoint, based on referentiality, realism, and facts that repress heterogeneity, toward a more particularized, multicultural construct of plural pasts. Berkhofer's term for the structure of these plural pasts is *polyvocalities*, wherein more than one viewpoint is present and contradictions and disjunctures abound, opening up historical analysis to different explanatory models.[6]

With filmmakers, archivists, and scholars analyzing the significance of home movies, *Mining the Home Movie* is constructed to explore how these histories from below can operationalize a historical method that assumes polyvocalities as an explanatory model for disparate kinds of evidence and different kinds of interpretations. Given the developments in critical historiography over the last thirty years that have advocated for an expansion of what is considered primary evidence, amateur film can be seen as a necessary

and vital part of visual culture rather than as a marginal area requiring inclusion.

The project has been designed with an international rather than a domestic U.S. focus, reflecting the necessity to rethink amateur film beyond the confines of the nation-state (usually the United States) and the domestic sphere. It places multiple locations, formations, and sites of home movie production in a structure suggesting contiguities across space rather than continuities across temporality. The range of amateur films discussed in this volume represents a diversity of voices operating within different discursive formations—travel films, missionary works, narratives, amateur ethnography, industrials, family films—which suggests the latent heterogeneity and polyvocality latent in the term *amateur film*. For example, in his essay "Home Away from Home," writer and archivist Nico de Klerk challenges the notion that all colonial imagery exoticizes and orientalizes indigenous people by concentrating on films of Dutch businessmen and colonial administrators in the Dutch East Indies, where everyday encounters indicate filmmaking created interactions, a more participatory status, and familiarity, but also different imaging strategies depending on whether the administrator was posted to an urban or rural area. He conjectures that Dutch colonialists employed servants who most likely shot the home movies.

These heterogeneous locations and functions of amateur film suggest the need for a parallel pluralization of methodological approaches to chart this large, variegated, multicultural, and international domain of home movies and trauma. A range of methodologies can serve as different vectors with which to map the variegated practices of the home movie. Thus this volume's writers include a semiotician (Odin), a film historian (myself), a geographer (Nicholson), a film theorist (Villarejo), a philosopher of history (Roth), an anthropologist (Homiak), a librarian (Glynn), archivists (Kirste, Gomes, Homiak, Wintle, Lipman, and Davidson), postcolonial critics (de Klerk and Fung), a writer and producer (Ishizuka), and filmmakers (Abraham, Fung, Nakamura, and Forgács).

Further, the essays included in this volume engage different polyvocalities of amateur film. Some essays discuss the archival object of the film fragments themselves as a historical artifact. For example, Karen Glynn's discussion of black farmers' mule racing, a spoof of thoroughbred racing, in the American South in the 1930s and 1940s, argues that these amateur films provide evidence about race relations in the Jim Crow South that are unavailable in any other source. Through oral histories with black and white participants, comparisons with Farm Security Administration photos of the region at the same time, and analysis of the images in the films, she shows

how different perspectives on mule racing were racialized. Some essays in this volume discuss how such artifacts are reactivated within the works of filmmakers exploring new ways to represent histories from below. Others look at more coherent amateur films that were edited into organized wholes. Our strategy is to place archival primary evidence, filmmakers, archivists, artists, and scholars from a variety of disciplines into productive dialogue with one another by creating contiguities and resonances.

Ranajit Guha, in his *History at the Limit of World-History*, argues that the complicity between history and imperialism should not be viewed as only an "expropriation of the pasts of the colonized by the colonizers,"[7] but instead as a necessary component of globalization that installs Europeanized development into the rest of the world by disconnecting stories and histories from the everyday. The state and history become intertwined, redefining temporality as a linear narrative progressing from the storyteller down, rather than emerging from interaction with the listeners gathered together to hear a story again and again and again. As a consequence, Guha observes, "the noise of world history and its statist concerns have made historiography insensitive to the sighs and whispers of everyday life."[8]

Guha suggests that history requires regrounding in the specifics of everyday life through a creative engagement with the human condition: "No continent, no culture, no mark or condition of social being would be considered too small or too simple for its prose."[9] For Guha, the elite histories of Indian nationalism narrated history from the point of view of the colonizer and were thus incomplete, ignoring the subaltern, defined as the people and the everyday. Subaltern history is not unified, but expressed in "living contradictions" that must be charted by looking at the overlaps, contacts, struggles, and accommodations between elites and subalterns.[10] Partha Chatterjee has also elaborated on subaltern history as a more "intricately differentiated and layered" process of restoring active agency to the everyday that involves not unities, but a "constant process of interrogation and contestation, modifying, transforming and enriching."[11] Guha advocates for an opening up of all the pasts, not simply one, to retrieve retellings, reperceptions, and remakings of our narratives, which are always, and ultimately, acts of invention of possible futures.

Guha's critique of historiography and his vision for a historical practice that is renewed and revitalized through a grounding in life rather than in the maintenance of state power are instructive for thinking through a different film historiographic practice that includes amateur film. Although the histories of narrative commercial cinema have taught us how to understand the operations of global culture in its corporate phase, this work perhaps has

operated as a statist historiography issuing forth from narrating the nation, rather than emerging from the listener.[12] In Guha's terms, home movies are stories from the listeners, not the storytellers. It is not that home movies are new, but that our historiographic vision of them is new, a vision that considers these works by the listeners grounded in the everyday as important and valuable.

*Mining the Home Movie* hopes to open up a way of thinking about film and media historiography that would entail analyzing a more diverse media ecology of a range of discourses and practices. Two contributors to this volume illustrate this diverse media ecology within amateur films themselves. Nico de Klerk describes a collection in the Nederlands Archive/Museum Institute in Amsterdam called *Onze Filmsterren* ("Our Film Stars"), promotional Hollywood films for Dutch audiences produced at the time of the internationalization of the American film industry. The films show movie stars as ordinary people with private lives in the visual idiom of home movies, thereby complicating any easy definition of the amateur as dislocated from industry. On the other hand, Michele Kribs explains how a collection of films from the Oregon State Historical Society's Moving Image Archives, which were shot during the Depression, feature footage of activities ignored in nearly all other amateur films: the Depression and the labor process involved in coastal fishing. This book hopes to excavate and reclaim these variegated lost cinemas of amateurs as a vital and necessary act of agency and storytelling against inaction and amnesia. Rather than analyzing inert artifacts, our project proposes a collective action of digging up, exhuming, mining, excavating, and recontextualizing that which has been buried and lost— amateur films and home movies. This work is not exclusively about reclaiming lost cinematic objects. It marshals a range of methodologies and strategies to enrich our explanatory models, and thus to understand the significance of amateur film for film and social history.

## The New Amateur Film Movement

The home movie is a subset of the amateur film movement located within individual and/or familial practices of visual recording of intimate events and rituals and intended for private usage and exhibition. The European organization for amateur film, Association Européene Inédits (Inédits), for example, defines a home movie as a moving image recording any aspect of society but never intended for professional distribution or access: "*Inédits* images are of any aspect of our life in our societies, past and present. These

amateur films and videos can be produced in all formats but are originally not meant for viewing in professional audio visual circuits."[13]

Amateur film encompasses a much wider field than home movies and includes any work that operates outside of exchange values and is not produced to function as an exchange commodity. It includes a variety of ethnographic, industrial, labor, scientific, educational, narrative, travel, missionary, explorer, cine club, art, and documentary forms produced for specialized exhibition in clubs, churches, and schools and on lecture tours. The home movie is a small subset of the larger, multilayered complex of international amateur film.

Home movies assume many shapes and elude fixity. Consequently, some home movies are enfolded into other articulations of amateurism, such as industrial or travel or missionary genres. The borders between home movies and these other forms—including narrative film—constantly shift within different historical, cultural, and minority configurations. As unresolved, open texts, home movies operate as a series of transversals, translations, and transcriptions between history and memory, between text and context, between the public and the private.

For the last twenty years, a disparate group of scholars and archivists have been working toward expanding the notion of the film archive and film history beyond the borders imposed by considering only commercial film or national cinemas. They seek to democratize film history by expanding its range of discursive formations, locations, and practices. It is important to place their essential work within the larger context of international film preservation. According to most archivists and historians, approximately 50 percent of all Hollywood features before 1951 shot on nitrate are now lost. It is estimated that 80 to 90 percent of all silent films are lost. For post-1951 cinema, deterioration of color stocks and negatives is massive, and this loss includes works dating from as recently as the 1980s and 1990s.[14] Many archives around the world are public institutions, dependent on national arts funds to support their acquisition, preservation, and access. Since 1989, economic and social privatization of formerly public resources, as well as defunding of artistic production, has severely reduced available funds, placing film archives in a position of continual lobbying and politicking for significance. By necessity, film archives, as organizations dedicated to creating historical legacies, have entered the realm of public policy advocacy.

However, in the shifting economic terrain of transnational media corporations, the most valuable real estate of the Hollywood studios now resides in their own film archives. Within the context of new digital technologies for distribution and the multiplication of distribution channels beyond the theater, archival materials present significant cost savings that enable the endless

recycling, repackaging, and reformatting of work without the risky outlay of production costs.[15] Works now live in multiple formats, traveling from film to video to cable to DVD, and they are also reedited and repackaged for different target markets in endless iterations. The transnational media industries' economic incentive to capitalize on their archives as a way to generate a higher return on investment, combined with their transformation from production to protection of intellectual property, creates the larger economic context for the expansion of the film archive.

Scholarly and archival interest in both the United States and Europe has signaled a move to consider visual historical evidence from sources other than commercial production houses as a way to expand visual representation and to represent a wider and more diverse range of historical experience. Since the early 1980s, spurred by "the new history," many disciplines, including sociology, communications, history, politics, and cultural studies, have moved toward analyzing everyday life.[16] The scholarly, archival, and artistic interest in home movies as an important body of repressed knowledge to be reactivated and reworked within new historiographic and artistic paradigms emerged within this larger scholarly context of searching for a form of history that was diverse, multicultural, racialized, feminist, and regional.

A large body of independently produced experimental and documentary work emerged in the 1980s, often intermingling genres and source material like home movies and influenced by the feminist, civil rights, and antiwar movements of the 1960s and 1970s. These works moved beyond the compilation-focused, evidentiary-driven histories that so identified independent documentary in the 1970s, exemplified by such diverse works as *Amerika, The War at Home, The Good Fight,* and *Rosie the Riveter,* with their epic quality of giving voice to unknown everyday figures of political history. These newer works combined historical exhumation of lost voices with artistic manipulation of lost images, interrogating the fracture between archival history and personal memory. The work of artists like Richard Fung, Daniel Reeves, Lise Yasui, and others conceptualized history beyond great events, moving it toward a tactic of psychic tracings. These artists positioned the family and identity formation as sites for politics, history, and resistance to larger events and structures by hybridizing diverse source material such as newsreels, interviews, experimental forms, testimony, and home movies.[17]

By 1988 in the United States, there was an escalation in the conflict between public archives, interested in the preservation of historically significant materials, and the Hollywood film industry, which was intent on capitalizing on and creating new markets for archival films through new technologies.[18]

Ted Turner was colorizing classic black and white films, a practice vocally protested by film archivists, who argued he was destroying material culture and altering the originals. The ensuing battle pitted the moral rights of authors, the position adopted by film historians and archivists, against the economic rights of producers. Jack Valenti of the Motion Picture Producers Association, the trade organization and lobby for transnational media corporations, advanced the industry's position of economic rights, while the Film Foundation, a consortium that included directors Martin Scorsese, Steven Spielberg, and Francis Ford Coppola, argued for moral rights. The compromise legislation, enacted into federal law in 1988–89, focused on preservation of films.[19] The new U.S. law elaborated protections against the material alteration of film. It also established the National Film Registry in direct response to Turner's colorization of films for cable broadcast. Each year, the National Film Registry was to enlist nominations from scholars, directors, curators, and other film professionals and develop a list of twenty-five historically significant films that were at least ten years old.[20]

By 1993, the U.S. government had held hearings in Los Angeles and Washington, D.C., to assess the state of film preservation, access, and archives. Testimony from various archivists at both large national archives and smaller regional archives explained that extensive areas of film culture beyond the commercial Hollywood studios had been ignored. The archivists argued that these works comprise a significant part of the historical record of American life. Some testimony estimated that perhaps less than 1 percent of amateur film and home movies had been archived. Other testimony identified many other areas of cinema in need of acquisition, preservation, and restoration by archives that would expand, revise, diversify, and complicate American film history: corporate industrials, training films, travel films, scientific films, independent documentaries, experimental films, educational films, amateur films, and home movies.[21] The hearings demonstrated the need for the film archive to move from the univocality of studio productions to the polyvocality of a diverse media ecology that also has a historical legacy.

Many regional and smaller specialty archives sent representatives to testify, including Northeast Historic Film in Maine, the Prelinger Archives, the Human Studies Film Archives at the Smithsonian Institution, and the Japanese American National Museum in Los Angeles. These archives were at the forefront of amateur film collection in the 1980s and 1990s. The archivists' testimony emphasized that amateur film and home movies were often the only cinematic materials documenting and tracing regional history and minority voices. Their testimony illustrated that commercial Hollywood films constituted only one layer of our national visual culture legacy. A plethora

of other forms of cinematic practices suggest a much more diverse media ecology and history.

In 1996, U.S. federal law authorized the formation of the National Film Preservation Foundation (NFPF), a consortium composed of members of the public and private sectors with the explicit purpose of preserving and making accessible regional and orphan films.[22] The term *orphan films* was coined to categorize this wide range of works that were produced outside of commercial venues and without copyright. Federal law defines orphan films as noncommercial films without a home (such as amateur film, home movies, industrials, educational films, independent films, documentaries, and experimental work) that deserve archival acquisition, preservation, and access. The foundation's primary mission is to save orphan films, films without owners able to pay for their preservation. As the Library of Congress notes in its explanation of the law, "The films most at-risk are newsreels, silent films, experimental works, films out of copyright protection, significant amateur footage, documentaries, and features made outside the commercial mainstream. Orphan films are the living record of the twentieth century. Hundreds of American museums, archives, libraries, universities, and historical societies care for 'orphaned' original film materials of cultural value."[23] In 2000 the NFPF produced a collection entitled *Treasures from the American Film Archives,* consisting of five DVDs (and a descriptive book) containing fifty restored regional orphaned films, including experimental films, animation, home movies, propaganda films, and early silent films. This landmark project collected a range of works from 1893 to 1985 and made them accessible for screenings to a wider range of audiences, especially in university film studies and American studies classrooms, by pricing the set at an affordable $99.

In 1999, the Association of Moving Image Archivists had established the Small Gauge Task Force, composed of representatives from archives that had cleared the path for collecting amateur film, including the Japanese American National Museum, Northeast Historic Film, and the Smithsonian in the United States and the National Archives of Canada. The Task Force works to define the selection criteria for small-gauge films, establish technical criteria, and develop strategies for outreach.[24]

In 1999, film historian Dan Streible and several other interdisciplinary faculty members at the University of South Carolina initiated a symposium on orphan films that drew together archivists, film historians, artists, curators, and others to discuss and screen these works within a rigorous scholarly context. Orphan Film Symposium I was entitled "Orphans of the Storm: Saving Orphan Films in the Digital Age" and was held in September

1999. Orphan Film Symposium II, "Documenting the 20th Century," was held in March 2001; Orphan Film Symposium III, "Sound/Music/Voice: Listening to Orphan Films," in September 2002; and Orphan Film Symposium IV, "On Location: Place and Region in Forgotten Films," in March 2004. These four symposia have functioned to generate new research and curatorial activities and have lent increased visibility to the orphan film cause. They have also provided a significant academic and curatorial context for amateur film research.

The Orphan Film symposia, together with an important presence for orphan, amateur, and small-gauge films within the Association of Moving Image Archivists throughout the 1990s and afterward, suggest the coalescing of various international and regional movements to look more closely at these subaltern cinemas. Until the 1990s, home movies and amateur film were typically not archived; instead archives around the world focused primarily on the preservation and restoration of feature films representing the various expressions of national cinemas, with secondary attention to documentary. A few public archives—most notably the Japanese American National Museum, Northeast Historic Film, the Human Studies Film Archives, and the Nederlands Archive/Museum Institute—and a few private collectors who were mostly experimental documentary filmmakers—such as Alan Berliner (United States), Péter Forgács (Hungary), Daniel Reeves (Scotland), and the organization Reel Folks (Canada)—have created an international movement to redirect film history and film archives away from an exclusive emphasis on commercial features and national art cinemas toward noncommercial works produced by everyday people. Significant archival reclamation of amateur films has also been undertaken by regional film archives across the world, in part as a response to limited development of national feature film industries in certain countries. Archives in Wales, Scotland, Singapore, Mexico, and Colombia exemplify this strategy of using amateur film to redefine national identity in the absence of a significant indigenous film industry.

Various academic and journalistic sectors of the international amateur film reclamation movement have also published books, monographs, and special edited volumes dedicated to analyzing and understanding home movies and amateur film as an untapped area of film history requiring further exploration and theorization. In 1986, the *Journal of Film and Video* was one of the first scholarly journals to dedicate an entire issue to the question of amateur film and home movies, with articles spanning technological history, the use of home movies in the avant-garde, and the deployment of amateur film in documentary and narrative film. In France in 1995, the Centre Georges Pompidou published *Le je filmé,* a collection of essays that

investigated how experimental filmmakers invoked home movie forms in their work. In 1995, my *Reel Families: A Social History of Amateur Film* (Indiana University Press) was the first book-length history of amateur film to be published in the United States. The Association Européene Inédits, dedicated to advancing the cause of amateur film archiving, preservation, and scholarship, published a special volume on amateur film in 1989. In 1999, Roger Odin, working through his research group on amateur film at the Université de Paris–Sorbonne Nouvelle, published a special issue of the prestigious French journal *Communications* on amateur film and home movies, demonstrating the variety of methodological approaches that could be deployed to understand amateur film from multiple national origins.[25]

In 2001, the Association of Moving Image Archivists (AMIA) launched its own scholarly journal, *The Moving Image,* founded and edited by film historian and archivist Jan-Christopher Horak. The journal has pioneered publishing international research articles on a wide range of amateur film and home movie issues, including theoretical works, preservation and restoration topics, film reviews of artists' works recycling these materials, and examples of innovative exhibition and educational outreach initiatives. Virtually every issue of the journal features an article on amateur film, spurred in part by the long-term interests of AMIA members in the subject and by the impact of federal laws identifying orphan films as a specific category of international film culture requiring systematic attention. As a result of this publication orientation, *The Moving Image* is considered the leading international journal for groundbreaking scholarly and archival work about amateur cinema, and is virtually the only publication of its kind that integrates discussion of the theory, practice, filmmaking, acquisition, preservation, and restoration of amateur film.

Starting in 1989, Association Européene Inédits, with members from Germany, Belgium, France, Finland, Portugal, Holland, Spain, Hungary, and Uruguay, began to meet, publishing its proceedings in a monograph entitled *Images, Mémoire de L'Europe.* Afterward, Inédits expanded to include members from Scotland and Wales and published a periodical called *Inédits Memo.* Currently Inédits includes scholars, archivists, television producers, filmmakers, sociologists, geographers, semioticians, and film historians.

By the late 1980s, the North American Association of Moving Image Archivists Inédits group had been formed with the purpose of supporting archives and curators with an interest in developing amateur film as an archival subfield. This group became a major presence in the Association of Moving Image Archivists. North American archives with substantial collections of amateur film, most notably the Japanese American National Museum,

Northeast Historic Film, the Smithsonian, and the National Archives in Canada, spearheaded this initiative. In 1996, two separate issues of the *Journal of Film Preservation* (published by the Federation Internationale du Archives du Film [FIAF]) investigated various aspects of amateur film in collections around the globe from the point of view of selection, preservation, restoration, storage, and significance.

In 1996, the U.S. National Film Preservation Board named the Japanese American home movie *Topaz*, shot during World War II by prisoner Dave Tatsuno at the Topaz War Relocation Authority Center in Topaz, Utah, to the National Film Registry. *Topaz* was the second amateur film named to the registry, following the Zapruder Film of President Kennedy's assassination. The naming of *Topaz* to the registry was extremely important because it signaled that home movies had achieved recognition as historical documents worthy of protection, shelf space, and preservation. Karen L. Ishizuka's and my essay in this volume called "The Home Movie and the National Film Registry" provides a detailed insider chronicle of how the film was recovered, donated to the Japanese American National Museum, used in exhibitions and independent films, and broke the color line in the National Film Registry. Several other amateur productions were subsequently named to the registry: *Multiple Sidosis* (1970), an experimental film with multiple image processing techniques done by an amateur; *Cologne* (1939), an amateur travelogue chronicling a town in Minnesota; and *From Stump to Ship* (1930),[26] an amateur industrial from Maine.

In 1997 in Cartagena, Colombia, the FIAF Congress—for the first time in its history—ran its entire meeting on the theme of amateur film, with archives around the globe presenting works (including a presentation by Karen L. Ishizuka and Robert A. Nakamura on their home movie retrieval project of films shot in the World War II relocation camps for Japanese Americans) and a few scholars, including myself (United States), Roger Odin (France), Nico de Klerk (Holland), and John Homiak (United States) also participating.[27] In 1998, the Getty Museum hosted a landmark event, sponsored by research director Michael S. Roth and organized by Karen L. Ishizuka, then a Getty fellow, entitled "The Past as Present: The Home Movie as Cinema of Record," at the just-opened Getty Research Center. Ishizuka elaborates on this symposium in her foreword.

Then, in 2002, a small group of film archivists that included Snowden Becker, Brian Graney, Chad Hunter, Dwight Swanson, and Katie Trainor launched "Home Movie Day," an annual grassroots event focused on screening and collecting amateur films from regional communities in the United States. Each year a contact person in various communities from Florida to New

York to California arranges a public screening of home movies brought by their makers (or collectors). These public screenings highlight the need for home movie preservation and archiving, and also serve to create public awareness about the importance of amateur films as part of the record of the twentieth century's visual culture.

## Transformative History

Hayden White has argued that history is an imaginative and transformative act, one in which fiction and fact endlessly flow in and out of each other. He sees the historian's work as a process of active engagement of transforming archival materials, rather than the delivery of facts and evidence. He argues that historiographic practice needs to be reimagined: "I think the problem now, at the end of the twentieth century, is how we re-imagine history outside of the categories that we inherited from the nineteenth century."[28] In his essay in this volume, "Remaking Home Movies," Chinese-Trinidadian Canadian film and video artist Richard Fung explains how his films, which extensively use home movies, map relationships among the social, historical, and familial in transcultural contexts. Fung points out that home movies cannot speak for themselves; they require juxtaposition of other images and ideas so their embedded ideologies are denaturalized. In his film *Sea in the Blood* (2000), he juxtaposes his lover's AIDS with his sister Nan's death from thalassemia, figuring the home movies of her as acts of commemoration. For White and for Fung, the real is not a fact, nor is it an inert object located in the archive. White expands history beyond factual evidence by mobilizing the imaginary and new categories to deepen historical explanation.

*Mining the Home Movie* situates home movies as active recoveries of histories and memories that seek to engage in collaborative discourse with others. By creating larger spheres of collectivity, fractures of trauma are repaired.[29] These home movie images cannot be viewed as inert documentary evidence, but need to be reconsidered as mobile constructs, activated in different ways through different historiographic and artistic strategies. In her essay "*90 Miles,*" film theorist Amy Villarejo unpacks how this independent documentary film by Juan Zaldívar about being Cuban American and queer deploys a composite, mosaic, layered effect through a visual collage of familial, national, political, and home movies. She shows how the film was produced in collaboration with the Florida Moving Image Archive, the organization that has amassed a substantial collection of amateur film of Cuban immigrants in Miami. As they move from attics to archives, from private use

to public reclamation, home movies transform into public memory, mobilizing history as something particular, local, specific. What was fictional can transform into fact; what was factual can suggest a new fictional alchemy.

Because authorship has frequently been denied to people of color, women, and working people, in this project we focus on home movies that rewrite the body of difference into the text to sustain larger contexts. Our project sites home movies as complex, sedimentary, active, and contradictory practices of imaginative and transformative historiography rather than as a unified discourse. Karen L. Ishizuka, in her piece *"Something Strong Within,"* uses home movie images from her and Robert A. Nakamura's film to emphasize how an insistence on the everyday in oppressive circumstances can function as racialized identity formation and authorship. In his essay *"Something Strong Within* as Historical Memory," film scholar Robert Rosen's close textual reading shows how the film, composed out of home movie images by various Japanese Americans in the concentration camps during World War II, constructs a polyvocal text of multiple voices, temporalities, and dissonances: those of the original home moviemakers, Nakamura the documentary filmmaker, the musical score, and the spectators.

Developing this line of thought about the political function of history, Tzvetan Todorov has advanced that "totalitarian regimes of the twentieth century have revealed the existence of a danger never before imagined: the blotting out of memory. These twentieth century tyrannies have understood that the conquest of men and territories could be accomplished through information and communication and have created a systematic and complete takeover of memory, hoping to control it even in its most hidden excesses."[30] F. K. Ankersmit has similarly argued that "the time has come that we should think about the past, rather than investigate it."[31] Similar to Guha and White, Ankersmit argues for a reconceptualization of history as an interrogation of the incongruities between the past and the present and the invention of new languages for speaking about their juxtaposition. For White, the idea of an inert, immobile past that is evidentiary and empirical is a fallacy. He claims, "It is impossible to legislate the way people are going to relate to the past because, above all, the past is a place of fantasy. It does not exist anymore. You can't replicate, by definition, historical events."[32] This book, in a small way, hopes to develop a new language for thinking about White's historical "place of fantasy."

For home movies, signification is often not embedded inside the representation. In his essay "Ordinary Film: Péter Forgács's *The Maelstrom*," intellectual historian Michael S. Roth argues that this film, composed from home movies shot by a Jewish family, the Peerebooms, during the Nazi occupation

of the Netherlands, focuses on the banal and the ordinary rather than the metaphysical, preserving the ordinariness in the extraordinary times of the Holocaust. He demonstrates how Forgács's editing and soundscapes balance the contingency and ephemerality of these joyful amateur films, suspended in the interstitial zone between trauma and representation, with fate and necessity. As dreamscapes condensing and displacing memory and history, home movies suggest a rethinking of and reorientation about which language and theoretical models are appropriate to decipher their syntax, grammar, codes, and production of knowledge. Amateur film and home movies occupy an ambiguous zone of practices and knowledges, demonstrating extensive variegation and complexity.

## The Endless and Open Archive of Home Movies

Home movies constitute an imaginary archive that is never completed, always fragmentary, vast, infinite. This imaginary archive is transnational in character, a depository of linkages among nations, communities, politics, identities, and families. Three contributions from archivists illustrate how the national is always imprinted by the international, and how it is always problematized in amateur film. Carolyn Faber, discussing the WPA Film Library, explains how amateur filmmakers photographed the World's Fair and then made travelogues of their foreign travel. Brian Taves elaborates on footage in the Library of Congress that includes Hollywood director George Stevens's images of World War II, travelers' explorations around the globe, and Hollywood stars, indicating the multiplicity of visions and formulations of the international in one archive. On the other hand, Iván Trujillo from the Filmoteca de la Universidad Nacional Autónoma de México shows that the term *amateur* includes a range of materials that question the formation of national identity as unified and the construction of amateur film as a stable category. He describes a 35mm film that straddles the line between professional and amateur, the films of an Ecuadorian priest in Mexico, and home movies with images of dancers and bullfights that typify Mexico.

This book recenters the visual document as historical artifact.[33] Its essays address the home movie's visual articulations of histories, always a plural and multiple formation. The essays that discuss the contemporary representation of historical footage within contemporary media productions conceptualize home movies as microgeographies and microhistories of minoritized and often invisible cultures that are social and highly political. Home movies are fractured, always incomplete, historical memories.

This book also connects the various sectors of the growing international movement dedicated to investigating amateur films and advocates a multi-disciplinary imperative of academic, archival, and artistic inquiry in the study of home movies. Multiple methodologies and theoretical models generated from a variety of disciplines are necessary. As historical artifacts, home movies are deep condensations of the sociological, aesthetic, economic, and cultural spaces of the places and time periods in which they were created and of the people who created them. As visual representations, they comprise a distinctive intimate authorship that graphs the depths and complexities of collective memory. As a means of expressive communication, they are reflexive constructions inflected by both deliberate and unconscious social, political, and psychic dynamics, symptoms of the contradictions between everyday and popular culture.

In the popular imagination, archives often are framed as the depositories of old, dead cultural artifacts. But archives are never inert, as they are always in the process of addition of new arenas and unknown objects. The archive, then, is not simply a depository, which implies stasis, but is, rather, a retrieval machine defined by its revision, expansion, addition, and change. Jacques Derrida, in his book *Archive Fever,* has stated, "The archivist produces more archive. The archive is never closed. It opens out of the future."[34]

The archive functions as the custodian of collective memories laced with contradictions and ambiguities. It is marked by and inscribed into power relations: who has the power to keep records of the past?[35] What is saved in archives often determines what gets theorized, analyzed, interrogated, deconstructed, activated. In "Deteriorating Memories," her essay in this volume, Ayisha Abraham confronts the issue of producing an archive for amateur film when no public archive in India now collects it. Using the metaphor of archaeology, she explains her journey to recover amateur films, the fossils of cinema, in India, only to discover that the category expands to visual artists working in film, documentaries that blur fact and fiction, the short film movement, semiprofessional narratives, and independent works and family films.

Over the last two decades, movements in such areas as feminist studies, minority discourse, poststructural historiography, postcolonial theory, and public history have challenged conventional assumptions, definitions, and perspectives of history-writing as objective, empirically based, and causal.[36] These critical areas have underscored how conventional history-writing reproduces the power relations of the testimonies, documents, and archives it cannibalizes. They have impelled historians to move not only toward analyzing documents, but toward creating and finding new archival sites. These

methodologies have propelled a shift in historiography toward considering not only the nature of evidence, but also the nature of the archival collection, its gaps, fissures, silences, vacancies, elisions. Home movies offer a still emerging, yet to be congealed, constantly expanding historical archive of imagery and imaginaries.

## Collaborative Histories

As first-person documentation of history and culture, home movies provoke reexamination of issues of identity, culture, history, politics, and memory from the point of view of images made outside the dominant channels of representation. Home movies are always gendered and racialized. Sometimes referred to as "auto-ethnographies," home movies position history as memory generated from the point of view of participants. Three important archival collections exemplify this idea of home movies as auto-ethnographies from the inside. In his chapter in this book, Kay Gladstone discusses a collection of home movies in the Imperial War Museum in London that chronicle childhood in wartime: the concealment of Jewish children in Belgium during the German occupation and the home movies made during this time by one family. He explains how the museum involved the original participants in oral histories while they were watching the footage. In his essay, Ross Lipman highlights the Stephen Lighthill Collection at the UCLA Film & Television Archive. Now a professional cinematographer, Lighthill began his career as an amateur in the San Francisco Bay area with virtually no formal training, documenting the civil rights and antiwar movements from the inside in collaboration with the American Documentary Collective. On the other end of the political spectrum, Steven Davidson shows that amateur films donated by Anita Bryant's ex-husband provide an important record of the antihomosexual Save Our Children campaign she promoted in the early 1980s. Davidson goes on to explain how the vast collection of amateur films in the Florida Moving Image Archive that date from the beginning of the twentieth century documents the economic development of the south Florida region. In other words, home movies constitute memory from the inside rather than history from the outside, a narration and signification that dismantles the representation of minority cultures as victim.[37]

Home movies, then, can be framed as collaborative histories. Anthropologist and filmmaker David MacDougall has proposed to move ethnographic film away from making a film "about" toward making a film "with." Rather than a filmmaking strategy that is an omniscient monologue, he proposes

the act of cinema as a contemplative and participatory act that is always a relation and an encounter, an act of collaboration and dialogue between the subject and the person filming. MacDougall argues for interconnection rather than separation to produce a compound work and an elaborative, embodied knowledge. In detailing his ideas about a collaborative ethnography, he explains, "The goal is not simply to present 'the indigenous view' nor to invade voyeuristically the consciousness of other individuals, but to see social behavior and indeed culture, as a continual process of interpretation and invention."[38] In their chapter, archivists Karan Sheldon and Dwight Swanson, from Northeast Historic Film in Maine, describe the *Movie Queen* films of Margaret Cram, an example of community-based amateur filmmaking that combined traveling actors, local performers, and shots of local sponsors' storefronts to tell the story of a local woman who returns from Hollywood and then is confronted with gangsters. Through interviews with participants in the small Maine towns where these films were made, Sheldon and Swanson show how amateur films conflate with community-based filmmaking in narrative film practice. A form of collaborative history from the viewpoint of labor is found in Virginia Callanan's explanation of trade union films shot by participant observers in New Zealand during the marches, meetings, protests, and waterfront lockouts of 1951, one of the most significant moments in New Zealand labor history. MacDougall's conception of a collaborative ethnographic film practice is a useful construct for a theorization of amateur film as a form of auto-ethnography, because it is a form of cinema in which, typically, both sides agree to participate in an act of performativity to make a collaborative history.

In this book, we situate home movies as a collaborative history of trauma. Home movies, because they are both interactive and subaltern, necessitate a reexamination of visual evidence, film history, and historiography. The historical reclamation of home movies is linked explicitly with the developing area of trauma, a response to the surface vacuity of postmodernism and a return to the referent and the real.[39] Home movies are not simply documentary evidence of some lost event, but are symptomatic tracings of a trauma that is unresolved yet worked out through images, words, testimonies. In their chapter, anthropologist John Homiak and archivist Pamela Wintle focus on three collections from the extensive amateur archival holdings of the Human Studies Film Archives of the Smithsonian Institution that function as symptomatic microhistorical mappings of geopolitical conflicts. The films discussed graph the overt political traumas of the Czech invasion in 1968, the complex identities of a Greek American, and South African apartheid. We define historical trauma in our project as those traumas that exceed the self and are so

large, so contradictory, that they become silenced and invisible. They form the girders of history, yet are often unseen and unknown, hidden streams beneath the larger events. These traumas require testimony with others to move beyond the symptom into history.[40] Public memory is that ephemeral, constantly shifting, and imagined construct that moves from the private, silenced, and repressed trauma to the public, performative, and activated mode of historical agency. Public memory speaks beyond the self of a past mobilized for the future.[41]

As a cinema of recovery, home movies unsettle homogeneous, unified official history by locating records as incomplete, fragmentary articulations of difference—in locale, ethnicity, sexual identity, gender, region, nation—and hence provoke a reexamination of what constitutes evidence. As a cinema of memory, home movies not only function as empirical evidence of otherwise lost events; they are at the same time political interventions, dreamscapes, and phantasms suggesting collisions among different spheres and contiguities across differences.

For many ethnic/cultural/regional communities, amateur film footage may very well be the only source of moving image documentation that exists. For underrepresented communities, family albums and home movies provide visions of history and culture that would otherwise go unseen and unknown by the general public.

## Toward Historical Collage

This book confronts a historiographic challenge: how to organize a series of seemingly disparate texts from multiple theoretical perspectives (such as those of the scholar, artist, and archivist) and different locations. Some of our writers analyze the amateur films themselves. Others theorize how amateur films operate within independent documentaries as a form of counterhistory. Another group of essays theorizes the practice of archival recovery and the practice of amateurism as a condensation of psychic and historical movements.

How can these different approaches be mobilized into a collaborative project to demonstrate the resonances between amateur film practices separated by time, geography, and disciplinary approach? It would be far too facile and ultimately reductive to organize this book according to groupings by logical type, with all the archives in one section, all the scholarly and theoretical essays in another, and all the works that recontextualize amateur films in another, because that would suggest a separation between each of

these uses and locations when, in fact, they are interdependent and resonate with one another. The polyvocality and heterogeneity of materials in this volume are congruent with theoretical developments asking how to create explanatory models out of fragmentary evidence, subaltern voices, and multiple approaches. Rather than continuities or a linear progression, contemporary theory has looked toward contiguities, the idea of spatializing through association and collage, as a way to connect evidence and ideas through conceptual connections rather than causality.

Contemporary theory in both ethnography and historiography has grappled with the problem of how to construct historical models based on heterogeneity, plurality, and polyvocality, moving from one set of evidentiary groups to many different registers and kinds of evidence. Commenting on the need for a transcultural ethnography that takes into account multiple interstices and disjunctions, David MacDougall has observed that "the transcultural makes possible an overlapping of experiential horizons, where certain indirect and interpretive leaps of understanding can take place."[42] Arguing that the politics of including minorities in the history of India goes beyond the embrace of a new set of archives and instead raises questions of explanatory models, Dipesh Chakrabarty claims that the past is disjoined in nature and always plural: "Thus the writing of history must implicitly assume a plurality of times existing together, a disjuncture of the present with itself. Making visible this disjuncture is what subaltern pasts allow us to do."[43]

Robert Berkhofer has pointed out that historiography's engagement with Foucault and postmodernism has pushed aside coherency, continuity, and univocality for fragmentation, differentiality, and polyvocality to demonstrate how the local and the contingent can become more salient. He shows how traditional notions of historical continuity are displaced by heterogeneity and discontinuity.[44] And in cinema studies, Philip Rosen has advocated for a model of temporal hybridity that is counterposed to the linear coherences of historiography and the pursuit of an authentic, transcendent "pastness."[45]

In history, the process of explaining an event by collecting what seem to be isolated facts under a general hypothesis is called *colligation*. In the arts, the connection of different kinds of materials and forms to create collisions that in turn generate new ideas is called *collage*. Montage, the cinematic form of collage, has a long history in cinema as well, derived from the theories of Dziga Vertov and Sergei Eisenstein, who advocated for different ideas operating in collision to create new synthesis and conceptual ideas.[46] *Mining the Home Movie* takes these ideas about colligation, hybrid temporalities,

polyvocality, and plurality and organizes itself around the idea of collage: here scholarly essays are intertwined with writing about artifacts by archivists and mobilization of artifacts by media artists.

In designing this structure, we have created a conceptual model that moves the reader from essays that recontextualize amateur films to narrate history from below through difference, to an exploration of the problematics inherent in the expansion of the amateur film archive, to metatheoretical essays that propose new models for amateur film analysis and archives. Throughout, we have sought to create contiguities and congruencies between and through materials through juxtaposition and resonances. For example, Rosen's essay about *Something Strong Within* is followed by an essay from Karen Ishizuka describing less traumatic amateur films of daily life in the Japanese American National Museum, the museum that initially located these materials. Heather Norris Nicholson's essay on amateur films about the workplace is next to the New Zealand Film Archive's discussion of material chronicling the labor movement. Ross Lipman's discussion of the UCLA Film & Television Archives' Stephen Lighthill Collection, which chronicles the antiwar movement and raises the issues of what is amateur and what is semiprofessional, is placed between Roger Odin's and my essays, which argue for a more complex and more fluid notion of amateur film practice that involves combining political and psychoanalytical theorization. Karen Glynn's essay on amateur films of African American mule racing in the South as a form of racialized spectacle is bookended by Lynne Kirste's discussion of images of the Negro Leagues baseball teams and Carolyn Faber's discussion of travelogues and world's fair films.

*Mining the Home Movie* reclaims amateur film as an active, constantly changing historiographic practice that creates contiguities, continuities, collaborations, and convergences across borders of nations, identities, genders, ethnicities, races, sexualities, and politics. Through their different modalities, home movies work through—in the psychoanalytic sense of moving beyond repetition—memory and meaning, text and context, politics of representation, historical inquiry, auto-ethnography, and racialized, localized histories.[47]

Yet, overarching these academic concerns, these essays remind us that the images we recover are always acts of mourning for those who have passed, markers of loss and trauma. It is our responsibility to name these ghosts and make them real through materialization. And it is our responsibility to remember, not with nostalgia for that which is lost, but with hope that the materiality of these images can be restored and opened to the future through a reconnection with history and others.

## Notes

1. For an overview of the historical development of amateur film in the United States, see Patricia R. Zimmermann, *Reel Families: A Social History of Amateur Film* (Bloomington and Indianapolis: Indiana University Press, 1995).

2. For discussions of Hollywood narrative, see, for example, Joanne Hollows and Mark Nacovich, eds., *Approaches to Popular Film* (Manchester, UK: Manchester University Press, 1995); Jim Hillier, *The New Hollywood* (London: Studio Vista, 1992); David Bordwell, Janet Staiger, and Kristin Thompson, *The Classical Hollywood Cinema: Film Style and Mode of Production to 1960* (New York: Columbia University Press, 1985); Jon Lewis, *The New American Cinema* (Durham, NC: Duke University Press, 1998); and Geoff King, *New Hollywood Cinema: An Introduction* (New York: Columbia University Press, 2002).

3. For overviews of the impact of these different schools of historiography, see Alun Munslow, *Deconstructing History* (New York: Routledge, 1997); and Vinayak Chaturvedi, ed., *Mapping Subaltern Studies and the Postcolonial* (London: Verso, 2000).

4. See E. P. Thompson, "History from Below," *Times Literary Supplement,* April 7, 1966, 269–80; E. P. Thompson, *The Making of the English Working Class* (London: Vintage, 1966); Natalie Zemon Davis, *Society and Culture in Early Modern France* (Palo Alto, CA: Stanford University Press, 1977); Emmanuel Le Roy Ladurie, *Montaillou: Cathars and Catholics in a French Village, 1294–1324* (London: Penguin Books, 1990); and Eric Foner, *Who Owns History? Rethinking the Past in a Changing World* (New York: Hill and Wang, 2002).

5. Jim Sharpe, "History from Below," in Peter Burke, ed., *New Perspectives on Historical Writing* (University Park: Pennsylvania State University Press, 2001), 39.

6. Robert F. Berkhofer Jr., *Beyond the Great Story: History as Text and Discourse* (Cambridge, MA: Harvard University Press, 1995), 53–75.

7. Ranajit Guha, *History at the Limit of World-History* (New York: Columbia University Press, 2002), 45.

8. Ibid., 73.

9. Ibid., 22.

10. Ranajit Guha, "On Some Aspects of the Historiography of Colonial India," in Vinayak Chaturvedi, ed., *Mapping Subaltern Studies and the Postcolonial* (London: Verso, 2000), 5.

11. Partha Chatterjee, "The Nation and Its Peasants," in Chaturvedi, *Mapping Subaltern Studies and the Postcolonial,* 12–22. See also Partha Chatterjee, *The Nation and Its Fragments* (Princeton, NJ: Princeton University Press, 1993); and Partha Chatterjee, *Nationalist Thought and the Colonial World: A Derivative Discourse* (Minneapolis: University of Minnesota Press, 1993).

12. For cogent analysis of how history in film articulates and negotiates popular history, nationalism, and the state, see Marcia Landy, ed., *The Historical Film: History and Memory in Media* (New Brunswick, NJ: Rutgers University Press, 2001); Marcia Landy, *Cinematic Uses of the Past* (Minneapolis: University of Minnesota Press, 1996); and Robert A. Rosenstone, *Visions of the Past: The Challenge of Film to Our*

*Idea of History* (Cambridge, MA: Harvard University Press, 1995). For a discussion of the relationship between narrative structure and conceptions of national identities, see Homi K. Bhabha, ed., *Nation and Narration* (New York: Routledge, 1990).

13. www.aeinedits.org, retrieved July 14, 2005.

14. For a discussion of the development of film archives and the national heritage, see Penelope Houston, *Keepers of the Frame: The Film Archives* (London: British Film Institute, 1994).

15. For a discussion of how the new postindustrial Hollywood depends on archival holdings and their endless recirculation, see Nitin Govil, John McMurria, Richard Maxwell, and Toby Miller, eds., *Global Hollywood* (London: British Film Institute, 2001).

16. For example, see Lynn Hunt, ed., *The New Cultural History* (Berkeley: University of California Press, 1992); Elizabeth Fox-Genovese, *Within the Plantation Household* (Chapel Hill: University of North Carolina Press, 1988); Lizabeth Cohen, *A Consumer's Republic: The Politics of Mass Consumption in Postwar America* (New York: Vintage, 2003); Janet Staiger, *Bad Women: Regulating Sexuality in Early American Cinema* (Minneapolis: University of Minnesota Press, 1995); Ronald Takaki, *From Different Shores: Perspectives on Race and Ethnicity in America* (Oxford: Oxford University Press, 1994); and Ronald Takaki, *A Different Mirror: A History of Multicultural America* (Boston: Back Bay Books, 1994).

17. For overviews and analysis of hybrid compilation documentaries as they emerged within feminist, queer, and racialized politics, see Patricia R. Zimmermann, *States of Emergency: Documentaries, Wars, Democracies* (Minneapolis: University of Minnesota Press, 2000); Diane Waldman and Janet Walker, *Feminism and Documentary* (Minneapolis: University of Minnesota Press, 1999); and Chris Holmlund and Cynthia Fuchs, eds., *Between the Sheets, in the Streets: Queer, Lesbian, and Gay Documentary* (Minneapolis: University of Minnesota Press, 1997).

18. Author interview with Jan-Christopher Horak, Hollywood Entertainment Museum, phone interview, August 1, 2002.

19. National Film Preservation Act of 1988 (Public Law 100–446), United States.

20. Author interview with Eric J. Schwartz, attorney specializing in film archival issues, Smith and Metalitz, phone interview, July 15, 2002.

21. *Redefining Film Preservation: A National Plan: Recommendations of the Library of Congress in Consultation with the National Film Preservation Board* (Washington, DC: Library of Congress, 1994), available at www.loc.gov/film/plan.html, *Film Preservation 1993: A Study of the Current State of American Film Preservation*, vol. 1 (Washington, DC: Library of Congress, 1994), available at www.loc.gov/film/study.html, retrieved July 16, 2005; *Film Preservation Study: Washington, DC Public Hearing, February 1993* (Washington, DC: Library of Congress, 1993), available at www.loc.gov/film/study/html, retrieved July 16, 2005; *Report of the Librarian of Congress, June 1993*, available at www.loc.gov/film/hrng93la.html, accessed June 8, 2005; *Film Preservation 1993: A Study of the Current State of American Film Preservation*, vol. 3: *Hearing, February 26, 1993* (Washington, DC: Library of Congress, 1993); *Report of the Librarian of Congress, June 1993*, available at www.loc.gov/film/hrng93dc.html, accessed June 8, 2005.

22. Title II, The National Film Preservation Foundation Act (Public Law 104–285), October 11, 1996, United States.

23. Available at www.loc.gov/film/filmabou.html, accessed June 8, 2005.

24. www.amianet.org/committees/PastProj/SmallGauge/mandate.html, accessed June 8, 2005.

25. Patricia R. Zimmermann, *Reel Families;* Roger Odin, ed., "Le cinéma en amateur," *Communications,* no. 68 (Paris: Seuil, 1999); Association Europeéne Inédits, *Jubilee Book: Essays on Amateur Film* (Brussels: AEI, 1997).

26. Janna Jones, "Confronting the Past in the Archival Film and the Contemporary Documentary," *The Moving Image* 4, no. 2 (fall 2004): x–21.

27. Jan-Christopher Horak, "Out of the Attic: Archiving Amateur Films," *Journal of Film Preservation,* no. 56 (June 1998): 50–53.

28. "Interview with Hayden White," in Ewa Domanska, ed., *Encounters: Philosophy of History after Postmodernism* (Charlottesville: University of Virginia Press, 1998), 34.

29. Dipesh Chakrabarty, *Provincializing Europe: Postcolonial Thought and Historical Difference* (Princeton, NJ: Princeton University Press, 2000), 180–213.

30. Tzvetan Todorov, "The Uses and Abuses of Memory," in Howard Marchitello, ed., *What Happens to History: The Renewal of Ethics in Contemporary Thought* (New York: Routledge, 2001), 11.

31. Quoted in Domanska, *Encounters,* 294.

32. Ibid., 16.

33. For explorations into the visual as historical document, see David J. Staley, *Computers, Visualization and History: How New Technology Will Transform Our Understanding of the Past* (London: M. E. Sharpe, 2003); Barbie Zelizer, ed., *Visual Culture and the Holocaust* (New Brunswick, NJ: Rutgers University Press, 2001); Bonnie Brennen and Hanno Hardt, *Picturing the Past: Media, History and Photography* (Urbana: University of Illinois Press, 1999).

34. Jacques Derrida, *Archive Fever* (Chicago: University of Chicago Press, 1998), 68.

35. For critical discussions on the political and social implications of archives and museums as institutions that collect and create typographies of data, artifacts, and records, see Foner, *Who Owns History?;* Houston, *Keepers of the Frame;* Richard Roud, *A Passion for Films: Henri Langlois and the Cinémathèque Francaise* (Baltimore: Johns Hopkins University Press, 1999); and Susan A. Crane, ed., *Museums and Memory* (Stanford: Stanford University Press, 2000).

36. For an analysis of the linguistic turn in historiography, see Berkhofer, *Beyond the Great Story;* Keith Jenkins, ed., *The Postmodern History Reader* (New York: Routledge, 1997); and Guha, *History at the Limit of World-History.*

37. For insightful analysis of how amateur and familial photography can be reclaimed, reframed, and remobilized through intervention and transformation, see Marianne Hirsch, *Family Frames: Photography, Narrative and Postmemory* (Cambridge, MA: Harvard University Press, 1997); and Marianne Hirsch, ed., *The Familial Gaze* (Hanover, NH: University Press of New England, 1999).

38. David MacDougall, *Transcultural Cinema* (Princeton, NJ: Princeton University Press, 1998), 95.

39. For a lucid discussion of the relationship of trauma to historical events and historiography, see Cathy Caruth, ed., *Trauma: Explorations in Memory* (Baltimore: Johns Hopkins University Press, 1995); and Cathy Caruth, *Unclaimed Experience: Trauma, Narrative and History* (Baltimore: Johns Hopkins University Press, 1996).

40. For an insightful and far-reaching analysis of the relationship between trauma and testimony, see Shoshana Felman and Dori Laub, M.D., *Testimony: Crises of Witnessing in Literature, Psychoanalysis and History* (New York: Routledge, 1991).

41. See Kelly Oliver, "Witnessing Otherness in History," in Marchitello, *What Happens to History,* 41–66.

42. MacDougall, *Transcultural Cinema,* 272.

43. Chakrabarty, *Provincializing Europe,* 109.

44. Berkhofer, *Beyond the Great Story,* 200–25.

45. Philip Rosen, *Change Mummified: Cinema, Historicity, Theory* (Minneapolis: University of Minnesota Press, 2001), 20–87.

46. Dziga Vertov, *Kino Eye: The Writings of Dziga Vertov,* Annette Michelson, ed. (Berkeley: University of California Press, 1985); and Sergei Eisenstein, *Film Form: Essays in Film Theory* (New York: Harvest Books, 1969).

47. For an analysis and explanation of trauma in literature and history as a working through of symptoms beyond binaries, see Dominic LaCapra, *Writing History, Writing Trauma* (Baltimore: Johns Hopkins University Press, 2000).

# 1   **Remaking Home Movies**

RICHARD FUNG

After I left Trinidad in 1971 to go to school, my mother would send me care packages. In typical Caribbean style, they were seldom mailed but rather entrusted to relatives or family friends. At one point in the 1980s I received such a parcel in Toronto that, instead of the usual guava jelly and Julie mangoes, consisted of a plastic bag containing two dozen reels of 8mm film. In an enclosed note, my mother explained that she had placed the film in an old iron safe—one of several ancient appliances she just couldn't bring herself to discard—that sat in the back of our house. In time, bees had colonized the safe and sealed the lock with wax. After many years, Mom had finally managed to pry it open. Did I want these pictures, she asked?

Alone one night, I ran the film through a Super 8 viewer borrowed from a filmmaker friend. The screen was tiny. The images were almost abstract. Yet each luminous frame opened a successive drawer in an archive of memories. From my present-day life in a gay, leftist commune in downtown Toronto, I was sucked back into the '60s to a Chinese Catholic home in suburban Port of Spain. Even more unsettling than the time travel was the fact that the images on the screen did not sync up with the recollections in my head. I could identify most of the settings and events, and I recognized the actors as my family and myself, but these films contradicted everything I remembered of the tone and texture of my childhood.

These images led me to question the selectiveness of both my own memory and the camera's version of my childhood. I became interested in probing the social and historical processes that helped mold these slanted visions, and I began to ponder how both the pictures and the apparatus of home movies functioned within my family. Over a period of twelve years, I have returned to these questions and to the footage that triggered them. From the original home movies I have produced three single-channel videotapes: *The Way to*

*My Father's Village* (1988), *My Mother's Place* (1990), and *Sea in the Blood* (2000). In differing ways, each of these pieces maps a relationship among the personal, the familial, and the social within a transcultural context. There is a symbiotic relationship between the home movies as illustrations of ideas, and the ideas provoked by viewing and deconstructing the home movies. Like this essay, they are as much reconstructions as excavations of the past.

## The Movies

As a child I remember sending off little yellow envelopes of film for processing and receiving them again in the post weeks later. On the Sunday night after the reels returned from America, the family would gather in the open upstairs porch that served as our living room. Sometimes even my father, who normally spent Sunday nights at the family farm, would stay in the city to attend. My mother would perch the projector on a stool, and I would turn off the buzzing fluorescent ring that was the sun to an inverted savanna of grazing moths and predatory geckos. (I was terrorized by those darting lizards, sure that one would lose its grip and drop on my head as I watched TV.) Once the light was off, the insects would disperse to the nearest street lamp, and the geckos retreated to their lair behind the faded Chinese embroidery that hung above the couch. Mom would turn on the Bell and Howell, and the glamorous beam would shoot across the balmy night.

The screenings elicited a great deal of laughter drawn from a mixture of embarrassment and pleasure at seeing ourselves in a medium reserved for Hollywood movie stars. Sometimes there was disappointment: the reels were double exposed, so that a jet appeared to taxi on the skirt of a wedding dress, or crowds of dancing Carnival revelers seemed to shimmy across a family picnic at the beach. Less often, the cap had been absent-mindedly left on and there was no image at all.

Eight-millimeter film was not available for purchase or processing in Trinidad; both had to be done in the United States. This made movie-making an expensive hobby. Little wonder, then, that special occasions predominate in the films: weddings; departures and returning visits by my siblings studying abroad; Carnival; a royal visit to mark Trinidad and Tobago's independence from Britain in 1962; Christmas and other holidays; and a series of trips abroad.

My mother says that the camera and projector were purchased as a distraction for my second sister, Nan, who suffered from beta thalassemia major, a hereditary blood disease with a poor prognosis. A brother, Ian, had

died from the same disease the year before I was born. The Bell and Howell Perpetua Electric Eye camera and the Bell and Howell 8mm automatic thread-ing projector were bought in North America and sent home by my eldest brother, who was a student in Canada. No one in my family remembers ex-actly what year that was, but the span of the camera's use is suggested by the ages of the children, by the fashions, and by the dateable events and absences in the footage. At the beginning there are shots of my second brother at the airport, leaving for Ireland in 1961. That there are a few sequences featuring his friends in Trinidad, undoubtedly shot by him, suggests that the camera arrived shortly before he went away. At the later end, there are no images of my elder sister's wedding in 1966, and thus I suspect the filming stopped well before that.

My mother says she stopped filming because by then all the children had grown up and gone away; there was nothing left to shoot. Nan and I were in fact still at home, but for a woman who had given birth to eight children and lived in a large, extended family for much of her life, the house must have been as good as empty. My mother kept the projector, which now sits in its original box in the basement of her suburban Toronto home. She told me that she sold the camera when she left Trinidad, but on a visit during the writing of this essay I found the camera waiting for me, wrapped in an old plastic bag sitting on a bed. She discovered it when cleaning out a closet.

Though it is now hard to picture my mother with a movie camera—at ninety-one, she is intimidated by the controls of a VCR and refuses to touch an ATM—it was she who shot the movies. My older siblings took occasional turns behind the lens, but I don't remember my father ever handling the camera or projector. Although both amateur still photography and 8mm moviemaking are linked to the leisure-time activities of the working dad, my father saw his role strictly as that of breadwinner and had no time for hobbies of any sort.

As Patricia Holland notes in *Family Snaps: The Meanings of Domestic Photography*, "From the earliest days advertisements for cameras have shown women behind the lens. This is, no doubt, a device to indicate how simple it is to take a snap; nevertheless it demonstrates a form of photogra-phy in which women are urged to participate."[1] Indeed, each of the Bell and Howell manuals that came with my family's camera and projector opens with an image of a woman displaying the equipment. Whereas the technical aura of moviemaking might place this activity in the masculine sphere, its domestic role of producing family opens it to the arena of the feminine. As Holland remarks, it is mothers who generally maintain the family album and are "the historians, the guardians of memory, selecting and preserving the

family archive."[2] It was left to my mother to constitute the family. It was she who took charge of our education and who wrote to us after we left home as teenagers. It was she who oversaw the treatment for my siblings' illnesses, taking Ian to Johns Hopkins Hospital in Baltimore and Nan to Saint Bartholomew's in London.

In *Reel Families,* Patricia R. Zimmermann describes how in the 1950s increasingly accessible home movie equipment interfaced with the rising discourse of the nuclear family and the expansion and commodification of leisure time: "Corporations targeted a substantial amount of this leisure-goods marketing at the suburban nuclear family. A pervasive and somewhat idealized popular ideology, this advertising construct of the family grafted intimacy and togetherness to consumerism."[3] The illustrations in the Electric Eye's user manual reveals this aspect of the camera's appeal. Instructions on how to frame a shot depict three couples at a stately swimming pool. The section on indoor and outdoor film shows a mother with a toddler in a bedroom and a heterosexual couple playing tennis. The effects of different lenses are demonstrated by photographs of two children running through a field of flowers. In close-up shots, the hands at the controls are both male and female, but all the faces, whether drawn or photographed, are white and not yet middle-aged. The nuclear family as a unit of consumption did not begin with the lifestyle marketing of the home movie camera, however, and Don Slater traces similar links between "the development of domestic photography and the structuring of the domestic": "What is so striking is not that the family is so conventional in photographic marketing, but that photographic marketing portrayed the same family as every other key consumer-product publicity. Your family photographed, the advertising promised, would be the ideal advertised family, the site of modern consumption and domesticity. Simply and reliably, the snapshot camera would reproduce the right family."[4]

These images of a "right family" were precisely what unsettled me when I first reencountered my family's home movies as an adult. They contradicted what I remembered. I was the last of eight births, and by the time I was born my parents had risen from shopkeepers in humble circumstances to relative affluence. Yet our family culture was rooted in poverty, and in my mother's eyes there was no greater virtue than thrift. She was a dedicated recycler before recycling became fashionable. Nothing was thrown away, especially food. She sewed clothes from poultry feedbags until the neighbor who tutored me after school made fun of my shorts by calling, "Chicky, chicky." After that, I refused to wear them. The family in the movies is different: no chicken-feed shorts, no leftovers. If they are not at the beach,

they are dressed up in Sunday best. My family usually ate in the kitchen, but the only meals in the movies are Christmas dinners in the dining room.

I was taken aback by the extent to which the movies cast our first-generation, middle-class Chinese Trinidadian family living on the outskirts of the empire according to the template of suburban America. Not long before I was born, my parents moved from urban Port of Spain to a new residential area. With the house and its suburban lawns, and the recurring image of our petal-pink and white Dodge Kingway imported from the United States a decade earlier, many of the sequences might have been shot in Southern California. And that may have been the desired effect, to reproduce our family in the image of *Good Housekeeping,* the American magazine to which my mother subscribed for many years. This magazine was one transmission route for a whole body of knowledge about how to produce a nuclear family, and for my mother it was also a guide on how to be a housewife. This was the word my mother used to describe herself on official forms, even though she worked at the shop six days a week. When she was triggered by an article in *Good Housekeeping,* I first overheard her wonder aloud about my possible homosexuality.

But my mother was not a passive receiver for pedagogical disseminations in gender and family relations; they were part of the package in upward mobility my parents sought for themselves. And in that colonial context, moving up in society meant becoming more like people "away," especially people in America. Trinidad had been a British colony from the end of the eighteenth century, but during World War II, two American military bases were opened. In the '60s my mother's cousin worked at a leper colony on a small island between Trinidad and Venezuela. To visit her we had to catch a government launch, which involved crossing the base at Chaguaramas. Inside the guarded gates, the landscape changed. The narrow, potholed road widened, flanked by broad shoulders of neatly mowed lawns. The buildings were different, too: large, airy hangars and low bungalows with screened-in porches. Trinidadians prefer insecticides over wire screens, which are deemed to be both hot and expensive.

The Americans made an impact outside the base as well. Lord Invader's wartime calypso, "Rum and Coca-Cola," a plagiarized version of which was made into an international hit song by the Andrews Sisters,[5] laments the military's affront to Trinidadian hetero-masculinity:

Rum and Coca-Cola,
Go down to Point Cumana,—
Both mother and daughter,—
Working for the Yankee dollar.

The U.S. presence in Trinidad promoted a cultural reorientation away from Britain and toward American values and products, especially for those people with the means to indulge in the new consumerism. Both the ownership of the movie camera and the images it produced reflect this process. My parents, siblings, and I played out the role of the middle-class nuclear family for the camera. But as a gadget clearly imported from America and on top of that associated with the glamour of moviemaking, the camera itself was a prop in the performance of status and class mobility.

## The Videos

In the late '70s, I was introduced on the job as a community television producer to documentary production. Unless I was an on-air reporter, I was taught to erase my presence from the screen and to edit out the questions I asked in interviews. My image and voice were distracting and unnecessary, I was told. But as I mastered these conventions, I began to be bothered by the erasure of the production context. So when I directed my first independent documentary, I reacted against those rules and opened the tape with a shot of the crew and myself reflected in a large mirror. Subsequent tapes were increasingly self-referential until I had moved clearly into the territory of autobiography.

The Way to My Father's Village was the first of three pieces dealing with family history, produced over a twelve-year period. The tape traces my relationship to my father and to China, his birthplace. When I began the research, I had never been to China. But even halfway across the globe from Trinidad, this distant land nevertheless seemed to circumscribe my life. It was the code my parents used to police my siblings' and my behavior, with some activities deemed appropriate for Chinese children, others not. It was also the criterion against which I was judged outside the home. When in high school I failed yet another math test, my frustrated teacher declaimed, "But you're Chinese!"

The Way to My Father's Village was precipitated by my father's death. The tape is composed of five discrete but interlocking sections, the first four representing different routes through which children of immigrants come to know about the land of their ancestors: documents and official history, memory, oral accounts, and travel. Each section draws on a different approach to documentary form. The last, minimally dramatized, section illustrates the cultural ruptures of the diasporic condition. China was to be the key to unlocking the enigma of my father. But at the end of the journey no singular truth emerges, only veils of mediation.

The home movies are used in the second section of the tape, entitled "History and Memory." They are edited into a montage with video close-ups—breaking open a tropical sugar apple, goldfish swimming in an aquarium—and intertitles that variously repeat, shift, and contradict the voiceover narration describing memories of my father. The similarity and/or dissonance between the written and spoken texts are meant to conjure the uncertainties of remembrance. The home movies are suggestive of nostalgia by their subject matter (children playing at the beach), by the way they are processed (slow motion), and by the visual quality of the celluloid itself (deteriorated footage). In the digital age, the cracked emulsion and spots of pure color, blurry and vibrant all at once, point not only to something that is physically old, but also to an outmoded technology.

As opposed to *The Way's* psychic and physical journeys retracing routes of diaspora to the distant fatherland, *My Mother's Place* takes as its starting point my third-generation Chinese Trinidadian mother's rootedness in the Caribbean. The tape unfolds in a series of back-and-forth glances between my mother's images and stories and my own, and between colonial and postcolonial subject positions, not as discrete points of view, but as a kind of dialectical double vision. Like *The Way,* the tape is organized into sections. But here they are not so strictly delineated; the three movements are differentiated one from another mainly by an emphasis in subject matter. In the first, my mother tells of her family history: she was born in Trinidad in 1909, the granddaughter of indentured laborers from southeast China. The second section features tales from old-time Trinidad such as the night-flying, bloodsucking, witchlike *soucouyant,* and the indigenous Warahun traders arriving in dugout canoes from the South American mainland. The final movement hones in on the social and political. Through stories of everyday life, it lays out the process of coming to know one's allotted place in the social hierarchies of race, gender, class, and sexuality in colonial and postcolonial Trinidad.

The family footage is concentrated in the final segment of *My Mother's Place.* Unlike *The Way to My Father's Village,* in which the home movies are inserted principally to illustrate and create an ambience, the 8mm films in this tape serve as evidence and as objects of interrogation. Home movies do not speak for themselves. By the use of juxtaposition, slowing down the images, and adding onscreen captions and voiceover narration, my aim was to get beyond the surface of the images, to denaturalize them and foreground the embedded ideology. In one segment, for example, my sister Nan and I are seen running in and out of a tent made from an old blanket tied to a fence. In the background and to the side an old woman is standing. This is Vio, the

African Chinese woman who took care of us. The spatial relations of the subjects to one another and to the camera reveal geographies of power that are brought to the viewer's attention through text and narration: "The camera focuses on the children and their fun. *She* stands in the background, at the edge of the frame. The apron makes her invisible. It tells the viewer that she is not part of the story they should be concerned with. In a culture in which children are taught to be polite to their elders, I called her by her first name—Vio, short for Violet . . . and no one ever thought it was strange."

Notwithstanding the precarious position of domestic workers in that postslavery society, and especially of women of Vio's generation, my memory of Vio was not of a passive victim. Out of Vio's earshot, my mother often pointed to Vio's Chinese genealogy, saying that she was related to friends of our family. Vio, on the other hand, found pride in telling us children about her African ancestor who had bought his freedom and rose above his station.

After almost a decade of other projects following *My Mother's Place*, I returned to family history and home movies in *Sea in the Blood*. The name derives from the literal translation of thalassemia, a genetic disease that runs in my family. The sea refers to the Mediterranean, as the disease was first identified among Italians and Greeks; when Nan was first examined by British hematologists in 1962, it was still little known that Asians could be affected. *Sea in the Blood* was to be a meditation on race, sexuality, and disease, juxtaposing Nan's illness and eventual death from thalassemia with my longtime partner Tim's life with HIV/AIDS. It was in fact the enormous artistic and intellectual response to the early characterization of AIDS as a gay and a Haitian disease that inspired me to consider the discursive aspects of thalassemia and its relationship to social identity. And it was Douglas Crimp's essay "Mourning and Militancy" that gave me permission to examine the personal and emotional stakes as well as the political dimensions of AIDS.[6] As in *The Way to My Father's Village* and *My Mother's Place*, autobiography was to be an alibi to explore larger political and social issues. It did not turn out that way. The core of the tape is psychological and emotional, enabled by a context in which the accumulated body of "multicultural" film and video released me from a burden of representation. I no longer felt I had to declare or explicate gay, Caribbean, or Asian identities and their intersection.

*Sea in the Blood* is built around two trips. The first was in 1962, when I was eight years old and taken out of school in Trinidad to accompany Nan to London. It was my first time away from the West Indies and my first taste of winter. The second trip was in 1977, when after college graduation in Toronto I joined Tim in an overland journey across Europe to Asia. This journey signified my independence from my family, and it sealed Tim's and

my relationship. However, Nan died the day before our return to Canada. This skeletal storyline is fleshed out with segments on the nature of thalassemia, the ubiquity of death in my family, and the politics of medicine. The tape is a visual pastiche of travel slides, medical instructional media, social documentary photography, original videography that includes underwater imagery, and home movie footage. There is a richly layered sound design, but no sync sound images.

In keeping with a turn away from a theoretical and toward a psychologically driven narrative about love and loss, the home movies in *Sea in the Blood* provide occasions for commemoration rather than distanciation. In *My Mother's Place,* the treatment of the family footage is at times confrontational, with onscreen text contradicting the apparent meaning of the images: "This shows more about my family's desires than how we really lived," states one subtitle over an image of my mother and me walking in front of a mansion, in fact the prime minister's residence. But the decade that separates the two tapes saw the blossoming of digital technology and a widespread cynicism about the truth of images. The kind of self-reflexive strategies I employed in *My Mother's Place* have as a consequence lost some of their political and aesthetic edge.

I replayed the London footage for my mother and surviving sister and audiotaped their reactions to seeing their images after almost forty years. My older sister, who had already left Trinidad when we acquired the camera, did not remember the existence of the footage, and it took some time before she recognized the events depicted. I overlaid this audio interview onto the first images of home movies that appear in the tape, underscoring the psychic leap into the past. In another sequence, I lifted a voice-of-God narration from a 1979 educational slide show on thalassemia and illustrated it with footage of the family playing in the snow, tags superimposed on each member indicating their medical status. The slide show also appears in what is perhaps the tape's most pointed image, in which a profile drawing illustrating the facial features common to children with thalassemia is digitally melded with a slow-motion home movie image of Nan looking directly into the camera. Meanwhile, the narrator of the slide show relates that "[a] tendency to a slanted shape of the eyes and a yellowish brown pigmentation of the skin lead to the descriptive term 'mongoloid' to describe these features; however, 'thalassemia facies' may be an even more appropriate term for such characteristic changes."[7] This sequence was an attempt to draw out the tensions between the caring aspects of medicine and its connections to regimes of social control. More specifically, it was a response to the depersonalized photographs of children used to illustrate the medical literature on thalassemia.

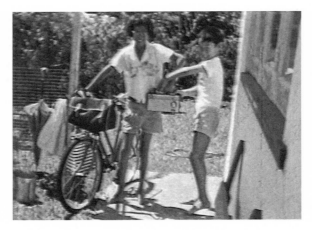

**Figure 1** From *Sea in the Blood,* by Richard Fung, 2000.
Courtesy of Vtape.

The home movies show the mutual dependency between Nan and me as children, and they perhaps account for my later need to separate. Most of the footage is taken from the 1962 trip to London. A physician there was Nan's last hope, and she spent three weeks in the hospital undergoing a splenectomy. Yet there are no signs of illness or hospitals and no hint of anxiety in any of these shots of snowball fights and tourist sights. In developing an aesthetic strategy for *Sea in the Blood,* I used these absences—the mendacity of the image, in fact—as a guide, communicating through what is not said, what is not seen. In addition to reflecting something of Nan's and my family's approach to fatal illness, it worked against the bog of sentimentality in which this subject matter could easily become mired. I wanted to engage the emotions, but not to deaden the intellect.

## Movies within Movies

Television arrived in Trinidad and Tobago with independence in 1962. This technology symbolized a new era and an opening of connections to a wider world. The programming, starting at a single hour a day, nevertheless betrayed the country's neocolonial status: almost all the shows were from Britain or the United States. My family's home movies span the years of the introduction of television, a time when there was little recording of public, much less private, Trinidadian life in moving images. This economy of scarcity amplifies the significance of the family films as historical documents.

They provide a record of middle-class urban life in a Chinese merchant family. But my mother also shot at public events, and the body of film includes the Independence Day celebrations of Trinidad and Tobago in 1962 as well as footage of Carnival in the early '60s. Trinidad is home to one of the three important pre-Lenten Carnivals in the Americas. Newspapers and other photographs capture the costumes of that decade, but my mother's films of Carnival Monday's *J'ouvert* and Carnival Tuesday's "pretty mas" record the movements of the dancing: the "chip" of the daybreak celebrants, the "wine" and display of the costumed performers, both differ from the way that Carnival dancing has evolved today.

In their recording of private lives and private perspectives on the public, home movies are invaluable documents of everyday lived experience. My family's films reveal much about the time and the society in which they were made. Nevertheless, my family's desire to inscribe themselves into the conventions of the technology, and all that this was associated with, means that the films are not always what they seem; their familiarity can be deceptive.

Because 8mm movie technology was widely available in the United States and Canada, home movies strike a note of identification with a large cross-section of North Americans. Home movie footage, actual or simulated, is therefore used in independent and commercial contemporary media to evoke midcentury nuclear family life, particularly in the suburbs. It suggests the commonplace, the ordinary. But in Third World countries, home movies were accessible only to the relatively privileged, and the footage draws attention to social difference rather than commonality. Its use therefore undermines, or at least provides a counterpoint to, the inclination to conflate the "I" of the Third World autobiographical film or videomaker with the "I" of the nation, to extend Henry Louis Gates's formulation about identity and race in African American autobiographical writing.[8] Thus, in the essay film *Lumumba: Death of a Prophet* (1992) by Haitian-born director Raoul Peck, footage of Peck's childhood in Zaire—whether he is seen dancing the twist or riding a bike with a group of black and white children in a visibly upscale neighborhood—visualizes his complex relationship to Africa as both a diasporic African and a privileged foreigner whose father was an agricultural expert. I believe my family-based videotapes perform similar acrobatics of affiliation and demarcation: my family is and is not Chinese, Trinidadian, Canadian. In this task, the home movies are crucial. Their specificity ruffles neat categories. Yet as a videomaker reworking these films into my own counterhegemonic projects, I have had to manipulate their context and their surface to reveal these meanings. Otherwise they would be easily consumed as nostalgic, quaint, or exotic.

I am unsure which came first, my interest in unofficial histories or my rescreening of the home movies in the mid-'80s. In any case, my rediscovery of the family films has led me to tackle some of the ways in which large historical events and movements reverberate in the everyday lives of ordinary people far away from the metropolitan countries and great urban centers. In *My Mother's Place,* my mother talks about her ability as a child to recite the names of all the bays of the British coastline. As a pupil in a British colony, useful knowledge was about the center, not the periphery where one lived. History occurred somewhere else. As she ponders her education, my mother begins to question its validity: "When you think about it, it didn't make sense," she laughs. While never escaping hegemonic knowledge, my family's home movies cut a chink in the one-way (neo)colonial mirror. They allow another history to surface. For a brief instant, they allow the forever-outsider, the spectator, to be seen and to recognize herself.

## Notes

1. Patricia Holland, "History, Memory and the Family Album," in Jo Spence and Patricia Holland, eds., *Family Snaps: The Meanings of Domestic Photography* (London: Virago, 1991), 7.

2. Holland, "History, Memory and the Family Album," 9.

3. Patricia R. Zimmermann, *Reel Families: A Social History of Amateur Film* (Bloomington and Indianapolis: Indiana University Press, 1995), 114.

4. Don Slater, "Consuming Kodak," in Spence and Holland, 49.

5. For an account of this famous plagiarization lawsuit, see Louis Nizer, *My Life in Court* (Garden City, NY: Doubleday, 1961).

6. Douglas Crimp, "Mourning and Militancy," in Russell Ferguson, Martha Gever, Trinh T. Minh-ha, and Cornel West, eds., *Out There: Marginalization and Contemporary Cultures* (New York: New Museum of Contemporary Art; Cambridge, MA, and London: MIT Press, 1990), 233–45.

7. "Thalassemia Slide Show," presentation at Michener Institute for Health Sciences, Canada, 1979.

8. Henry Louis Gates Jr., "Writing 'Race,' and the Difference It Makes," in Henry Louis Gates Jr., ed., *"Race" Writing and Difference* (Chicago: University of Chicago Press, 1985), 11.

## 2 The Human Studies Film Archives, Smithsonian Institution

*Washington, D.C.*

JOHN HOMIAK AND PAMELA WINTLE

The Human Studies Film Archives (HSFA) was founded in 1975, as the National Anthropological Film Center in the National Museum of Natural History, through the coordinated efforts of a small but passionately committed group of anthropologists and filmmakers. In 1981, as the result of a reorganization, the HSFA was given its current name and became a part of the Department of Anthropology, National Museum of Natural History. Although the HSFA was initially conceived as a repository for historical and contemporary ethnographic film records, staff soon realized that a much broader range of films would significantly contribute to a moving-image history of world cultures, many of which underwent rapid changes during the twentieth century. Amateur films have proved to be an important source of visual documentation of cultures in transition.

The HSFA's archival collection is composed of over eight million feet of original film and a thousand hours of original video. In addition to film documentation made specifically for ethnographic use, the HSFA's eclectic collection also consists of theatrical travelogues, travel-lecture films, theatrical and television documentaries, video and film oral histories, and amateur films. These amateur films were generated by a wide variety of creators, including missionaries, colonial agents, adventurers and explorers, educators, and tourists, as well as social and other scientists working in remote areas. Approximately 20 percent of the archival collection could be described as amateur film or video.

The HSFA selects amateur film based on a number of criteria, including geographical area, cultural group or groups, creator, uniqueness of content, donor requirements and restrictions, condition of collection, and availability of supplementary information. The two criteria of greatest significance are availability of supplementary information or annotation (synchronized

sound commentary), which is valuable for providing contextual information, and donor requirements and restrictions, which impose undue burdens on the HSFA's resources.

The study of amateur images is still underdeveloped. Serious consideration of amateur images is new territory for most researchers. In part this is due to problems of intellectual access related to both cataloging procedures and the need for documenting such films. These challenges include providing a description of the content of amateur films, a task that often calls into question the knowledge and intentions of the amateur filmmaker. Equally important, and oftentimes more critical, is the need to capture other kinds of information outside the frame, which is often extremely difficult to assemble due to the unrecorded history of amateur works. Such information includes the intended audience for a film, the actual history of its use by the filmmaker or others, its resonance with prevailing ideological and historical contexts, and information about the variable meanings and interpretations attributed to a film by its viewers. These factors point up the need to evolve a language for studying amateur images. Although we can identify several films that illustrate the theme of this book, numerous others await the work necessary to unpack their meanings by careful content identification and closer biographical and historical analysis. Nonetheless, three compelling examples from the HSFA follow. Two are straightforward film records of traumatic historical situations, and the other is a conventional amateur travelogue that, with careful reading and understanding of the context, reveals more than was intended by the maker.

### Czech Invasion (1968)

*220 feet (7 minutes); 16mm Kodachrome with magnetic sound stripe and ¼-inch audiotape narration*

This edited amateur film was shot by Frank Kreznar, a retired Western Electric engineer and an established amateur cinema enthusiast in the Milwaukee area. This is one film out of a collection of seventeen titles received from the Kreznar family; the HSFA also received extensive supplementary documentation including production notebooks, articles, awards, and listings of each screening. *Czech Invasion* was shown on Milwaukee television, at amateur cinema competitions, and to family and friends. Frank Kreznar thoroughly documented and meticulously cared for his

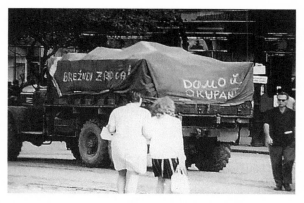

**Figure 2** "GO HOME" written in Czech on the side of a
Russian truck, filmed by Frank Kreznar, 16mm, Bratislava,
Czechoslovakia, 1968. Courtesy of Human Studies
Film Archives, National Museum of Natural History,
Smithsonian Institution, and Sonia Kreznar and
Loraine Kreznar Martray.

films, and he also continuously explored film technology, including devising his own synchronized sound method.

Frank Kreznar died in 1993. At the urging of a friend, his wife, Sonia, contacted the Smithsonian Institution in 1997, seeking an archival repository for *Czech Invasion*, which was seen as having unquestionable historical importance. In the summer of 1968, the Kreznars toured Eastern Europe, intending to spend nine days in Czechoslovakia, but on the seventh day Soviet tanks entered that country. The film opens with images of a peaceful countryside, but the footage then dramatically shifts to show the aftermath of the invasion. There are images of an anxious population crowded around radios, standing in bread and fuel lines, and wandering tank-filled streets in astonishment. The footage also shows the confused and nervous Russian soldiers in their graffiti-scrawled tanks. Bullet-ridden glass, blood on the pavement, and makeshift shrines to victims killed on the streets of Bratislava are captured to bear witness to the violence that occurred. Sonia Kreznar's low-key narration relating their immediate and personal observations heightens the tension and seriousness of this historical episode.

The original Kodachrome film of *Czech Invasion* is in very good, stable condition, but the magnetic soundtrack was blank. Consequently, the ¼-inch master audiotape was used by Film Technology, a film preservation facility, to resync the narration in creating a master video copy.

**Figure 3** Young Greek women having their palms read, from *Present Day Greece and Its Mediterranean Islands*, filmed by John Nicholson, 16mm, Greece, 1946–51. Courtesy of Human Studies Film Archives, National Museum of Natural History, Smithsonian Institution, and Dr. John N. Nicholson.

### *Present Day Greece and Its Mediterranean Islands* (1946–1951)

*6,400 feet (3 hours); 16mm color silent reversal print*

This edited film was created by John Nicholson, an American medical doctor who had immigrated to the United States from Greece as a young boy. His stated purpose in producing this film was to present a positive image of Greek people to American audiences in order to dispel what he perceived as Americans' negative beliefs about southern European peoples. (During the 1950s, Nicholson provided lectures at screenings of the film in Chicago and the surrounding area.) In a dramatic opening title, Nicholson dedicates his film to "Georgie, Jimmy and Pete," the "sons of Hellas" who were forced to leave a land that was "poorer than poor." Shot during the post–World War II years, 1946–51, the film depicts a modern Greece marked by the organization and discipline of student athletics and military parades. The visibility of the military in the footage indicates the fact, never fully explored by the film, that Greece was embroiled in civil war during these years. The themes of economic and social development are implied in the juxtaposition of travelogue shots of ancient monuments with shots of the high-rise architecture of modern Athens, leaving viewers

with the distinct impression that it was no longer necessary to go "farther West" to "get ahead."

This film presents a striking document on the phenomenon of the "hyphenated American" and the complexities of cultural identities. The immigrant success story gives way to the pathos of the displaced person, that is, the outsider who embraces the values of another culture and returns home unable to recognize an original difference or alternative. The film's interplay of notions of progress, America, and modernity is perhaps most articulate about those issues on which it remains silent, such as the loss of regional traditions and increased cultural homogeneity, the impact of economic dislocations, and increased militarization. As this film demonstrates, a "travelogue" is never just a travelogue.

### Civilization on Trial in South Africa (circa 1950)

*846 feet (24 minutes); composite black and white print*

The Reverend Michael Scott, an Anglican clergyman and tireless campaigner for human rights, secretly documented the appalling and oppressive conditions of the majority African and colored (Indian) population of South Africa, intending to use this film to generate international support for their plight. The film dramatically demonstrates the reality of harsh conditions by using contrasting shots of "the minority whites' lifestyle" with shots of the Johannesburg township areas and government housing, and by capturing such scenes as overcrowding, lack of public services, street life in Sophiatown (a freehold township in a Johannesburg suburb that was razed by the South African government during the years 1955–63), and intertribal fights organized by police to control the African population and entertain white spectators. Narrated by Reverend Scott, the film was screened in England and the United States in order to raise consciousness and funds. The film was also shown several times at the United Nations, where Reverend Scott lobbied the UN General Assembly on behalf of the Herero tribe in order to secure their independence by resisting incorporation within South Africa.

The film came to HSFA as part of a larger collection from the anthropologists Colin Turnbull and Joseph Towles through the Avery Research Center for African American History and Culture, College of Charleston, South Carolina. The HSFA made a preservation picture and track negative from the print, which is in good condition. The HSFA will return the original print to

the Avery Center. (The National Film and Television Archive, England, also has an original print, but in fair condition with many splices.)

These three films are only brief examples of films held in the HSFA that depict a world where human and geographical landscapes have been dramatically altered as a result of the acts of man, including wars, pollution, and global warming. These moving images, which document man's changing world, are vulnerable technologies that could disappear without the intentional intervention and care of the world's dedicated moving image archivists.

## Notes

Two other members of the Human Studies Film Archives at the Smithsonian Institution also contributed to the research and writing of this article. Mark White worked on the section on the Greek film, and Lynanne Rollins worked on the section on the Czech invasion film.

## 3 *Wittgenstein Tractatus*

### Personal Reflections on Home Movies

PÉTER FORGÁCS

"Amateur": from Latin amator, lover, from amare, to love.
*Merriam-Webster's Dictionary*

"Amato"/it./means: the lover, the amateur, the one who makes film for love.

The limits of my language mean the limits of my world.
**Ludwig Wittgenstein,** *Tractatus Logico Philosophicus* (5.6)

Over the past ten years I have made seventeen video-films based on private movies, most of them Hungarian sagas. Some of them are essays; others are comparative, international stories; two others are Dutch sagas. The source material for most of my work is archived in the Private Photo and Film Archive in Budapest, which was founded in 1983 to collect the vanishing fragments of the Hungarian past. Until 1988 my involvement was merely "archaeological," but from then on, thanks to my first commission, I have produced for television, museums, and archives. Essentially, making these films and the research they require constitute my terrain: I try to see the unseen, to de- and reconstruct the human past through ephemeral private movies.

What is thinkable is also possible.
WITTGENSTEIN, *Tractatus Logico Philosophicus* (3.02)

Film's intrinsically naïve quality of capturing whatever is before it is characterized by the home movie. The family movie as a cinematic form is more

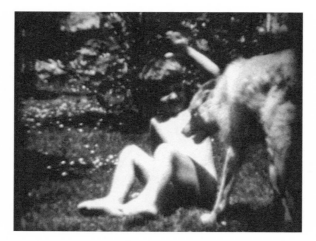

**Figure 4** From *Wittgenstein Tractatus,* by Péter Forgács,
1992. All images in this chapter courtesy of Péter Forgács.

than a simple film phenomenon. The private film is an imprint of culture
rewritten by a motion picture that has a certain self-reflective impact on the
overall face of culture. One of the sources of understanding for family films
lies within the context of screening—specifically the role of narration or
commentaries offered up by the family while viewing the films: "This is me,
that is him," "This happened then, and that happened then," "Now we see
this and this," "How happy we were at that time." Spontaneous comments
that, in effect, constitute the metanarration.

What can be shown cannot be said.
WITTGENSTEIN, *Tractatus Logico Philosophicus* (4.1212)

The contexts of both filming and screening define the relationship of the op-
erator and the spectator. The maker of a home movie acts as the narrator, in
a manner that recalls that of the silent film. The private filmmaker com-
ments on the phenomena taking place on the film, identifying the people,
subjects, and topics presented. In addition, the filmmaker him/herself often
will have structured the material beforehand by editing or subtitling that
does not necessarily follow the linear process of time. The "dramaturgy of
private film," then, often includes unplanned forms and random sequences,
even shifts of time. Awareness of this attributive meaning in the sphere of

home movies is important for our understanding of them. The spectator is "guided into" the private context.

> It cannot be discovered from the picture alone whether it is true or false.
> WITTGENSTEIN, *Tractatus Logico Philosophicus* (2.224)

The amateur film is generally considered amateur art, not without reason. Many amateur filmmakers enjoy imitating art by making fictions or documentaries. In comparison, the home movie is not simply an imitation of professional filmmaking, but an attempt to achieve an aesthetic result. The home movie or private film, not unlike the letter and diary, is biographical. It is one of the most adequate means of remembrance. It is a meditation on "who am I?" The original context of the private film is the home screening rite, the celebration of times past, of recollection, and of hints of the nonverbal realm of communication and symbols. It is a recollection of the desired, intimate vision and aims to immortalize the face of a lover, son, or father, or to capture ephemeral moments, landscapes, and rites. The meditation inspired by these screenings is: What has been revealed by making visible that which had remained imperceptible before?

> Ideas too sometimes fall from the tree before they are ripe.
> WITTGENSTEIN, *On Culture and Value*

In home movies we observe a rite of visual narration, which can also be called a kind of "vernacular narrative imagery." Similar to everyday expression and/or language, these movies are full of "mistakes" and even Freudian slips. The private film diary is a type of psychological autobiography, a ritually organized record of life events in a subconscious and/or conscious form. The spectator interprets the fragments of planned and random acts of living caught on film. This reconstruction could be called an archaeological "map of human fate." The filmic autobiography is under permanent construction, recomposed continually with new footage and editing.

Another significant quality of the private film is the comprehension of death. In a feature film the character dies even as the actor lives. Conversely, in the private film we are aware that the person who appears on screen may well be dead even as he/she seems to be alive on the screen. It is as if they have sent a message with skeletal traces for today's viewer.

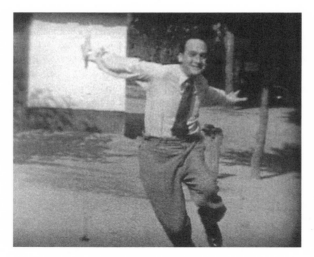

**Figure 5** Man dancing, from *Wittgenstein Tractatus.*

> That the world is my world, shows itself in the fact that the limits of
> the language (the language which I understand) mean the limits of my
> world.
> WITTGENSTEIN, *Tractatus Logico Philosophicus* (5.62)

The attitude of the makers of home movies is similar to that of diarists: they both seek to record things as they happen. However, while the written diary is a conscious reflection on what has already transpired, filmmaking is an immediate recording launched at the push of a button. This difference leads to different results, both semantically and syntactically. The written diary is under the conscious control of syntactic and semantic laws of the written language. The film record encompasses whatever unfolds before the camera's lens, without being structured by grammatical formulas or even photographic skills.

> What the picture represents is its sense.
> WITTGENSTEIN, *Tractatus Logico Philosophicus* (2.221)

The average private filmmaker shoots things that are "worth filming," that is, subjects that are important, beautiful, interesting, and funny. However, what is it that defines something as important, beautiful, interesting, or funny? The consensus of these notions and criteria rests on ever-changing pillars of individualized and cultural meanings. The events recorded by the

private cinematographer behave like a paradoxical mirror. One moment is captured in its randomness. And then another and yet another is captured, subsequently fixing those moments into an ordering of facts. The film memory from that point on presents a moment as the only way it could have been. Could it have happened differently? Any accident of circumstance can be fixed as fact by the captured image. Yet very different variations of this life script could be deduced from this variable set of facts. Home movies feature a veritable stock of fact-images.

> The world is independent of my will.
> WITTGENSTEIN, *Tractatus Logico Philosophicus* (6.373)

Whenever an image lacks beauty or compromises so-called measures of acceptability, it is considered to be a mistake or failing. Despite the fact that the sequences of an amateur film aim at perfection—for they seek to represent a happy and balanced life—they nevertheless remain in the realm of imperfection because of the inevitable presence of "mistakes." Mistakes are never part of a film's intentions, yet they are always present. In fact, mistakes make the genre of home movies powerful and real. Even the best, most sensational feature film or journalistic newsreel cannot compete with the latent authority of the home movie. I call that the "perfection of imperfection."

> A confession has to be a part of your new life.
> WITTGENSTEIN, *On Culture and Value*

Of the many things that happen in human life, most are not "suitable," not "fit" for filming. It is not necessarily the costs of filming that account for the "missing images," but most probably what is considered taboo. While marriages on film are many, a home movie will never feature divorce—or abuse, aberration, or aggression. The number of missing pictures is endless. Happy moments abound, more frequently than happens in life. Taboo is the paradigm of lack. When a professional photographer was no longer needed for image-taking, private films would increasingly include intimate accents, uncensored yet still legitimate forms of behavior. Funny faces, skirts flipped up, even sexual taboos are recorded. Perhaps the home moviemaker, the "hero" of this essay, lies somewhere between the citizen and the voyeur.

Anyone can either be the case or not be the case, and everything else remain[s] the same.
WITTGENSTEIN, *Tractatus Logico Philosophicus* (1.21)

The camera is none other than the extension of the perceiving, recording eye. And the perceptions immortalized by the camera afford important knowledge about the operator. The questions of when, what, and why someone shoots what he does involve a process of qualitative and quantitative selection of the given amount of spectacle available. Film is not a "frozen second," but the representation of a temporal process, perceived in fragments of twenty-four, sixteen, or eighteen frames per second. Filmmaking involves selecting "excerpts" from the continuous flow of time and space. The private film can be described as a series of details culled from the continuous flow of time. Obviously, it is impossible to film a lifetime in its entirety from birth to death. It would take another entire lifetime to see it. That surely must be the domain of God.

What the picture represents is its sense.
WITTGENSTEIN, *Tractatus Logico Philosophicus* (2.221)

From the very beginning, silent films have featured an element of "overacting" by mimicry and gestures. The melodramatic performance of the characters in amateur films, in addition to their "natural" behavior, was influenced by silent films. The home movie—until the audio dubbing of Super 8mm and regular 8mm films—kept alive the tradition of silent film acting, along with the intertitles of the early cinema. The main difference is that people in home movies represent, "act" themselves. Even in home movies' burlesque gags, they play roles that "become them," or they wink to us from "behind" the role: "I'm only playing myself!" Beyond ego representation, the amateur film provides a kind of imprint of the codes of behavior of age, hierarchy within the family, and gender.

The picture is a model of reality.
WITTGENSTEIN, *On Culture and Value*

The "real" and the "performed" act is twofold in the home movie. Our many different roles exemplify the separation and interrelation of our public and private lives. The act of mimesis seems to signify "I exist" or, rather, "I represent myself here for immortality." This imitation of ourselves is an authentic "copy" of the original, since actor and role are identical. For

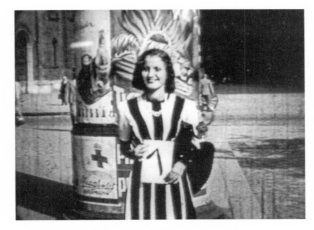

**Figure 6** From *Wittgenstein Tractatus.*

example: a woman smelling a flower can appear spontaneous or be a reenactment. Which one was the one caught on film?

> How hard I find it to see what is right in front of my eyes!
> WITTGENSTEIN, *On Culture and Value*

In baroque paintings the subjects gaze distantly out of the picture. Their iconographic function and spiritual strength are well known to scholars and visitors. There is something similar about home movie actors' gazing out of their movies. They look out of the "local time" of the filmmaking moment into our "present time," a projection of the filmed ego for the future, as the local time will have become past time when it is screened. We, the spectators, connect the filmed time fragments and bridge the missing parts by association. The film diary is a method of rendering the past and of looking back from the future. By condensing time, the private autobiographical film becomes private history.

> What you are regarding as a gift is a problem for you to solve.
> WITTGENSTEIN, *On Culture and Value*

The film diary follows the changes of point of view, and of the personal features of perception. Private film equals private history. Private history is a challenge for interpretation and invites new explanation as we seek to

establish logic by our knowledge of culture and history. Our interpretations create a new context that can be independent and completely different from the intentions of the original filmmaker. Any life story is a series of fortuitous events, which later the home movie presents as a comprehensible and "logical" life story.

> Everything we can describe at all could also be otherwise.
> WITTGENSTEIN, *Tractatus Logico Philosophicus* (5.634)

Private films are "affirmative statements," spontaneous film recordings of the amateur reflecting on his own world: the way he saw a particular thing at a particular time and in a particular way. What we later evaluate as a film-statement is only a reflection in the moment of filming. And as an intervention it has an influence on the event. The presence of the camera can be sensed, which affects the home movie actors' behavior. Pushing the button of the camera is an immediate reflection on the present situation. The world "happens" and we record a bit of it.

> That the sun will rise tomorrow is a hypothesis.
> WITTGENSTEIN, *Tractatus Logico Philosophicus* (6.36311)

Virilio describes the absence of conscience, the "epileptic" blackout, as "picnoleptical," the perception of missing meanings that have dropped out of the interrelated flow of vision and picture serials. Let us make a calculation based on this framework. One of my favorite home moviemakers, the Dutchman Max Peereboom, lived a mere thirty-four years, which is approximately 300,000 hours. In 1933, at the age of twenty-two, he bought an 8mm camera in Amsterdam and filmed for about ten years. In his lifetime he shot thirty rolls of film, which amounts to approximately three hours of footage. Assume the standard human daily routine to be eight hours of work, eight hours of sleep, and eight hours of leisure time. If we consider Peereboom's leisure time as being potential filming time, from his first shots till his death he would have had 30,000 hours for filming.

> When I came home I expected a surprise and there was no surprise for me so, of course, I was surprised.
> WITTGENSTEIN, *On Culture and Value*

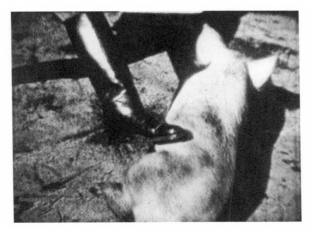

**Figure 7** From *Wittgenstein Tractatus.*

We have no better evidence of Peereboom's existence, of who he was, than his films. All the other things—ashes, memories of surviving and now distant relatives, a few personal belongings—refer only indirectly to the personality of Peereboom. Given the three hours of footage he shot, hypothetically Peereboom's actual average filming time was, in effect, only one out of every 10,000 hours. His films represent every ten-thousandth hour of his life. The rest of his life—what was not preserved by motion pictures—can be considered the so-called picnoleptical period. Therefore, as far as we are concerned, it does not exist. This calculation is a ratio between the forgotten, disappeared time and the filmed times assigned to the immortality of Peereboom.

> Everything we see could also be otherwise.
> WITTGENSTEIN, *Tractatus Logico Philosophicus* (5.634)

Peereboom's film diary features thematic, personal, temporal, and microhistorical phenomena. Only the framing dates of his birth and death add "logic" to his fate. Peereboom did not intend to make his films for us to view later. He took them for the family record, to entertain, and to make himself and his environment remembered. From these "film-notes" the fate-line of the Peereboom family can be reconstructed. With all its factuality, the reconstruction is closer to archaeology than to an actual biography. The private history of a private life can hardly be seen in its totality through only the filmed moments. However, we cannot say that the unfilmed moments represent the complete life either. The two together—the unseen and the recorded—are

valid only for our observation or meditation. Our conclusion would be that reframing a life script more closely resembles a novel than a history book.

The horrors of hell can be experienced within a single day; that's plenty of time.
WITTGENSTEIN, *On Culture and Value*

The Peerebooms' fate of not foreseeing the end of their lives and of the Jewish community was caused by the Nazi laws and extermination industry imposed on the Netherlands, conducted by Arthur Seyss-Inquarts, the Austrian petit bourgeois who was the Reichskommissar of the Netherlands from 1940 to 1945. Seyss-Inquarts's home movies also survived the war and were preserved in the Royal Dutch Archives. When I discovered the Peereboom films at the Inédits Conference in Holland in 1992, I was amazed by their visual quality, richness, and variety of themes. After many years of contemplating how to find a narrative and visual counterpoint to the Peerebooms' happy family images, I decided to integrate Seyss-Inquarts's films, their strict Austrian Catholic character and dry banality providing an almost embarrassing balance as the heart of the film's vortex. My film composition *The Maelstrom* (1997) is a comparative study in the historical perspective of the lives of these two European middle-class men—Peereboom and Seyss-Inquarts—living in the same country, for different reasons, at the same time, using each man's home movies. Although I have completed *The Maelstrom*, I have yet to imagine the different, unseen parts of their lives. The question remains: was this how it actually happened? Their unpredictable fate was a secret to them, as they were simply living their everyday lives. Given our historical distance, we can play the "wise spectator," but the future is as invisible and unimaginable to us as to the filmmaker. The totality of life cannot be judged.

Whereof one cannot speak, thereof one must be silent.
WITTGENSTEIN, *Tractatus Logico Philosophicus* (7)

# 4   La Filmoteca de la Universidad Nacional Autónoma de México

IVÁN TRUJILLO

I define amateur cinema as films without an interest in profit, produced by technicians and actors who are not financially compensated. One subset of amateur film is family movies that focus on social events and celebrations. However, sometimes a more complex argumentative or documentary movie, often initiated by one or more amateurs, emerges. The basic purpose of these productions is to share a fun and enjoyable activity in order to make a more ambitious movie that circulates and is sometimes exhibited beyond the confines of the family home.

In places where a more professional cinematographic industry did not exist or where there was not access to filmmaking, films made by beginners played an important role in generating local cultural awareness. These movies are more than documents that become testimonies or judicial proofs; they provide important cultural information about certain places and periods that rivals that found in more professional films. Because amateur films are intended as leisure-time pursuits, with almost infinite exhibition in circles of family and friends, they imply conservation and preservation of memory, in contrast to the commercial film's immediate objective of recovery of investment.

The Filmoteca de la Universidad Nacional Autónoma de México's (UNAM) film archives houses several collections of amateur cinema. The archive is especially interested in films related to Mexico and Latin America. Some reels came from outstanding cultural figures who used films to complement their professional activities. Examples include indigenous dances and rites shot on film by the musician Carlo Chavez and the painter Miquel Covarrubias. Both artists not only filmed their trips, but also used this material as case studies for their more professional work.

I would like to comment on four cases of amateur production from Mexico and Latin America to observe different stages of amateur cinema. The Filmoteca de la UNAM has taken part in the preservation of these collections.

## The 1926–1940 Buil-Papantla Collection:
## A Small Preservation Conflict

In the early 1990s, Mexican filmmaker Pepe Buil found films in the Pathe Baby 9.5 format by his grandfather in Papantla, Veracruz. Papantla is a small city well known as the largest production center of the orchid from which vanilla is extracted. It is also legendary for the dance of the so-called flyers, who descend on long ropes in circles from a post of about twenty meters high.

The films led Pepe Buil to an intense investigation and the idea of producing a more professional documentary about his grandfather's filmmaking. He documented the precise date when his grandfather, Dr. José Buil Belenguer, acquired his equipment in order to show movie features in remote locations in Mexico. His screenings of Chaplin films, comedies, cartoons, and documentaries in Pathe Baby versions attracted a large crowd of neighbors. Soon, Dr. Buil began his activities as a cameraman.

The scenes of local customs, such as vanilla drying in the city streets, the flyers' dance, and various Buil family excursions to the Tajin archaeological area, provide important documents about regional geography and social change. For example, Dr. Buil filmed each of his children year after year in the same place. Seventy years later his grandson edited these films: we see several characters growing from babies to children to adolescents.

At the Filmoteca de la UNAM, we arranged with José Buil to use a homemade copying machine built by photographer Arturo de la Rosa to transfer the 9.5mm materials to 35mm film to secure acceptable quality. Buil himself participated in and evaluated the duplication of the rolls. After several months of work, the archivists at UNAM obtained internegatives of almost all the films by Dr. Buil as well as video copies.

One day, Pepe Buil came to the archives with happy news. He had transmitted his enthusiasm for these cinematic discoveries to the Mexican Film Institute (IMCINE), which would support a 35mm documentary about these films. He needed the internegatives to cut into the 35mm celluloid version.

Pepe did not like our answer. We informed him that the internegatives were the result of roll-by-roll preservations of his grandfather's cinematic successes and failures. We could not allow him to cut this material; the process would need to be repeated. Although Pepe reluctantly accepted our decision, the production was delayed. He agreed to recopy these images for use in his film biography of his grandfather, *La Linea Paternal.*

### *The Return:* A Censorship Case in Amateur Cinema, and a Box Office Success Sixty-Five Years Later

Some movie enthusiasts have more money than others. The Costa Rican producers who filmed *The Return* in 1930 had a 35mm camera as well as knowledge of filmmaking because their family was involved in the film exhibition business. *The Return* straddles the border between amateur and professional cinema. An initiative of wealthy people, it did not need profits from movie productions.

The home movie's social intentions of enjoyment did not have a happy ending in this case. The finished film provoked anger from some family members who considered show business too scandalous. Carlos Jinesta, cinematographic manager, observes, "My family decided to put the film away as a sign of respect towards some of the people that are shown in the picture. In its time, the exhibit provoked uneasy feelings in some; these situations are now surpassed, they belong to the past."[1]

Since 1930, the movie had remained in the storehouse of Cine Variedades, a very popular movie theater in Mexico City. Sixty-five years later, on November 16, 1995, a copy of the film was exhibited for the first time in that same movie theater, garnering uncommon box office success in Costa Rica. More copies needed to be struck. These exhibition facts suggest different regions and nations want to see their own communities on screen. They also show why it is so crucial that different countries and regions promote—and find—their own cinemas.

*The Return* is now considered Costa Rica's first feature film—the only example of a silent fiction film in that country. Its preservation was done by William Miranda of the Centro Costarricense de Producción Cinematográfica (Costa Rica Center of Cinematographic Production) at the Filmoteca de la UNAM, with support from the Agencia Española de Cooperacion Internacional (AECI), UNESCO, the Fundación de Nuevo Cine Latinoamericano (Latin American New Film Foundation), and the Jinesta Urbini family.

## Father Crespi: Cinematography as an Evangelical Auxiliary

A Salesian priest, Carlos Crespi arrived in Ecuador in 1923 as a missionary. In his native Italy, Father Crespi had received a doctorate in natural sciences and degrees in music, and hydraulic engineering. Between 1929 and 1931, he settled in Cuenca, spending less time on spiritual activities to found the first museum and several schools in the region.

The priest discovered the great educational potential of films. With a projector and 16mm films, the local population became acquainted with Chaplin, Laurel and Hardy, Tarzan, and the Lone Ranger. Public enthusiasm most likely led Crespi to transform the townspeople from spectators into actors. In 1932, he began filming the 16mm *Invincible Sahuaras of the High Amazons,* in which, for the first time, he portrayed the customs and natural beauties of this Ecuadorian Amazon town for its residents.

Crespi's film was not a completely finalized edit, although the titles and numbering of the rolls indicate his intentions. It was rescued by the Cinemateca Nacional del Ecuador (Ecuador's National Cinema Library), where a technician named Bolívar Regalado arranged the rolls and produced a voiced version with the assistance of UNESCO financing and UNAM's film archive facilities.

Bolívar Regalado died tragically in Quito months later. Ulises Estrella, the director of the Cinemateca de Ecuador, explains the significance of these rolls: "With these materials the Cinemateca de Ecuador recreates a painteresque journey of a courageous fan of untamed nature."[2] And thus the Cinemateca also reclaims the pioneer of Ecuadorian cinema, a courageous fan of moving images.

## The Vela Collection: An Example of a Double Enthusiasm

Hobbies and sports are often filmed, and these films are intended for a specialized public. The cameramen who make such movies possess a double enthusiasm: one for the hobby or sport itself, and one for cinematography. An example of a sports film at Filmoteca de la UNAM is a collection of thirty-six ten-minute rolls of 16mm film that record Mexican bullfights between 1941 and 1946.

Daniel Vela Aquirre, at the time an important Mexican manager in the natural gas business, was a fan of "Fiesta Brava" (bullfight). He acquired a 16mm camera and, from his seat in the Mexico City plaza, filmed each phase

of the bullfights on color reversal film. Over time, his photographic abilities and image quality improved. More than fifty years after printing, the Ektachrome film still maintains fidelity of color and tone.

Without question, bullfighting is polemical in Mexico: one side celebrates bullfights, while the other denounces them. Arguing about bullfights has long been a fundamental feature of Mexican social life and interactions. As soon as it was publicly announced that the Vela family had deposited these materials in our archives, well-known specialists wanted to view them. As I listen to the comments of experts while they watch the material, the amount of information revealed about different phases of bullfights is quite surprising. The size of the animals and the way in which the matadors put their feet in the sand are fundamental parts of the complicated assessments of bullfighting history.

The Vela collection reiterates two ideas about how home movies are produced with a latent archival impulse. First, their very production suggests a drive to record and historicize. Vela, for example, inserted a shot of a poster promoting a bullfight at the beginning of the roll of film as a way to identify the contents. Second, home movies operate within a social context of friendship, conviviality, and leisure time. When I see spectators filmed in Don Daniels's bullfighting pictures who are unable to repress their shouts of "¡Olé!" they remind me that these rolls—and all home movies—are imprinted by group activities, time away from work, and sharing good times with friends.

The variety and scope of these films in UNAM exceed and problematize the conventional notions of the home movie. These films function as a form of public memory of national and cultural identities, showing these identities are always being remade, revised, and reinvigorated.

## Notes

1. Interview with the author, Mexico City, June 2000.
2. Phone interview with the author, Mexico City, July 2001.

5 **Ordinary Film**

Péter Forgács's *The Maelstrom*

MICHAEL S. ROTH

*Maelstrom:* A large, powerful whirlpool, often resulting in unusual reconfigurations of objects in its vicinity.

*The Random House College Dictionary*

**I**

The opening of *The Maelstrom* presents a silent image of small, seemingly fragile beings tossed on a stormy sea. Silence draws us out—where are we, and what are we looking at?—and then the film pushes us back. The remainder of the film—with only a few punctuations—uses sound (music, cries, sound effects) to bring us along. But we start with silence and the sea drawing us out. Where are we being taken?

When sound emerges near the beginning of *The Maelstrom,* we see people drawn to waves that crash ominously against a floodwall. They are drawn to the raging sea and then they retreat from the waves. They want to feel that power—but they fear being swept away by it. We, the audience, want to be swept away, so we approach. And then we run for our lives.

The figures in the grainy footage run up to the floodwall and seem to lean out to look at the churning sea, fascinated by its power. They are alive, and they are looking out into the death-dealing waves. How long can they stand there as the swell approaches? When will it be too late to run?

The word *maelstrom* originally referred to a whirlpool off the coast of Norway, a whirlpool so powerful that it could draw down boats from miles around. To know this whirlpool, you had felt its pull, been reconfigured by it. Would you want to approach it more closely to be sure it was really pulling you; would you want to feel more of its force? How much pull would you want to feel before you lunged away and escaped?

Péter Forgács is the magician of the whirlpool. He is our navigator around the maelstrom. His maelstrom is what others have called "the black hole of meaning" in the twentieth century: the Shoah, the Holocaust. The metaphor of the maelstrom signals our inability to make sense of what led up to these devastating historical events and what has happened in their wake. He cannot bring us too close, for then we would close our eyes to what is before us. But if he turns away too quickly from what he has found, we will see nothing that matters to us, for us. How can he navigate in these waters?

Forgács finds films. That's simple. They are old movies, home movies, which were taken for no good reason: just to mark occasions, to create a record; to remember daily life and the bodies we used to have and the people we used to be. Banal. The running joke of home movies is that you want to flee from your neighbor (or even your cousin) who inflicts his movies of the wedding, the children, the last vacation on you. And yet the neighbor is oblivious of the boredom he causes. He has no reason to be bored, because he is looking at himself. But how can the home movies of other people hold any interest for us? How can we feel their pull?

Forgács warns us early on. After we see the waves, and after we hear them, we are given the subtitle of the film: *A Family Chronicle.* And the family that will be chronicled is the Peerebooms. Now we are introduced to several solid citizens. Why should we care about them? They are good bourgeois, Jews. To label them is already to begin to care, or at least to create a quality of attention. I am already framing them in this way because we are given a date, 1934. And then all the signs, from the family's name, to their profession, to the newspapers they edit, to their physiognomy (I know, but I can't help thinking about how Jewish they *look*) . . . all of these signs spell doom. They are silent, these movies that Forgács found; but we can hear the maelstrom churning in the distance. Drawing us—or is it just the Peerebooms?—closer.

Forgács finds films from the 1930s. But it's not that simple. He buys them, trades them, negotiates with people who are holding onto their private archives. And, along with his great creator of soundscapes, Tibor Szemzo, he turns these home movies into something else. He takes them out of the home, making them *unheimlich*, uncanny. But to say this is already to overdramatize, and Forgács consistently refuses to do so. He wants to remain with the banal, to draw us into it. He does not bestow on his films the dignity of historical, metaphysical, or even theoretical importance. When we approach a Forgács film, we have to allow ourselves another mode of attention, another rhythm of seeing. Why can't we just ignore these Peerebooms? What have they to offer us that we don't have already, that we

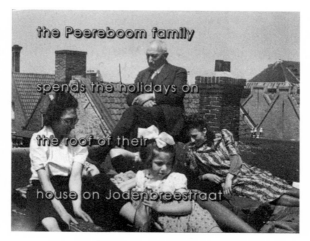

**Figure 8** From *The Maelstrom: A Family Chronicle,* by Péter Forgács, 1997. All images in this chapter courtesy of Péter Forgács.

don't know already? We know what it means that this is the 1930s in Europe: they will all be destroyed. How many stories of murdered Jews do we need? Yet here they are in front of us: planning marriages, making babies, opening shops, frolicking in the snow. We watch them, shocked not only by their own ordinariness (what, after all, can bring the ordinary to us here, now?) but also by their capacity to maintain those everyday lives even as the maelstrom sucks them closer and closer to its murderous turbulence. "Why don't they pay attention?" we say as we watch them. "Can't they feel themselves sinking?" But who are we talking about?

Forgács's challenge as a filmmaker, as a film explorer, and as an archivist is to preserve the ordinariness of his subjects even as he frames them for us in extraordinary times. The Peerebooms are trying to maintain their normal rhythms of family life as Jews in the Europe of the 1930s. And when we see them in these pictures, it doesn't look that hard. They have the commerce, the family alliances, their work with the Red Cross, the vacations. Jozeph edits the *Nieuw Israelielisch Weekblad,* eldest son Max finds a happy bride in Annie, while daughter Loes marries the strong-shouldered Nico (wherever did she find him?). We begin ominously enough because we begin in 1933. This is a date of great significance for the Peerebooms because it is the year that Max and Annie get married. Somebody get the camera to record the momentous event! We viewers bring different criteria of importance: 1933 is the year that Hitler becomes chancellor in Germany,

and, when we hear the weather forecast of the following summer, "sunshine all over," we know there is going to be trouble. We don't really need the frames of the pet black cat, but here is one of the few times that Forgács permits himself to emphasize the tension he more typically just allows to swell up into the viewer's consciousness.

## II

Marriage and vacations. Sunshine all over. How to maintain that ordinariness? There is a danger in exposing it. The ordinary can be an embarrassment for those who notice it because to do so is an acknowledgment, maybe even a confession, of one's own banality. Artists, theorists, philosophers often flee ordinariness or, as some like to say, "try to make the ordinary extraordinary." I prefer Stanley Cavell's project, which he has called, after Wittgenstein, Emerson, and Thoreau, a "quest for the ordinary," the ordinary being that place where "you first encounter yourself." How are we to think about our lives and about the pictures from them without separating these images from ourselves, from our ordinary world? Are we prepared to run the risks of skepticism, of melodrama, or of the cage of irony? The skeptic might ask how we can be sure that our experiences of images have any meaning at all. What if they are merely found footage, the dreck of home movies into which we pump significance that we later claim to discover? The seeker of melodrama might demand that we underline the lachrymose history of those pictured. Are these not always already tragic figures, martyrs who cry out to us to act as their witnesses? The ironist might smile at our attempt to take seriously what we might normally glide by, artful images that we should see at a festival lubricated by drink and cryptic conversation. We do leave ourselves open to these questions and variations on them when we pay attention to the everyday. Skepticism, melodrama, and irony are three standard responses to the nonfiction film, responses that may have even more potency in regard to the reframing and rethinking of home movies that is part of Forgács's project. Leaving oneself open to these responses is a key to his project and is (as Cavell has taught for more than thirty years now) necessary for any kind of real thinking.

Real thinking about the ordinary is problematic because of the insistence of particularity. The problem of home movies is the problem of particularity, trying to find a way to make sense of something individual, on its own, distinct, without erasing its individuality, its oneness, its distinction. This is a *problem* because making sense of something, knowing something, means

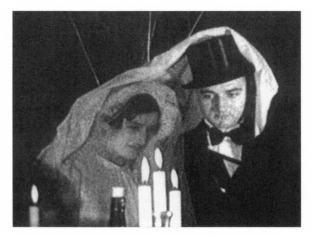

**Figure 9** Wedding, from *The Maelstrom.*

to put that thing in relation to something else, or to subsume it under some broader conceptual scheme. To the extent that we know something, we know it *in relation* to other things. There is a happy, optimistic side to this feature of understanding: our connection to the individual object of knowledge is enriched, made more complex, and deepened by enwebbing that object in the world that we know. But there is a frightening, sad side to this feature of our understanding, too: we lose the specificity, the particularity of the object as we come to see it as one among many objects that are similar to and different from it.

We know all this from our everyday experience. As soon as the home movie is taken out of its native environment, it has the capacity to become either senseless or *unheimlich*. We need to wrap the home movie in something else: filmmakers like Forgács and Robert Nakamura use music and history to bring the private film—the orphaned film—into the world of sense. Comparison—with other families, groups, histories—is supposed to make the other-person's-home-movie into *ours*. But comparison always involves a loss of meaning as well as a gain, and persistent comparison with others can feel like a mode of erasure. We can see this in private life: think of the lover who tells you how much smarter and neater you are than all of his or her exes; think of the sibling who is always measured by the brother's or sister's achievements. The problem of particularity is a problem of the home, but it is not limited to the home. Think of the strenuous efforts to have a heinous crime labeled a crime against humanity; think of the contested use of the words *genocide* and *holocaust*.

The problem of particularity is also apparent when we consider people or places of extreme beauty. We may be content to simply take pleasure in these people and places, in other words, to leave them aside from our understanding. They invite delight more than comparison and knowledge. To engage in the attempt to *know* the beautiful often spoils our delight or, what's worse, spoils the delight of others. This issue is visible in the museum world if you ask academically minded interpreters to talk about beloved works of art. Curators and the general public often feel their pleasure is being compromised by the savant. To hear a gray-bearded professor describe to you how Monet was really painting the bourgeoisie's sense of triumph over nature might seem like an assault on your own *experience* of the painting itself. This is no mere error of pedantry. It is, I think, a feature of understanding and of knowledge (but not of wonder). Understanding and knowledge demand that you move away from the intimacy of your relation with any object or event. Understanding may promise a richer experience in the end, but there is risk in the movement-toward-distance that knowledge entails.

Forgács is a filmmaker who has visualized with unprecedented attention the domestic horror of the process that led to extermination camps. He is seduced by beauty and revels in the joy of his subjects. Home movies are a medium of joy, and he wants us to feel that with his subjects. The movie camera comes out for the vacation, for the new baby, for the first snow of the winter . . . as if the ephemerality of those moments commanded us to record them, to capture them. Or is it that the sight of the camera triggers a certain glee—a universal commandment to smile and find the Esperanto for "Cheese!" The Peerebooms seem incredibly *happy*, full of a life force. Here they are skipping, no, dancing, down the street. (Forgács seems to delight in the sight of large, encumbered bodies leaping through space with joy. His short films around Wittgenstein's *Tractatus* return to this kind of image.) And then we see the clan on the beach leapfrogging one over the other. The comic failures of Mama are a total success as Peerebooms tumble to the sand. It is 1934. For the rest of the decade we see them building families, houses, businesses. The vacation in Paris in 1939 would be the last trip abroad. And watching their ferocious play in the snow makes us feel how alive they were. It is the winter of 1940.

The problem of particularity—although evident in relation to beauty—can be seen in an especially acute way in regard to trauma. The modern concept of trauma points to an occurrence that both demands representation and refuses to be represented. The intensity of the occurrence seems to make it impossible to remember or to forget. The traumatic event, Freud wrote in his *Introductory Lectures on Psychoanalysis*, is

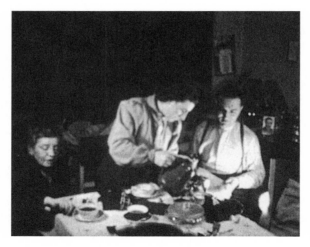

**Figure 10** Last supper, from *The Maelstrom*.

"unfinished"; it appears to the individual as "an immediate task which has not been dealt with." Contemporary psychiatry tends to define trauma as an event that overwhelms one's perceptual-cognitive faculties, creating a situation in which the individual does not really experience the event as it happens. This may be why victims often describe themselves as spectators of their own trauma. In any case, the traumatic occurrence is not remembered normally because it was not registered through the standard neurochemical networks. The lack of a reliable memory of the trauma is felt by many as a gaping absence, sometimes filled by flashbacks or other symptoms. Yet the occurrence was too intense to be forgotten; it requires some form of re-presentation.

The intensity that makes forgetting impossible also makes any specific form of recollection seem inadequate. The traumatic event is too terrible for words, too horrifying to be integrated into our schemes for making sense of the world. Yet any representation of the trauma may have to rely on words and will be limited by the very schemes that were initially overwhelmed. I have argued in various essays that a "successful" representation (a representation that others understand) of trauma will necessarily seem like trivialization, or worse, like betrayal. The intensity of a trauma is what defies understanding, and so a representation that someone else understands seems to indicate that the event wasn't as intense as it seemed to be. No direct speech is possible.

If we ignore the traumatic event (if we try to leave it alone), we seem to have neglected a moral obligation to come to terms with horror and pain. If we understand the traumatic event by putting it in relation to other events (if we try to make it a part of our history), we seem to be forgetting the intensity that engendered the obligation in the first place. This, then is the problem of particularity: You can't leave it alone. But it does not abide company.

Perhaps it is already clear how particularity is a problem for history in general, and for translating home movies into historical or aesthetic objects, in particular. The American historian Robert Dawidoff has talked about this in terms of the resistance we have against seeing something we love become *merely* history because this means it gets swept up with all sorts of things that reduce its distinctness for us. There is a tension between the distinct clarity of vision in the particular artifact and the comprehension that comes through establishing interrelationships. To treat something as historical means *at least* to connect it via chronology to events before or after. *The Maelstrom* is punctuated by dates; the chronicle extends a bridge between private and political history. The singular, disconnected phenomenon cannot *be* historical; entrance into the historical record requires a kind of contextualization that is a denial of singularity. Thus, when we try to historicize an event that is dear to us because of its intensity, we necessarily reduce its singularity. As Carl Schorske has noted in his introduction to *Thinking with History:* "Thinking with history . . . relativizes the subject, whether personal or collective, self-reflexively to the flow of social time." Making something *history* means making it part of something else, or placing it in relation to something else. That is why there are no unique historical events—except in a trivial sense (in which everything is unique).

There has been an effort to adopt a religious or sacralizing attitude vis-à-vis certain extreme events, which is in part an effort to keep a distance between them and the run-of-the-mill occurrences that we remember or write about as history. We can understand these efforts as aiming to prevent a catastrophic event from becoming "merely historical," that is, something that fits easily into the narratives we tell about the past. But the efforts can backfire, creating an easy target for those who would confuse our caring about particular events with a refusal to pay attention to others. This, obviously, has been one of the sources of debate about how to understand the Holocaust historically. To do so means necessarily to understand it comparatively. Comparison can feel like a mode of erasure, as noted above; but it can also be a mode of memory and sustained attention.

## III

Forgács introduces a mode of comparison into *The Maelstrom* that is both delicate and extreme. The Peerebooms are not the only family pictured in the film. He also takes us—very briefly—into the world of the Seyss-Inquarts. The paterfamilias is the Reich Commissioner for Holland in 1940. Forgács has prepared us to meet this family by showing us earlier clips from an amateur film of a Nazi youth group in Holland in 1935 and by voiceovers that announce Hitler's welcome in Vienna in 1938 and the attack on Western Europe in 1940. In two of the rare instances in the film where sound is synchronized with image, a baby's cry is heard as we see an infant shriek. Target shooting at a carnival booth suddenly erupts in an audible shot. We hear the "Sieg Heil!" as we watch a child walk down the street.

The Seyss-Inquart clan has its own home movies. We see this family at more restrained forms of play—riding, or playing tennis with the Himmlers. And when we see the private life of the Reich Commissioner, we hear about new laws affecting Jews: stopping the production of kosher meats (kosher slaughter avoids unnecessary suffering of the animal and follows prescribed religious laws); forcing Jews to put their funds in special accounts; creating a ghetto in Amsterdam for all Dutch Jews. Meanwhile, time is running out for the Peerebooms. We know that, and perhaps they begin to know also. It is so hard to tell from these glimpses into their lives. Here the viewer just becomes more sharply aware of a tension that has existed from the very beginning of the film: we have knowledge of history (of *their* history) that the families in the film lack. Did they hear the maelstrom pulling at them? Did they feel themselves being reconfigured by its force? It is so difficult to tell from these found films because home movies have a logic of their own. The powerful conventions of home movies ("Over here!" "Smile!") makes the problem all the more acute. There is a strong imperative to show something positive. The home movie is something you will want to look back upon. It is meant as a *nostodisiac*, a stimulant of nostalgia. We see the Seyss-Inquart grandchild playing while she eats; we see the Peerebooms again on vacation—this time just on the roof in the ghetto, no longer at the beach or in Paris. Images of happiness . . . colliding in history.

Forgács introduces another kind of film clip into *The Maelstrom:* chilling, clandestine recordings of Jews being led from their homes. These are not family chronicles but historical documents. We are into the 1940s and Nazi domination. Family members Louis and Nico have already died in Mauthausen when Jews are forbidden to appear in public in 1941. The home movie cameras continue to record: the Nazi official's grandchild giving a

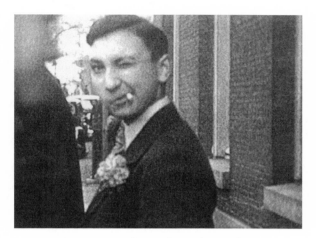

**Figure 11** Simon Peereboom, from *The Maelstrom.*

kiss, the new baby born to Max and Annie, named, as an act of resistance or hope, "Jacques Franklin." It is late 1941 when they record the last time they would light the Hanukkah candles. The following fall they film themselves preparing to leave for a "work camp" in Germany. As throughout the film, we know better. We hear the pull downward, even as we watch the women sew for the trip. Max, Annie, the children, Flora, and Jacques Franklin are going to die in Auschwitz. The home movie records the women sewing as if they were preparing for another vacation, another event to be remembered in the family chronicle. But can there be a family to look back on these events? From where do *we* watch and remember?

The only survivor of the Peereboom family is the youngest of the siblings, Simon. We have seen him throughout the film, playing the role of the baby, the jester, the wiseguy. As a youngster, he is trying to look tough, cool, and we laugh as he blows cigarette smoke at the camera. As the film and family near their awful conclusion, in the month after Max, Annie, and the children are deported, Simon, the wiseguy, marries—we don't know whether it was in defiance, for survival, or for love. But he does survive, and he returns to Holland. In discussions of the making of *The Maelstrom,* Forgács has told how a postwar chance encounter led Simon to the family films. Walking down the street one day, Simon bumped into Chris, the non-Jew who had worked in the family shop. Chris had buried Max's home movies. They, too, survived the war. The most banal images you might imagine had now become a buried time capsule from another world.

Forgács is fond of quoting and responding to Wittgenstein, that great

philosopher of the ordinary. In describing why he makes films from found footage, the director cites the *Tractatus:* "Everything we see / could be otherwise. / Everything we can describe at all / could be also otherwise." This resonates nicely with the fragility of Simon's survival, of the film's survival, and of the montage that is *The Maelstrom.* But there is another ingredient in Forgács's work that is not captured in the philosopher's aphorism. When the figures run to the floodwall, they know that the waves will return. They must return. When we watch the Peerebooms go about their lives as Jews in the years of Nazism, *we* know that they will confront death in ways that *they* could never have conceived. We who live on the other side of that war have passed beyond a contingency, beyond "it could be otherwise"; we look back with knowledge of a destiny we can never unlearn.

Forgács's films balance the feeling of contingency and ephemerality with the feeling of fate and necessity. We approach the maelstrom or the floodwall of our recent history wanting to have a closer look, but knowing the horror beneath those swells. This was a horror, a history that was never recorded in Max's films of the lusty lives of his family. It may be a horror that Peter Forgács's films can provoke in us, but it was one that, perhaps until near the end, the Peerebooms were spared.

## Notes

An earlier version of this essay was published as "Ordinary Film," *Raritan* 25, no. 2 (fall 2005): 1–11.

6 **The Imperial War Museum Film and Video Archive**

*London, England*

KAY GLADSTONE

**Archiving Amateur Film**

The Imperial War Museum Film and Video Archive (IWM Film and Video Archive) originates from the end of World War I, when the films taken by British official cameramen attached to the Army and the Royal Navy were passed to the newly founded museum for preservation. This material, together with the record film shot by combat cameramen during World War II and videotapes of more recent conflicts, constitutes the official core of the archive.

When in the 1960s amateur film began to be offered to the archive, the material acquired for preservation was composed mainly of films shot by officers during their service careers, and generally complemented the official material through providing personal records of training and off-duty scenes overseas. Since 1990, however, the acquisition policy has expanded to include themes of wider social interest, reflecting both a broader interpretation of the museum's own terms of reference (all aspects of conflict involving British or Commonwealth forces since 1914) and recent exhibitions that have explored the impact of war on civilians.

One of these themes, ideally suited to representation on amateur film, is childhood in wartime. Whether shot by a mother, father, foster parent, or teacher, these films generally depict children being sheltered from the dangers of a war waged beyond the camera's frame. Arguably the archive's most significant amateur film related to childhood is a collection allocated the title *Country Life in a Belgian Family during the German Occupation, 1940–1944* (76 minutes; mixed black and white and color; Standard 8mm).

In 1942, as antisemitic persecution in Belgium escalated, Carl de Brouwer, a banker living with his wife and five children in a château outside Ghent,

**Figure 12** Concealed Jewish children Adrien (far left) and
Monique (far right) with the de Brouwer children, with
whom they lived, filmed by Carl and Denise de Brouwer,
8mm, Ghent, Belgium, 1943. Courtesy of the Imperial
War Museum Film and Video Archive.

agreed to house two unrelated children whose Jewish parents were in hiding: Monique, a twelve-year-old girl, and Adrien, a six-year-old boy. For the next three years the two children were looked after by Carl and Denise de Brouwer alongside their own three daughters and two sons. Their lessons and games within the grounds of the château, and their occasional, more perilous journeys beyond to visit de Brouwer relatives, were recorded on 8mm film by the parents, like any other family record of childhood.[1]

The archive first heard of the existence of this film from one of the de Brouwer daughters, Mme. Brigitte van der Elst, in 1994.[2] Its historic value was obvious on two counts: first, as documentary evidence of the successful concealment of Jewish children from the Nazis and their local collaborators; and second, as a rare film record of a very unusual experience.[3] It was also obvious that there was an urgent need not only to preserve the five fragile reels, but also to record the memories of those people best able to reveal the secret history behind these images of happy childhood.[4]

Since the de Brouwer parents were no longer alive, Brigitte van der Elst offered to speak over a projection of the film, which covered her own childhood between the ages of six and twelve.[5] With the aid of some brief notes made by her father before his death, she meticulously identified the people and places in the film, in effect providing a factual catalogue entry for the archive. It was, however, only in the separate interview that she recorded

immediately afterward, when she recalled the children's first sight of the young boy Adrien "Simons" (Adrien Sheppard's assumed identity), that some of the emotions behind her father's film were revealed: "I can still now remember his arrival, sometime in the evening; of course it must have been very frightening for him." She relives her feelings as a girl, when, too young to understand what she knew, she was desperate to share with any-one the "terrible secret" of Adrien's Jewish identity; then as an adult she re-flects on her parents' wish after the war not to be officially thanked for their courage in sheltering Adrien and Monique, based on the family's beliefs that "it was the only thing to do anyway."[6]

The chance to record another perspective on the film occurred six months later when Adrien Sheppard,[7] on a visit to Brussels, agreed to watch and com-mentate on the film in the company of his childhood friend Brigitte. This was an extremely emotive occasion, which unlocked deeply personal memories. He recalled how her father "used to brainwash me every night not to say who I was." Despite this coaching, as Brigitte remembered, Adrien had approached some German soldiers passing in front of the château in the final days of the Occupation. While the children all watched, he declared, "You know, I'm Jew-ish and you didn't take me." By such comments as these, triggered by view-ing the film rather than by actual events on the screen, the two adults con-verted these amateur images of their childhood years into a historic record of one hidden aspect of World War II.[8]

With the approval of the de Brouwer family, an edited excerpt from the film is now running continuously in a two-minute loop in the museum's new Holocaust Exhibition, in a section showing how a small number of Jews survived in hiding. Here in context these private images of happy childhood become part of the massively incomplete visual record of the Nazi Holo-caust, challenging the viewer's imagination no less than the more obviously shocking official films and photographs on display nearby.

## Copying and Conserving the de Brouwer Film

DAVID WALSH, *head of preservation, IWM Film and Video Archive*

The original was a Standard 8mm film assembled from black and white and color sections. In order to provide access copies, IWM sent the two reels to a film laboratory that specialized in amateur-gauge films to have a 16mm blowup copy made—a new intermediate negative and, from that, a new print. As making duplicates of black and white footage on color film stock is far from ideal (color material is less stable and it is virtually impossible to

achieve "true" black and white without a degree of color cast), the original was broken down into numbered black and white and color sections so that it could be printed on appropriate stocks and then reassembled in order.

The limitations of film chemistry and of the printing equipment (especially when dealing with the tiny image size of 8mm film on filmstock more than fifty years old) mean that the quality of 16mm blowups is considerably less than perfect—black and white and, especially, Kodachrome print stock is not intended for duplication, so that the resulting copies tend to be overly contrasty, the graininess and lack of resolution of the tiny images tends to be exaggerated, and with the lab used in this case, the optics of the printing equipment (designed to give a satisfactory result for the average user) were set to crop the frame edges fairly severely, resulting in a loss of image around the edges. However, at the time (1995), this approach was still considered to be the safest method of ensuring the film's future; with the advent of good-quality video copying and projection, improved storage for masters, and the disappearance of such specialized film printing labs, such an approach is no longer taken. In 1995, there were very few places capable of producing adequate-quality video copies from amateur-gauge films (Standard 8mm and 9.5mm), so to produce a video access copy, the new 16mm print, reassembled into the original running order, was copied (using a professional "telecine" machine) onto a video submaster, from which a VHS viewing copy was made. The original and the new intermediate negative were placed into long-term storage.

When, a couple of years later, the IWM designed and built new equipment for making high-quality video copies directly from Standard 8mm and 9.5mm film, new policies for dealing with such materials were implemented. Video access copies are produced directly from the originals wherever possible, and those originals are placed in long-term storage to ensure that they have a long life expectancy. The quality of the video images made in this way is far superior to those produced via the 16mm blowup copies. In the case of the de Brouwer film, new video copies were made in 1998 by this method. It should be noted that developments in film to video technology continue, and there are now a number of professional video facilities that can make extremely high-quality video transfers from such films.

Partly on account of these technological improvements, and partly thanks to archivists documenting these small-gauge reels more rigorously than in the past, the value to both program makers and historians of films like those shot by the parents of Brigitte van der Elst is happily now greater than ever before.

## Notes

1. See Debórah Dwork, *Children with a Star—Jewish Youth in Nazi Europe* (New Haven, CT: Yale University Press, 1991).

2. Née de Brouwer, 1934–2000, formerly executive secretary of the International Federation of Film Archives (FIAF). This article was conceived in memory of Brigitte van der Elst, who devoted her life to the art of film and who also appreciated the importance of amateur film.

3. "Rare film record" needs qualification. The previous assumption that shortage of stock and official bans constrained amateur filming in Europe during World War II has been undermined by recent television programs based entirely on such material. In fact, in Belgium and northern France, "films having family life as their subject" were excluded from an ordinance dated April 25, 1941, specifying that the production of narrow-gauge (i.e., amateur) films was subject to the authorization of the military commander. Reference taken from André Huet, "Approche de l'univers des Inédits," in *Jubilee Book—Essays on Amateur Film* (Charleroi: Association Européene Inédits, 1997), 24–25.

4. Where practicable, and when merited by the historic interest of the amateur film acquired, the practice of the IWM Film and Video Archive is to ask either the cameraman or one of the subjects of the film to comment on audiotape over an uninterrupted screening of the film (generally after its transfer onto video). Various circumstances, ranging from the unstoppable projection to fallible memory, may constrain the commentator from fully describing the events on the screen, so the archivist normally then records a separate interview. This enables the cameraman or subject to speak in greater detail about his or her life, and allows the archivist to ask any further questions needed to clarify the historical context of the film.

5. Although normal IWM archival practice is to duplicate unique material before further projection, it may not always be appropriate to ask owners of amateur film to stop projecting reels they habitually screen without archival qualms.

6. Despite these assertions, Carl and Denise de Brouwer were posthumously awarded the title "Righteous among the Nations" by the Yad Vashem commission, after a proposal made by Adrien Sheppard in 1999.

7. Born Adrien Sapcaru in Ghent, 1936; now Professor Adrien Sheppard, School of Architecture, McGill University, Montreal.

8. Regrettably, this second recording was a technical disaster. Surviving written notes made during the recording barely recall the range of emotions evoked by Adrien Sheppard during his first viewing of the film and during the interview that followed. He very kindly agreed to record a repeat interview in November 1999.

# 7 *90 Miles*

## The Politics and Aesthetics of Personal Documentary

AMY VILLAREJO

When I was growing up, I used to think that Santa Claus was Russian. If you ever put on a Santa suit, dance salsa and eat *lechón* [roast pork] in the same hour, then you'll know what it's like to be a Cuban American.

**Juan Carlos Zaldívar**

*90 Miles* (Juan Carlos Zaldívar, 2001) is a personal documentary, a story of becoming Cuban American. What makes *90 Miles* particularly interesting to me is that, unlike some filmic journeys narrating how ethnicities combine to become "hyphenates," this film names and records the failure, rather than the successful resolution, of that hyphenation. The three playful requisites cited in the above quote cannot provide sufficient glue to bind Cuban and American: those two names, those two histories, those two complicated and fractured formations.[1] *90 Miles* is literally the measure of the distance between the two countries, but the film also *takes* the measure of the distance, tracing lines between intimate personal history and collective identity, and offering a layered, complicated meditation on familial belonging, political participation, and (more subtly) queer sensibility. The film's tools are simple: time (it took five years to make) and footage (it was cut down from 250 hours of archival materials, home movies, Super 8mm footage, Hi-8, and digital video interviews). Its results are worth exploring, with an eye especially toward two stories, elegantly interwoven: the story of a gay son and his father, and the story of a return to Cuba, told through what I call a form of retrospective fantasy that is built on the materials of childhood memory.

**Figure 13** From *90 Miles* by Juan Carlos Zaldívar, 2001.
Courtesy of the filmmaker.

## Introduction

Juan Carlos was a thirteen-year-old Communist in 1980, living with his extended family in the Cuban town of Holguín, participating in demonstrations and "acts of hate" against the thousands of Cubans deserting the island in the Mariel boat lift. A student of film and television who had been selected to spend his academic years at a government boarding school, Juan Carlos had already begun to drift away from his father's intimacy. As a gesture of faith and trust, yet one only retrospectively understood as such, Juan Carlos's father, Pachuco, asked a shocking question and left the decision up to Juan Carlos and the older of his two sisters: Should the entire family of twelve leave Cuba with over a hundred thousand others at the port of Mariel, to join Pachuco's brothers/Juan Carlos's uncles in Florida, or should they stay and continue the work of the Cuban revolution?

This was quite a decision for a thirteen-year-old, and it forms the apparent core of the film's personal story as it acquires affective weight. Juan Carlos recalls that he was angry at that time, a young teenager filled with misconceptions about life with "the enemy." He was devoted to the revolution and to Cuba itself. In one sequence in the film, featuring caricatured images of Jimmy Carter, American decadence, and Yanqui militarism, Juan Carlos recalls in voiceover: "I said to [my parents], 'How could you take us to a place where I'll be forced to take drugs in school, where you can't go out at night, and where my grandparents won't be able to see a doctor if they get sick?'" One can easily imagine these words flowing from the mouth of a Cuban emigré in Miami, recalling how he had been duped by Fidel's propaganda, and

how he then savored the truth of life's freedoms in the United States. But in Juan Carlos's case, as with many others we might imagine, the deception had come from his closest family, and the truth is revealed, strikingly, in images. In order to make sense of the putative story at the film's center, we need to pause to examine how *90 Miles* entangles the familial and the national right from the beginning, refusing the certainty of a counter-myth.

The personal narration focuses on anguish: a son is asked to make a monumental decision, determining the fate of his entire family, including his aging grandparents. He is asked, however, not only to leave all that he knows, to exchange the familiar for the unknown, but also to confront the inseparable dimension of political belonging: he must forsake his leader, switch allegiances, join the enemy. In the course of making the decision, he learns that he has been deceived, that his parents were less committed to the revolution than he (with his state-sponsored educational scholarship), and that they had also withheld the evidence of another America.

That evidence comes in the form of photographs: "That's when they took out the family pictures and the correspondence they had been keeping with my uncles to explain to us for the first time that the United States was not what we believed it was." We, the audience, see color snapshots of the uncles' families, posed in groups before the amateur lens, then one uncle's medical license, and finally a few photographs of the families at play on the beach. Offered as data of American life, the photographs alone do not combat myth; they instead provide a more nuanced understanding of what the thirteen-year-old Juan Carlos might have seen when he saw the United States anew. The photographs thus function subjectively, as they will in other key moments of the film. These photographs are layered with superimposed abstract images drawn largely from architectural sources (shot much later, when Juan Carlos traveled to Cuba as an adult in 1998), creating a mosaic effect repeated throughout *90 Miles*. This mosaic effect is the key aesthetic strategy or motif of the film, uniting the illustrative or evidentiary role of photographs with the interior burden of meaning they also carry. The layered imagery, however, functions also as the film's affective center, its topic, if you will, its true raw material. This layered effect is what otherwise resists symbolization: it is, as we shall see, a gay son's hold on kinship and a Communist's hold on community.

*90 Miles* is thus a film about the circles of affect and belonging that ripple outward from the decision Pachuco asks Juan Carlos to make in 1980, a decision with untold ramifications. Once in America, Pachuco, unable to succeed financially as much as he would like for his family, falls into a severe depression. Juan Carlos's mother, Nilda, must supplement the family income,

and she works long hours at a costume jewelry warehouse in addition to her considerable domestic labor. Juan Carlos's sisters, Nilvi and Annie, adjust to the United States as Juan Carlos does; Annie's daughter, Taylor (whose birth we witness), becomes the first member of the family who isn't Cuban. Juan Carlos moves to New York, musters up the courage to kiss a boy, and becomes a filmmaker. But father and son, Pachuco and Juan Carlos, are estranged, caught in a circuit of resentment and antagonism and such in a looming chasm of blame. By tracing the interior landscape of his affect and desire, Juan Carlos seeks to return to the source of that conflict in order to resolve it. By tracing the external geography of America and Cuba, Juan Carlos seeks, in a very different movement, to restore images to memory. In a press release promoting the film, the director puts it this way: "With *90 Miles*, I attempt to repair the damage that my relationship with my father suffered when we made the decision to leave Cuba in 1980 on an overcrowded boat. The film puts a face on a politically charged topic and serves as a testament to the Cuban and Cuban-American experience."

In the charged environment of the Cuban immigrant community of Miami, the couplet at the end (Cuban *and* Cuban American) can be understood as a necessity in the face of tensions that seem insurmountable, but, no matter how one characterizes the poles of political conflict, it remains the filmmaker's task to "put a face" on the topic, to give images to ideas.

**The Raw**

Because the film is a composite—rendered through the editing of interviews, contextual footage, and still photographs/home movies—understanding their assemblage requires some attention to each component. Before turning to these three elements in more detail, however, a word is required about what the film chooses *not* to incorporate or address, particularly in relation to the issues of gay identity that receive scant overt attention in *90 Miles*.

Julian Schnabel's 2000 film, *Before Night Falls* (based on the memoir of the same title by gay Cuban writer Reinaldo Arenas), is one in an increasingly long line of American and European films that uses the fulcrum of gay identity as the basis for a full-frontal attack on Cuba's repression of human rights. Anchored firmly in the liberal language of rights and tolerance and arguably following upon the inflammatory rhetorical strategies of Nestor Almendros's and Orlando Jimenez Leal's *Mauvaise conduite* (*Improper Conduct*, made for French television in 1984), these films have returned over and again to a particularly atrocious moment in Revolutionary Cuba's early

history and to the forced labor (UMAP) camps in which many gay men, among many others, suffered.[2] Using dubious testimony and evasive chronology, these films have been surprisingly successful in convincing the Western left that Cuba retains a repressive and violent stance toward its queer citizens. More significant to the present context, these films have been surprisingly influential in prompting queer filmmakers in the United States to redress their allegations (as in Sonja DeVries's 1995 film *Gay Cuba,* or Graciela Sánchez's 1988 film *No Porque Lo Diga Fidel Castro* [*Not Because Fidel Says So*]). In these films, artists who are generally sympathetic to the work of the revolution have, perhaps unwittingly, reinforced the sense that "gayness" and "Cuba" remain in a tension best resolved through the discourses of the liberal West.

That Zaldívar chooses not to narrate the history of Cuban gay culture is important because it is true to the self-imposed constraints of the personal form he embraces in *90 Miles.* He has limited himself, in other words, to the ways in which the past seems to etch itself on his own present; his purview in treating Cuban history is limited to his parents' meeting and subsequent union and—in line with the narcissism the personal form blissfully allows or wistfully imposes—to his own formation as a Cuban young man before he leaves the island in 1980. In a stubbornly literal way, we might then see Zaldívar's coming out as a distinctly American process, one in fact impossible to name in Spanish. Zaldívar explains: "I said 'kissed a boy' [in the film] because there is no term equivalent to 'gay' in Spanish—the choices are: the clinical term 'homosexual' or a few derogatory names. I have always been a creative person, perhaps more sensitive than the average person, but I don't think that has to do with sexuality per se. I always felt more comfortable around women and the sex was fun, so I dated them until I fell in love with a boy for the first time."[3]

In a less literal way, we can understand the film via the above confessions as filtered through something like a queer sensibility, built on the scaffold of a resolutely powerful Cuban identification. Zaldívar's pure pleasure in the company of women, his care toward kinship relations (his Cuban relatives and compatriots), his charm, and his gestures of love are finally what carry us through the various trajectories of the film's explorations, not a topical treatment of gay life. (He mercifully avoids almost every pitfall thereof, except a quick cut to Wigstock, for which we ought to forgive him.) And despite the occasional cliché through which he is compelled to summarize or recapitulate psychologized self-understanding, his record of his life is energetically fresh and moving, without simplifying the complexities in which he is caught.

Those complexities are revealed, first, in the familial present tense, a time that extends over a period of five years in videotaped interviews. Appearing on a panel devoted to the use of the Wolfson archives (to which we turn shortly), Zaldívar expressed real amazement about what the video camera enabled with his family: "I found that by having the camera and asking the questions, you get answers. With no objection! And the camera really became a tool to start talking to them. . . . even though I was close to them, I felt a gap between me and my father. Pretty soon the film became about trying to breach that gap and asking him questions and talking about things we hadn't talked about before."

Starting with a Hi-8 camera and moving ultimately to digital video, Zaldívar recorded his family's recollections of "how we came from Cuba."[4] Because he was at school until the moment just before the family reunited in Havana on the way to the port at Mariel, young Juan Carlos knew only selectively about the components—collective and personal—of that experience leading to emigration. The family recollects the monumental events in their history: the prehistory of the revolution, the successful overthrow of the Batista regime in 1959, the movement to socialism and then to Fidel's communism in 1961, periods of difficulty and scarcity, the occupation of the Peruvian and Venezuelan embassies in 1980, Fidel's attitudes toward the "parasites" and "deserters," the demonstrations in support of the revolutionary attitudes, and the flotilla they joined at Mariel. But their remembrances also spark more local and personal reflections: Pachuco's secretive construction work on a family house on an empty lot across the street, the gathering of the family in that home, the scheme they laid to "kidnap" Juan Carlos from his boarding school, and the house and life they found on the shores of the United States. These are memories in search of images, events that had already happened without a visual or aural record *of* them; these are images, finally, that Zaldívar will find in or reconstruct from the archives.

Although much of the interview footage is devoted to the father/son relationship, there are several particularly poignant moments that also ask for both visual answers and visual illustration. Early in the film, Pachuco responds to Juan Carlos's "coming out" moment: "It is better to deal with things sooner than later. To know things sooner. It gives you more time to mature together." What lends the moment significance is, of course, the dense weight it is accorded in contemporary identity-politics (whereby coming out represents an unmediated transition from shame to pride, from isolation to community, and so on),[5] but the film also locates this moment within the larger swells of affect that define the tensions between father and

son, and therefore between Cuba and America, as I suggested above in notic-
ing their entanglement. For Juan Carlos fears that his father "would think
that I had been lying to him all my life" by withholding, as it were, Juan
Carlos's other America: New York, his queer life. The repetition of the de-
ception Juan Carlos felt at thirteen looms in this exchange, and it therefore
asks the viewer to loop backward and forward once again, to mark the dis-
tance between the New York of Juan Carlos's present life from the Cuban
life in Miami, and to underscore therefore the ways in which Miami may
be in some ways *closer* to Cuba culturally and ideologically than we think.
How is it possible to visualize *this* distance, other than as ninety miles?

Another, more disturbing moment involves Pachuco shaving at the
bathroom sink. The preceding discussion has been about Juan Carlos's par-
ents' visits to him at boarding school. Pachuco claims he rarely visited, be-
cause their talk always devolved to school: "We never confided in each
other." Black and white photos of a young Juan Carlos prompt him to ask
his mother the same question about the visits. She claims to the contrary
that Pachuco would sometimes visit Juan Carlos, but that he also had to stay
with his younger sister, Annie. In what feels to me like an ambush, Juan
Carlos is then seen to enter the bathroom with the camera in hand and ques-
tions his father: "Why do you say that I abandoned you? Why do you al-
ways tell me that I left you when I was little?" Pachuco hides behind his
hand, begins to weep, and moves away from the camera. In voiceover, Juan
Carlos wonders, over the footage of a home movie, whether his father was
keeping something from him: perhaps he secretly hoped that Juan Carlos
would have made the decision to remain in Cuba. Again in this example, we
witness a reversal that is also a repetition: Juan Carlos attributes his own
sense of abandonment to his father, literalizing an element of fantasy. Such
literalization is caught within the figurations that photographs (or home
movies) provide, memories that are mummified, static, frozen. To animate
them, Zaldívar turns to the archive, to which we also now move before
exploring these transfigurations of fantasy further.

An enormous amount of material in *90 Miles* is footage from archives,
primarily from the Florida Moving Image Archive (formerly the Wolfson
Media Center) in Miami (introduced and described at greater length in
chapter 8 of this volume by its director, Steven Davidson). While the fam-
ily provided the filmmaker with photographs and home movies, and while
Zaldívar shot countless hours of videotape interviews and Super-8 film (for
the more abstract effect I mentioned earlier), it was up to the Florida Mov-
ing Image Archive to provide over twenty minutes of film that help to il-
lustrate a collective memory of what many Cuban Americans experience as

exile. Supplemented by material from Cuban television and ICAIC (the Cuban Film Institute), the material from the Florida Moving Image Archive includes television reports from the Miami area, footage of the Mariel arrivals, and specific footage of Miami's Cuban community. In only the first few minutes of *90 Miles*, we see: images of Cuba in 1980, Cuban soldiers marching, a mural, crowds of children cheering on Fidel, more soldiers with rifles, Fidel giving a speech about Mariel, images of the embassies with crowds on their rooftops, still images of the bus that drove into the Peruvian embassy, more embassy crowds, a Miami television (Channel 4) report including images of the Miami Cuban immigrant community protesting, with Fidel hanging in effigy, footage of Fidel speaking, and a march in support of the revolution and against its "deserters." All this before the film's actual title appears.

Although it largely serves an illustrative function, the archival footage constantly reminds us that even if memories can be arrested or caught, meaning is never static. *90 Miles* is an exercise in the reinterpretation of the past, whereby new uses are found for old footage. These archival materials also demand new ways of seeing the past in relation to the present: Zaldívar sought to find footage, as he puts it, "of what my family had been talking about." The images, that is, had been in the filmmaker's head, but he hadn't *seen* them: such is precisely the enigmatic nature of memory itself. With the footage supplied by the Florida Moving Image Archive, Zaldívar begins to provide a visual counterpoint to family lore, enlisting other "personal" stories for his own, and thereby providing points of contact for viewers with similar experiences, similar memories, similar images shaping their stories. But it is not simply Zaldívar's final *use* of these materials that is most important for our discussion of this component of *90 Miles*, since he is not, at least in this case, the sort of filmmaker (as are, for example, Jay Rosenblatt, Craig Baldwin, and Péter Forgács) who exploits found materials at the level of the signifier, for their surfaces and their forms, their capacity alone to enlist our attention and response.

Instead, Zaldívar's time in the archive seems crucial in terms of *process*, both the process of selection and the process of creating meaning that is determined by selection. Unlike commercial archives (that largely sell stock footage to the media industries), the nonprofit Florida Moving Image Archive is a public institution, responsive to independent artists and public media activists, as well as to more commercial enterprises. Its role in aiding filmmakers, at the level of research, selection, and even at the level of promotion, is an active one. The archive in this case collaborates in the production of cinema, fostering and nurturing an embattled documentary film culture. Making history affordable, archives such as the Florida Moving

Image Archive ultimately play an extremely significant role in shaping what Marcia Landy calls the cinematic uses of the past.[6] In the case of *90 Miles*, the Florida Moving Image Archive not only staged the film's Florida premiere, but also engaged publicly the processes and politics of archival images in the three-day festival (titled "Rewind/Fast Forward" and held at FMIA) at which Zaldívar's film premiered.

The process of collaboration between archivist and artist is significant in the face of the enormous financial constraints independent filmmakers face in choosing materials. To take but one example Zaldívar offered during a panel discussion of archival footage at the conference: the filmmaker thought a popular-cultural illustration of his adjustment to life in the United States would be an entertaining shorthand, in the form of ten seconds of the title sequence of the television program *Bewitched.* The price? Over $10,000, necessary to cover the cost of the footage, the clearances for the music, the rights to the likeness (it is an animated sequence) of Elizabeth Montgomery, the rights owned by others involved with the production, and the like. Especially for filmmakers who seek eventually to screen their work on television, such clearances are an absolute necessity.

But the selection of materials can also influence the process of creating meaning. One example in *90 Miles* stands out and not only because it struck Zaldívar anew during the editing process. Zaldívar includes a lengthy television news report from a Miami station, focusing on the children of Mariel then new to the Miami-Dade school system. A schoolteacher had asked her students to look into the mirror and paint what they saw, suggesting that they paint a self-portrait. The camera slowly pans across the students' paintings from left to right. In that movement, we discover that each student has painted the same thing: a portrait of Fidel Castro.

The moment is haunting. The television reporter enigmatically intones, "We have a lot to learn about who they are, and so do they." Since Zaldívar fades then to black following this comment, I shall take his film-grammatical cue to see this television story as providing a significant, emphatic point (worth contemplating in the fade) regarding the enormously complicated process of identity-formation, to which the film itself is devoted. Cuban-American, that is, a hyphenated instant identity category, woefully mismanages the processes of becoming it seeks to name, wherein misrecognition and collective imagination play no small parts. And since home movies and family photographs—the last of the three categories I mentioned as constitutive components of *90 Miles*—also function in the film as embalmed proxies for contemporary identity, it is to these that we might now turn, in a very brief examination prior to some concluding analyses of the

combinatory logic of Zaldívar's film that focus largely on the role of this footage. What is important to understand in regard to Zaldívar's use of these photographs and films as illustrative of the past is his affective relationship to image-production, that is, his stake in having been and in being a filmmaker, giving images to ideas. To be a filmmaker is to also be a gay son, making a film about his father. These strands of personal and professional identity, Cuban *and* Cuban American, cannot finally be untangled.

Although Zaldívar fetches his own past through family photographs and home movies, using these to supply evidence of the version he provides of the family's life in Cuba and subsequent experience in southern Florida, they serve a much more complicated function in *90 Miles*, two dimensions of which immediately come to the fore. First, Zaldívar offers these images as *gifts* to his father. After Zaldívar decides to return to Cuba in 1998, on a quest for the source of his father's depression, the production of images takes on a new meaning, documented in the film as representing the risks entailed in healing: "I didn't know what the trip would do to me, but after eighteen years of seeing my dad unhappy, I thought it was worth the risk." The question Juan Carlos then poses to his father, "What do you want me to bring you back from Cuba?" (to which Pachuco replies, "What can you possibly bring me from there?"), is even *more* loaded than it appears, for the son's gift to the father seeks to provide the very continuity that memory ought to supply, the tools for taking the measure of distance. When Zaldívar returns from Cuba, he presents his parents, but particularly his father, with a book of family photographs he retrieved while in Cuba; Pachuco cries on camera, yet the film refuses the idea of resolution, or full incorporation, of the wound that causes Pachuco's pain. The son's gesture simply speaks, as does the father's reaction, and they speak through images.

The second complicating factor in Zaldívar's use of home movies also has to do with continuity: the young Juan Carlos found refuge in image-production (he seems to have made some rough and amateur camp horror films in his formative years), and he continues to do so. He trained in Cuba as a filmmaker, even if he was a terribly young one, and he records images upon his return (accompanied by his producer), both in Super 8mm and in video. In a marvelous sequence during his first return visit to Cuba, he reconvenes with the film projector that has been passed along to his relatives after his family's departure. Reminded as we are of his intimate relationship to cinema, we learn more: when his father used to project films on a sheet strung up in the living room, young Juan Carlos discovered that the images also appeared on the reverse side of the sheet, only backward. From then on, he preferred the back side.

In the most literal sense, Zaldívar here offers a figure for understanding his innovative relationship to images: not content with the normative, everyday conditions of spectatorship, we understand the budding filmmaker to invent a new gaze, to pursue new avenues for vision, or to enjoy a perverted glance at the underside of cinematic illusion. We might forge a way, however, to read this anecdote as something other than a paean to the Artist. The underside of the image, the tain of the mirror, the layered and composite elements of memory and fantasy: these lie at the core of a more general queer relation to belonging. In the final section of this piece, I turn to the imbrication of the personal and fantasmatic with the contextual, in what is certainly only a preliminary analysis of the queer hyphenated conundrum presented in *90 Miles*.

## The Cooked

What version of "identity" can account for the portraits I mentioned above that were painted by those schoolchildren, newly acculturated to the excesses of the American commodity lifeworld, when they quite literally saw each of themselves as a cigar-smoking, bearded, and aging charismatic revolutionary leader? From our vantage point in the United States (and I realize that I speak in a generality we also likely will want to fracture), we have yet to understand the torsion that follows from the incorporation of the powerful, sure, strong center. That incorporation, however, requires an elaborate apparatus of social, pedagogical, and cultural support; otherwise, it cracks, reveals its fissures, loses coherence. A certain habit of reading (one I would not endorse) would find the father always and necessarily at the center: when all is said and done, that is, Juan Carlos the son returns to the scene of the powerful father, only to find that the support has yielded, and not because he fully "identifies" as an American or even as a Cuban American, but instead because, in the midst of the furor over Elián that frames his return to Cuba, he cannot secure his *own* father's place as stable.

There is a theoretical danger in reducing power to a single figure, however, and an equal hazard in accepting the terms of the personal, whereby multidimensional social conflicts find manageable substitutes in individual and familial structures. We have yet further to understand the *particularly* freighted kinship relations surrounding gay people's lives, our fears of those acts of exclusion that render gay sons and daughters (or aunts and uncles, mothers and fathers, sisters and brothers) abject and unsayable, or simply "not." What I suggest in the remainder of this reading, then, is that in *90*

*Miles* as elsewhere, queerness finds its elaboration in the articulation of "being" along its *multiple* strands: familial, pedagogical, professional, affective, erotic, national, and more broadly social. In *90 Miles,* however, the visual collages, specifically incorporating home movies and family photographs alongside the newer Super 8mm footage, challenge a stable or known ground for its path.

Recall Bazin's complicated sentence regarding family albums, those densely charged images that have the capacity to fulfill our "deep need" for a mimetic substitute for ourselves: "Those grey or sepia shadows, phantomlike and almost undecipherable, are no longer traditional family portraits but rather the disturbing presence of lives halted at a set moment in their duration, freed from their destiny; not, however, by the prestige of art but by the power of an impassive, mechanical process: for photography does not create eternity, as art does, it embalms time, rescuing it simply from its proper corruption."[7]

Those who have been attentive to the images produced of current life in Cuba will hear reverberations with the notion of a time embalmed; in Cuba's case, it is the life of a collective people whose lives seem halted or frozen at a particular moment. Juan Carlos comments on how little has changed visually in Holguín, except for the changes in scale an adult can see only in retrospect: "The streets look the same to me as they did eighteen years ago, but the town seems smaller, and I couldn't recognize everyone who remembered me. I was a familiar stranger."

Zaldívar offers this wonderful figure, "the familiar stranger," to us formally in the composite, or mosaic, effect to which I alluded earlier. He recodes a temporal similarity—itself an effect of the United States' trade embargo as much as a return to childhood—as an abstract figure for identity-formation. In his return to Cuba, then, Zaldívar rediscovers his past *as* an image, actively produced in the present through composite editing; elements of Cuban life, recorded by his Super 8mm camera, mesh with images of memory supplied through home movies and still photographs. In his rediscovery, Zaldívar also reconstitutes a network of kin, particularly with his mother's first cousin Lilia and her husband, Otero (who function as nuclear familial surrogates for Juan Carlos while he is in Cuba during the first visit, and who also allow him concentrically to expand his circle of association). As a familiar stranger, Juan Carlos recombines memory, childhood, family, and image-making into a newly coherent whole: it is that renewed Juan Carlos who can now supply his father with the images that represent reconciliation. In the return, he actively *produces* "home" as a gift for self-understanding.

Zaldívar does not romanticize life in Cuba now. When confronted, during his second visit for the Havana Film Festival, with crowds demanding the

return of Elián, he responds as a familiar stranger again: remembering his own allegiances to the revolution and realizing that, had he stayed, "I would be up on that stage." The young man who *is* on the stage, moreover, denounces the United States in terms with which we have become familiar from Juan Carlos's childhood: "They are offering Elián a paradise of drugs, the country where he can get rich by selling children's organs for transplant." To the extent to which the plight of Elián mobilizes familiar discourses of national belonging, Juan Carlos remembers all the more palpably his own belonging, and he responds with resentment to the conflict in which he finds himself, a conflict he characterizes melodramatically (over violin strings): "It broke my heart that I was being forced to choose."

Although Zaldívar wants to conclude *90 Miles* with a sense of resolution, he cannot: social structures, psychic or affective pressures, families and nations remain forceful conduits of what might appear to be the most intimate elements of ourselves. What *90 Miles* does most powerfully is to remind us of the reverse corollary: to know something of Cuba and America is to travel among families and communities we can remake through new forms of self-production, new ways of editing our fantasies and memories. To know something of the hyphen that continues to haunt what it is to be Cuban and what it is to be American is to take the journey Juan Carlos gives us without hesitation, incurring our debt to the filmmaker as we travel.

## Notes

I am grateful to Juan Carlos Zaldívar and Steve Davidson for their help and generosity.

1. For a nuanced discussion of the role of the hyphen in designating contradictory national, ethnic, diasporic, and erotic modes of belonging, see David L. Eng, "Out Here and Over There: Queerness and Diaspora in Asian American Studies," *Social Text* 52–53, nos. 3 and 4 (autumn–winter 1997): 31–52.

2. See Marvin D'Lugo, "From Exile to Ethnicity: Nestor Almendros and Orlando Jimenez Leal's *Improper Conduct* (1984)," in *The Ethnic Eye: Latino Media Arts*, Chon A. Noriega and Ana M. López, eds. (Minneapolis: University of Minnesota Press, 1996). The original and most powerful critique of the film and its lack of contextual information is B. Ruby Rich, "Bay of Pix," *American Film*, no. 9 (July–August 1984): 57–59. Also see Lourdes Arguelles and B. Ruby Rich, "Homosexuality, Homophobia, and Revolution: Notes toward an Understanding of the Cuban Lesbian and Gay Experience, Part I," *Signs* 9, no. 4 (1984): 683–99, and "Part II," *Signs* 11, no. 1 (1985): 120–36.

3. LoAnn Halden, "Bridging the Miles," *The Weekly News*, July 19, 2001, 12.

4. Ibid.

5. See Judith Butler, "Imitation and Gender Insubordination," in *The Lesbian and Gay Studies Reader*, Henry Abelove, Michèle Aina Barale, and David M. Halperin, eds. (New York and London: Routledge, 1993), esp. 309.

6. Marcia Landy, *Cinematic Uses of the Past* (Minneapolis: University of Minnesota Press, 1996).

7. André Bazin, "The Ontology of the Photographic Image," in *What Is Cinema?*, vol. 1, essays selected and translated by Hugh Gray (Berkeley: University of California Press, 1967), 14.

## 8 The Florida Moving Image Archive

*Miami, Florida*

STEVEN DAVIDSON

Since its founding in 1986, the Florida Moving Image Archive, formerly known as the Louis Wolfson II Media History Center, has become one of the largest and most active moving image archives in the United States. The archive was established with a donation of over two million feet of television news film and thousands of hours of videotape from the first television station in Florida, WTVJ, which began broadcasting in 1949 and is one of the oldest in the country.

The archive's policy is reflected in our mission to collect, preserve, and make accessible film and video materials made in or about Florida. From the beginning, we realized the importance of broadening our collection to include other types of moving image materials, particularly home movies and amateur footage. Now our ever-growing collection contains over ten million feet of film and thousands of hours of video, spanning eight decades, ranging from home movies and amateur film dating from 1910 to contemporary newscasts. These materials provide a visual record of our South Florida community, its history, culture, and development.

The fastest-growing component in the Florida Moving Image Archive is our collection of home movies and amateur films. We continually investigate, research, and acquire images. This collection is most significant for its diversity and coverage of many decades. While our television collection is among the largest in the United States and spans five decades beginning in 1949, those images tell only part of South Florida's history. The collection's home movies and amateur footage trace our region's history almost forty years earlier, to around 1910. The home movies in the Florida Moving Image Archive's collection—particularly those dating from 1910 through the 1950s—are unique because the images chronicle a relatively early time in the history of this region. Significantly, they reveal life in Southern

Florida and the surrounding areas as never seen before: they document the growth, development, and daily life of this region.

South Florida and motion pictures both mark 1896 as their year of origin. The City of Miami was incorporated in 1896, the same year motion picture film was introduced, and because of that the area's history and everyday life have been documented by amateurs and their home movie cameras. Our photogenic tropical region has always attracted cameras. The home movies and amateur footage shot by families, residents, or tourists spending the winter at our beaches have encouraged migration to this region. Historically, tourism is a major economic force in South Florida. Home movies and travelogues have promoted economic and social growth here. Images of cars and family life from the 1910s to the 1950s show the impact of development. For example, some of these films contain images of the clearing of the swamps to build Miami Beach circa 1910. They also show 1920s Havana, Cuba, a much more cosmopolitan city than Miami and Miami Beach at the time and a popular vacation spot.

The home movies and amateur films encompass a range of topics and themes, from the more personal family and life-cycle events to the development and history of this region. They chronicle images of hurricanes that struck in 1926, children attending school, religious ceremonies, construction, and the skylines of Miami and Miami Beach over the years. There is also footage of the Florida Everglades and the Miccosukkee Indians who lived there. Other home movies show family life in the '50s in Overtown, the African American community in Miami, which contrast markedly with broadcast television coverage of the African American community at the time. These images provide extraordinary views from uniquely personal perspectives. The films are also deeply contextual: they reflect the life of the person behind the camera, the region, and the historical period.

Collecting and acquiring the materials represent only the beginning of the archival process: ensuring their accessibility to the general public, researchers, film- and videomakers, and others is even more important. The Florida Moving Image Archive's collection includes home movies and amateur footage in a range of formats—35mm, 16mm, 8mm, and Super 8. Each format requires specialized equipment and supplies, and so preservation and restoration may be a long, arduous process.

There are unique challenges in preserving older films in our region. When South Florida's tropical climate combines with the age of a film and poor storage conditions over decades, a film may deteriorate beyond restoration. The preservation process often requires that new negatives and prints be struck to ensure long-term image stability. Even films in the best

condition require extensive lab work. While laboratory costs prohibit striking new negatives, prints, and/or blowups from 8mm to 16mm for every reel of amateur film or home movies, archives must nonetheless select films for preservation. In order to preserve these films and increase their accessibility, the archive has received grants in recent years from the National Film Preservation Foundation and the American Film Institute/National Endowment for the Arts, as well as from local funding sources such as the Miami Dade Department of Cultural Affairs and the City of Miami Beach Cultural Arts Council.

Video transfers of all materials greatly extends accessibility, prompting more donations and other sources of funding for preservation. From the beginning, the Florida Moving Image Archive has had a very active public access program. These activities create public awareness, increasing both donations and the availability of public programs. Our outreach includes screenings, seminars, exhibitions, two daily programs on cable television, film and video bus tours, and individual access to our collection. The cable television programs feature home movies, amateur films, and other moving image materials placed within historical and cultural contexts.

The film and video bus tours—also known as Magical History Video Bus Tours—represent our most unique public program. Specially equipped luxury buses have six video monitors onboard. As the bus travels around Miami and Miami Beach, moving image materials—including home movies—are screened on the monitors. The subjects correspond to the bus route. As modern-day Miami passes by, passengers are transported back in time with home movies of those same locations from previous decades. These bus tours have been a great success with the general public, schools, senior citizens, and tourists.

Other activities include public screenings of the work of film- and video-makers who have utilized home movies and amateur footage in new productions. The archive has also collaborated with arts, cultural, and educational organizations to reach new audiences. Our project "Deja View: Home Movies in South Florida" began with an exhibition at the Historical Museum of Southern Florida. It is now a traveling exhibition, currently on view at the Miami Beach Public Library and the main Miami-Dade Public Library. "Deja View" makes accessible recently preserved, rare home movies and amateur footage culled from the earliest days of South Florida's history.

From the outset, the Florida Moving Image Archive has taken a proactive approach to publicizing and marketing its activities. Media coverage of the archive's activities has significantly enhanced donations of both film and artifacts. Press releases and compilation reels are regularly sent to local

**Figure 14** Display showing home movies from the exhibit "Deja View: Home Movies in South Florida," Historical Museum of Southern Florida, Miami, Florida, 2004. Courtesy of Louis Wolfson II Florida Moving Image Archive.

television stations and still photographs to newspapers. Feature stories have showcased the preservation process and the importance of amateur films and home movies. As a result of the public programs, marketing, and promotion, the archive has become a vital part of the cultural landscape of South Florida.

The archive's outreach programs led to one of the most interesting, unexpected donations of materials to date—the home movies of Anita Bryant, donated by her ex-husband, Bob Green. In the spring of 2001, our "Deja View" home movie exhibition was underway at several venues. Another project, "Past Out," which examined local television news coverage of South Florida's gay and lesbian community, was in the middle of a three-month run. Green contacted the archive and said he wanted to donate the family's home movies and other items, known as the Green/Bryant materials. In the 1970s, Anita Bryant and her then-husband, Green, were leaders of a campaign against homosexuality. They founded the organization Save Our Children, whose history was already well documented in the archive's newsfilm collection. The Green/Bryant materials included home movies of their 1970s crusade against homosexuality, film of their family life in the 1960s, and film of Anita Bryant's life as an entertainer, including her appearances on several USO Tours with Bob Hope and other entertainers. The donation also contained many Florida Orange Juice commercials and assorted network coverage of

their lives, including a program from the *Tomorrow Show* with Tom Snyder. In making the donation, Green stated that "now the public will be able to judge the complete picture of our lives and that period in history will now be preserved and accessible." Ironically, the Green/Bryant materials were donated during Gay Pride Month and on the twentieth anniversary of outbreak of the AIDS epidemic.

For the archive, the donation was important on many levels. The home movies in the Green/Bryant materials provide a counterpoint to local news coverage of gay rights. The span of years of the home movies (from the 1960s through the early 1980s) reflects a period of dramatic change in South Florida from the perspective of a family that was often in the news. Because the donation was featured in the evening news and local press, several filmmakers have considered producing documentaries about the life and times of Anita Bryant, an unimaginable undertaking before this collection came to the archive.

However, despite the fame and notoriety of the Green/Bryant materials, all donations are equally important. Each donation of amateur film and home movies offers valuable discoveries. In most cases, the films have not been viewed in years. Even when accompanied by extensive written descriptions or detailed notes, each reel usually yields surprises. Our policy and donor agreements provide for the transfer of copyright of the materials to the Florida Moving Image Archive; in exchange, we provide the family or donor with free video transfers. The archive has the right to use the materials for screenings, seminars, exhibitions, and licensing. The Florida Moving Image Archive receives hundreds of requests from filmmakers to use footage in new productions. Increasingly, the footage supplied to these filmmakers comes from the home movies and amateur footage of South Florida life.

The archive has also taken a proactive role with its home movie and amateur film collection, and has reached out to filmmakers, making them aware of new acquisitions or footage that might be of interest to them. In many cases this has led to the archive's footage being used in new productions. Two notable examples are recent projects by the independent filmmakers Jay Rosenblatt and Bill Morrison. The archive had invited both filmmakers to participate in its "Rewind/Fast Forward" film festival and in the process developed a rapport with each of them. When he read and saw some of the publicity about the Bryant/Green collection provided to him by the archive, Rosenblatt had an immediate interest in the material. After he made several visits to Miami and viewed hours of preview tapes, the beginnings of a film took shape. Almost three years later, Rosenblatt premiered *I Just Want to Be Somebody*, which almost exclusively utilized footage from the Bryant/Green collection.

Similarly, after several visits to Miami to screen his films, Bill Morrison became more and more familiar with the archive's collection. Morrison was just beginning to work on a new film and asked for preview materials about backyards, family homes, and related materials. The result was Morrison's film *Porch*, which relied almost entirely on footage from the Florida Moving Image Archive, after Morrison had culled through and previewed hours of home movie materials.

While these high-profile projects underscore the importance of home movies and amateur films for use in new productions, the value of these materials is in their documentation of our region's culture and history. Early on, when the archive expanded the scope of its collection policy to go beyond television newsfilm and to encompass home movies and amateur film, it was precisely for this reason. The television materials date from 1949, but home movies and amateur footage take us back almost five decades earlier and continue through the television era. For the public, for researchers, and for anyone using the archive's collection, the home movies and amateur film provide unparalleled views and possibilities.

# 9 *Something Strong Within*

A Visual Essay

KAREN L. ISHIZUKA AND ROBERT A. NAKAMURA

During World War II, the United States government incarcerated over 120,000 men, women and children of Japanese descent—two-thirds of whom were American citizens by birth. They had committed no wrong and were imprisoned without due process of law. Although the U.S. was at war with Italy and Germany as well as Japan, only Japanese Americans were subjected to this mass removal and incarceration.

The following are actual home movies of this chapter of American history. Most were taken by inmates while in camp. Since cameras were considered contraband, some of the films were taken surreptitiously. As time passed and certain restrictions were lifted, some of these films were taken openly.

This text appears at the beginning of the video production *Something Strong Within* (40 minutes, black and white and color, 1994), an intimate journey into life behind barbed wire using only transferred 8mm and 16mm home movies taken by inmates while they were incarcerated. It was directed by Robert A. Nakamura and produced by Karen L. Ishizuka for the Japanese American National Museum exhibition "America's Concentration Camps: Remembering the Japanese American Experience."[1] The video features home movie footage from the museum's Moving Image Archive.[2]

There is no narration, nor are there any interviews or voiceovers from former inmates or scholars. Except for this brief summary appearing before the titles, occasional text cards with quotes from inmates throughout the video, and identification of sequences by camp and home moviemaker, little cognitive information is presented. Instead Nakamura, who was himself in a camp, paints an intimate collage of camp life using a palette of home movies he carefully edited to maintain the integrity of the original home moviemakers' style. The images play out against an evocative music score composed by Dan Kuromoto with the intention of engaging the

viewer to emotionally experience, rather than intellectually learn about, camp life.

In like manner, the following is a storyboard of video frames from the production that is intended to tell the story through images rather than words.

In chapter 10, Robert Rosen analyzes the historical memory embedded in *Something Strong Within*. He points out that it is only when viewers internalize a work that it becomes operative as a cultural force. Attesting to this, Joy Yamauchi writes in a review of the production:

> It would be so simple to look at this film and say, "There, look. They're enjoying themselves. . . . They don't look like they are suffering at all." Truth is, there are no scripted scenes of misery, no one caught sobbing in uncontrolled grief. These are home movies. Yet unlike home movies taken under normal circumstances, there is an underlying poignancy that transcends the innocent, naïve faces on the screen. . . . The message is clear—life continues, people endure, they survive.
>
> The true power of this film is the fact that it does not apologize for showing scenes of children playing, people laughing and teasing. There is no apology needed.[3]

This article is written with images instead of words to remind the reader of the medium that is the ultimate message of this anthology. It seeks to recenter the visual document within the usually dominant mode of text as historical reference. At twenty-four frames per second in 16mm film and sixteen frames per second in 8mm film, the following forty-eight frames provide but a haiku of the original film. And like a haiku, it invites the reader to read between the lines.

Two girls run across a playfield—but the yard is barren and enveloped in a dust storm. Boy Scouts and Girl Scouts march with American flags while children run alongside them—not in a town street, but on a stretch of dirt against a backdrop of barracks. Children play ring-around-the-rosy— against a backdrop of barracks. Grandfather and grandson go for a walk in the snow—against a backdrop of barracks. The ubiquitous backdrop of barracks raises questions: what are these barracks, where are they, and, ultimately, why are they?

Framed out of the images are the answers. Except for rare long shots, such as the image of the guard towers, hinting at a place of confinement, there are no shots of the barbed-wire gates surrounding the barracks, armed sentries patrolling the compound, or the vastly better facilities of the Caucasian personnel.

While home movies traditionally capture leisure activities associated with good times, these home movies capture the forced leisure activities of

 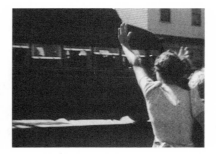

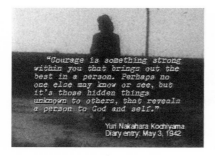 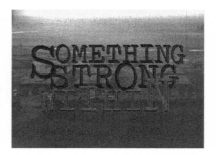

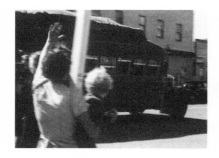 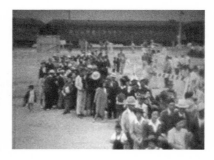

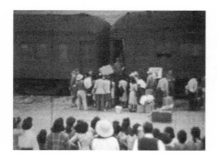 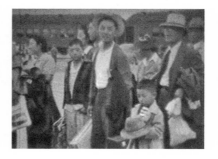

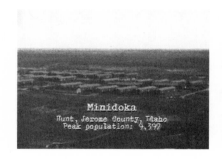

Minidoka
Hunt, Jerome County, Idaho
Peak population: 9,397

Home movie taken by Norio Mitsuoka

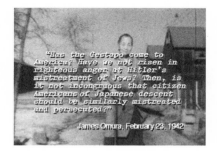

"Has the Gestapo come to America? Have we not risen in righteous anger at Hitler's mistreatment of Jews? Then, is it not incongruous that citizen Americans of Japanese descent should be similarly mistreated and persecuted?"

James Omura, February 23, 1942

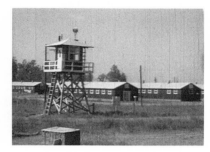

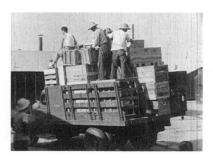

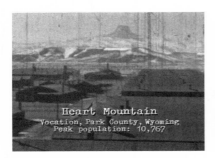

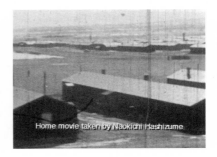

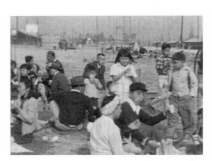

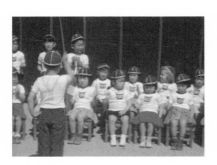

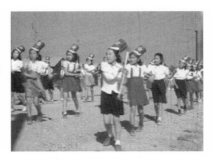

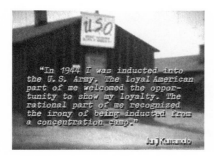

"In 1944 I was inducted into the U.S. Army. The loyal American part of me welcomed the opportunity to show my loyalty. The rational part of me recognized the irony of being inducted from a concentration camp."

Juji Kanando

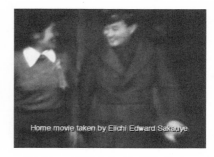

Home movie taken by Eiichi Edward Sakauye

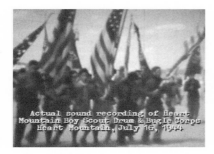

Actual sound recording of Heart Mountain Boy Scout Drum & Bugle Corps Heart Mountain, July 16, 1944.

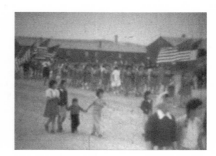

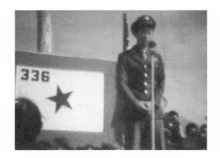

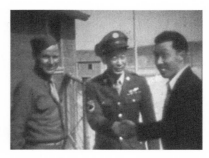

Names of men from Minidoka serving in the U.S. Army

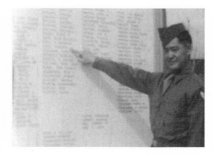

Rohwer
McGhee, Desha County, Arkansas
Peak population: 8,475

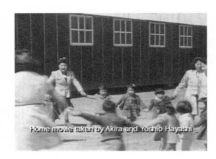

Home movie taken by Akira and Yoshio Hayashi

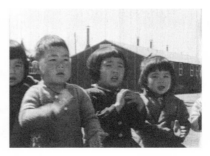

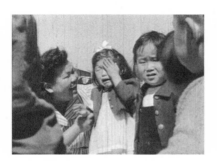

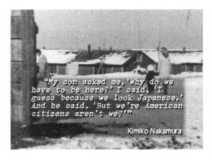

"My son asked me, 'Why do we have to be here?' I said, 'I guess because we look Japanese.' And he said, 'But we're American citizens aren't we?'"

Kimiko Nakamura

"If I can still make my art,
I am feeling not so bitter."

Henry Sugimoto

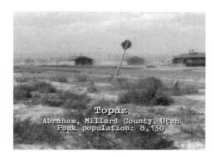

Topaz
Abraham, Millard County, Utah
Peak population: 8,130

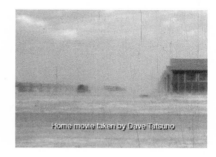

Home movie taken by Dave Tatsuno

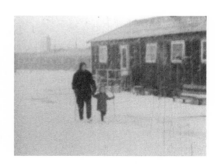

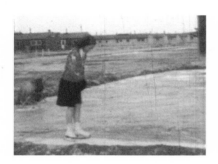

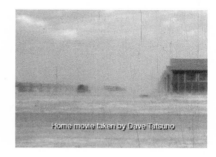

"Despite the loneliness and
despair that enveloped us, we
made the best we could with the
situation. I hope when you look
at these you see the spirit of
the people; people trying to
reconstruct a community despite
overwhelming obstacles. This, I
feel, is the essence of these
home movies."

Dave Tatsuno, home movie maker

life in an American concentration camp. The primal motivation—as well as the unrefined product—of home moviemaking is still evident. And the naive quality of these subversive images makes them the more remarkable.

## Notes

All images in this chapter are reproduced courtesy of the Japanese American National Museum.

1. The exhibition (and film) also was exhibited at the Ellis Island Immigration Museum, New York, from April 13, 1998, to January 31, 1999; the William Breman Museum of Jewish Heritage in Atlanta, Georgia, from August 27 to November 5, 1999; the California Historical Society in San Francisco, California, from March 21 to June 17, 2000; and the Little Rock Statehouse Convention Center in Little Rock, Arkansas, from September 24 to November 28, 2004.

2. Home movies featured are from the collections of Masayoshi Endo, Naokichi Hashizume, Akira and Yoshio Hayashi, Franklin Johnson, Eichi Edward Sakauye, George Sagara, Dave Tatsuno, and Gunji Watanabe.

3. Joy Yamauchi, review of *Something Strong Within*, *Tozai Times* 11, no. 122 (December 1994): 3.

10  **Something Strong Within
as Historical Memory**

ROBERT ROSEN

*Something Strong Within* (1994), directed by Robert A. Nakamura and writ-
ten and produced by Karen L. Ishizuka, is a documentary film that illumi-
nates the stateside detention camps established by the U.S. government for
Japanese Americans during World War II. Pursuant to an executive order by
President Franklin D. Roosevelt, over 120,000 men, women, and children—
two-thirds of whom were U.S. citizens by birth—were wrested from their
homes and communities without due process of law. They were detained in
quickly constructed camps at ten desolate sites across the United States for
up to three years. The legal injustices, widespread racism, and legacy of per-
sonal humiliation left an indelible imprint on the Japanese American collec-
tive memory that has commanded the attention of film- and videomakers in-
tent on setting the record straight. Nakamura and Ishizuka's forty-minute
video documentary is unique among these works in its total reliance on
home movie footage shot contemporaneous to the event.

*Something Strong Within* poses a wide range of conceptual and theoret-
ical questions of general interest to anyone concerned with the use of mov-
ing image materials as historical narrative. What constitutes historical
memory? How is it created and disseminated? Who makes it? Who con-
sumes it, and to what uses is it put? What qualities of moving image mate-
rials make them suitable, or unsuitable, for the expression of historical
memory? How can amateur film and home movies be used for this purpose?

A film is the product of a complex process involving a diverse array of
purposively motivated participants, whose intentions must be harmonized
in order to convey a coherent message. A film that treats historical events
is even more complex because its multiple creators are themselves products
of diverse historical circumstances. And the work itself does not become rel-
evant as historical memory until after its meaning has been consumed and

hence transformed by audience members, who are themselves intentioned and historically determined actors. To be an operative cultural force, historical memory requires the intersection of two groups: filmmakers and audience. *Something Strong Within* is distinctive in involving a third group: the home moviemakers who, for reasons entirely their own, shot the home movies in the first place. Considered metaphorically, *Something Strong Within* can be conceived of as a building site where three groups of intentioned memory workers converge in the construction of meaning.

## The Filmmakers as Memory Workers

One of the decisive factors leading Nakamura to build *Something Strong Within* out of home movies was his experience as a boy living in Manzanar, one of the ten domestic concentration camps that detained Americans of Japanese descent during World War II. It was located in Lone Pine, California.[1] In the company of his parents, extended family, and more than ten thousand other Japanese Americans, he spent three years of his childhood as a prisoner. As he conceptualized this film, his own memories suggested, obliquely, an original approach to the material.

Among the films and videos dealing with the camps, there is a predominance of issue-oriented documentaries that explore issues of racism and the failings of the American system of justice.[2] Others conceived from a more personal perspective, such as Nakamura's film *Manzanar* (1972), tend to review the past from the vantage point of the present. The subjective insistence of *Something Strong Within* suggests questions of a different kind. How was camp life actually experienced by those who were there? What was the texture of daily life for ordinary people as viewed from the eyewitness-level perspective of those who lived it? What insights are to be gained from an intensely subjective and nonjudgmental empathy with the seemingly mundane routines of day-to-day existence?

With these questions in mind, what resource could be more ideally suited for conveying the subjective realities of camp life than home movies shot by inmates in the camps? Despite the alienating context of the camps, the cameramen (they were all men)—very much in the spirit of home moviemakers—focused on subject matter that underscored the continuity of daily life. Additionally, they shot what is ostensibly a subjective portrait of the camp environment: interiors of the mess halls and barracks, faceless buildings, desolate landscapes, and numerous images of people at meals, at play, or simply passing time. The validity of the films as representative of

popular attitudes was significantly enhanced by the status of the cameramen as participant-observers, fellow prisoners who shared in the experiences themselves.

In order to fully realize the potential of these home movies to capture life as it was lived, Nakamura and Ishizuka made several key decisions in strategizing the film's construction. The first was to restrict all of the film's visual information solely to home movie footage. There are no newsreels, news photographs, or present-day footage. Another decision was to prominently foreground the identities of the men who shot the films. Rather than simply list the amateur filmmakers in the credit roll at the film's conclusion, the filmmakers chose to prominently display the names of the cameramen within the body of the work itself, thereby underlining the intensely personal perspective of each segment. Instead of following the more familiar path of freely editing amateur film footage in conformity with the narrative intent of the filmmaker, a third strategic decision was to maintain the essential integrity of the cameramen's work by editing within collections and presenting the works in a form as close as possible to the spirit of their original conception.

Most critically, based on the conviction that the images must speak for themselves, Nakamura adopted the risky and self-effacing strategy of directorial restraint. Explanatory and ideological framing devices are kept to a minimum, primarily expressed in a short introductory statement, which provides a historical context for the camps, and periodic onscreen quotations taken from individuals who lived through the experience. There is no contrived dialogue, no melodramatic musical score, no fancy editing, and no significant laboratory transformation of the footage. By allowing the home movies to stand on their own, and by maintaining a low directorial profile, Nakamura enhances the empathetic involvement of viewers with what is on the screen. In believing that less can be more, Nakamura embraces an approach to documentary filmmaking reminiscent of Dziga Vertov. Both believe that a film as advocacy is most persuasive not through the message it delivers overtly, but as the result of subtle rhetorical strategies that invite intensive viewer interaction with richly textured images on the screen.

How did the filmmakers, without appearing to have intervened at all, transform what could have been merely a compilation film into a fresh interpretive analysis? While presenting the home movies in the spirit in which they were originally conceived, beneath the surface Nakamura tightly structured a narrative in three acts preceded by a prologue and interrupted after the second act by an ironic interlude. In order to reconcile deference to the home moviemakers with his own interpretive goals, he relied on low-profile narrative strategies. These include thematic recurrence, an undulating alter-

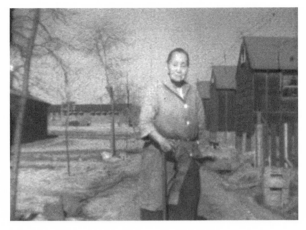

**Figure 63** From video essay *Something Strong Within,*
by Robert A. Nakamura, 1994. Courtesy of the Japanese
American National Museum; gift of Norio Mitsuoka
(94.54.7).

nation of tonality, nonintrusive ideological framing, nonredundant musical
scoring, and the discreet application of traditional cinematic language.

In the cinematic prologue before the opening titles, the story of life within
the camps is prefaced by the only sequence depicting activities outside their
boundaries and the sole use of footage shot by a home moviemaker who was
not himself a prisoner. This footage was sensitively filmed by the Caucasian
superintendent of schools in a small town in California. It shows Japanese
American men, women, and children under military scrutiny being loaded
onto buses for places unknown after having been forcibly wrested from their
neighborhoods and ousted from their homes. The prologue is critically im-
portant for establishing the film's narrative direction and for positioning
spectators to read its meaning. It establishes the tangible reality of normal
American life prior to the camps as a fixed reference point against which to
gauge the severity of what follows. These compelling images depicting in-
voluntary departure under armed guard remain with us for the entire film
and serve as a subconscious corrective to any tendency to equate the signif-
icance of behavior in the context of a free community with ostensibly simi-
lar activities in a setting of involuntary incarceration.

Act I is unrelentingly grim. Nakamura selected the grainiest, darkest, and
most abused footage to introduce the camps: barely visible images printed
on badly scratched and deteriorating film stock. Overexposed ghostlike

apparitions of isolated individuals are set against the surreal backdrop of desolate landscapes and makeshift streets. The images have the qualities we associate with troubling memories, remembrances so painful we desperately want to repress them, but so powerful that they force their way into consciousness. Like the prologue, the first act is intended to set an emotional tone that is an anticipatory corrective to possible misinterpretation of the images to follow, which might somehow serve as an apologia for the camps.

Act II encompasses sequences shot at a number of camp locations by separate amateurs. Despite frequent shifts of focus among widely dispersed sites, the same types of activities and conditions—hostile weather, food preparation, dull camp architecture, and crowds of people eating together in huge communal mess halls—thematically reappear. What might be faulted as redundancy becomes an effective narrative strategy for Nakamura. The concurrence of images independently shot by different men at widely separated locations serves to corroborate the shot selection as representative of camp life, and to engender spectator confidence in the overall truthfulness of the film. These seemingly repetitive themes function in Nakamura's strategy to structure the narrative as an undulating alternation of scenes with conflicting emotional tonalities. First we see images that affirm the humanity of the people in camp: acts of communal sharing, expressions of familial affection, evidences of artistic expression, or simply the presence of smiling faces. Then there is an abrupt turn to scenes that foreground the realities of hardship: incessant wind, intolerable weather conditions, guard towers, bleak barracks. And then there is a return to more positive images and then a return to the negative.

The impact of this alternation on the spectator is not simply additive but dialectical. Each image inflects the other and thereby alters its meaning and emotional resonance. A simple expression of affection among family members reveals its deeper complexity when it is followed with images of a camp that, by its very existence, served to destabilize family life. Affirmations of humanity in such a dehumanizing setting becomes an implicit refusal to accept the grinding logic of long-term incarceration.

Following Act II there is a brief ironic interlude that is the functional equivalent of the theatrical use of audience asides and comic relief that inserts critical commentary. Suddenly, the contemplative musical score is interrupted by the strident tones of a Boy Scout drum and bugle corps, the only actuality sounds in the film recorded in the camps. Black and white images dramatically segue into supersaturated Kodachrome color as Sergeant Ben Kuroki, a celebrated Army Air Corps tail gunner—and also a Japanese American—is triumphantly welcomed into the camp, which is prison to

other Japanese Americans, as a war hero. Adding to the understated irony of this commentary is footage of a gala parade, complete with American flags fluttering in the breeze, military music, a festooned grandstand, and Kuroki shaking hands with a fellow soldier—but one who is Caucasian and guarding the camp.

Act III returns to the undulating rhythms of Act II, but as the narrative moves toward its conclusion the tonal contradictions grow increasingly intense. On the one side there are some of the film's most inspiring images: children graduating from grammar school and a community art class taught by a distinguished painter. On the other side we see the natural elements at their worst, as if they were attacking the camp with wind, snow, and blistering sun. The technical quality of the images are among the best, and the music score hints at the possibilities for drawing positive lessons from what has been shown.

The concluding scene conveys the filmmaker's core message about life in the camps without him ever having to deliver it directly. A solitary teenage girl skates awkwardly on a frozen pond behind a black tar-paper-covered barracks. We see at once the girl's determination to wrest the joys customarily associated with growing up from seemingly impossible circumstances; the improvised skating rink, no doubt the result of communal effort; the camp's lifeless architecture, a reminder of its function as a place of confinement; and the existential loneliness that results from being forced to live outside the boundaries of a free society. When taken as a whole these elements come together to transform commonplace recreational activity into a powerful expression of refusal—the unwillingness of an individual and her community—to accept the diminished status of prisoners without hope.

Nakamura employs three additional strategies to gently coax spectators to find for themselves the overall interpretation intended by the filmmakers. The first is the use of nonintrusive ideological framing. The film's title, *Something Strong Within,* comes from a quote used at the beginning of the film: "Courage is something strong within you that brings out the best in a person. Perhaps no one else may know or see, but it's those hidden things unknown to others that reveals a person to God and self." It hints broadly at the film's interpretive objective. Subtitling throughout the film provides factual information about the home moviemakers, the camp sites, and identification of specific activities. Without interpretive commentary, the sheer number of prisoners and camps at remote sites across the country by itself makes an important point. The most explicit interpretive comments in the film are eight quotations located over freeze-framed images at junctures separating the home movie segments. But all are taken from individuals

who had experienced the camps firsthand and therefore fall within Naka-mura's self-imposed guidelines for sources of evidence. Even the quotation from Franklin Delano Roosevelt affirming that "Americanism is not and will not be a matter of race and ancestry" is taken directly from a sign posted in a camp and faintly visible on the footage. Nakamura may desire to pursue advocacy goals, but the means are uniformly oblique, noncoercive, and largely implicit in structure rather than content.

A second additional strategy uses the musical score to successfully straddle the line between spectator autonomy and filmmaker-induced consciousness. Dan Kuramoto, who composed and performed the music, is widely respected both as an accomplished musician and a dedicated cultural activist. Having family who were incarcerated, he brings his own perspective to the history of the camps through a score that rejects the familiar choices. There is no period music to nostalgically evoke the era, even for the dance sequence at the makeshift USO located in a camp barracks, no popular songs with lyrics that propose contemporary relevancies, and no musical motifs that can be stereotypically identified as Japanese in origin. Most importantly, his music is never used redundantly to underscore the meaning of specific images or to evoke a predetermined emotional response.

Rather, the original music score expresses a more universal level of meaning not limited to the restrictions of a specific time and place. By carrying a musical motif or rhythmic beat across images that alternate between positive and negative representations of camp life, opposing perspectives become so emotionally interlaced that each is experienced in terms of the other. Moreover, the score evolves in resonance with the film's overall narrative direction. The unrelentingly dark tonalities that accompany the prologue and the first act give way to a more ambiguous interplay of motifs during the second act, which are relieved in the final act by at least a hint of hope for the future heard in the synthesized wind instruments.

Nakamura also utilizes other traditional stylistic devices that pass largely unnoticed but nevertheless leave their mark on audience sensibilities. Subtle sound effects are discreetly layered on a limited number of silent images. The howling wind of a snowstorm conveys the inescapable intrusion of harsh climactic conditions. The sound of axes falling on firewood connotes communal effort. An indecipherable hubbub of human voices suggests the pivotal importance of the mess hall as a site for sociability. Freeze frames are used to conclude segments and to provide a visual background for the textual quotations. They punctuate and accentuate changes in the narrative and open a momentary breathing space that allows the expressive tonalities of the music score to be altered.

## The Picture Takers as Memory Workers

The use of the descriptor "picture takers" to refer to the nine men who shot the home movies used in *Something Strong Within* is in no way intended to be diminutive. It is important to underscore their status as amateurs rather than professionals especially since much of the credibility of the home movie footage as an accurate reflection of life in the camps results from our knowledge that the men who took them were nonprofessional participant-observers. In addition, the term "picture taker" carries with it connotations of photography as an appropriative act. Pictures are "taken" by photographers and events are "captured" on film. These photographic metaphors become literal statements, however, under the circumstances of these World War II camps where cameras were considered contraband.

Based on evidence within the body of their films, the picture takers shared two objectives with home moviemakers in general. The first was the selection of subject matter showing special events and people. These include school graduations, holiday celebrations, patriotic parades, community events, children growing up, and portraits of relatives and friends. Undoubtedly, a second objective was to share in the pleasures characteristically associated with the picture-taking event itself as a positively welcomed ritual of family and community solidarity. Having your picture taken is intrinsically a good experience. It subconsciously recalls the special moments when pictures were taken in the past, and it establishes a data bank of images intended to be enjoyed as nostalgic memories in the future. Even under the worst of circumstances, camp residents of all ages seemed to derive pleasure from participating in the act of being photographed. An elderly worker respectfully doffs his cap to the picture taker, an artist proudly displays his paintings, an older brother fusses with younger siblings to set up the shot properly, a young woman responds to the camera's attention with mock shyness, and, conversely, a group of men oblige the picture taker by continuing their board games without looking up at the lens.

The consciously expressed intentions of the picture takers may well have been the same as other home moviemakers, but it is reasonable for unarticulated objectives to resonate when home is a prison camp and the cameramen are themselves prisoners. The logic of circumstances in the camps and the content of the images point clearly in that direction. As evidenced by the images they shot, the picture takers moved beyond the limited objectives characteristically pursued by home moviemakers. Consciously intended or otherwise, they came to be chroniclers of history as well, with the added responsibility of creating an accurate record of daily life in all its aspects to be

passed on to future generations. This role is implicit in three areas of deci-
sion making.

The first choice was to augment their affirmative images of family life
with subject matter that went far beyond the pale of traditional home
movies. The picture takers dedicated a surprisingly high percentage of their
extremely scarce film stock to images conveying physical and psychologi-
cal hardship. First there is a stifling feeling of confinement. Beyond row
after row of tar-paper-covered barracks lay vast stretches of barren desert
or distant mountains, an inhospitable landscape that intensified the physi-
cal isolation and social abandonment. The painful passage of time is con-
veyed by two shots of the same guard tower shot from the same vantage
point in winter and spring. The hostile climates are palpably evoked through
telling close-ups: of parched and cracking earth, an old woman huddling in
a heavy coat, and men, women, and children gathering coal or chopping fire-
wood. Recurrent images of the lifeless camp architecture convey overall an
oppressive and dehumanized environment: uniform black barracks monot-
onously aligned along treeless streets that criss-cross in a rigidly static grid.
And finally, the most chilling sequence of all, resonant with images of Nazi
concentration camps, a train brimming with men, women, and children who
disembark onto a tumultuously crowded and sunbaked landscape to go
through inspection before being loaded onto military trucks for trans-
portation to places of confinement. Ironically, a sign greeting the new ar-
rivals reads, "WELCOME TO HEART MOUNTAIN," the name of the camp in
Wyoming.

A second decision made by the picture takers is the mundane subject
matter at the complete opposite pole from evidences of hardship, but equally
atypical of home movie practices. The role of historical chronicler resulted
in the recording of banal details that captured the specificity of time and
place: dirt streets devoid of people, pans of the camp sites; interior shots of
kitchens, mess halls, and washrooms; a shipping yard full of crates; and signs
tacked onto barracks announcing the presence of a barbershop, library, or
school. These are not the special events and expressions of family life that
are the mainstay of home movies, but the accumulation of bland details,
when considered in their totality, that reveal the texture of life as experi-
enced in the camps.

Finally, the third area of decision making by the picture takers entails the
fusion of compositional strategy with the selection of subject matter. Re-
peatedly throughout the film, images are framed to encompass the coexis-
tence of mutually incompatible elements. The resulting clash of opposites
contextualizes the positive aspects of family life within the oppressively

negative setting of the camps. For example, a warmly comical scene of a rhythm band composed of enthusiastic kindergarten children dressed in funny hats is indicative of the community's profound commitment to the young, but the shot reveals that they are gathered outside the alienating backdrop of a tar-paper-covered barracks. People are photographed in the makeshift dirt streets talking, walking, or otherwise amusing themselves, but the streets themselves are treeless and unlike any in a normal town—urban or rural. Just like at home, families enjoy themselves around the dinner table, but in the camps they include hundreds of people clustered together in communal mess halls. A young girl at a homemade dressing table combs her hair in front of a mirror, suggesting a moment of private reverie in the visibly cramped and improvised barracks space that is shared with the entire family. An elderly painter demonstrates his artistic skills, but the resulting picture is of a bleak barracks.

Moreover, the decision to shoot film required a strong will and unyielding determination. For much of the period, cameras had to be brought into the camps surreptitiously, in one instance with the connivance of a friendly official who was himself a home movie buff. Film stock was extremely precious, secured by one picture taker when he was fortuitously assigned to secure supplies from an off-site hardware store, and by another through the good graces of a Japanese American GI on leave from the war. With daunting obstacles to surmount on all fronts, home moviemaking came to require cunning, risk-taking, and unyielding commitment. The logic of circumstances transformed an otherwise innocent hobby into an ongoing test of personal will. Without unduly romanticizing the past, it seems both fair and accurate to characterize the work of the picture takers as acts of resistance.

## Spectators as Memory Workers

Although they played no role at all in the film's creation, from the perspective of film as an expression of historical memory, it is only when viewers internalize a work that it becomes operative as a cultural force. Spectators do not come to a film as empty vessels passively waiting to be filled. Rather, they are purposive social actors with specific cultural and historical baggage, and as a result the information and interpretations presented in a film become socially relevant only after they have been refracted through the idiosyncratic viewpoints of a diverse array of spectator groupings.

This transformation of a work into an expression of historical memory involves spectators in two ways. At one extreme, there are historical films

that strive to seduce a spectator into becoming a passive recipient of the film's point of view through the use of manipulative rhetorical and stylistic devices to drive home a predetermined message. At the opposite extreme, films can simply provide information in a form as neutral and free of intention as possible, thereby leaving viewers completely free to do with it what they will. *Something Strong Within* stakes out a middle ground as it finds a way to present as persuasively as possible the filmmakers' interpretive approach while at the same time encouraging an autonomous and self-directed spectator.

To achieve these seemingly contradictory goals simultaneously, the film relies primarily on two textual strategies that recur in various forms throughout the work. The first divides spectator attention among a multiplicity of perspectives, thereby problematizing the narrative, discouraging passive viewing, and encouraging interaction with the work. The second persistently foregrounds irresolvable cognitive oppositions that evoke disquieting feelings of emotional dissonance. The quest for relief leads spectators to dig more deeply into the underlying meaning of what is presented on the screen.

## The Polyvocal Text as Discourse Strategy

A polyvocal text is characterized by the coexistence of multiple "voices" that retain their integrity as separate points of view within the same work. In *Something Strong Within,* a plurality of perspectives is expressed in three ways. The first is through a multiplicity of independent points of view that share responsibility for interpreting the historical content; the second, an interplay of three separate temporal perspectives on the same event; and the third, a use of multilayered forms of discourse such as irony.

Individual voices are heard interacting with one another. The picture takers retain their identity. Instead of becoming suppliers of stock footage, they are elevated to the status of players within the historical narrative itself and co-creators of the film's overall meaning. At the same time, without negating the autonomy of the picture takers, the director's point of view is conveyed by his sequencing of the home movies to arrive at an implicit narrative and by his discreet use of interpretive framing devices. The composer introduces still another voice. While the score is broadly supportive of the director's overall narrative objectives and consonant with the perspective of the picture takers, it has a life of its own as well. Never redundant with the emotional content of specific images, the music's contemplative pacing and subtle tonalities invite spectators to seek broader meaning from what they

see. Finally, through their behavior and demeanor, the people in the camps are also allowed to retain their own voices, free from the distortions that might have resulted from manipulative editing, voiceover narration, or melodramatic scoring.

The coexistence of these multiple voices throughout the film has a twofold impact on viewers. First, it intensifies the subjective involvement and emotional empathy of audiences with camp life as experienced by people who were there. Knowing that the footage was shot by specifically identified individuals who were themselves prisoners serves to personalize and authenticate the images. The names of the picture takers displayed on screen at the onset of each segment serve as the functional equivalent of over-the-shoulder shots that are used in fiction film to invite spectators to experience a scene subjectively through the eyes of the characters.

At the same time that multiple voices augment spectator empathy with the events depicted on the film, they also promote the emotional distancing necessary for intellectual reflection. An interplay of independent perspectives suggests to spectators that the ultimate significance of the events depicted onscreen remains an unresolved question that calls for their participation. An implicit open-ended dialogue among the picture takers, filmmakers, and people in the camps encourages viewers to add their own voices to the discussion.

Polyvocal textuality is also expressed through a complex interplay of perspectives toward time. In *Something Strong Within* the past is represented on its own terms through the home movies; the present is served by the interpretive agenda of the filmmakers; and the future by a work that avoids closure and thereby encourages an unending reinterpretation of its significance. The coexistence of multiple temporal perspectives toward history further serves to problematize the narrative and to require the active participation of spectators in the quest for the meaning of past events.

Some modes of discourse, such as irony, are intrinsically polyvocal. Several scenes described earlier illustrate how ironic statements come to interlace two opposing voices, one that affirms a truth and a second that questions its validity. Positive and negative commentary are indissolubly fused in two scenes dealing with Japanese American soldiers—one showing a group of GIs being entertained at a USO situated inside the camp, the other a gala welcome "home" celebration for a local war hero. Simultaneously the images positively affirm the basic patriotic loyalties of Japanese Americans and subversively undercut that very same affirmation by questioning the rationality of patriotism in the context of a prison camp.

## The Dissonant Text as Discourse Strategy

A second stylistic and narrative strategy that runs throughout the film is the presentation of unresolved and possibly unresolvable oppositions that leave spectators with an unsettling feeling of dissonance. Elements are juxtaposed that cannot be reconciled with one another emotionally, intellectually, or cognitively. Their coexistence within the same physical space creates a surreality that defies conventional explanation. A clash of meanings, tonalities, and associations is evidenced at every level of the film's construction. Within the images themselves we have already noted the evocative impact of situating positive aspects of family life within the oppressively negative setting of the camps. In the overall structure of the narrative we have pointed to an undulating to-and-fro alternation between scenes with conflicting emotional resonances.

The behavior of camp residents as captured by the home movies is in stark contradiction to the environment in which it takes place. Scenes of family bonding, humane personal relationships, and community solidarity are inextricably intertwined with images of physical hardship, alienation, and the psychological rigors of confinement. These emotionally wrenching oppositions are intensified by a second dissonance creating contradiction: the polarity between spaces outside and inside the camp. On the outside lie the homes and communities that have been left behind, the encompassing context of a free society, and the distant realities of a world war. On the inside there are bleak barracks fashioned as homes, fences and guard towers as omnipresent reminders of confinement, and memories of a world out there from which the Japanese Americans have been excluded. Worst of all are the dissonance-inducing images that bring the inside and the outside together: trucks and trains coming and going, the post office and the shipping dock with their constant flow of objects in and out of the camps, and periodic oblique reminders of the war in the form of Japanese American GIs on leave from fighting at the front.

There is also a degree of spectator dissonance at a meta-textual level resulting from a clash of expectations ordinarily associated with home movies and historical documentaries. Home movies convey the immediacy of personal experience and are assumed to be of interest only within the sphere of the family and immediate intimates. Historical documentaries attempt to draw more overarching conclusions and speak to a broader and more anonymous audience. Home movies are usually overwhelmingly positive in what they show; historical documentaries show the realities of the past, whatever they may be. Thus, there is something unnerving about seeing a supposedly

naive film form transformed into a devastatingly powerful document recording one of the grimmest episodes in the history of American civil liberties.

The overall impact on the spectator resulting from the totality of dissonant communications takes two forms. First, dissonant discourse, like polyvocal discourse, intensifies our emotional involvement with the camps and the people in them. The inner need we feel to resolve the contradictions posed by discordant images leads to heightened spectator empathy, if only to comprehend how the surface tranquility of the prisoners could possibly be reconciled with the unmitigated tragedy of their circumstances.

This visceral need in turn leads to a second result that is more contemplative and analytical. When cognitively incompatible communications are combined with the undeniable facticity of photographic images, the result is a troubling discordance that cries out for resolution. Insofar as the answers cannot be found by relying on a reading of surface content alone, and in the absence of didactic framing by the filmmakers, there is a powerful incentive for spectators to dig more deeply into the work and to mobilize their own analytical and intuitive resources.

Passive spectatorship becomes difficult when we feel an inner need to relieve the uneasiness that results from an inability to comprehend what we see. If the images are sufficiently powerful and the contradictions are both emotionally evocative and intellectually challenging, a film's structure can induce spectators to become actively engaged in a quest for understanding. Therein also lies the salvation for a filmmaker such as Nakamura, who has something to say about the subject matter but disdains heavy-handed didacticism. When spectators are encouraged to search for meaning beneath the surface, they are more likely to discover his rationale for naming the film *Something Strong Within.*

It is difficult to avoid arriving at the conclusion that, above all else, the Japanese American community survived the dehumanizing and destabilizing impact of long-term confinement by drawing on a profoundly unshakable inner strength. They exhibited an unabiding and dogged determination to lead normal lives in abnormal circumstances and thereby resist both personal and cultural disintegration. The quiet dignity of ordinary people leading ordinary lives is, in the end, a form of resistance. They resisted the inclination to lose hope in the face of daunting challenges, to abandon the future of their children, to deny a cultural identity and community solidarity that had singled them out for persecution in the first place, and, most surprising of all, to abandon their commitment to a nation that had abandoned them.

## Notes

1. Background and factual information about the filmmakers and the filmmaking process was obtained through a series of interviews with Karen L. Ishizuka and Robert A. Nakamura in 2000.

2. A few of the issue-based films on the camps include *Conscience and the Constitution* (2000) by Frank Abe, *The Color of Honor* (1981) by Loui Ding, and *Unfinished Business* (1986) by Steven Okazaki. These films are available from the Center for Asian American Media, 145 Ninth Street, San Francisco, CA 94103, www.asian americanmedia.org.

# 11 The Moving Image Archive of the Japanese American National Museum

*Los Angeles, California*

KAREN L. ISHIZUKA

The Japanese American National Museum is a private nonprofit organization incorporated in March 1985 as the first museum in the United States devoted to presenting the history and culture of Japanese Americans. Its mission is to make known the Japanese American experience as an integral part of our nation's heritage in order to improve understanding of and appreciation for America's ethnic and cultural diversity. Through the development of a comprehensive collection of Japanese American material culture and through a multifaceted program of exhibitions, educational programs, films, and publications, the museum tells the story of Japanese Americans from the first Japanese immigrants who arrived in the late 1800s to the rich diversity of today's community.

The Moving Image Archive of the National Museum was established in 1989 by myself and Robert A. Nakamura as a repository of moving images, consisting primarily of home movies that provide visual documentation of the history and experience of Japanese in America. While the majority U.S. society was routinely documented in newspapers, magazines, newsreels, and feature films, until the 1960s life in ethnic America had been routinely overlooked and therefore went undocumented. Home movies made by ethnic Americans thus provide the only existing motion picture documentation of early ethnic Americans' lives from their own points of view.

When the 16mm moving image camera was introduced to the public in 1924, Japanese Americans began taking what are now referred to as "home movies." While most home movies do not usually document everyday activities, such as eating, going to school, reading a newspaper or book, or listening to records, these are depicted in amateur films taken by Japanese Americans. Not only do they provide visual records of lifestyle and behavior, they provide evidence of intangible social constructs, such as cultural

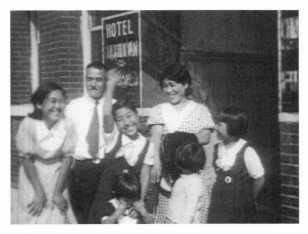

**Figure 64** Family friends filmed by Naokichi Hashizume, 16mm, Los Angeles, California, circa 1930s. Courtesy of the Japanese American National Museum; gift of Hashizume, Uemura, and Ouchi families.

adaptation. For example, in a rare interior shot from one film in the archive, a wife/mother puts a phonograph on the record player in her living room, and her two young daughters start to dance to the music—one in Western dress and the other in a Japanese kimono. The mother is seen on the couch reading, and from the way she is turning the pages, we know she reads a Japanese book. The father is also shown, stereotypically reading a newspaper. However, upon examination, the paper is seen to be a Japanese American newspaper—not a Japanese newspaper or an American one—but one signifying the evolution of a new Japanese *American* culture.

The immigrants filmed everyday activities because these new cultural renditions of familiar roles and functions were so novel. Many films were sent to Japan, presumably to show what life in America was like. Via this new technology, primary Japanese American historical themes of work, family, and community were recorded. These images were taken by Japanese American amateur filmmakers of their social, cultural, and symbolic worlds, and with the passage of time and the lack of documentation outside the ethnic community, what were once simply personal and family home movies now have become historical documents. Rather than simply nostalgic mementos, home movies made by Japanese Americans constitute both records and interpretations of life in America.

The footage provides direct visual expression of ethnic Americans doing what are considered typically "American" things, such as playing football,

as well as typically "ethnic" things, such as participating in Japanese dances. We see them doing what can be said to be American things in "Japanese ways," such as celebrating the Fourth of July with Japanese food, as well as doing Japanese things in new "American ways," such as including Shirley Temple dolls among Japanese dolls displayed on Girls' Day. Besides having some of the earliest known surviving American home movies, the museum's collection also includes rare footage of life inside what has become known as America's concentration camps, where Japanese and Japanese Americans were incarcerated for the duration of World War II.

The Moving Image Archive consists of over a hundred collections, totaling over 1,000 reels and over 50,000 feet of 16mm, 8mm, and Super 8mm black and white and color silent film footage. The films were taken from a range of eras: the mid-1920s, when 16mm home moviemaking was first introduced; the 1930s, when the 8mm format was introduced; the 1940s, during the mass incarceration of Japanese Americans in World War II; and the postwar 1950s. The archive also contains 110 reels of half-inch videotape of significant events, interviews, and performances of the Asian American Movement in the early 1970s. Films selected for preservation contain images that further the museum's mission to make known the experience of Japanese in America. Specific criteria include the following:

1. *Historical/cultural significance.* Moving images selected for preservation are treated as cultural artifacts surrounded by social and cultural contexts that capture and present the Japanese American experience. They fall into three main categories: (1) images that illuminate historical figures, events, and eras in Japanese American history; (2) images that document Japanese American community, family, work, and leisure activities; and (3) images that provide insight into Japanese American customs and values and their perceptual and symbolic worlds.

2. *Age and physical condition.* Many of these films were shot on reversal stock, meaning no negative was created. The prints in our collection are our only preservation elements. The oldest images are given special attention because of their probable historical significance, fragility, and advanced age. By virtue of their age, they are the most likely to document early life in America as well as to be the most susceptible to damage, fading, and deterioration. In cases of extreme deterioration of very old and historically significant images, the images may be selected for preservation because of their research value but not for purposes of exhibition.

3.  *Technical quality.* The quality of the image is a critical factor in its selection for preservation. While artistic or technical excellence is not a dominant factor, the footage must be clear enough to create a meaningful image and impart information. In general, the image must be in sufficiently proper focus to have sharpness of detail. It must have sufficiently proper exposure for contrast of tones, and the subject must be composed in an arrangement that creates a meaningful image. Without these qualities, the image may have little value for research. Nonetheless, attention is given to images that are of a low level of quality yet of a high level of intellectual content.

The Japanese American National Museum seeks to document, preserve, and exhibit the Japanese American experience—too often marginalized between Japan on the one hand and the United States on the other—within its own integrity. To this end, the museum's Moving Image Archive contains a unique intersection of film, history, and culture that provides visible evidence of Americans of Japanese ancestry creating new cultural forms and indeed contributing to the richly diverse society that distinguishes the nation.

## 12 The Home Movie and the National Film Registry

The Story of *Topaz*

KAREN L. ISHIZUKA AND PATRICIA R. ZIMMERMANN

Called "the biggest surprise" of that year's list by *The Hollywood Reporter*,[1] in 1996 home movies taken in one of the United States' World War II prison camps for Japanese Americans were inducted into the National Film Registry. Established by Congress in 1988, the Registry is composed of an illustrious slate of American films that are selected by the Librarian of Congress for their enduring cultural, historical, or aesthetic significance. The year before *Topaz* was selected, the Registry numbered only 175 films selected from the thousands nominated, the majority of which were commercial studio productions directed by white males. *Topaz* is only the second home movie to be selected, after the sensational Zapruder Film of the assassination of President John F. Kennedy. And it is the first film in the Registry to emanate from the grassroots of any American ethnic community, much less an American concentration camp.

This is the story of how *Topaz* made its way from the silenced terrain of deliberate exclusion to national distinction and, once there, how its presence has strengthened the original virtue of the National Film Registry. Memory is always incomplete. In the ongoing attempt to make visible the invisible, this essay seeks to share the process of recovery and demystify the road to national recognition. It charts how images change their meaning as they move from the private to the public realm, as memory shifts into history. As it is the margins that inform the mainstream, the *Topaz* footage and its story of recovery represent far more than simply an expansion of the Registry to include minority voices. It signals a fundamental shift to recenter the Registry to reflect America's true film heritage.

## The Home Moviemaker

The *Topaz* footage was taken by Dave Tatsuno, a Nisei (American born of Japanese immigrant parents) and longtime amateur film enthusiast who died in January 2006 at the age of ninety-three. Between 1943 and 1945 he was incarcerated in a camp called Topaz, which was located on 19,800 acres in Millard County, Utah.[2] During World War II, the U.S. government put Japanese Americans into what has come to be known as America's concentration camps.[3] After a series of highly bureaucratized dislocations that included numerous internment camps under the jurisdiction of the Justice Department and sixteen so-called Assembly Centers run by the Wartime Civil Control Administration, Japanese Americans living on the West Coast, in Hawaii, and in Alaska, and even persons of Japanese descent living in Central and South America, eventually were transported to ten camps administered by the War Relocation Authority (WRA) for the duration of the war.[4] By the end of the war there were 120,000 men, women, and children in the ten WRA camps. Surrounded by barbed wire and armed guards but officially and euphemistically called "relocation centers"[5] by the U.S. government, these camps were located in some of the most desolate areas in seven different states, ranging from California to Arkansas. Although the United States was at war with Germany and Italy as well as Japan, only the Japanese—two-thirds of whom were U.S. citizens by birth—were incarcerated en masse.

Filmmakers Robert A. Nakamura and Karen Ishizuka had known of Tatsuno and the amateur footage he took in Topaz since the early 1980s. Concerned with the preservation of the original footage, they, on behalf of the Japanese American National Museum, contacted Tatsuno in 1990. Tatsuno proved to be a tenacious documentarian when he visited Ishizuka at the National Museum many letters and telephone conversations later: he greeted her at her office door with outstretched hand—and videocamera to his eye. "And this is Karen Ishizuka, who I've been corresponding with," he said, more for the camera than to her. He entered the office while continuing to videotape, panning from the desk to the bookshelf, to the windows, and then back to Ishizuka in what was apparently by then a video documentation made for no particular reason than posterity, as it were. "So this is where you work," he said. "Now I can picture you when we talk on the phone."

In 1997 Ishizuka and Nakamura interviewed Tatsuno at his home. Although he was then eighty-four years old, his exuberance and energy, as well as memory and quick-wittedness, were those of a person half his age. He showed them the camera he shot the *Topaz* footage with, as well as other

camera equipment, including a custom Plexiglas unit he built for an 8mm Canon movie camera in 1965 so he could shoot underwater. He took them through his tiny study, crammed with the manual typewriter he used for all his correspondence, his family photos, and the file cabinets and bookcases that held his vast and meticulously kept personal archive. His holdings ranged from the scrapbooks and diaries he had kept from 1924 to the 33,000 feet of 8mm film he shot from 1937 to 1986 and the 145 videotapes (most two hours long) he shot from 1986 to 1997.

Tatsuno began his home moviemaking avocation in 1936, when 8mm first became available. That year his best friend died suddenly. Two months after his death, Tatsuno felt he had miraculously reunited with the friend he thought he'd never see again—through the magic of a home movie. He said, "I thought if film could do this—bring my friend back to me—then I wanted to make film."[6] And so he did—consistently and diligently—beginning in 1936, when he bought the least expensive Eastman Kodak 8mm camera he could find for $34. From that day Tatsuno recorded his life through film, and later videotape. What began as personal memory became social history as his hobby captured topics of regional and national concern such as Northern California in the 1930s—the Bay Bridge; Golden Gate Park; the campus and football games of the University of California, Berkeley; and events of the YMCA, as well as meetings of the Young People's Christian Conference and the Japanese American Citizens League (JACL)—and most notably the 1940 National Convention, held a year before Pearl Harbor and its aftermath that forever dichotomized the history of Japanese Americans.

With two consumer VCRs, Tatsuno made *This Is Your Life* videotapes as wedding gifts for each of his five children. These documented their lives from the day they were born to their wedding day. He also made *The Tatsuno Family Album,* which spans the years from 1943 to 1984 in seven volumes. To thank Ishizuka for her efforts in recovering and gaining recognition for his *Topaz* footage, he regularly sent her videotapes of his latest scuba diving excursions, which he titled and inscribed like an author would a book. Truly, he was the embodiment of Jonas Mekas's proclamation, "I make home movies—therefore I live. I live—therefore I make home movies."[7]

## The *Topaz* Footage

As we all now know firsthand, after the terrorist attacks on New York's World Trade Center on September 11, 2001, when the eyes of the world are on war and outrage turns into revenge, people who look like the enemy are mistaken

for being the enemy. By nightfall on December 7, 1941, Japanese community leaders were arrested for no reason except that they were presumed to be "potentially dangerous." In the weeks that followed, Tatsuno's father was one of the 2,192 Japanese[8] who were arrested by the FBI on the West Coast and imprisoned in a separate but parallel system under the jurisdiction of the Justice Department. In April 1942, Tatsuno and his family were sent to the Tanforan race track, which was hastily converted into an "Assembly Center." In September they were sent to Topaz, which was officially called the Central Utah Relocation Center, where they stayed until May 3, 1945.

For Japanese Americans during World War II, cameras, as well as radios, were considered contraband and were to be turned into authorities. But Tatsuno figured that he couldn't turn in what he didn't have, so he reluctantly gave his precious 8mm camera to a friend to keep for the duration of his imprisonment. In this web of racialized war hysteria, civil rights violations, and illegal incarceration, the prohibition on image-making added to the silencing of an entire ethnic group. In this context, Tatsuno's footage is especially poignant and historically significant, since the very act of shooting in the camps defied this government-sanctioned embargo and gave voice and image to the silenced and the absent.

In 1990 Tatsuno wrote about his home moviemaking in camp. His text is provided here in its entirety, as a document of record that is best told in his own words.

### BACKGROUND TO TOPAZ FILMS
*by Dave Tatsuno*

The movies were taken at the Topaz War Relocation Authority center in Topaz, Utah, from 1943 to 1945. Topaz was located 16 miles into the desert from the little town of Delta, which is 156 miles south of Salt Lake City. At its inception in September 1942, Topaz had a population of around 8,000, which dwindled as the years went by because of relocation, student leaves, work furloughs, army service, etc.

These movies were taken secretly as no cameras were allowed in Topaz, which was within the Western Defense Command Zone. Cameras were later allowed in centers like Heart Mountain beyond the Western Defense Command Zone, but of course, most of the evacuees by then did not have cameras. Immediately after Pearl Harbor, all contraband articles such as cameras, swords, guns, short-wave radios, and transmitters had to be turned in to the police station. However, in our case, we loaned the cameras (both movie and still) to a very good Caucasian friend living in Oakland. So, we did not turn them in.

How did the movie camera get to Topaz? One day my WRA Co-op supervisor (I worked as manager of the Dry Goods Division of the Co-op), a grad

of the University of Washington and a YMCA man, was taking a shot with his 8mm movie camera. I made a chance remark: "Gosh, I would give my right arm to have my camera here now." His reply was: "Where is it?" So, I told him that it was loaned to a friend in Oakland for the duration of the war. Instead of ending the matter there, he said: "Why don't you have your friend mail it to me?" Here is where this WRA friend was a key help. Since all packages mailed into the centers for the evacuees were opened and inspected, it would have been impossible for me to get my camera without the help of this friend. The camera arrived, he brought it to my barrack and said: "Dave, here's your camera . . . just be careful where you take your shots. . . . I wouldn't get too close to the [barbed-wire] fence."

So, I had my camera—but how about movie film and color film—when films were so scarce because of the wartime shortages? As a buyer for the Topaz Co-op I made three buying trips back East. When I was in Chicago, I would go to Bass, the largest camera store there, and buy several rolls of Kodachrome film. However, once I got the rolls into camp, processing was a problem. I couldn't just drop the developed film in a mailbox, since films were processed in Los Angeles (within the Western Defense Command Zone). So, instead, I had the films mailed outside the camp from Salt Lake City and returned to my brother, who was a student at the University of Utah. He would then give the processed films to someone coming into camp. So, that is how I was able to get these now-priceless shots of camp life in Topaz. It was sheer luck.

When viewing these home movies, there are several things to keep in mind: (1) These films were taken secretly. Since I was afraid to take many shots in fear of being discovered, you will not see scenes of the guards and sentry at the gate, the barbed-wire fences, sentry watchtowers, etc. (2) These films are in color. They tend to make the scene more colorful than the bleak, dusty, and arid wasteland it actually was. (3) These are home movies. As I was merely a hobbyist who enjoyed taking home movies, these films were taken without the intent of being documentaries. As a result, I focused on family and friends. Most of the shots look peaceful and almost happy, because whenever I took shots of evacuees, they would "ham it up" and smile as you might do today. I did not get candid shots of evacuees in a pensive and dejected mood. The camera shots, thus, do not fathom the emotions hidden within the evacuees—the fear, the loneliness, the despair, and the bitterness that we felt.

Despite these shortcomings, I hope my home movies share with you one aspect of the camp experience that we older folks would like to leave with the sansei, that is, the spirit of the Japanese American community. Despite the loneliness and despair that enveloped us, we made the best we could with the situation. I hope when you will look at the scenes of mochitsuki [rice cakes made at the New Year], pipe repairing, dining hall duty, and church service, you look at the spirit of the people. You will see a people trying to reconstruct a community despite overwhelming obstacles. That, I feel, is the essence of these home movies.

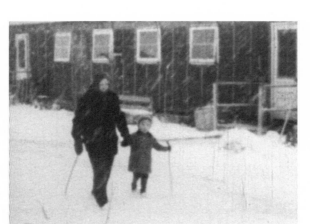

**Figure 65** Dave Tatsuno's father and son, filmed by Dave Tatsuno in Topaz Concentration Camp, 16mm, Utah, circa 1943. Courtesy of the Japanese American National Museum; gift of Dave Tatsuno in memory of Walter Honderick (91.74).

All in all, what were just some home movie shots made as a hobby are now, with the passing of nearly a half-century, a movie of historical interest. I am glad that because of one chance remark made to a kindly and understanding WRA friend, these scenes are preserved for the sanseis and other generations to follow. Sometimes I wonder whether it was just sheer luck or not.[9]

And so Tatsuno shot his wife showing off their newborn daughter, friends chatting after a church service, his father and son trudging through the snow, girls trying to escape a dust storm, a lone teenager ice-skating on a makeshift ice rink. The film focuses on the details of daily living and the persistence of community under the extreme conditions of incarceration. It does not show images of the barbed wire fence, sentry towers, armed guards, deprivation, or protest. Rather than presenting the illegal incarceration and deprivation of freedom one might anticipate in concentration camp iconography, these everyday images instead remind us that we must unrelentingly find the contradictions of history in each image.

When asked if he ever felt scared because he wasn't supposed to have a camera in camp, Tatsuno replied that it never occurred to him because, he said, he wasn't a spy. "It was merely a hobby, a home movie. I didn't have any evil intent, so therefore I didn't have a guilty conscience. I never even thought that someday this would be interesting."[10]

## The Process of Recovery

No historical record is ever finished; it is always an open text, continually exposed to revision and expansion. And, as many historians and theorists of historiography have argued, all history bears the stigmata of its own silences and exclusions. A process of recovery is therefore required, which must travel a course of ethics to bring that which is marked by alterity into salience. But it is not as easy as simply adding to the archive. Reviving and resuscitating that which has been lost and buried involve confronting the deliberate exclusions that created the silence in the first place.

The first level of recovery began with Tatsuno himself. It is important to acknowledge that he had the archival foresight to keep the footage safe. Considering that he and his family traveled from Topaz back to San Francisco to reconstruct their life, and with another child as well, the film might easily have been left behind. Then, although he had shot the original footage for no audience but himself and his family, at some point he decided to share it with others. He edited the reels together, meticulously splicing out any images he deemed too precious to be publicly displayed. Because he was active in his church, the YMCA, and the JACL, and was infectiously gregarious, he screened his edited version at camp reunions, church gatherings, and whenever and wherever he could. Contextualized by the Asian American Movement,[11] which broke the years of silence surrounding the camps, the *Topaz* footage spent the 1980s at this level of community exposure.

The second significant layer of recovery began when filmmaker Rea Tajiri used excerpts of Tatsuno's footage in her award-winning video *History and Memory: For Akiko and Takashige* (1991).[12] Her exploration of personal and cultural memory juxtaposes Hollywood images with stories from the videomaker's family. Although Tatsuno's footage is not presented as his own but is seamlessly woven into Tajiri's artistic interpretation, its use in the acclaimed production brought an added level of interest in images of the camp. More importantly for the physical well-being of the film itself, Tajiri transferred the much-used 8mm film to 16mm as well as 1-inch videotape. Other 16mm and videotaped copies were subsequently made and can be found at places such as the University of California, Berkeley, where it has been used to educate the general public about the World War II incarceration. Tatsuno also provided a copy to the Topaz Museum[13] to be reproduced on VHS and sold to raise awareness of the camp and funds for the museum.

The third layer occurred when Ishizuka and Nakamura worked with Tatsuno to donate his home movies to the Japanese American National Museum[14] for safekeeping in 1991. The museum is a private nonprofit

institution devoted to presenting the history and culture of Japanese Americans. Through the development of a comprehensive collection of Japanese American material culture and a program of exhibitions, educational programs, media productions, and publications, the museum tells the story of Japanese Americans from the first Japanese immigrants who arrived in the late 1800s to the diversity of today's community.

As a curator at the museum, Ishizuka first encountered home movies taken by Japanese immigrants while on a research trip in Seattle in 1989. This first home movie collection turned out to be some of the earliest extant home movies in the United States—twenty 400-foot reels of 16mm black and white film taken as early as 1925, just two years after Eastman Kodak had introduced 16mm film to the American public. They were taken by Masahachi Nakata, an early immigrant from Japan who was a successful businessman. On this early home footage was visual documentation that is rarely captured even in still photographs: extensive coverage of Nakata's lumber export business, early street scenes of Seattle, rare interior scenes of a Japanese American bank with Caucasian workers talking on upright telephones and a Japanese worker calculating figures on an abacus, and a typical American picnic scene with soda, races, and American flags— except the participants all had Japanese faces. Clearly these were not the seemingly endless vacations, birthday parties, and kids learning to walk that are usually associated with home movies. These early home movies were personalized but nonetheless documentary footage of cultural and historical significance. They constituted the inaugural collection of what is now the Moving Image Archive of the Japanese American National Museum (see chapter 11).

An advisory committee of Los Angeles–based veterans in the film preservation field provided critical guidance during the development and early years of the archive. They included Michael Friend, director of the Film Archive of the Academy of Motion Picture Arts and Sciences; Stephen Gong, Pacific Film Archive; Howard Hayes, head of commercial services at the UCLA Film & Television Archive; Greg Lukow, National Center for Film and Video Preservation at the American Film Institute; Edward Richmond, UCLA Film & Television Archive; and Robert Rosen, director of the UCLA Film & Television Archive.

Convinced of the historical significance of home movies in general and of Tatsuno's *Topaz* footage in particular, Ishizuka was eager to promote them in the field of museum and film studies. *Topaz* was selected by the Yamagata International Documentary Film Festival for their 1991 program "Media Wars Then and Now," an examination of documentaries made during World

War II on the occasion of the fiftieth anniversary of the attack on Pearl Harbor. That same year Ishizuka showed excerpts from *Topaz* and other home movies at the first conference in 1991 of the Association of Moving Image Archivists (AMIA) held in New York City, after which archivists like Karan Sheldon of Northeast Historic Film and Pamela Wintle of the Human Studies Film Archive, Museum of Natural History, Smithsonian Institute, provided advice and assistance. In 1992 *Topaz* was screened as part of the Pacific Film Archive/University Art Museum's Asian Pacific Film Series in Berkeley, California. The same year, it was submitted to the Museum of Contemporary Art (MOCA), Los Angeles, in response to their call for random artifacts by local museums that would in turn be randomly selected—through the divinations of a computerized *I Ching*—for an experimental exhibition by composer John Cage. The footage was subsequently selected and became part of the exhibition "Rolywholyover a Circus" at MOCA in 1993. Nakamura and Ishizuka featured the *Topaz* footage along with eight other home movie collections in *Something Strong Within* (1994),[15] which is discussed in other essays in this book. When the Hollywood production *Snow Falling on Cedars* (1999), a film that references the camps, was in development, *Something Strong Within* was used as part of the filmmakers' research, and a three-second excerpt from the *Topaz* footage ended up in the final cut.

### The Road to the National Film Registry

The United States Congress established the National Film Preservation Board[16] in 1988 as an advisory group consisting of representatives of major organizations in the film community. Appointed by the Librarian of Congress, the board's initial mission was to recommend for inclusion in the National Film Registry motion pictures that have lasting cultural, historical, or artistic distinction. Selected by the Librarian of Congress, twenty-five films per year have been added to the National Film Registry since 1989. The list, for the most part, replicates the economic power relations of film culture in the United States, as the majority of the films included are commercial studio productions. The selection of the *Topaz* footage marks a seismic shift in this elite body to include the nonnarrative, nonmarketed, and nonprofessional and infers the unseen dynamics between national legislation and political action to exhume that which was silenced.

In 1993 the National Film Preservation Board conducted two public hearings[17]—in Los Angeles and Washington, D.C.—to hear testimony from a variety of film scholars, industry executives, archivists, and filmmakers

regarding the current state of American film preservation. Stephen Gong, a veteran in the field who had assisted in the development of the Moving Image Archive at the Japanese American National Museum, and Annette Melville, who was instrumental in putting the hearings together, asked Ishizuka if she would speak to the significance of home movies as a genre that was being overlooked in the national effort to preserve the nation's film heritage.

In Los Angeles, Ishizuka and twenty others addressed the state of American film preservation from their various perspectives. It was fortuitous that the Librarian of Congress, Dr. James Billington, was among the five-member panel. His interest in Ishizuka's testimony would prove to be ultimately significant for the eventual inclusion of the *Topaz* footage three years later. When the formal presentations were completed, Billington opened the question-and-answer period by asking Ishizuka, "Has there been any national inventorying of these at all? Or is your experience with the Japanese American archive, which I think we all found fascinating, simply a unique phenomenon? Are there other such archives? Is there any central database or is information about these archives included in any other central reference works?"[18] Clearly he was interested. His remarks on Ishizuka's testimony indicate that the Registry's later inclusion of *Topaz*, as deviant as it was from the status quo, was not so much a fluke as it was intentional.

> It seems to me there are two aspects to the problem that you pointed out. One is the sort of multicultural diverse ethnic community's records, which are not solely home movies. One of the things that I think has been an interesting discovery on the film registry is the amount of these [ethnic audience] films. . . . They had commercial release and so forth, but have been generally neglected. So that's one aspect. But the other aspect is that the home movie thing—which is not confined to any one ethnic group—is a general American and modern phenomenon. . . . I just think of the closets of America. [laughter] I mean, we really have a potential history bonanza for the twentieth century which I don't think anyone has very much tapped.[19]

In 1994 the board created four advisory task forces to build upon the 1993 findings and provide specific recommendations for a national plan to save the United States' motion picture heritage. Ishizuka was asked to serve on the Public Awareness Task Force of the National Film Preservation Board.[20] Along with three other advisory task forces, their yearlong discussions, working papers, and recommendations went into the development of "Redefining Film Preservation: A National Plan, Recommendations of the Librarian of Congress in Consultation with the National Film Preservation Board" (1994). Ishizuka's testimony at the hearings and work on the task

force undoubtedly helped pave the road for eventual induction of the *Topaz* footage into the Registry in 1996.

In June 1996, Milt Shefter, who, as a member of the National Film Preservation Board was on the panel that heard Ishizuka's testimony, called to ask her to assist him in promoting a home movie from the Japanese American National Museum's collection for the National Film Registry. He indicated that the Librarian had maintained his interest in home movies since her testimony in 1993, that a year afterward the Zapruder Film of the Kennedy assassination was selected, and that the time might be right for another home movie. In addition to this environment, there were other knowledgeable members on the board who would actively support such a nomination, namely Robert Rosen, who was one of the first experts to advise Ishizuka on the value of the National Museum's collection.

At that time there were approximately sixty home movie collections in the National Museum's Moving Image Archive. But Shefter had responded strongly to the National Museum's exhibit "America's Concentration Camps: Remembering the Japanese American Experience" and the production *Something Strong Within,* featuring footage from the World War II camps, and so he felt that the nomination should be a home movie from a camp. Shefter knew that it would have to have the emotional cachet to compete against the likes of Hollywood blockbusters such as *The Graduate* (1967), *M\*A\*S\*H* (1970), and *The Deer Hunter* (1978), which were nominated and inducted that same year.

Shefter nominated the *Topaz* footage and spoke on its behalf at the next meeting of the National Film Preservation Board. On December 4, 1996, Dr. Billington announced that year's list and recognized the recent passage of the National Film Preservation Act of 1996 that reauthorized the National Film Preservation Board[21] for seven more years and created the National Film Preservation Foundation to support the preservation of non-Hollywood films of vital educational and historical importance. And so, along with *Woodstock* (1970), *The Jazz Singer* (1927), and *Flash Gordon* (1936), *Topaz* took its place among the anointed.

*Topaz*'s unique quality was immediately reported by the Hollywood trade magazines. The *Hollywood Reporter* opened its front-page article on the Film Registry with this lead sentence: "An obscure home movie about life in a Japanese American internment camp during World War II and [a film on] the famed 1969 Woodstock music festival were among the 25 films selected by the Library of Congress for the National Film Registry."[22] And later in the same article: "By inducting Topaz into the 200 film national archive, Dr. Billington said he was fulfilling one of the library's mandates to preserve not

just Hollywood movies but examples of the broad spectrum of film."[23] The *Reporter* also dedicated a separate article to *Topaz*, titled "U.S. Camp Was Captured by Secret Camera";[24] *Topaz* was the only nominated film to garner such attention. The *Daily Variety* stated, "The Library of Congress once again demonstrated its willingness to reach deep into obscurity as it added 25 films to the National Film Registry, ranging from home movies taken 50 years ago at an internment camp for Japanese Americans to Clint Eastwood's *The Outlaw Josie Wales* and Mel Brooks' debut feature, *The Producers*."[25] Ishizuka received many calls from print and television journalists expressing their surprise and interest. As the editor of one international film journal wrote, "It's mind-boggling to think that a governmental commission is actually doing its job and preserving the national heritage of significant film culture."[26]

From a community perspective, the induction of the *Topaz* footage into the Film Registry not only recognized the genre of home movies as a national cultural resource, but also memorialized the experience of forced exclusion and incarceration at one of the highest levels of governmental recognition. As Shefter stated, "In the true role of a documentary, it held the mirror up to society, and what we saw was not the fairest."

## Recentering the Registry

*Topaz* provides an antidote to the glorification of World War II as the last great, honorable war fought on distant shores, as found in movies like *Pearl Harbor* and *Saving Private Ryan*. Against the monumentalism of Hollywood's fantasy projections, *Topaz* functions as a reminder that World War II was fought not just in Europe and Asia, but on our own shores. In contrast to the other documentaries and feature films relating to World War II in the National Film Registry, such as *Yankee Doodle Dandy, Why We Fight, Battle of San Pietro,* and *Best Years of Our Lives, Topaz* is the only work from the World War II era to graph the racialization of the war as it was enacted within our own borders.

*Topaz* maps the war, often visualized in melodramatic display, and the incarceration, often figured within a trope of victimization, as a process of continual negotiation with state power, community, resistance, and agency. In contrast to the propaganda films produced by the U.S. government to justify the concentration camps, the *Topaz* footage "speaks" from the point of view of the Japanese Americans in the camps. If anything, the quotidian images of *Topaz* not only provide visual evidence of something that was previously

thought to be invisible and lost, but also constitute an actual record of historical agency in the face of victimization.

*Topaz* can be analyzed vis-à-vis the Zapruder Film. Both films document historical traumas to the nation-state: the assassination of a president and the incarceration of an ethnic group during wartime. Both films operate on multiple levels of visual evidence, incomplete texts, historical crises that are not yet resolved, and rarity of imagery. Both films visualize larger social and historical traumas where gaps and absences in historical knowledge are present. However, the *Topaz* film differs considerably from the Zapruder Film as a home movie in several important ways. The Zapruder Film documented a public event and tragedy by virtue of its creator being at the scene of the crime with a camera and obtaining images that are unique and rare. The *Topaz* film was produced with much more intentionality and at great risk, considering the prohibitions against making photographic images in that camp. The quiet scenes of domesticity and community documented in the *Topaz* footage invert the Zapruder Film's death drive and horror; *Topaz* presents visual documentation of the incarceration as the persistence of daily life, an incomplete narrative of survival.

From the point of view of the preservation of America's film heritage, however, the inclusion of *Topaz* is perhaps most significant for what it says about the Registry itself. For the most part, the National Film Registry reflects the economic hierarchies of film culture in the United States with an emphasis on productions that are capital-intensive, massively marketed, and employ classical Hollywood narratives of linear causality. The films on the list also replicate the racialized formations of American cinema. In the context of large-format Hollywood narratives directed by primarily white studio notables, *Topaz* is the antithesis: community based, nonnarrative, shot on 8mm by a Japanese American hobbyist. It is virtually the only footage in the Registry that was produced as a form of participant observation from a nonprofessional. In the larger theoretical context of decades of debates about the misrepresentation of marginalized groups in American cultural practices, the *Topaz* footage demonstrates the power of visual documentation from within a minoritized culture to present alternative images of American life.

The fact that the *Topaz* footage was named to the National Film Registry condenses the complex threads about how the very notions undergirding a national film culture have expanded from a unitary, high-art, individualistic construct to a more pluralized, social, and collective formation. It suggests that an ethics of remembering, and recovery of historical traumas that have been repressed, can balance the fantasies of Hollywood narrative. By

including it, the National Film Registry tacitly acknowledges not only the diversity of film practices, but also that the national film heritage must include film as historical evidence as well as film as an example of artistic contribution. The inclusion of the *Topaz* footage, antithetical as it is among the others on the list, indicates that the Registry more accurately reflects a national film culture that is not bounded by white narrative but can be expanded to include new, more complex views of American history, art, and culture.

## Notes

Sincere thanks to the following for reading and commenting on this chapter: Eddie Richmond, Milt Shefter, and Karan Sheldon.

1. Brooks Boliek, "U.S. Camp Was Captured by Secret Camera," *The Hollywood Reporter*, December 5, 1996, 41.

2. The literature on the experience of Japanese Americans during World War II is extensive. Brief summaries of specific topics pertaining to the Japanese American experience can be found in Brian Niiya, ed., *Encyclopedia of Japanese American History: An A–Z Reference from 1868 to the Present* (New York: [Japanese American National Museum] Facts on File, 2001); updated edition, originally published in 1993. For general information on Topaz, see Sandra C. Taylor, *Jewel of the Desert: Japanese American Internment at Topaz* (Berkeley: University of California Press, 1993).

3. The earliest use of the term with regard to the World War II incarceration of Japanese Americans is a White House memo to the chief of operations by President Franklin D. Roosevelt dated August 10, 1936, in which he states that "every Japanese citizen or non-citizen on the Island of Oahu who meets these Japanese ships or has any connection with their officers or men should be secretly but definitely identified and his or her name placed on a special list of those who would be the first to be placed in a *concentration camp* in the event of trouble." Also see Allan Bosworth, *America's Concentration Camps* (New York: W. W. Norton, 1967); Roger Daniels, *Concentration Camps USA: Japanese Americans and World War II* (New York: Holt, Rinehart and Winston, 1971); Michi Weglyn, *Years of Infamy: The Untold Story of America's Concentration Camps* (New York: William Morrow, 1976); and Richard Drinnon, *Keeper of Concentration Camps* (Berkeley: University of California Press, 1987).

4. It is critical to note there were separate but parallel systems of incarceration of Japanese Americans during World War II. Technically the terms "internment" and "internees" refer to the Justice Department camps. The term "concentration camps" refers to the ten War Relocation Authority camps. See Roger Daniels, "Words Do Matter: A Note on Appropriate Terminology and the Incarceration of the Japanese Americans," in Louis Fiset and Gail Nomura, eds., *Nikkei in the Pacific Northwest: Japanese Americans and Japanese Canadians in the Twentieth Century* (Seattle: University of Washington Press, 183–207).

5. The government employed euphemisms such as "relocation center" and "non-alien" to shroud and mitigate the unconstitutionality of the incarceration. See Raymond Okamura, "The American Concentration Camps: A Cover-Up through Euphemistic Terminology," *Journal of Ethnic Studies* 10, no. 3 (fall 1982): 95–108.

6. Interview with Dave Tatsuno by Karen Ishizuka and Robert Nakamura, April 12, 1997, San Jose, California.

7. Jonas Mekas, *Walden: Diaries, Notes, and Sketches,* 16mm, 1969.

8. Niiya, *Encyclopedia of Japanese American History,* 209.

9. Typed statement provided by Tatsuno to the author.

10. Interview with Dave Tatsuno by Karen Ishizuka and Robert Nakamura, April 12, 1997, San Jose, California.

11. For more on the Asian American Movement, see Amy Tachiki, Eddie Wong, Franklin Odo, and Buck Wong, eds., *Roots: An Asian American Reader* (Los Angeles: UCLA Asian American Studies Center, 1971); Emma Gee, ed., *Counterpoint: Perspectives on Asian America* (Los Angeles: UCLA Asian American Studies Center, 1976); and Steve Louie and Glenn Omatsu, eds., *Asian Americans: The Movement and the Moment* (Los Angeles: UCLA Asian American Studies Center Press, 2001).

12. Available through Women Make Movies, located at 462 Broadway, Ste. 500WS, New York, NY 10013; (212) 925-0606; www.wmm.com, retrieved July 15, 2005.

13. The Topaz Museum is located at 1576 East Tomahawk Drive, Salt Lake City, UT 84103; (801) 364-5802; topazmuseum.org.

14. The Japanese American National Museum is located at 369 East First Street, Los Angeles, CA 90012; (213) 625-0415; www.janm.org, retrieved June 2, 2005.

15. *Moving Memories* (1993) and *Something Strong Within* (1994) are available on VHS through the Japanese American National Museum Store; www.janm.org/store.

16. For more on the National Film Preservation Board and the National Film Registry, go to www.loc.gov/film, retrieved June 18, 2006.

17. Complete transcripts of the hearings can be found in *Film Preservation 1993: A Study of the Current State of American Film Preservation* (Washington, DC: Library of Congress).

18. Remarks by Dr. James Billington to Karen Ishizuka's testimony on retrieval and cultural significance of home movies, ibid., 21.

19. Ibid.

20. Appointed by the Librarian of Congress, the members of the Public Awareness Task Force were Milton Shefter, Gray Ainsworth, Jean Firstenberg, Tom Gunning, Karen Ishizuka, Leonard Maltin, and Jayne Wallace.

21. In 1997, the Librarian of Congress appointed Karen Ishizuka to the National Film Preservation Board. In 2001 she was reappointed.

22. Brooks Boliek and Kirk Honeycutt, "Eclectic Year in Film Registry," *The Hollywood Reporter,* December 5, 1996, 1.

23. Ibid., 41.

24. Boliek, "U.S. Camp Was Captured," 41.

25. Christopher Stern, "National Film Registry Taps 25 More Pix," *Daily Variety*, December 5, 1996, 1.

26. E-mail from Timothy Lyons, editor, *The Magazine of the International Documentary Association*, to Karen Ishizuka, December 5, 1996.

# 13 The Nederlands Archive/ Museum Institute

*Amsterdam, The Netherlands*

## NICO DE KLERK

The Nederlands Archive/Museum Institute is a national, general film archive engaged in a variety of activities: preservation, restoration, selection and acquisition, cataloguing, research, publication, presentation, and distribution. These activities encompass the full array of materials in the archive: films, posters and other publicity materials, personal and business papers, scripts, stills, books, and so forth.

"National" means, of course, that the Nederlands Archive/Museum Institute is first of all responsible for the Dutch film heritage. This mission is often misunderstood as preserving only national film productions. But as the Netherlands has always had a small film industry, most of the film fare has been imported. In this context, I would argue that a country's cinema culture knows no borders: each cinema artifact, of whatever origin, leaves a memory trace with its audiences. This approach distinguishes the Archive/Museum Institute from other audio-visual archives in the country.

Rather than focusing on national production (a controversial concept, given the neglect of so-called colonial films in national film historiographies and in national archives), or the content or information conveyed in films, the Archive/Museum Institute employs the concept of a national cinema culture that includes not only production but also exhibition and reception.

"General" means that the archive is not restricted to certain topics or genres. As a result, amateur film constitutes a relatively small, but important, part of the archive's holdings.

Home movies made in the Dutch East Indies have particular significance for the Nederlands Archive/Museum Institute. In contrast to its holdings of home movies produced in Holland, the Archive/Museum Institute boasts a number of fairly large collections of films shot by families during their residence in the Indonesian archipelago. Most significantly, these films provide

a counterpoint to the "official" productions made in this former Dutch colony.

The films I want to highlight from our holdings are more evocations of the home movie rather than real home movies shot by families for family use. They form part of a series of films called *Onze Filmsterren* (which can be translated as "Our Film Stars"). The archive has five episodes: the second, sixth, seventh, and tenth episodes, plus an unnumbered one. The original title of the series is *Photoplay Magazine Screen Supplement;* it was produced by the fan magazine of that name. The series was advertised in the issue of March 1919 as "twelve single-reel subjects showing 'the stars as they are.'" The series contains items on such film personalities—not just stars—as Harry Carey Sr., James Cruze, Douglas Fairbanks, Geraldine Farrar, William Hart, Thomas Ince, Clara Kimball Young, Jesse Lasky, Anita Loos, Mary Miles Minter, Gloria Swanson, and Ben Turpin. Furthermore, they allow looks behind the scenes, such as views of the World Studio in Fort Lee, New Jersey, or the Triangle-Goldwyn Studio in Culver City; the filming of Cecil B. DeMille's *Male and Female* (1919); and demonstrations of various special effects (stunts, double exposures). In a personal communication (December 1, 2003), film historian David Kiehn stated that the Library of Congress holds prints of episodes numbers one and five, although the latter is badly deteriorated; the George Eastman House, according to the same source, also holds two prints, but he doesn't know which episodes they are. I have no knowledge of other extant prints.

A contemporary Dutch advertisement states that the entire series consisted of twelve episodes, which ran in Dutch cinemas simultaneously since late 1920.[1] They were all released by Filma, a Dutch commercial distribution company in business from 1914 to 1948. Each episode contains five to seven items, alternating scenes of the private lives of American film stars through behind-the-scenes exposes and bits of information about Hollywood film techniques.

The average length of these 35mm films is about ten minutes—a length typical for films belonging to a program of shorts. The nitrate prints in the Archive/Museum Institute's archive were all distribution prints. Titles are missing, suggesting that these reels most likely had been screened fairly regularly. All the prints have been preserved and transferred to safety prints, using the internegative method, although not all the tinted nitrate prints have been transferred to color safety prints.

Finally, all the films have Dutch intertitles. However, the translations are not always accurate, as Filma seized the opportunity to work in plugs for other films in its catalogue. For example, in the item about Harry Carey Sr.,

it is noted that Filma has distributed all the films starring this actor. The Archive/Museum Institute has exhibited some episodes of these films in various programs on silent nonfiction films. They were also featured in the 2004 Amsterdam Workshop "Re-Assembling the Programme," on the film program.

These films are enormously significant. They testify to the increased internationalism of the American film industry and the popularity of its products. In 1920, this penetration of the global market was a fairly recent phenomenon. Until World War I, European films—notably from Italy, Germany, and France—dominated Dutch cinema programs. At the same time, the series underscores Dutch audiences' knowledge of and familiarity with American films and actors: after all, the Dutch title of the series suggests that these Hollywood movie stars are "our" stars, too.

The *Onze Filmsterren* series also constitutes a fairly rare example of a genre that is the visual counterpart of a fan magazine. The films provided publicity for the distributor through a mixture of gossip and background information.[2] Judging from the holdings in the Archive/Museum Institute archive, in later years such items would usually be part of the much more varied genre of the newsreel.

These films are especially significant because they all contain items referencing a home movie visual idiom. From a spectator's point of view this is even more significant because before the introduction of less expensive gauges in the mid-1920s, experience with private filmmaking was not widespread. In this historical context, the films reflect home moviemaking at a time when this leisure activity was primarily a privilege of those who were rich, famous, or both.

As in most home movies, the "private" scenes in *Onze Filmsterren* are arranged for the camera, although the scenes in these films were much more carefully scripted and acted than in a family film. This professional mode of production is echoed in a number of scenes documenting actors' private lives that allude to their occupations.

The marriage between items about the industry and its stars is often quite smooth: many an actress's spouse also happens to be a film director. For instance, in episode number seven, in a scene about actress Enid Bennett, an intertitle calls her "an economical woman" because she takes advantage of both her house and her husband—Fred Niblo—to shoot a scene. Of course, the audience is supposed to forget that information later on when she turns all the lawn sprinklers on the crew.

Pranks are typical of the convivial, performative nature of many home

movies. Humorous intertitles are often interspersed. In *Onze Filmsterren*, intertitles are also the place where the phenomenon of fandom becomes most explicit. For instance, in a scene set in the house of actor Bryant Washburn in episode number seven, the intertitle proclaims: "The small boy calls her mother, the big boy calls her Mabel, but we have to address her as Mrs. Washburn (This statement may well upset a lot of young admirers' dreams)."

The home movie idiom is most explicit in scenes that simulate one of the most important aspects of this genre: personal memories. We do not just see the film stars, but also their children and/or their parents, especially their mothers. Extending the series across three generations suggests the temporal dimension of traditional home movie scenes. Furthermore, the stars are often represented at various ages. Episode number two contains a scene that reenacts how Bessie Love applied for a job as an extra at the Triangle Studio, only to become a film star herself within months, boasting "a house with five servants and a beautiful yellow Buick."

The same episode features "baby pictures" of Douglas Fairbanks and Geraldine Farrar, although the pictures actually show them as toddlers. In fact, it is here, I think, that the home movie idiom is used to greatest effect to create an image of ordinariness that audiences could identify with. For instance, the intertitle preceding the "baby picture" of Geraldine Farrar (whose life story, incidentally, was simultaneously run in a series in the fan magazine *Photoplay* in 1919) says: "Would anybody ever have guessed that this perfectly ordinary kid would once play Carmen and Alaskan women?" Of course, the audience would not have guessed: in baby pictures, everybody is the same, everybody can potentially be everything. The implied sense of self-realization, the quality of being self-made, links the series most intimately to its printed counterpart, particularly its advertisements: the promise that everybody can be a star. The numerous ads for soaps, makeup, or hair care, as well as announcements for courses in scriptwriting, music, and beauty lessons (star-endorsed or not), supply the average viewer with many instructions about how to achieve a life of wealth and fame. Only then can one make it to the feature.

The *Onze Filmsterren* series shows that, besides the usual arsenal of explanatory concepts (genre, nationality, personality), the "slow lane of film history"—the unexplored ways of making or exhibiting film—or extrafilmic considerations (other entertainment practices or fan magazines, to name just two) also provide important interpretative frameworks for mainstream film productions. Of course, as home moviemaking, in 1919, was still

quite a privileged activity, the series' positioning would have been felt as highbrow. Nevertheless, it would be interesting to trace whether the idiom it uses may have provided its spectators, insofar as they later took up amateur filming themselves, with an example to emulate. In this respect, incidentally, the series converges with the many manuals for private filmmaking that were published since the 1920s, when equipment for private use became more widely available. These books postulate that the relative lack of sophistication of both the equipment and its users led to a similar focus: documenting everyday (staged) private events, preferably short so as to be entertaining.[3]

Secondly, as an element of commercial film production, the series' episodes also suggest that the program of shorts is more than just a lineup of films with traditional programmatic functions, notably instruction and entertainment. There are other parameters to distinguish between genres of shorts. One way to start analyzing the program of shorts is to look at the various ways its constituting elements addressed audiences (or sections thereof). For instance, one type of short was being made by theaters for announcing premieres, anniversaries, policies (a modern version is the reminder to switch off one's mobile phone), and so forth. These films were designed to orient spectators' minds toward matters related to the theater they were in, including requests to behave in a certain way. Explicitly or implicitly, these films usually center on the figure of the manager; direct address, therefore, characterizes this type of film. *Onze Filmsterren,* on the other hand, is an example of a genre through which the *production* branch of the film industry communicated with its audiences. A number of such genres have been developed, among which is the trailer. What these films often have in common is that they focused on the star; the star was—and still is— the industry's pivot in establishing a link with its audiences, wherever they are watching. Such films acknowledge, pander to, and thrive on spectators' knowledge of stars and the films they appeared in. In return, of course, spectators are expected to contribute to this "relationship" by buying a ticket for a star's next feature (or a fan magazine's next issue). It is this reciprocity that suggests, again, that the worlds of mainstream and other cinema practices are at times closer than one is inclined to think. Because of the knowledge these films appeal to, spectators in commercial cinema theaters, while watching films such as *Onze Filmsterren,* become temporary participants, as they are invited to draw on and update the cognitive world they are induced to share with the film industry. This, more even than the series' idiom, is what links it with the characteristically cooperative practices of home movies.

## Notes

1. This advertisement for *Onze Filmsterren* was published in the weekly trade magazine *Kunst en Amusement* 6, no. 5 (February 4, 1921).

2. Descriptive titles following the general title *Onze Filmsterren* vary from episode to episode. Whereas episode no. 7 promises "interesting glimpses of famous film stars' private life," no. 10 goes one better by announcing "interesting glimpses of the movie world and shots of film actors and actresses in their daily life"; the actual films, though, are quite similar. In the other episodes no such descriptive titles are present or have survived.

3. Martina Roepke, "Situation und Ambition: Sich-selbst-Wahrnehmen im Familienfilm," unpublished paper, 2000.

# 14  Home Away from Home

## Private Films from the Dutch East Indies

NICO DE KLERK

Home movies in their intended family settings differ from other types of movie screenings, as Eric de Kuyper and Roger Odin have argued.[1] The most significant difference is that home movies have participants rather than spectators. Not only do family members participate in the making of the home movie to the point of handing the camera from one family member to another, they also participate in creating coherence in and making sense of their images while these are being screened. It is in the conversations among family members that a home movie or series of home movies is made into a meaningful whole. Dates, locations, events, and people are identified, wider contexts are provided, stories elicited, and relations between individual shots are established or disavowed. Many things will not be mentioned during such screenings as they are mutually presupposed by those present. Conversely, the images also give rise to remarks concerning matters not explicitly represented. Home movie screenings in their intended family settings are, one might say, a gathering of *bonimenteurs* (lecturers).

## Memories

Once home movies become separated from their original settings, however, they undergo changes in coherence and meaning. Two amateur film compilation series, *Cinememo* (1990) and *Volkskino: Amateur Films from the GDR* (1991), illustrate this shift quite clearly, not in the least because they imitate the original viewing situation by having participants comment on their films. "The film is so old, I can hardly remember the images. . . . We shot it, watched it a couple of times. What it is will be as new for me as for

you, too," says a participant in *Volkskino,* while waiting to see the images he made more than thirty years earlier.

But not only do home movies slip from memory, memories tend to slip from home movies too. What is striking when watching *Cinememo* or *Volkskino* is that the comments of participants decades later do not significantly differ from what we, nonparticipants, would come up with. Their descriptions generally stay quite close to what the images show, while knowledge of locations, dates, events, and/or wider contexts has sometimes all but disappeared. "That *must* have been in Spreewald," says the maker of a film of a company outing. But when the intertitle appears, saying, "In Coswig we cross the Elbe," he corrects himself: "No, in Coswig . . . on the Elbe, right." And even things that would ordinarily have been recognized instantly can cause problems of retrieval: "That's my husband, I think." Once home movies have left their intended settings, original participants tend to become spectators.

Home movies, then, although only *fully* meaningful for and understandable by participants, do not necessarily remain obscure when participants' memories, or the participants themselves, fail. Moreover, as Odin argues, home movies do not by definition exclusively contain only family scenes but *anything* that is considered relevant to the maker. Such scenes need not even be made by the filmmaker himself. For instance, the collection of the Dutch private filmmaker Van Schaik contains two 16mm films that he purchased and included in material that he shot himself. In *Van Schaik in Italy* (1936) there appears a tinted Kodak Cinegraph film titled *Ancient Rome, the Strong-Hold of the Caesars.* In *Home Passage* (1933–34), a record of his journey from the Dutch East Indies back to Holland, shots of the various ports are combined with another tinted film about the Eiffel Tower. For private screenings the origin of the material seems to a certain extent irrelevant.

This is another reason for conceiving of participants and spectators as partly interchangeable positions. Scenes of a more public nature, those "homemade" and certainly those purchased, not only reduce the participatory aspect, but also, to some extent, allow nonparticipants to gain entry to these films. References to commercial cinema, such as people imitating Chaplin, facilitate the same. And, of course, a large number, if not the majority, of home movie scenes contain a set of stock ingredients—children, holidays and other highlights of family life, as a result of which the very private world of unknown others is nevertheless often easy to identify, or identify with. In a sense, such images may be conceived of as "standing in" for nonparticipants' memories. Intertitles, finally, provide clues for both participant and nonparticipant audiences. Clearly they are often meant to enliven the images—as in "Life is one dam' bath after another," a title

inserted in a series of baby-bathing shots. But they also serve as external memories, to remind participants where or when the events recorded happened, who participated in them, and so on. They also thereby underline how quickly these films' meanings can fade.

For an archive, surely an unintended setting, home movies present a special case in the sense that the very distinguishing characteristic of home movies—the memories and comments of participants—makes normal, "philological" archival activities, such as recovering missing parts or reconstructing "original" copies, virtually pointless. Without their original participants home movies have no preeminently meaningfully reconstructable order. Yet, that does not mean that they have no sense or significance at all.

## Upholstery

What, then, is the significance of home movies outside their natural home? The most obvious treatment would be to regard them as no different from other types of documentary film and use them as a library of visual evidence of what people and places looked like at a certain time. Eric de Kuyper writes that once a home movie has become separated from its original setting, it tends to become a source of historical knowledge rather than a repository of shared experience.[2] The humanities and the social sciences, however, have been reluctant to occupy themselves with film—let alone the "humble" genre of the home movie—as source material. For example, in the recent boom of colonial studies, many types of artifacts have been subjected to analysis, yet film, of whatever type or genre, has been conspicuously absent. In fact, only students of the history of cinema have devoted their thoughts to colonial films, albeit largely to the more prestigious feature fiction film.

Admittedly, part of the problem was—and to some extent, unfortunately, still is—the limited accessibility and availability of film materials in archives. But a more fundamental reason why film records appear to be unattractive to the humanities and the social sciences is that their interests often do not dovetail with what the medium of film can do. While history or sociology is usually concerned with making general, abstract statements, for example, about social structures and developments, film is particular and concrete. (Only insofar as social behavior is considered from its situational aspects would film be a directly relevant source. In fact, a specific microsociological analytical unit has been proposed, the interaction order, in which commonly analyzed aspects of social organization—such as differences in political, economic, ethnic, or legal power and status—do not always, immediately, or directly apply.)[3] Of

course, specialist expertise can be helpful in identifying objects, locations, and events portrayed as well as in contextualizing the images. But it is doubtful whether film images can be seen as being *directly* expressive of wider contexts. In addition, projected moving images have a peculiar effect, as the presence of human activity can be equally prominent as uneventful details: a dog wagging its tail, leaves swaying in the wind, or the reflection of light in a puddle. Film furnishes the elements—our appearances, our homes and gardens, their flora and fauna, the weather—that are normally absent in mainstream history or sociology. Film, one might say, provides the upholstery for these disciplines.

If moving images are a source of historical or sociological knowledge, they provide circumstantial evidence at best; to claim otherwise would be to overstate the documentary possibilities of film. This is not to deny that documentary films, through montage and the assumed synecdochic use of images or scenes, can be made to suggest issues of wider scope.[4] But with such narrative or argumentative strategies film is in some sort *doing* history or sociology. For information about macro-analytical aspects, however, other documents are more appropriate. After all, filmed—and photographed— records until recently required direct contact with the object of filming, that is, an interactive situation.

Of all types of film, home movies are the examples par excellence of the situational rootedness of filmmaking, because they comprise the only genre close enough to daily life to register ordinary events and interactions, including its moments of posing and staging. And as home movies do not usually lay claim to issues of wider social or historical significance, it is only through these situations that one may gain entry to these films. Only through these moments may one get a glimpse of what it is the films provide circumstantial evidence of.

## Rapport

Home movies made in the Dutch East Indies, that is, during the colonial era, offer the possibility of inspecting records of everyday encounters between people of different backgrounds and positions. Small though their number is, it is a feature that these materials uniquely allow. To evaluate these materials, film archives will have to propose their own reflections, as academic film historical work on both amateur and colonial films has only just begun. The emphasis on commercial and/or artistic productions in most film histories has forced amateur and private films into the slow lane of film history, an

apparently uninteresting area devoid of technical or stylistic innovations and developments. This approach has ignored the not unimportant fact that for at least two, maybe three generations amateur and private films may well have been for many people worldwide their first exposure to and experience with moving images. Colonial films also constitute a virtually uninspected territory, a void created by the national film historiographies of both the former colonizing countries and the former colonies. As far as the Netherlands and the Dutch East Indies are concerned this is certainly no exaggeration. In no publication that aims to provide a general overview of Dutch cinema is there any account of the films made, ever since the 1910s, by Dutch crews in the Dutch East Indies (nor, for that matter, in the West Indies), let alone by other foreign crews. A perspective focusing on production, largely in the homeland, dominates the notion of Dutch national cinema. Systematic consideration of location—which would imply pictures made in and of the colonies—or of what national audiences saw—which would also imply foreign films—are absent.[5] In recent books on Indonesian cinema the films made by Dutch (or other foreign) crews for their homeland markets are not discussed either. Mention is made of preindependence "Dutch-Indonesian"—as well as "Chinese-Indonesian"—productions, referring to films made *and* exhibited locally. But these films merely constitute the run-up to the emergence of a "truly" national Indonesian cinema. These histories are about local productions made primarily for the domestic market and focus on the postindependence era and the formation of national identity. Hence, location or the—predominantly foreign—films on offer are less urgent issues in national film history.[6] Insofar as the emphases in the film historiographies of both countries were reinforced by the connotations and memories of colonialism, they point up the conceptualization of "national cinema" is often politically expedient rather than historically justified.

Although understandable, such expediency is unfounded, especially with respect to home movies. Being the closest visual records of the "grassroots" level of interaction in the colony, these films invite, if not force, us to suspend the wider colonial context and ask ourselves whether or to what extent they actually *are* colonial. I would maintain that the epithet "colonial" already destroys their power of expression. Besides bypassing generic distinctions, the term is not a merely neutral coordinate of the time and place of the films' origin. Rather, it triggers an anticolonial reflex, fed by current connotations of colonialism (and imperialism). The term tacitly turns these films into propaganda for colonial politics and policies. That ignores, first of all, all kinds of changes in and differences between colonial societies. Second, it identifies daily life with colonial ideologies.

Nevertheless, I would like to look at a collection of films that *was* meant to propagate an image of what the Dutch accomplished in the colony: the first films commissioned by the Colonial Institute in Amsterdam. Shortly after its foundation in 1910, this institute decided to produce films for purposes of information, education, propaganda, or recruitment. J. C. Lamster, a former army captain then with the Topographical Department in the Dutch East Indies, was asked to do the filming. Lamster was selected not because of his experience with film, but for his knowledge of life and culture in the colony—which in a sense makes him an amateur filmmaker. The films were shot during 1912 and 1913 on the islands of Java, Madura, and Bali. In 1919 the fifty-five films he made were reedited into seventy-six titles, with additional material bought from Pathé, intertitled and tinted;[7] almost sixty titles have survived. Interestingly, these materials sometimes exemplify the situational aspect of filmmaking.

It is not surprising to find in this collection a large number of films meant to show how well the Dutch took care of their colony and its people and made the most of its natural resources: the cultivation of various cash crops, the new infrastructure, the administrative and penal system, the army, education and medical care, and the urban centers. There are also a number of films about "indigenous" topics, such as landscape and fauna, village life, religious ceremonies, court dances, or cottage industries. But what *is* surprising is that some of the films retain moments that could only have come about as a result of the filmmaking situation. These recurrent moments when people look into the camera—invited rather than intrigued—or laugh and smile to it suggest contact, even perhaps mild provocation or flirting on the part of the filmmaker. In *Native Cottage Industries*, for example, a female weaver now and then interrupts her work to exchange a word or smile with Lamster; or in *Dances of Wirèngs in the Cratten of Surakarta*, he jokingly converses with two rather shy female dancers in a separate close shot, made before or after their performance.

The range of subject matter may reflect the so-called ethical policy, officially proclaimed in 1901, which proposed that a moral obligation to consider the benefit of the native populations should prevail over self-interested exploitation. Also, it may reflect Lamster's capacities as both a representative of Dutch colonial rule and an expert on indigenous cultures. In a history to be written about filmmaking in the Dutch East Indies such matters should not be ignored. Yet, what may have more directly contributed to the various ways Lamster made these films is the interaction that his assignment required. Watching these films, it becomes clear that the very act of filmmaking affected his relationship to his subjects. It is as if Lamster's filmmaking

during these obviously noncommissioned moments created an opportunity, for both himself and the people he filmed, to establish a different footing, a sense of rapport, albeit only a momentary one, lasting no longer perhaps than the time it took him to make the shot.

Insignificant as these moments may seem, the significance of Lamster's films is that they remind us that so-called colonial filmmaking is not colonial all the time. That does not mean that the minute Lamster's films escape colonial schemata he ceased being a representative of Dutch colonial rule. To think so would be an anachronistic act of appropriation, betraying an eagerness to bring his film records in line with current beliefs and opinions. No, what makes these films valuable is that they have captured the moments in which interacting in the traffic of daily life takes precedence over acting in an official capacity. And such, of course, is the stuff home movies are made of.

## Cement

Dutch East Indies private films contributed a few specific scenes to the home movie repertoire; for instance, the parting scene on a quay in either the colony or in Holland, where people took leave of relatives and friends, of colleagues and employees. Even more frequent are views of the subsequent voyage: the ports called at along the way, fun and games on board, and so on. Then, there are a large number of scenes showing work-related activities.

It is easy to imagine why scenes of leave-taking (or "shoving off," in Dutch East Indies parlance) and work were felt worthy to be recorded: they reflect important moments in the lives of expatriates, or those who would be soon. Still, the initial conspicuousness of such scenes is matched by the impression that these home movies are also not really different from comparable films made elsewhere. Once the expats had settled, a substantial amount of footage was devoted to scenes around the house, children, visits, or touristic outings. That these films were meant to send or take back to the homeland to update relatives and friends might have contributed to their conformity to traditional home movie scenes.

However, Dutch expatriate families in the colony—as well as people of other origins, Western or non-Western—seldom lived by themselves. Most importantly, and much more commonly than in Holland, they employed servants. Even though these employees are only occasionally visible in the home movies, they were undoubtedly there. In fact, the absence of servants in most Dutch East Indies home movies is probably the best indication of their

presence: as amateur camera operators. After all, if servants, as some films show (and many writings confirm) were entrusted with driving their employers' cars, surely they would have been allowed to operate a much cheaper and less complicated machine. And this, of course, corresponds with the characteristic practice of switching the camera from one participant to another. This supposition is suggested quite strongly by the collection of some twenty home movie compilations of the Sanders family filmed in the 1930s.

The home movies of the Sanders family, who lived in Lebong Donok, a small community in the Barisan Range in southwest Sumatra where Mr. Sanders managed a gold mine, often include shots of both Mr. and Mrs. Sanders at home or on one of their outings or visits. As the Sanders family had no children, servants seem the most likely candidates to have operated the camera. That their servants may have had a more pronounced participatory status is underlined by a film that is devoted entirely to them. The very time and effort taken to make this film demonstrates that these employees were not just taken for granted.

*The Servants of the Sanders Family* shows a large household involved in various activities. It also suggests a strong sense of familiarity. Although most of the scenes are staged, they evoke a quite relaxed kind of interaction. The most telling example is the wedding scene of two of the Sanders family's servants, which shows Mr. Sanders beaming with pride while he holds his arm around the groom, as if it was the wedding of his own child. This is not to imply that the servants are substitute children, which would render it a mere paternal gesture. And it is not meant to imply that the servants are childish, as some contemporaneous colonial discourse proposed; that would render it a mere paternalistic gesture. I emphasize this, because it has been argued that the image of the child is central to representations of servants. That argument is based on written material, partly of a prescriptive nature.[8] In other words, these sources were meant and, given their popularity, considered to be exemplary reflections on the way interactions between the Dutch and native populations should be conducted. The interactional basis of home movies, however, as well as the fact that their private use did not lay claim to any instructional or educational value, does not lend itself to such ideological, colonial "readings." Moreover, the Sanders film, although a single but nonetheless real instance, contradicts such a reading.

The only other extensive scenes showing servants are somewhat more ambiguous. In *Ledeboer Family* (1926), these scenes have a more uneasy quality. Particularly the scene in which the family has gathered in the garden to present their servants a gift: their four servants are as it were waiting in the wing, ready to be fetched when needed. The fetching itself is interesting,

because one of the Ledeboer daughters takes the servants by the hand. Again, this may be suggestive of the typical, contemporaneous colonial image of the child. But it may also be indicative of the intimacy that often developed between children and servants, the warnings in advice literature notwithstanding. Only in the leave-taking scene, with which this film ends, do things become less ambiguous. Servants accompany family members to a boat but we do not see them on board amid all the members of the Western community who have put in an appearance to say goodbye to their peers.

The impression we get of the Sanders and Ledeboer households, apart from showing their servants at all, is that their home movies contain interactions on a footing different from what colonial discourse or the professional, hierarchical relationships would lead one to expect. Indeed, for people who interact daily and for extended periods of time within relatively small perimeters there inevitably arise habits, sympathies, and affections. And although this will normally not affect the distribution of positions and tasks, it modifies the interactions of such microsocieties. As a result, there are moments of "time out" in which the official capacities of the participants do not apply. The home movie camera, one might say, cannot *but* capture the particular ways in which these interactions are conducted.

In the Sanders material, moreover, such interactive situations are echoed in the frequently shown intermingling with people employed in the mining company Mr. Sanders managed as well as with various high-ranking representatives of the community. Most of these scenes are records of official or semiofficial events (such as presentations of awards, the opening of a factory, various local celebrations, or the Sanders' final departure for Europe). Particularly the presentation of awards for merit and loyalty, compiled in *Views of the Company* (1931–35), show how local relations with workers and native aristocracy were maintained.

Comparable scenes can be found in other amateur films. For instance, in the Sandberg collection there are various reels showing the activities on a sugar plantation near Kudus, on the north coast of Java. Their most conspicuous quality is a lack of insistence: these films, as opposed to Lamster's work, did not need to propagate the extent of the plantation, the number of workers, or the bulk of the harvest. Rather, the films seem to have been made solely for memory's sake, considering the length and detail of the recorded activities and, most particularly, the close-ups of each individual water buffalo.

That all is not work is pointed up by a film called *Slametans* (1928), which shows a festive meal celebrating the end of the harvest. Here, Western planters and Javanese workers are united, yet the fact that all the workers

have thus been gathered was seized as an opportunity to focus mostly on the latter. The second part of this film, shot during a milling festival, is striking because the camera and its operator seem so to be so familiar that their presence appears not to distract anyone.

All the scenes described did not just record interactions between expatriates and their native servants or workers. To a greater or lesser extent they created these interactions. And what makes *The Servants of the Sanders Family* unique is that it not only stages the cementing of these relationships, it *is* the cement. So, the fact that these encounters were largely arranged for the camera does anything but diminish their value. After all, the staging was an event in itself: it required the cooperation of, and left a memory trace with, all the participants involved. Moreover, even if what they staged was also taken as ideal or exemplary, or at least as an exception to the household's usual routines, they show a different picture than what other sources would predict.

## Calm Wash

The collection of home movies of the Boks family contains a reel titled *Some Fragments of Ellen and Ab's Car Ride through Java from 22 May to 5 June, 1933* ("Ellen" and "Ab" are the first names of the Boks couple). What makes this reel stand out from the rest of the films in this collection is that it is the only one showing native personnel.

Being a record of a holiday trip, it is not surprising that shots of the Boks' driver and guide are included. In this collection, contacts with native people are recorded only in films of similar trips. But the remainder of the material, shot in the Boks' urban home, contains no such encounters. In that sense it appears to be typical of home movies shot in urban areas in the Dutch East Indies.

Unlike the films in the Sanders and Sandberg collections, the bulk of the home movies made in the urban centers is predominantly domestic. Servants come into view even less; in the few films in which they are visible, they merely happen to pass before the camera or enter its field of vision by accident. Even in a long 35mm film compiled from images made between 1918 and 1931, *The Song of Our Life*, which focuses largely on the ever-proliferating offspring of the Bandung-based Van den Bussche family, one catches only one or two inadvertent glimpses of the children's nurse—or *babu*. In all these films, work-related scenes are also extremely rare. Views of office work, most common for expatriate city dwellers, are entirely absent.

Finally, this subset of films is much less suggestive of the involvement of servants in their making.

In terms of encounters between natives and nonnatives, then, there seems to be a split in the home movie material. Whereas most urban home movies downplay daily interactions with servants or local personnel, usually by not including them at all, others quite literally play them up by staging them. It is tempting to see this split as a reflection of different conditions, even though the paucity of scenes involving servants and other natives hardly warrants an explanation in quantitative terms. Nevertheless, rare as the scenes in the Sanders or Sandberg collections are, what they do have in common is that the filmmakers lived in relative isolation.

May this circumstance have reinforced the way interactions with personnel and other local people appear to have been flavored? Insofar as these scenes are situated in relatively self-sufficient plantations, this is perhaps to be expected, given the contiguity, if not overlap, of the professional and private spheres. And from the Sanders material we learn that their residence was in a village surrounded by mountains, with a very small peer group of Dutch or European origin. Here, in the middle of nowhere, it may have been more difficult to restrict one's daily, face-to-face interactions to strictly separate circles. In other words, the size and location of the settlement may have contributed to more locally determined solutions of how day-to-day interactions between employers and employees, between peers and nonpeers, or between the European, Chinese, Indo-European, and indigenous populations were to be conducted.

Home movies made in urban areas in the Dutch East Indies, on the other hand, suggest that it *was* much easier to limit one's interactions to a separate circle. Besides the reasons already mentioned why Dutch East Indies home movies conform to traditional conceptions of the genre, the limited range of the subject matter of this subset of films may also have been reinforced by a specific circumstance: housing construction in the 1920s and 1930s. To house the growing number of Western immigrants since the turn of the century, more efficient building on often smaller plots gradually altered the look of the Dutch East Indies cities. The newly built houses did not, often could not, accommodate separate living quarters for servants anymore.

Watching the Boks family's home movies we see a modern, European-style house, surrounded by a relatively small garden. European households in the cities relied less on servants—and on less servants, whose tasks, moreover, were increasingly restricted to day jobs.[9] The film *Kerbert Returns from Leave* (1939), from the collection of home movies of the Kerbert family, shows Mrs. Kerbert working in the kitchen *with* two servants.

One might venture to extend the above observation and conceive of these quite numerous urban films in an even wider context. Their predominantly traditional idiom, their focus on family life, suggests that they may be associated with the increasing Europeanization, or modernization, in and of the colony. Europeanization was a process that had been going on since the late nineteenth century. Improved connections with Europe (the Suez Canal, steamships, telegraph and telephone lines), modern improvements in infrastructure (such as interinsular steam shipping, trains, trams, motorways) and in more modestly domestic matters (connections to the water mains and the electricity grid), as well as demographic changes led to an increase of both the European female population and the number of European *families*.

These families, moreover, tended to settle in the colony for a limited number of years rather than permanently. Furthermore, there were changes in educational, medical, and other social services, shops and the wares they sold, public entertainments, and so on. As a result, some aspects of the typical contact culture that had developed over centuries changed or even disappeared, particularly in the cities. The way that expats dressed, the food that they ate, their means of transport, their homes, and their home life became increasingly indistinguishable from what they had been accustomed to in Europe. The practice, for example, of many, usually unmarried, European men living openly with a local *nyai* or concubine (more euphemistically called "housekeeper")—a practice, incidentally, undoubtedly deemed quite unfit for the traditional conception of home movies—was virtually, certainly publicly, discontinued.[10]

To a certain extent the context of Europeanization renders these images transparent again. It puts the presence of families in perspective, as well as the very activity of filming, and it shows the housing situation (and its upholstery). But can it also shed light on the very small number of recorded interactions with servants? While one might propose that this reflects both the increased general ethnic segregation and the segregation of employer/servant interactions in terms of time, place, and activities, one cannot fail to notice that the urban home movies appear to be an even more isolated cultural and ethnic enclave than the very homes in which they were shot. Nor does the *making* of these home movies bear out the boredom that is said to have been rife there.[11]

The term "Europeanization" should warn us that with such wider contextual considerations we move in the more tenuous spheres of interpretation. After all, Europeanization affected the entire colony—Sanders's mining company, too, was certainly part of it. And the changes in the wake of

this process themselves were debated widely. Both subsets of home movies, the urban ones as well as the ones made in more peripheral areas, are hard to render more fully meaningful, as it is unlikely that their respective situations actually compelled their makers to act and to interact the way they did. The fact, for instance, that urban home moviemakers hardly took the trouble of recording interactions with their servants and personnel does not imply that actual, unrecorded interactions merely conformed to officially prescribed behavior—Mrs. Kerbert's two seconds of screen time is sufficient to dismiss that idea.

The contexts suggested point up the limits of being a spectator rather than a participant. As spectators, archivists included, all we have to make sense of these images are notions like "isolation" or blanket terms such as "modernization" or "colonialism." But these notions may not bear any direct relation to what we see, let alone determine our evaluations. Terms such as "colonialism" are simply too abstract to be simply read from film images. Also, what we *can* say about what we see ranges from relative certainty—about Sanders's pride in his servants' wedding—and ambiguity—with regard to the gesture with which a servant is fetched in *Ledeboer Family*—to guesswork—as to the lack of interactions with native personnel in Dutch East Indies urban homes.

The relation between the general and the particular is not always just one of subsumption (or, inversely, of specification). The relation between home movie images and issues of wider relevance is loose. In the calm wash of daily life that home movies represent best, large-scale processes are—as it were—eroded to their commonly inconsequential proportions. One should be cautious, therefore, that reflections on films from the Dutch East Indies should not fall into the same trap as recent writings on photography in the colony. In these writings photographic representations are conceived of as expressing, and maintaining, an ethnicity-based dichotomy that in many ways was becoming even fuzzier than it already had been.

For instance, in an exhibition catalogue of photography in the Dutch East Indies a contrast is observed between "photographs of contented-looking Orientals and their unchanging way of life, alongside innumerable pictures of the latest production techniques, modern means of communication and prestigious building-works."[12] But for the conclusion that "it was in this way that the western community legitimised its dominance" one need not even have looked at the photographs, as feelings of Western superiority were quite common at the time. Moreover, that conclusion also simplifies the reality of the modernizing colony. With respect to the history of photography in the colony, such a view seems premature, not only because this

publication claims to be "no more than an initial exploration of the field," but also because it is based on a general overview *only*, largely irrespective of who made the photographs, for whom, for what purpose, and so forth.

Finally, this overview is based only on collections—admittedly large—of photographs held by a Dutch archive. That also goes for the comments of Dutch writer Rob Nieuwenhuys, who sees a similar contrast: "The number [of photographs] in which *kampungs* [villages or quarters] or even Indo-European neighborhoods or Arab and Chinese districts are depicted is relatively low. The Indonesians, then called 'natives,' and other sections of the population, many times more numerous than the Europeans, merely decorated the scenery, they were the background. This in itself is characteristic for a colonial society."[13] It makes one wonder what the "decorative" presence, or downright absence, of, say, servants or workers in photographs (and home movies) made in Holland would "in itself" be indicative of. Capitalism? Nieuwenhuys's statement that photography exclusively reproduced what Europeans saw is tautological as well as inaccurate. Not only were there numerous photographic studios run by non-Europeans,[14] there also *are* pictures of the native or Chinese quarters and populations, of spouses and lovers, of workers, coolies, servants, market vendors, shopkeepers, soldiers (dead or alive), dancers, administrators, and aristocrats that are more than mere "types." The intensified and multifaceted process of modernization in a society that was changing rapidly and in which people had multiple positions and loyalties is here made to fit simple, binary, and, above all, static colonial schemata.

## Notes

I thank Martina Roepke for her helpful comments after reading a draft of this essay.

1. Eric de Kuyper, "Aux origines du cinéma: le film de famille," and Roger Odin, "Le film de famille dans l'institution familiale," both in *Le Film de famille: usage privé, usage public,* ed. Roger Odin (Paris: Méridiens-Klincksieck, 1995), 16 and 35–37.

2. De Kuyper, "Aux origines du cinéma, " 13.

3. Erving Goffman, "The Interaction Order: American Sociological Association, 1982 Presidential Address," *American Sociological Review* 48 (February 1983): 1–17.

4. I borrow the term "synecdoche" from Brian Winston, *Claiming the Real: The Documentary Film Revisited* (London: British Film Institute, 1995), 134.

5. Karel Dibbets and Frank van der Maden, eds., *Geschiedenis van de Nederlandse film en bioscoop tot 1940* (Weesp, Netherlands: Wereldvenster, 1986); and Bert Hogenkamp, *De Nederlandse documentaire film 1920–1940* (Amsterdam and Utrecht: Van Gennep/Stichting Film en Wetenschap, 1988).

6. Salim Said, *Shadows on the Silver Screen: A Social History of Indonesian Film* (Jakarta: Lontar Foundation, 1991); Karl G. Heider, *Indonesian Cinema: National*

*Culture on the Screen* (Honolulu: University of Hawai'i Press, 1991); and Krishna Sen, *Indonesian Cinema: Framing the New Order* (London and Atlantic Highlands, NY: Zed Books, 1994).

7. Carinda Strangio, "Standplaats Soekaboemi: de Lamster-collectie van het Filmmuseum," *Tijdschrift voor Mediageschiedenis* 2, no. 1 (1999): 22–35.

8. Elsbeth Locher-Scholten, "'So Close and Yet So Far': European Ambivalence towards Javanese Servants," in Elsbeth Locher-Scholten, *Women and the Colonial State: Essays on Gender and Modernity in the Netherlands Indies 1900–1942* (Amsterdam: Amsterdam University Press, 2000), 85–119.

9. Esther Wils, *House and Home in the Dutch East Indies* (n.p. [Den Haag]: Stichting Tong Tong, n.d. [2000]), 105; and H. W. van den Doel, *Het rijk van Insulinde: opkomst en ondergang van een Nederlandse kolonie* (Amsterdam: Prometheus, 1996), 192–93.

10. Elsbeth Locher-Scholten, "Summer Dresses and Canned Food: European Women and Western Lifestyles in the Indies, 1900–1942," in *Outward Appearances: Dressing State and Society in Indonesia*, ed. Henk Schulte Nordholt (Leiden: KITLV Press, 1997), 154.

11. H. W. van den Doel, *Het rijk van Insulinde*, 193.

12. Hein Reedijk, "Foreword," in *Toekang Potret: 100 Years of Photography in the Dutch Indies 1839–1939*, ed. Paul Faber et al. (Amsterdam-Rotterdam: Fragment Uitgeverij-Museum voor Volkenkunde, 1989), 4–5.

13. Rob Nieuwenhuys, *Baren en oudgasten. Tempo doeloe—een verzonken wereld: fotografische documenten uit het oude Indië 1870–1920* (Amsterdam: Querido, 1998), 37.

14. Steven Wachlin, "Commerciële fotografen en fotostudio's in Nederlands–Indië 1850–1940: een overzicht," in *Toekang Potret: 100 Years of Photography in the Dutch Indies 1839–1939*, ed. Paul Faber et al. (Amsterdam-Rotterdam: Fragment Uitgeverij-Museum voor Volkenkunde, 1989), 177–92.

# 15    The Library of Congress

*Washington, D.C.*

BRIAN TAVES

Beyond preservation issues, a primary challenge for an archive is always the task of gaining bibliographic control over its holdings. A feature, television program, or short is usually able to be matched with information from reviews, catalogs, or copyright records that mention the title in question. However, even the minimal level of knowledge on the most obscure commercial production is greater than the extant records on the background of most home movies. The home movie is bound to be sui generis, unpredictable and quirky. By definition, there is no record of the film except in those rare cases when a scrupulous donor has provided logs maintained during shooting or editing. The events and activities recorded—historical events, family celebrations, travels—may be otherwise impossible to decode in retrospect.

All of these accumulated conditions render home movies the most problematic artifact for an archive to describe. Moreover, examining the footage, a time-consuming and often arduous task, may be imprudent until preservation work is completed. Because such effort is usually motivated by known content, largely unknown home movies fall into obscurity, becoming the most neglected film archive material.

Unlike commercial films, home movies generally lack proper titles, with information supplied by the archive, reflecting donor and subject. The following examples of home movies at the Library of Congress were received on 16mm reels and in black and white unless otherwise noted.

The *George Stevens Color World War II Footage Collection* consists of partially edited footage, mostly without sound, shot by director George Stevens and his crew during their work for the United States Armed Forces in the European and North African theaters between 1943 and 1945. Of a total of eleven reels and tapes, one group of materials is in black and white

and the other is in color. The color footage was copyrighted by George Stevens Jr. and includes a detailed guide to the images. A brief inventory of the black and white footage was prepared at the Library of Congress. Organized by region or event, topics in color include (per the Stevens guide and the organization of the footage) North Africa, D-Day at Katz, Saint Lo, Paris, Chateau Thierry, Torgau—Russians, Dubbed Dachau—Brenner, Dubbed to Dachau, Berlin, and Italy—Copenhagen—Home. Subjects in black and white include, according to notes on each reel, Atrocity (on the Concentration Camps), Paris Liberation, General Grow—Paris, and Eyewitness at Dachau.

Other important historical events appear in the home movie holdings of the Library of Congress. Andrew P. Batch photographed the 1929 inauguration of President Hoover. Paul R. Wolfensperger shot amateur footage of the Japanese attacks on Shanghai (year unknown). The American Film Institute/Anastasia Collection contains 1,700 feet of scenes of Eskimos shot by an unknown filmmaker in 1938. Charles Webster Hawthorne, a prominent American painter of the early part of the twentieth century, shot 100 feet of color footage of various national pavilions at the 1939 World's Fair in New York. The Mary Anglemyer video of a 1952 trip to Manila includes footage from a variety of locations around the Philippines, as well as a trip to Thailand and Saigon on Independence Day.

The Library of Congress collection of home movies also features images of famous personalities in American history. A. E. Hotchner photographed two reels of color footage of the writer Ernest Hemingway. The 205 feet of 1931 Albert Einstein home movies show him at his country home near Berlin. Four reels of Charles Edison home movies contain footage of Thomas Edison, Henry Ford, their families, and their Florida estates. Highlights of this collection include Thomas Edison being recorded for a sound-on-film newsreel and the groundbreaking for the Henry Ford Museum.

Evelyn Walsh McLean (1886–1947), socialite, daughter of mining magnate Thomas F. Walsh, and owner of the Hope diamond, was a leader in Washington, D.C., social life from the 1910s until her death. A best friend of First Lady Florence Harding, she studied photography with D. W. Griffith. Her fifteen reels of home movie footage concentrate on family and friends.

In the 1920s, Eugene Meyer (1875–1959), editor and publisher of *The Washington Post*, and Agnes E. Meyer (1887–1970), an author and social reformer, produced vacation films as well as footage of scenes of the family's Seven Springs Farm in Mount Kisco, New York. Their thirty reels reveal the Meyer children, including Katharine Graham (Mrs. Philip L. Graham) and Elizabeth Lorentz (Mrs. Pare Lorentz). Other highlights in this collection include footage of sculptor Constantin Brancusi, trips to South America and

the Canadian Rockies, and a camping trip to Kern and Kings River Valley, California.

Mary Marvin Breckinridge Patterson (born 1905) was an airplane pilot, photographer, documentarist, journalist, community activist, broadcast journalist, and wife of a career diplomat, Jefferson Patterson. The two hundred films comprising this collection include home movies and miscellaneous works relating to the Patterson family before and during their marriage. The reels show recreational activities, especially swimming and boating; vacations; getaways at River House, a Breckinridge summer home in York, Maine; trips to the western United States, South America, and Europe; and the couple's 1940 wedding in Berlin.

The thirty-one cans of varied black and white, tinted, and color footage in the Ernest Lewis Collection of home movies, shot between 1929 and 1940, offer a wide variety of topics: scenes of Washington, D.C., historic Georgetown houses, a trip into Virginia, and a retracing of John Wilkes Booth's escape route. Several trips west are documented, including color shots of Yellowstone and Glacier national parks. Different modes of transportation shown range from railroads, an exhibit at the 1939 World's Fair, a 1929 barge trip down the Lehigh & Delaware Canal, and the first flight of the Transcontinental Air Transport. Other footage shows the Interstate Commerce Commission in 1929. The collection offers seven cans of family scenes. Other footage chronicles scenes around the United States and the world.

Travel footage is also in evidence in the Library of Congress home movie collection. The Elizabeth Sprague Coolidge Collection includes footage shot in the late 1930s of the music temple in Pittsfield, Massachusetts (90 feet) and the Berkshire Festival of 1938 (180 feet). F. B. Herman, a U.S. Navy commander, photographed the eruption of Mauna Loa Volcano on Hawaii. The 1,440 feet of color footage of the 1939 Harvard Columbus Expedition reenacts the explorer's routes through the Azores, the Madeira Islands, Trinidad, Curacao, and Cartagena. The 700 feet of color and black and white footage from Caroline Berg Swann shows a 1950s trip to Southeast Asia, Egypt, India, Jerusalem, and Puerto Rico. Harry Wright, a wealthy American residing in Mexico, often edited together black and white and color footage, incorporating professional silent films with his own home movies. His large collection documents his Mexican travels, including trips to Acapulco (in 1927 and 1933); Chichén Itzá; Cuernavaca (in 1928); the 1943 eruption of Parícutin; and a 1955 visit to a leper colony. Wright also filmed family trips to Java and Agra, India, and a 1939 Mediterranean cruise with stops in Greece, Rome, and Yugoslavia. Footage of a 1941 voyage from San Francisco

to Sydney, Australia, shows stops at Honolulu; Pago Pago; Fiji; Auckland, New Zealand; and Los Angeles.

The Library of Congress's collection of home movies evidences interesting connections to Hollywood actors, directors, and producers. There are 444 feet of the home movies of Jean Hersholt and 800 feet of Florenz Ziegfeld taken at his home in Hastings, Florida. Nine videos of Lou Costello's 1957 family films and a single tape of undated Jack Oakie home movies were received through copyright deposit. John Barrymore's 644 feet of 1926 home movies document a trip to the Guadalupe Islands on the schooner *Mariner* and numerous shots with his wife, Dolores Costello. The 500 feet of Lew Ayres's home movies include color footage shot from the 1930s to the 1950s at a variety of locations in California and shots at home with fellow performers William Bakewell and Marie Windsor. Nine reels of Warner Baxter's black and white and color home movies from the 1930s in the AFI/Manger Collection show the Baxters and friends acting in the woods; on a 1926 visit to Neil Hamilton's cabin; and Baxter on his ranch, in the desert, at Boulder Dam, on a yacht and hunting trip, on a boat trip to Catalina, at the beach, in his Bel Air home, and at the studio.

*Camille, or the Fate of a Coquette* (circa 1926) is a 1,173-foot edited parody of many of the movies of the time, created by Ralph Barton. The cast includes luminaries of the stage, screen, and literary world, such as Anita Loos, Sinclair Lewis, Paul Robeson, Charles G. Shaw, and Charlie Chaplin. Other home movies in the AFI/Barton Collection include Chaplin at work on *City Lights* and also at his home and Barton's apartment. Shots of Barton's friends and family in New York and Paris and on a European tour also appear.

The 1,596 feet of home movies shot at the Warner Bros. Studio and elsewhere in 1937 were discovered in a 16mm projector purchased at a flea market and subsequently donated as part of the AFI/Claypole-Smith Collection. The material documents a visit to California in 1936 or 1937, partly in color and roughly half in black and white. Rehearsals and filming of a musical number, "Love and War," are directed by Busby Berkeley for *Gold Diggers of 1937*. The footage shows camera setups, rehearsals, dances with rocking chairs, close-ups of chorus girls, and the stars relaxing between takes. The second half of the film consists of additional exteriors around the Warner Bros. Studio, shots of some of the directors, a drive into Burbank approaching the studio, sights around Southern California, a football game, and vacation resorts in the mountains. Other scenes include footage of what appears to be a World War I airplane film, *The Dawn Patrol,* shot at an airport exterior with a First National Pictures sign, apparently set in England.

This survey includes only some of the Library's best-documented and (probably as a result) most often demanded home movies. The preceding pages are only a beginning; the researcher will want to consult reference librarians to fully take advantage of the latest acquisitions. Sadly, some home movies that exist in print form are too shrunken to be screened for access at this time, or were received in dozens of small fragments, having been worn out through frequent viewing or poor handling. These difficulties too augment the problematic aspects of home movies as often the least-documented form of filmmaking, barring a scrupulous family member or donor who records for posterity the places, people, and years of the activities shown. Nonetheless, the Library continues to recognize the vitality of home movies as an expression of documenting life, and more examples of the form are steadily added to the Library's holdings. Such filmmaking has also been honored by the Library on the National Film Registry, including footage shot at the Topaz War Relocation Authority Center, a Japanese American internment camp, between 1943 and 1945; *Think of Me First as a Person* (1960–75), a father's loving portrait of his son with Down syndrome, and the Zapruder Film of John F. Kennedy's assassination in 1963.

# 16 Deteriorating Memories

## Blurring Fact and Fiction in Home Movies in India

AYISHA ABRAHAM

## I. A Patchwork History

As a filmmaker, I construct representations from already produced and imagined images: the readymade, the recycled, found footage, or found objects, the parts of an everyday culture inhabiting the private archives of memory. In the late 1990s, I embarked on a project to locate amateur films here in India that could provide me with raw resource material. In 2005, I made an experimental documentary entitled *Film Tales Is Straight 8,* featuring amateur filmmaker Tom D'Aguiar and his films. I was searching for found footage. No public or official archive collects this material in India. My intention was to create a private archive, which would narrate a different, more particular history of Indian film, multilayered on three levels: visual, metaphorical, and historical.

In my work, I critically examine amateur images of middle-class Indians to reveal this private history. The narratives in amateur films—as well as the narratives I fashion from them—blur fact and fiction. As a result, their more subjective vocabularies expand and complicate traditional conceptions of history, filtering history through families rather than through official utterances or commercial films. Severed from their "real home," these memories and images are made homeless: I house them myself. They thus assume the status of found footage. This essay tells the story of how I came to collect these images. In a different register, it also recounts the stories of the amateur filmmakers themselves, stories of how imagination survives and works its way into each life and each frame of film.

I will chronicle a patchwork history of amateur film in the city of Bangalore. My role in this project resembles that of an archaeologist: I unearth fragments of the past; I construct an outline of a cultural history of a medium; I explore the lives of creative, yet unrecognized, individuals.

I began my project by developing a model to shape the diverse film footage I anticipated collecting. I contacted people who could lead me to other people, living in anonymity, who dabbled in filmmaking as a leisure activity. I simultaneously read about amateur film. I searched the Net with terms ranging from "amateur film" to "Super 8 filmmaking" to "experimental filmmaking" to "home movies." This research mapped two vectors: first, how the term "amateur" can be defined; and second, how extensively filmmakers continue to recycle old technologies and obsolete formats like Super 8mm film.

This pursuit is not a reaction against the digital age, a resurrection of lost analog forms that the digital has rendered obsolete and quaint, even though it does seem anachronistic to venture into researching older film formats in the age of digital technologies. My interest in this analog technology grows out of my fascination with the iconic aspects of cinema: images burnt distinctly onto reels of celluloid. In this search to recover a hidden history of film that operates beneath the radar of popular conceptions, I discovered very little importance has been granted to amateur cinema. This disregard for amateur images is not unique to India. Amateur film tends to be pathologized as the "other cinema": it is the world of unprofessional productions, the naive cinema closer to a primitive form of expression. It occupies a position directly opposite that of mainstream filmmaking, which is bolstered by an industry and technical experts.

When I did contact film professionals for leads on amateur film caches, they cautioned that I would not find much material at all in India and that if such collections did exist, they were exclusively in the domains of the very wealthy and the erstwhile rulers of princely states. My archaeological digs into amateur film in India have yielded just the opposite conclusion: amateur film technology is prevalent if not widespread. I moved to Bangalore when the city was poised to take off as a global hub for many software companies. Rampant development and skyrocketing real estate and land prices meant that many old houses were bought up and demolished for apartment blocks to house an influx of immigrants flowing into the city to work in a host of new multinational companies. Surviving older members of Bangalore families moved out of large, spacious bungalows to make way for these new buildings. Remnants of the past were often left behind on vacant plots and street corners amid the rubble of these old buildings. Old photographs, furniture, doors, and windows lay orphaned or were sold, finding their way into the many antique shops of the city. I had always wanted to collect found film footage. Because I experienced firsthand these massive changes in the city, Bangalore became a site of a form of archaeology to reclaim these hidden— and now demolished—memories.

This essay, then, aims to create a sea of stories from the amateur filmmakers I have encountered, not as a way to close discussion or to establish a defining characteristic of Indian amateur film, but to assemble the fragments and tales from my interviews, to tell a larger story through their juxtaposition. Though I had originally intended to concentrate on the 1960s and '70s, the project expanded into the wider and more general territory of amateur film itself. This archaeological project tracks a journey. As I encounter more films and amateur practitioners, the variety and energy in this ostensibly "domestic" filmmaking is a revelation.

## II. Between Stillness and Movement

Home movies exist as fragments. Slices of differentiated reality come to life, frequently without a beginning or end. The projector plays a vital role in the reclamation process. Without projection, all this film footage is inanimate, a mass of junk lacking any value. Home movies function more as fossils than as discrete images. As a series of stills pass through the gates of a movie projector, this fossilized footage is transformed into movement and memory. For the amateur, possession of a camera and film is not as crucial as having a projector, which renders phantasmatic representations and creations. Once the projector light switches off and the darkness lifts, amateur films return to their dormant, worthless status. Their history invisible to the naked eye. A delicate balance is produced between stillness and movement, not only in the way that the film in the can becomes "still life" but also in the way that stills are literally animated to produce the cinematic effect.

In this animation, that which is rendered visible is not always what exists on the film because images are concealed in this process of projection. Bertrand Angst comments that the cinematic apparatus is responsible for both stimulating and repressing the spectator's desire for that which must be denied in order to manifest itself. "The 'film strip' can only turn into 'film projection' where the 'unreal' of the image is materialized if, in the instant that the film strip begins to file past the projector's gate, someone intervenes in the filmic operation in order to inscribe in it the position of the enunciator."[1]

For film theorist Christian Metz, the photograph and the film strip inhabit two different spatio-temporal axes. They are formally and socially different. On the formal level, the photograph is a silent, rectangular piece of paper, while film is informed by a larger axis due to the presence of sound and a screen. The photograph functions at an individual level, while film operates on a collective level. The photograph is cut off, a fragment, a moment

in a series of moments. In film, there is resolution, which allows one to be-lieve in many things and to fabricate a complete picture. A photograph con-centrates belief on only one thing.[2]

The home movie falls between these two definitions. Although home movies expose a temporality filled with beginnings, such footage seldom pro-vides any closure. The shot might end because the three-minute reel of raw stock ran out or the subject walked off the frame. An embarrassing moment transpires and recording stops. The viewer, then, is propelled to imagine be-yond the visible frame, as in a photograph. The silent aspect of amateur film also enhances this mystifying quality. The desiring anonymous viewer, who has not created the film, lip-reads what the character seems to say. Amateur films, then, evoke silence and opacity. The films consist of moments stretched yet arrested, and so they embed movement and stillness simultaneously, within their unique temporalities.

## III. A Public Archive for Private Film?

The National Archive of India in Pune is the only really expansive archive in the country. Although regional archives do exist, the archive at Pune houses thousands of films and provides facilities for preservation and res-toration. I interviewed the archivist in charge of the film collection, who em-phatically emphasized that the films selected for preservation and restora-tion require some historical value. I deduced that these criteria would imply the selection of a newsreel or early silent film, though few of these survive, or footage of a public event—not the trivial footage of family life. My in-formant said that amateur film acquisition would be an impossible task for an archive to assume, because the Herculean sourcing effort required would exceed archival capacities. The archive does accept films donated by private families, though very few such films have made their way to this storehouse of moving images. I asked my informant how much amateur footage the National Archive possessed. He responded, "Oh, only a few minutes."

These films include footage donated by a Maharaja of a cricket match that took place in the 1930s, a religious festival, and other miscellaneous public events. The archive lacks equipment to view 8mm or Super 8mm films or to telecine them onto a different format. Thus, it has no supporting infrastruc-ture for home movies from the past. My informant suggested that if I could copy the footage I had salvaged onto a videotape, they would be happy to house a copy. Because the national archive is not predisposed toward a sys-tematic amateur film acquisition strategy, private individuals have had to

undertake the excavation of home movies. I envision a proliferation of regional mini-archives that could somehow be made accessible to a larger public to preserve these documents of private worlds and specific locales.

## IV. Projecting Light

On my journey of excavation, I have endured many excitements and disappointments. Some films survive, while others perish: often it is the preservation of home movies that is amateurish, not their aesthetic, technique, or content. Many film cans have not been opened in decades. With no ventilation, the cans trap moisture and disintegration begins. Mold and other agents of decay, such as excessive humidity, moisture, and exposure to rust, dust, and insects, destroy many collections. My archaeology of these images and their review in the present also expose the mold and decay of memory to the possibility of moving into a more public history. If the film is not projected, these memories remain hidden, removed from family and community.

The projection of reels through light summons a reemergence of the past. The process functions as an Aladdin's lamp, offering wishes, dreams, and unknown images. This phenomenological and physical experience of projected light distinguishes the home movie from the photograph, which might deteriorate but is nonetheless continuously visible. Families classify the amateur film reels as junk to be discarded when houses are shifted, a family member dies, or someone emigrates. Because preservation and storage are low priorities, these homemade memories are often thrown away, or they turn to dust in the corner of a dark, neglected shelf.

## V. Silent Film

These silent home movie reels evoke the era of primitive cinema before narrative visual systems and sound developed. The amateur production differs from a professional production: the amateur works alone without the division of labor practiced by professional technicians, producing fragments. Technical professionals are employed to look after every separate activity. Historically, many silent films in India were experiments by individual amateurs who were also visual artists: examples are Dadasaheb Phalke and Baburao Painter.[3]

Even though their aim was ambitious, the silent filmmakers had to personally take on different aspects of production such as set and costume design,

lighting, publicity posters, and more. They painted their own sets, used their families/friends/technicians as actors, and converted their homes into studios. As financial returns mounted, they built independent professional studios. Sometimes, the studio doubled as domestic space.

Disowned by their families because acting was synonymous with prostitution, film actresses lived in the studios, cooking and cleaning for the crew. In the work of amateur filmmakers like Tom D'Aguiar and Iqbal Khan, I am reminded of a similar enthusiasm and robustness in their creative lives, where film production collapsed into the domestic. Bathrooms are transformed into processing labs, houses into studios, and family and friends into actors.

## VI. The Documentary

In the 1940s and 1950s, the camera was not a natural part of daily life in India. News barely penetrated into remote areas of the country. Most village people feared the camera and needed to be coaxed into being filmed. Tom D'Aguiar's (1910–2002) filmmaking can be seen within this larger historical context of Indian documentary practices. D'Aguiar is the most sophisticated of the amateur filmmakers I have encountered in that he always edited his footage and often blurred fact and fiction. For S. Sukhdev (1933–79), a pioneer of the Indian independent documentary, a documentary was not a slice of reality but "a slice of recreated reality." In his writings, he expresses a wish to make a documentary film without a camera. In his experience, as soon as he pointed the camera at a village woman carrying water from the well to her house, she forgot to walk, to carry her *mutka* of water, and began to sing. He often consciously recreated village life.[4]

The documentary form that preceded him was largely a propaganda machine churning out hundreds of films by the government-run Films Division. An independent, critical, and socially committed cinema did not exist. For Sukhdev, cinema had to choose between "the devil and the deep blue sea." In his view the Indian commercial cinema was "a golden nightmare! The trash that is produced as Hindi cinema is proof of the stunted mental growth of the majority of the Hindi Film maker's [sic]. They represent certain values, which are totally hypocritical, money minded and tasteless. The Hindi cinema is a perfect set up for rotation of black [market] money with its stars and superstars, monopoly financiers, distributors and exhibitors."[5]

There was little money, no infrastructure, and no government support in India to create 16mm films. The 35mm format was privileged. Eight-millimeter film was a hidden technology used by very few and remains

unwritten in the histories of Indian cinema. When Sukhdev died in 1979, the Festival of Amateur Film in Bangalore, one of the few festivals of its kind in India, bestowed a medal in his honor on the best film at the exhibition. Sukhdev himself had been an untrained filmmaker, working with Paul Zils, a German documentary filmmaker residing in Bombay, in the 1950s. In the 1960s and 1970s, a new breed of filmmakers emerged to counter the vitiating effects of the commercial cinema. They wanted to create films that would be restrained, that would educate working people about social issues. This movement paved the way for another cinema: the Middle Cinema. This cinema refused to mimic commercial Indian cinema, and instead of songs, studios, and fantasy, it focused on real locations and narratives of exploitation. These regional cinemas evolved outside of the large traditional centers of filmmaking such as Bombay, Hyderabad, Madras, and Calcutta.

## VII. Bangalore and Film

Since the nineteenth century, Bangalore has actually been two cities in one: Bangalore city, predominantly Kannada speaking, where the Kannada film industry took root; and the British cantonment, formed at the turn of the nineteenth century, with an extended railway line, railway stations, and military and artillery bases. I have pieced together fragments of a history of amateur filmmaking in Bangalore. This personalized account is gathered from conversations I have had with several of the filmmakers who live in this city.

Tom D'Aguiar, one of the amateur filmmakers I focused on in my research, lived and worked in the cantonment as a photographer, a filmmaker, a writer of nonsense verse and newspaper articles, and an amateur theater director.[6]

In the South, the Bangalore Kannada films were considered an inferior cinema compared to the more robust Tamil cinema. Overshadowed by the Tamil film industry, the Kannada film industry relied on the Madras studio to shoot their films. These low-budget Kannada films bridged the gap between commercial films and art films. The other art cinema evolved in the 1960s and 1970s. To help Kannada filmmakers and to avoid the humiliation of using the Tamil studios, the government started large subsidies for filmmakers in this period. A subsidy of 50,000 rupees (a little over a thousand dollars) was equivalent to about 20 percent of the budget for an art film. (Pattabhi Rama Reddy says this subsidy made it possible for him to contemplate a low-budget film.)

These subsidies encouraged amateurs to engage in the practice of cinema. As a new medium, cinema promised larger audiences than a poem, a short

story, or a play. A half-century ago Satyajit Ray directed *Pather Panchali*, using Subrata Mitro, a still photographer with no experience with film, as his cinematographer. Inspired by Ray and the desire to produce a film that was not "loud," like the average Tamil film, poet Pattabhi Rama Reddy used a government subsidy to direct his first feature film. Attracted to this possibility of a larger audience, he and his associates hoped to produce work that opposed commercial cinema. The film was to be shot on location in a village, but his Tamil industry–trained cameraman was not willing to shoot outdoors and insisted on a set. A recent college graduate visiting India from Australia, who had experience with documentary filmmaking, agreed to shoot the film on location.[7]

In *Samskara*, Pattabhi used amateur actors and technicians exclusively. Everyone was paid the same fee. Very few film technicians or directors had institutional training. The Film and Television Institute (FTII) at Pune trained young people in cinematography, direction, editing, and acting. Few from Karnataka were trained at this institute, and so aspiring directors began making amateur short films to gain experience before entering the film industry.[8] Iqbal Khan mobilized his self-taught filmmaking knowledge in amateur film to assist on a number of such films. Besides his own films, he also helped his friends make films. His dream to work in the commercial film industry never materialized.

## XIII. The Short Film Movement: Aseema (Bangalore, 1972–1979)

In 1972, a group of professionals—Bose, Raman Kutty, ABC Nair, Chandrasekhar, Shankar, K. Kashinath, N. Shashidhar, and one trained cameraman from FTII, Ramachandran—formed a group committed to making low-budget experimental amateur film shorts. They named themselves *Aseema* (which means "without boundaries"). Four members of the core group were scientists. One member, Shashidhar, later studied video art in New York. Filmmaking was an experiment shaped by their passion for cinema. Film societies, which had spread across India from the 1960s onward, inspired them to create alternatives to mainstream film. For them, amateur filmmaking meant incorporating amateur values. They did not compete for recognition or awards, nor did they intend to become professional filmmakers or directors. Although Ramachandran worked as a cinematographer, he enjoyed shaping amateur productions.[9]

Their group attempted to make films with very low budgets every month. Each member would get a chance to script a film; the other would

assist in production. They met once a week for four hours. They used the metaphor of poetry for their work, making "the film poem." They argued that a writer could be continuously creative, because materials were cheap. If filmmaking could be as inexpensive as writing, then poetic ideas could be scribbled on celluloid. Their guidelines stipulated the following: silent film, reversal film stock, 700-foot loads, 16mm or 8mm/Super 8mm formats. Each member contributed 20 rupees (or 50 cents), which amounted to 120 rupees ($3 U.S.). The raw stock cost 100 rupees for 700 feet. With one Bolex 16mm camera, they made a number of short films collaboratively.[10]

Aseema sponsored two film festivals of short amateur films. One festival's theme was the international year of the child. Through an open call for amateur films from across the country, they received forty short amateur films, all featuring a child. Their journal was brought out at minimal cost by cyclostyling the contents. They circulated about 150 copies of each issue and brought out about seven issues in all. The magazine featured film reviews and interviews with filmmakers, cinematographers, and other movie buffs. Some of the titles of the films were *The Kick, I Look Serene but I Am Atremble Inside, Help,* and *A Children's Film or How I Stopped Making Films and Started Loving Children.*

This group considered themselves rebels and were influenced by the politics of the 1960s and 1970s. They saw themselves as operating in opposition to the film establishment in India. *A Children's Film* ridicules the hypocrisy of politicians who mouth platitudes about children but turn a blind eye to child labor. Its protagonist is a filmmaker caught in bureaucratic red tape as he seeks funding for an amateur film on children. The silent film uses written signs pinned onto the actors or stuck on sticks. The main character carries a sign with "amateur film" written on it. Both Ramachandran and Iqbal Khan filmed this.[11]

Aseema was influenced by New Wave movements in Indian and European cinema. Filmmakers like Satyajit Ray, Michelangelo Antonioni, Jean-Luc Godard, Francois Truffaut, and Federico Fellini were inspirational for Aseema. The members of the collaborative shot their early work on 16mm, and then later moved to the 8mm format, which was less expensive and allowed a film to be twice as long for the same cost. After making a few films the group disbanded. The scientists in the group, for instance, immigrated to America for work, where video was becoming the preferred format for amateurs. Ramachandran, who graduated from FTII, continues to work professionally as a cinematographer in Pune, and has used video for years for his home movies and his experiments with form.

**Figure 66** Tom D'Aguiar, from *Film Tales Is Straight 8,*
by Ayisha Abraham, 2005. Courtesy of Ayisha Abraham.

## IX. Tom D'Aguiar (1910–2002)

Tom D'Aguiar was born in Calcutta to third-generation Anglo-Indian parents.[12] He was a flamboyant and charming man who had a routine job at the Post and Telegraph Department. He wrote poetry at his office desk. D'Aguiar loved telling stories and had a flair for witty narrative. Every time I visited him, he introduced me to a new art form: literature, theater, poetry, photography, filmmaking. In India, many 8mm/Super 8mm and 16mm filmmakers were avid photographers too. Tom D'Aguiar and his friend G. W. Benjamin, another 8mm and Super 8mm filmmaker, belonged to the Mysore Photographic Society, founded in 1941.

D'Aguiar even printed his color photographs at home, although the process was extremely tedious. He still considers photography a superior and more accessible art form, because composition for him was paramount. He used Super 8mm film to record events and his travels. Many of his films document his journeys across Karnataka with the Post and Telegraph Department. During wartime in the 1940s, British troops arrived in the cantonment in great numbers. As a result, cameras circulated. Many soldiers were avid photographers who documented their experiences in India for

**Figure 67** From *Film Tales Is Straight 8*. Courtesy of Ayisha Abraham.

their families. D'Aguiar made a few films for these soldiers for free. In a film of the dancer Ram Gopal, he illustrated every gesture *(mudra)* by juxtaposing Gopal's hand movements with natural symbols such as the actual opening of a lotus. He also created a fundraising film for the Bishop of Quilon in Kerala, featuring the activities of the church. He and the bishop wrote the script and shot the film together.

D'Aguiar's 1940s war film is a spoof of spy films entitled *Well Done, Walter*. According to him, a group of friends improvised the thriller over a series of weekends. The film opens with Walter, the butler, drinking a mug of beer and polishing shoes. His boss is asked to smuggle secret plans stolen from the Germans. He has an accident. The accident sequence is portrayed in a montage of shots showing Walter's boss on the road, a black car, and a bandaged man in a hospital bed. Walter is then recruited for the job. When his boss does not appear, Walter parachutes into Germany to meet a glamorous barmaid (Miss Bangalore 1941) with the plans. Two Nazis suddenly appear on the scene; she serves them drinks. Walter hides, then disguises himself as a woman to entertain the second Nazi. As the Nazi tries to kiss Walter, his hat falls off. A chase in a field commences. At the Ulsoor Lake, the barmaid and a dog jump into a boat. (According to D'Aguiar, it wasn't in the script, but the dog followed his mistress into the boat.) The intertitles state, "Many days pass . . . before they arrive in England." A French officer congratulates Walter for accomplishing the mission and the barmaid kisses him. Then an old

woman beats him on the head with an umbrella. "My wife," exclaims Walter in the intertitles, as the image fades and the film ends.

The painstaking details, technical proficiency, and montage in *Well Done, Walter* are remarkable for a home movie. D'Aguiar was self-taught in the craft of filmmaking. He processed the film in Madras or Bombay with Kodak distributors and edited it at home. Some of the actors were active in amateur theater, while others were European fighter pilots in the British cantonment of Bangalore waiting to fight the war in Southeast Asia. (During the war Bangalore was the official rest and recreation center for the European armed forces.) D'Aguiar produced other films as well. A film about the making of an English lady features a poor Chinese immigrant, who used flour, colored powder, and sticks to construct little figures of a Victorian memsahib. Other films include a picnic at Cubbon Park, a day in the life of his son, and travel films shot around Karnataka in Super 8mm.

## X. Iqbal Khan

Iqbal Khan was elated by my interest in his home moviemaking from twenty years ago.[13] Before he married, he had bought himself a secondhand Super 8mm camera with some money he had saved. He wanted to become a professional film producer or director in the Kannada film industry. In the beginning, he shot family, friends, and travel. Because he learned the technology, editing, and processing, a wide range of people contacted him to make their films or illustrate their ideas. He assisted in the production of a Kannada film, *Kankana* (1975), which won a national award, and a fiction film for a student union at Mysore University.

For me, out of all of Iqbal Khan's films, one of the most captivating is a film taken by him soon after his own marriage. A friend held his camera. After scenes of the public ceremony, a very private moment appears. A young woman, his wife, reclines on a bed, dressed in her wedding sari and jewelry. (Out of concern for their appearance in India, new brides wear new saris for days after their weddings.) The young bride looks directly into the camera with a kind of luminous twinkle in her eye. She is shy, conscious of the camera; and yet she is playful, yielding as she speaks to the man, her husband, who is obsessed with filming and documenting life. At the end of the sequence, she asks him to cease this embarrassing activity, but continues her dialogue with "the man with the camera," the man she has married. This scene expresses a muted eroticism. This fragment reflects very traditional representations of intimate relationships in Indian cinema: eroticism must be domesticated in real life and in film.

In Khan's later films, his wife, Mussarath Khan, holds the camera to enable him to be in front of it, or she is seen holding the children. She often remains in the background. Khan's wife enjoys performing for the camera. My reading is that his wife may have needed to compete with his film technology for attention; her bathroom was transformed into a darkroom for film processing. Khan bought huge blocks of ice for the tedious process of developing black and white film, dragging them across the front-room floor to the bathroom. His wife's clotheslines dried reels of film. Today, she says she hates film: it was just a headache for her. Yet, when she ventures out of her bedroom or the kitchen to watch an old Super 8mm film, she vividly remembers people, dates, occasions.

After Iqbal Khan got married, he realized he needed an alternative occupation to support his family. He started a school for underprivileged Muslim children at Shivaji Nagar, a cantonment of Bangalore. Iqbal Khan continued to make films for himself, the industry, other amateurs, students, friends, relatives. Because he had a salary, he never charged for his filmmaking services. Clients paid for raw stock, the production costs, and the overhead, but not for his own creative and technical labor. Now that he is in retirement, Khan and his family market readymade spice mixes.

Unlike many amateur film collections in India, Khan's film collection is in impeccable condition. He is a highly knowledgeable person who knew how to preserve the films. All his 8mm equipment is still in good working condition. His son, Javed, who studies acting at FTII and in the film industry in Pune and aspires to act in Bollywood films, has a similar passion for film. He would operate the projectors and sort his father's unwieldy collection of films. When I would visit, Javed often displayed a kind of resentment toward his father's inability to actually make it in any film industry.

In his own films, Iqbal Khan reveals his own narcissistic desire to be seen. He often gets his wife or a friend to hold the camera so that he may become the main protagonist of the event. In one film, he tells his children a story about a lion who runs after a deer. In another film, he has an extended boxing fight with his son on his bed. In both, he animates himself with exaggerated gestures and expressions.

In a 1960s existential fictional documentary about wanderlust, Khan meanders down the streets, discovering eating places and hangouts. This short film self-reflexively recounts the hero's journey. But Khan also shot more typical home movies. *The Family at Cubbon Park Playground* (1978) begins with his wife and the children climbing and descending the slide and then marginalized within the frame, as the focus shifts to the men/the fathers accompanying their wives and children. The men begin to perform: first, they

take over the swings; then, in direct address to the camera, they seem to be swinging from the edges of the frame. The film ends with a frontal shot of these men performing for the camera.

In an untitled animated piece from the 1960s, a marriage takes place between a chair and a table; this pixilated film manipulates small objects fashioned from thin strips of wood and cardboard. The film *A Trip to Mangalore* shows Khan's arrival in the city, shot through the windshield of his car. It ends with the extended family at the beach, looking out at the sea. After Iqbal Khan shot this film, he drove back to Bangalore late at night. He was impatient to see his film developed. He went out to buy ice from the ice factory so he could process the film at night. The reels of film had to drip-dry so the film could be viewed in the morning. The cyanide he used for developing the film could be acquired only with police permission, and its very presence in the house made his wife very anxious, as they had three small children. But for Khan filmmaking was a passion, and he diligently pursued his hobby at home.

## XI. Leela Anjanappa (1916–)

Leela Anjanappa is an example of a woman who made films as long ago as the middle of the last century.[14] Anjanappa was married at seventeen into an influential and wealthy family from the Mangalore Coast. Although she was talented and curious, she had little opportunity to continue her studies. As a housewife she became involved in a wide range of activities, like the Girl Guides movement and other social causes. In the 1940s she bought herself a 16mm camera. With this new toy, she prolifically documented daily events and special occasions: a wedding tea party, her children, the Dassehra festivities, Gandhi's ashes as they traveled through India, and innumerable trips to Europe and Japan through the Girl Guides Association. She even filmed Nehru's visit to Mysore. She proudly relates how she put her hand up while Nehru passed by, concerned that the camera noise might annoy him. Nehru turned around, smiled, and even posed for her.

Anjanappa never edited her films. She projected them at home to friends and family and occasionally at her women's club or one of her social work organizations. In our interview, she told me that she was never intimidated or self-conscious while filming in public places. She was well known in Mysore; all photographers at public events knew and respected her. Barbara Flaherty Van Igan, Robert Flaherty's daughter, was a good friend of hers. Married and settled in Mysore, Flaherty Van Igan was the only other woman known to have used a movie camera there. When I was finally able to open

the cans of Anjanappa's films, I found that they were in serious states of disintegration: obviously trapped moisture had facilitated their ruin. In some cases, the reels were reduced to sticky pulp. Others had dried up and become so brittle that even touching them turned them to dust. Anjanappa wanted her deteriorating films saved. The films had been in metal cans and had not been aired for ten years. The films had disintegrated to pulp. Anjanappa was extremely disappointed that the films could not be screened. I was very disappointed as well because I had looked forward to her collection: she was my only example of a woman who effortlessly adopted the technology to represent her life.

With T. Jayakumar, a projectionist, we spliced out any small sections that could be threaded through the projector without falling apart. We wrapped all of these bits around a spool and projected what we could salvage. I was amazed by the little we were able to see: the 16mm film footage showed richly colored images of travel, weddings, meals, and children from as early as the 1940s.

Yet much of the film stock had a piercing, pungent odor. We had to get rid of this footage very carefully; it was early nitrate film and far too dangerous to place in garbage cans close to homes, dogs, or cows. Thus, this archaeology of film fragments is also an archaeology of loss and disappointment.

## XII. Who's Afraid of Amateur Film?

My search for 8mm and Super 8mm film, and the subsequent transformation of the found footage into short films, has been confined to a relatively small collection. My role as a collector resides in finding specific kinds of footage appropriate to my own creative work as a visual artist and filmmaker. The metaphor of a journey describes this process. It is a journey of a "voyeur" who visits, and revisits, sites of tourism and family homes experienced through the "eyes behind the camera." These Indian amateur films encompass a panorama of images and represent a wide range of genres.

What purpose is served by these home movies, these deteriorating memories? They inhabit an invisible realm of cinema and film history. Yet, they are also invisible to the families who possess these documents and who at one time desired to see these reflections of themselves and their family groups. An inevitable dialogue ensues between constructing the imagined self for the camera and creating an imaginary identity. Home movies embed time into an image. These movies also expose a phenomenological paradox: sequential frames chart movement in time, yet they also

trap time. Laughter and self-consciousness abound: they suggest that, in the end, amateur film performs a dialogue with one's image.[15]

## Notes

1. Bertrand Angst, "La Defilement into the Look," in Teresa Hak Kyung Cha, ed., *Apparatus, Cinematographic Apparatus: Selected Writings* (New York: Tanam Press, 1981).

2. Chris Pinney quotes Christian Metz in his *Camera Indica: The Social Life of Indian Photographs* (Chicago: University of Chicago Press, 1997), 123–26.

3. See B. D. Garg, *So Many Cinemas* (Delhi: Eminence Designs, 1996), especially chapter 2, "Let's Praise These Men."

4. See S. Sukhdev, *A Documentary Montage* (Pune: National Film Archive of India, 1984), 12.

5. Suresh Kohli, "Documentaries: Crisis of Credibility, an Interview," in S. Sukhdev, *A Documentary Montage,* 42.

6. The cantonment was also inhabited by Tamil-speaking migrants. They came to work for the British, who, as part of a policy of divide and rule, did not employ the local population. The cantonment followed segregation policies in the bars and clubs. The Anglo-Indian inhabited an identity of in-betweenness and contributed to the cantonment's lively cultural life. See Maya Jayapal Bangalore, *Story of a City* (Madras: East West Books, 1997).

7. In conversation with Pattabhi Rama Reddy in 2001, I learned that his attempt to find a cameraman from the Tamil film industry had failed because the cameramen often insisted on shooting part of the film on sets, and this was not acceptable. This commitment to real locations, shared by many in the New Wave movement, helped to determine the form of the film.

8. *Samskara* was made in 1970 and was responsible for inspiring the New Wave or parallel cinema movement in Kannada. Experimental in form and political in content, it won the national award for best feature film in 1970. It was based on a novel by U. R. Ananthamurthy, and the film crew was composed of a community of close friends. The actors were mainly amateurs, and many belonged to an amateur theater group called the Madras Players. The cinematographer Tom Cowan was a recent graduate from film school in Australia visiting India, and the editor was unknown Englishman Steven Cartaw.

9. Author's conversation with Ramachandran, cinematographer, and Vasant Mukashi, filmmaker, Bangalore, 2001.

10. Ibid.

11. These films have seldom been seen in public; the history of the movement is now quite dormant. I viewed these films in private at the home of a filmmaker associated with the movement.

12. Information in this section on D'Aguiar is based on author's interviews with D'Aguiar from April through July 2001 at his home in Bangalore City.

13. Information in this section on Khan is based on author's interview with Khan from April through July 2001 at his home in Bangalore City.

14. Information in this section on Leela Anjanappa is based on an interview with Anjanappa in April 2001 at her home in Bangalore City.

15. I would like to offer a postscript to this essay. It has been five years since I wrote this article and there is much more interest in 8mm film than there was in the year 2001, when I first began this research. My first film of the series is titled *Film Tales Is Straight 8* and features the amateur filmmaker Tom D'Aguiar and his films. Completed in 2005, it has been screened in Europe and India. Tom D'Aguiar died before I completed the film on him. Pattabhi Rama Reddy died recently at the age of eighty-seven. I dedicate this article to them both, and to their spirit and undying creativity.

## 17  *The Movie Queen*

Northeast Historic Film

*Bucksport, Maine*

KARAN SHELDON AND DWIGHT SWANSON

Northeast Historic Film (NHF) collects and preserves moving images from the northeast of the United States: Maine, New Hampshire, Vermont, and Massachusetts. The collections include home movies, with particularly strong holdings from the 1930s; growing collections of 8mm and Super 8mm films; silent dramas; independent, industrial, and educational works; and television film and videotape. The archive houses more than seven million feet of film and three thousand hours of videotape.

The archive balances preservation and accessibility, offering access to scholars and researchers, "Reference by Mail" video loan services, stock footage to producers and students, teacher workshops and student field trips, and screenings in the 1916 Alamo Theatre. An annual summer film symposium highlights archival collections and scholarship.

In the 1930s, Margaret Cram traveled through northern New England and New York with a 16mm camera and a troupe of actors. On each stop, she made arrangements with local merchants to sponsor a production, which included both a screening of a film she directed and shot locally, invariably called *The Movie Queen*, and a stage show composed of traveling actors and local performers.

Margaret Cram (also known as Margaret Cram Showalter) was last heard from in the 1930s. She left a series of films that are slowly being recovered. Although we have found references to her in 16mm films and in newspaper stories, we have not yet found Margaret Cram herself or any family members—despite the dedication of a number of volunteer researchers and news outlets including the *Boston Globe* and WCVB-TV, Boston.

All of Cram's films have identical plots. A local woman in each town played the "Movie Queen" who returns to her birthplace after finding success in Hollywood. The Movie Queen arrives, sometimes by boat, sometimes

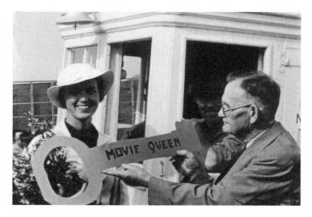

**Figure 68** *The Movie Queen, Lubec,* filmed by Margaret
Cram, 16mm, Lubec, Maine, 1936. Courtesy of Northeast
Historic Film, The Movie Queen, Lubec Collection.

by train. She participates in a celebratory parade through her town, and then
she stops at businesses where she samples goods, inspects appliances, and
greets the people who run the shops and restaurants.

In an interview with Karan Sheldon, Evangeline Morrison (the Lubec
Movie Queen in 1989) explained, "It shows me going into all these differ-
ent stores, given all these gifts." The mercantile tours are comprehensive
records of the towns' Main Streets.

After the Main Street visits, the documentary/promotional approach of
the films changes, and the remainder of the films are short dramas and com-
edy chases in town. Bandits in bandannas plot to kidnap the Movie Queen.
The gang, cast from local businesspeople, bungles the crime and seizes sev-
eral women who are not the Movie Queen. The captured Movie Queen is
driven about by gangsters until a local hero melodramatically rescues her
from the kidnappers before a closing embrace.

Each film consists of three parts—arrival, business tour, and kidnapping—
and each part displays many people and sites. The arrival parade includes cars
and trucks, a marching band, and observers lining the street. The business vis-
its showcase sellers proudly offering produce, baked goods, milkshakes, golf-
ing ranges, or automobile dealerships. The "kidnappers" are people of local
importance such as bank managers.

In the earliest days of motion pictures, cinema owners learned that au-
diences would come out to see themselves; the inclusion of many citizens
on screen ensured a large paying audience. The *Movie Queen* films are in
the genre of these "Our Town" pictures, locally specific and inclusive screen

presentations. North American itinerant practitioners of this kind of film, which could be advertised with the slogan "See Yourself in Motion Pictures," include H. Lee Waters, who made movies in North Carolina, Tennessee, South Carolina, and Virginia in the mid-1930s to early 1940s, and Melton Barker, who traveled in Texas and other states from the 1930s through the 1950s. The *Movie Queen* films constitute the only extant examples of such works by a woman director and cinematographer.

The presence of the filmmaker allowed the small Depression-era towns to represent their home. The townspeople who starred in these films most likely did not have their lives documented in many other ways. Although linked to some forms of popular culture (radio, vaudeville), the towns themselves were distant from the media spotlight. As a result, they risk historical erasure. The films have enormous power to provoke memories in those still living in these towns. Another aspect of the films is that they show life before sprawl evis-cerated small-town centers. They comprise an irreplaceable record of the lives of working people—garage mechanics, woodworkers, grocers, cannery em-ployees, and clerks of dry goods emporia.

The towns in the *Movie Queen* films have not grown since the 1930s, and their economic mainstays have mostly disappeared. Lubec, a coastal Maine town, had a population of around 3,000 when its *Movie Queen* was shot. Now it is just over half that size, with 1,600 people. A Lubec resident, Helen Burns, donated the first *Movie Queen* film to the archive in 1987; we did not know at the time that more would follow, or how many were lost.[1] We had been working in this corner of the state and had worked with several neigh-boring towns on 1930s amateur film records. These other town portraits were one-offs, not part of a series, and were shot by people from the area, not itinerant filmmakers. The Cherryfield-Narraguagus Historical Society brought forward a short 16mm film, *Cherryfield 1938*, amateur footage by Lester Bridgham of Columbia, Maine, showing citizens of rural Cherryfield in early spring. A relative of the filmmaker saved *From Stump to Ship: A 1930 Logging Film*, an amateur film by Alfred Ames, a lumber company owner, showing logging on the Machias River and work in the town mill and on the waterfront. (This film was named to the National Film Registry.) We preserved local portraits including a 35mm print found in a closed theater, *Aroostook County 1920s*, by C. W. Benjamin, a cinema employee; and, from the 1940s, *Knox County on Parade*, made by the Knox County Camera Club in Rockland, Maine.

The Lubec experience was outstanding because key participants were alive. We gathered audio reminiscences, undertook film restoration with funds from the National Endowment for the Arts through the Maine

Community Foundation, and premiered the restored *Movie Queen, Lubec* in 1989. The relationship of the film to the community over several decades is profound and poignant, as the following transcribed interviews with screening participants demonstrate:

> HELEN BURNS (the local historical society contact who brought the film to NHF): Brings back memories, doesn't it, Jim?
>
> JAMES SIMMONDS (who played the hero): My goodness, we had quite a town and didn't realize it.
>
> BURNS: It seems as if after the war things just started to fall down.
>
> ———
>
> SIMMONDS: I was nerved up all right. I was really nerved up, I'll tell you. We ran it a couple of nights, as I recall. And we packed that theater two nights in a row. Balcony and all. And that held quite a few people for our little town. Six or seven hundred people. And we packed it, there wasn't standing room in that place. It was really quite a show when you come right down to it. 'Course we had all local talent then, but they were doing a good job, apparently, they pulled a crowd in. I used to do a little singing.
>
> EVANGELINE MORRISON (who played the Movie Queen): You were good-looking. You are.
>
> SIMMONDS: I was no polished actor, that's for sure. It seems like all the locals were in on something, out to the Grange or after school. We were active in that sort of thing and I guess they kind of figured we had the talent for it. And I owned a bicycle. Oh, dear, that's been fifty or fifty-five years. Imagine it.
>
> ———
>
> SIMMONDS: That's why we say the good old days, those are good memories. Because as I say, there's some faces in there that to a lot of people in town could mean something. To get a chance to see them again, to see them in motion, in action. To see that whole carload of ruffians. All gone. They're all gone. And of course most of those merchants are gone. We were chickens then.[2]

Motion pictures can serve as a participatory community endeavor as well as a profession. Northeast Historic Film is dedicated to understanding our nation's rich and varied film heritage. Lack of familiarity with the intricate nontheatrical paradigm represented by instructional publications, such as *Film-Play Production for Amateurs,* the work of the Amateur Cinema League, genre-twisting productions from Ivy League–filmed theatricals in the 1920s, or semidocumentary labor dramas of the 1930s and 1940s, contributes to the marginalization of noncommercial film practices. Vernacular filmmaking by itinerants, women, and community groups must be found and preserved.

Northeast Historic Film is also interested in the relationship of cinemas to community identity. In the case of Lubec, the film was sent by rail for processing (Cram apparently edited very little), and was shown along with a live show at the Eagle Theatre the same week.

Cram was not a distinguished filmmaker. Her shots are short and unsteady. Her editing may charitably be described as functional. But the record she has created is not only important but rare. Because Cram used the same story structure for each film in each town, it is possible to compare different Main Streets. In the years since she made the films, many of the towns have lost population. They are no longer served by mailboats, ferries, and regular passenger trains. Fish-packing plants and other mainstays of the economy have closed. The films are structured along a binary of commerce and the kidnapping drama, exposing the duality of commercial reality and narrative fantasy.

The prints of the various *Movie Queens* were donated to Northeast Historic Film by libraries and historical societies of the towns in which the movies were shot. Each unique, one-of-a kind film was a 16mm black and white camera-original reversal.

Northeast Historic Film has undertaken a program of making duplicate negatives and new prints for exhibition. *The Movie Queen, Lincoln* (Maine) and *The Movie Queen, Newport* (Maine) films were preserved with funding from the American Film Institute/National Endowment for the Arts program. *The Movie Queen, Groton* (Massachusetts) was preserved by Jack Bruner with grants from the New York Women's Film Preservation Fund and the town of Groton. The Expansion Arts program of the National Endowment for the Arts through the Maine Community Foundation funded the Lubec and Bar Harbor preservation.

Documentation of the *Movie Queen* series has been underway at Northeast Historic Film since 1989, and has resulted in cooperation with institutions and individuals around New England.

While descendants of Margaret Cram Showalter have not been found, many other informants have contributed to the *Movie Queen* record. Prints have screened in the "hometowns" of Lubec, Lincoln, and Groton, and at the Maine International Film Festival in Waterville, Maine. Northeast Historic Film's "archival minute" screens excerpts before feature presentations in our cinema. A number of *Movie Queen* films are still missing, including several from New York State. Ironically, *Movie Queen* films from the archive's hometown, Bucksport, are missing—although the original key to the town presented to the Movie Queen is in our collections.

In 2000, NHF staff members and Bucksport residents embarked on a project to create a new *Movie Queen* film: 16mm silent, black and white. *The*

*Bucksport Movie Queen 2000* replicated the broad community involvement of the original. It premiered to a capacity crowd at Northeast Historic Film's Alamo Theatre during the archive's annual silent film festival.

Though not strictly amateur in their means of production, the original *Movie Queen* films represent a vernacular stream of film authorship—an essential part of the history of moving image media. We selected *The Movie Queen* for this book to advocate for the recognition of community-based filming and to promote further study of the original production and exhibition context of the films. We also hope to encourage further resources for their acquisition, preservation, and exhibition.

## Notes

1. At Northeast Historic Film:

*The Movie Queen* (Bar Harbor, Maine), 1936, Bar Harbor Collection, 400 ft. (dupe neg. only)

*The Movie Queen* (Groton, Massachusetts), 1939, John Bruner Collection, 550 ft.

*The Movie Queen* (Lincoln, Maine), 1936, Lincoln Memorial Library Collection, 900 ft.

*The Movie Queen* (Lubec, Maine), 1936, Lubec Collection, 800 ft.

*The Movie Queen* (Middlebury, Vermont), 1939, Sheldon Museum Collection, 900 ft.

*The Movie Queen* (Newport, Maine), 1936, Newport Historical Society Collection, 710 ft.

*The Movie Queen, Van Buren* (Van Buren, Maine), ca. 1936, Daniel Lapointe Collection, 750 ft.

*Bucksport Movie Queen 2000,* 2000, NHF Collection, 1,200 ft. (orig. neg. and print)

Known to have been filmed but not known to survive: *Movie Queen* films from Bucksport, Camden, Dexter, and Eastport, Maine, and Norwood, Massachusetts.

2. From oral history session in March 1989, Lubec, Maine, by Karan Sheldon (audio recording).

# 18 The WPA Film Library

*Orland Park, Illinois*

CAROLYN FABER

The WPA Film Library was founded in 1987 with the purchase of the Colorstock Library, a collection of educational films and outtakes produced by Lem Bailey. Bailey began working in Hollywood on these productions in 1953. After acquiring North American rights to the British Pathé Newsreel Collection in 1991, the WPA Film Library established itself as a major source for historical images. The archive, which is a private enterprise and not a public institution, houses numerous newsreel, documentary, animated, educational, feature, and amateur film and video collections that span the period from 1896 through 2001.

The WPA Film Library focuses its acquisition efforts toward unique collections of historical and contemporary moving images that are congruent with the interests of its clientele, who are mainly documentary film and television producers and advertising agencies. Occasional risks are necessary in order to maintain a potent, dynamic archive. For example, in the early 1990s, the WPA acted on requests for historical images of Chicago by inviting local families to donate their home movies to the library in exchange for video transfers of them. Although motivated by the potential market value of the *content*, the WPA lacked an established *context* for marketing erratically exposed, unsteady images to a more commercial clientele that demanded clean images with high production values. Sometimes, however, producers will seek out these amateur films because they offer a different cinematic texture or feeling from slicker images.

Search results sometimes omitted home movies entirely because of their technical flaws—whether real or perceived. Consequently, amateur film at the WPA was left to the whims of a market with little use for it beyond the occasional birthday party, Christmas celebration, or family vacation. Although the WPA's staff researchers have recently reconsidered the use of amateur films

beyond their trademark kitschy and nostalgic iconographies, the function of amateur films in the archive remains ambiguous. However, when several home movies with advanced vinegar syndrome[1] were recently evaluated as unprojectable, the archive quickly and definitively addressed the place of these films prior to decisions about their restoration.

The Altman family home movies, an eight-hour collection of 16mm black and white reversal films from 1926 through 1936, were donated to the archive in 1995. Born in Chicago in 1890, the filmmaker Robert M. Altman was an assistant manager with the S. Oppenheimer Company, a sausage casing supplier.[2] The collection contains several reels of footage from the 1933 World's Fair, a homemade industrial film for the sausage casing company, dramatic footage of the 1934 Chicago Union Stockyard fires, a Caesarean section, and family celebrations and vacations more typical of the home movie genre.

The thirty-five minutes of 1933 World's Fair footage were particularly intriguing.[3] Altman apparently intercut his own footage of the fair with a professionally made film of it. We have not yet identified the other film. Altman weaves a unique personal and family narrative into the professional footage that contrasts with newsreels of the fair. Altman's footage deploys title cards and editing to create a logical chronology: his homemade title cards identify his wife, Olga, and daughter, Flora Louise, as they visit the horticulture exhibit, visit mock European villages, and enjoy a hot-dog lunch.[4] Altman's handheld, inconsistently exposed shots starkly contrast with the static, balanced compositions, uniform exposures, wipes, dissolves, superimposed titles, and at least one matching action cut of the professional film.

Altman similarly employed title cards and editing to create a coherent narrative chronology in his travelogues of family vacations to California, Colorado, and Bermuda. He made an unusual fourteen-minute 1926 motivational sales film for the S. Oppenheimer Company called *The Skin Game: Tragedy, Comedy, Drama in 12 Acts*. The film opens with a two-minute homemade title sequence introducing all the characters, played by company employees (one of the cards lists "The Villains," although it is never clear who they are). It continues with an eight-minute introduction composed of shots of individual men walking out of a building and toward the camera, where each one stops and tips his hat. The last four minutes of the film contain the "action": a series of close-ups of invoices, memos, and checks (one for $5,000!) intercut with title cards instructing the viewer to "Study Your Customer's Requirements—Sell the Whole Line!" and "Please get in touch with the sales dept. we want to help YOU!" This early, perhaps somewhat strange, example of a corporate film produced by an amateur filmmaker using narrative techniques catapults the collection into unparalleled terrain

within the WPA: there are no other similar examples of such homemade industrials. The connection with Chicago industry also makes this film and the entire Altman collection an extraordinary asset.

Altman's personal documents of private, public, corporate, industrial, and recreational life in Chicago from 1926 through 1936 provide rich anecdotal evidence of the Midwest region's history. His documents of the World's Fair and the Stockyard fires resonate beyond the borders of local and regional history because these were internationally reported events. The WPA holds short, impersonal, distilled newsreels that reported on the 1933 World's Fair and the 1934 Union Stockyard fires for a general audience. In contrast, Altman's emotional and geographic proximity to these events, as well as his freedom to shoot and edit without restriction, personalizes his films in a way newsreel companies, conforming to the expectations of a mass audience, could not have achieved.

One of the most pressing challenges at the WPA Film Library is the constant negotiation between commercial profit-making interests and the need to properly care for the films. These interests create messy intersections when determining the value of the material to the archive against preservation costs for safe, long-term access. The WPA's home movies were originally acquired in order to meet many clients' expectations that, as a Chicago-area archive, it would have a substantial selection of historic Chicago images. While expressed client interest is an important part of the equation, the archive also has to consider its moral and ethical responsibility to properly maintain culturally and historically significant material.

In the case of the decayed Altman films, the WPA Film Library sent the films to a lab for evaluation and treatment so they could be run through a telecine.[5] It worked closely with another lab that made high-quality videotape transfers while simultaneously assessing the condition of the films to map the work required to strike negatives. These videotape transfers provide a way to review and research the films, to make the images available to clients, and to evaluate the costs for producing new negatives.

The amateur film holdings in the WPA Film Library highlight several important archival issues related to marginalized film material. First, an emphasis on regional film provides an example of microhistorical archival practice. Second, the archival process entails much more than acquisition, raising significant technical and preservation questions. Lastly, the WPA Film Library collections of home movies show that acquisition can be spurred as much by user and customer needs for specific, Chicago-based images as by historical significance, especially when the archival enterprise operates in the commercial rather than the nonprofit sector.

## Notes

1. "Vinegar syndrome" refers to the pungent smell of acetic acid due to triacetate film stock deterioration and decomposition triggered by heat and humidity. See www.kodak.com/us/en/support/technical/vinegar, retrieved January 5, 2007.

2. The S. Oppenheimer Company was a successful international business with factories and agencies in Canada, England, Argentina, New Zealand, Germany, and China.

3. At the time of acquisition, video transfers were made for the family that donated the Altman films. These transfers were made in-house on a rather crude system that provided mediocre results. They were used for cataloging the films, but some of the catalog entries—for reasons yet unknown—are incomplete, and in some cases incorrect. Some of the films did eventually get professionally transferred in response to client requests, but none of the films discussed here was among them.

4. The hot-dog eating scene is particularly notable not only because of Altman's connection to the sausage business, but also because the logo for the meat-processing giant Swift Company is visible in the background. Curiously—perhaps coincidentally—the logo is referenced again with the incongruous insertion of the 1934 Union Stockyard fires at the conclusion of the film.

5. Restoration House Labs in Bellevue, Ontario, Canada, used its Redimension process on all reels.

# 19  Mule Racing in the Mississippi Delta

KAREN GLYNN

## A Racially Mixed Event

Startling home movie footage of animated, well-dressed black farmers rac-
ing mules around a track in Mississippi in the late 1930s and 1940s contrasts
sharply with the more familiar still photographs of desperately poor black
Southerners made by the Farm Security Administration (FSA) during the
same period. Unlike professional photographs made by outsiders, this home
movie footage captures the spirit and vitality of black Southerners and dis-
plays it on the screen. Preserved in the Southern Media Archive at the Uni-
versity of Mississippi, the film of the Delta mule races presents a rare
glimpse of plantation culture and the world of African American farm-
workers.

Two Delta towns, Greenwood and Rosedale, held annual mule races
between 1938 and 1950. Both African Americans and whites old enough to
recall the mule races remembered them warmly as "good-time" events in
plantation culture.

This article utilized oral history interviews conducted by the author be-
tween 1993 and 1995 while pursuing a graduate degree at the University of
Mississippi, home movie footage of four Mississippi families housed in the
Southern Media Archive of the University of Mississippi, microfilm of the
*Greenwood Commonwealth* newspaper, records of the Greenwood Women's
Auxiliary, and FSA photographs of Mississippi Delta plantations. The oral
history interviews show that African Americans and whites perceived the
mule races differently. Rather than affirming the racial status quo, the event
temporarily subverted the social hierarchy by providing a stage for talented
black men to perform before the public and to be acknowledged by their
communities.

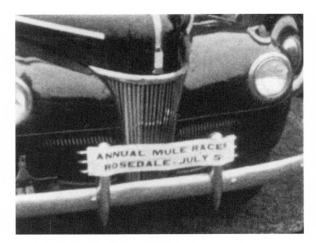

**Figure 69** Blow-up of a frame from an 8mm home movie: banner from annual mule race, filmed by Emma Lytle, Rosedale, Mississippi, circa 1946. Courtesy of Lytle Collection, Archives and Special Collections, University of Mississippi.

Fortunately, home movie footage exists of the Rosedale and Greenwood mule races. A total of ten minutes and sixteen seconds of 16mm and 8mm motion picture film provides a brilliant visual context to understand and interpret the interviews and newspaper articles. Within historical limits, the footage functions as a reference point to identify what is present and what is absent, as well as who is represented and who is not at the community gatherings. The material represents the point of view of the men and women who shot it, all members of the white planter class which organized the races. The Women's Auxiliary records and the Greenwood newspaper also represent the voices of the planter class. The oral history interviews include the voices of the African American riders and race attendees as well as the voices of the planter class.

The film footage plays a crucial role in helping to understand the different racial perspectives of the mule races. The material falls naturally into two categories: footage of the racetrack events and footage of the audiences. Two home movies of the 1940 Rosedale races, labeled HM1 and HM2, and footage recorded in 1941 at Greenwood, HM3, focus primarily on the racetrack. HM4, shot in Rosedale in 1946, concentrates on the people that attended the mule races. The following scene-by-scene transcription describes the silent 1940 Rosedale mule race footage.

## The Track

The Rosedale racetrack film opens with politicians delivering campaign speeches to a crowd from a platform elaborately decorated with red, white, and blue bunting. Seven speakers are shown, including then Governor Hugh Lawson White. Men in white shirts, ties, trousers, and hats lounge on the grass while women wearing flowered dresses and hats sit on chairs under tall shade trees listening to the politicians and fanning themselves. Young people sit in groups in the clubhouse drinking from longneck brown bottles. Outside, the camera pans over a canopied concession stand staffed by two busy white women selling refreshments. People line the counter.

A white boy wearing a red satin shirt and cap and carrying a horn rides a pony through a lane of trees. The young herald blows the horn as he rides, announcing the official start of the 1940 races. The camera pans from the messenger to the grandstand, covered with a brown pavilion-style tent. Red, white, and blue pennants fly from its peaks, reminiscent of descriptions of medieval jousting matches. The grandstand overflows with people in light-colored summer clothing. They mill about in groups along a walkway created by a white rope fence girding the racetrack and the benches of the seating area. The camera continues its sweeping pan over the grandstand, passing a handful of African Americans clustered under an isolated grove of trees to rest on a parking lot filled with automobiles.

Events begin with a bareback mule race. African American farmworkers race the animals clockwise around the track. A man standing on the bed of a truck parked in the middle of the infield announces the action over the public address system. Spectators and bettors line both sides of the track, though only men appear to be on the infield. Planters, acting as race facilitators, ride their horses onto the track, through the infield and through the crowd, towering over everyone. The number of the race and the names of the competing animals and their owners are posted on a large scoreboard erected to the right of the grandstand. Photographers snap pictures as the riders come around the curve of the track into the home stretch. A mule crosses the finish line. People immediately turn from the track.

The races alternate between mules and horses. The next recorded race is incomplete. A dark horse with a white rider gallops past the finish line, followed closely by a white horse ridden by a white man. A race facilitator, carrying a curve-handled cane across his saddle, symbolizing his authority, rides into the frame and smiles. People seem to be enjoying themselves, working, betting, or just watching. Small planes fly overhead between races, most likely crop-dusters enlisted to augment the festive nature of the event.

Both HM1 and HM2 filmed the next race between mules. A close-up at the starting post reveals six African American riders wearing regular clothing, billed caps, and large numbers on their backs. The official starter, a man standing to the front and side of the mules, drops his arm and the animals dash forward. Immediately, a rider with very fair skin takes the lead. The mules wear bridles and some have feedsack blankets on their backs. Both cameras turn around to record the winning animal racing toward the finish line. A gray mule ridden by a man wearing a red cap leads, hugging the outside of the track. A man in a white boater clocks the animal as it gallops by. The runner-up passes the camera and the finish line as the third-place mule abruptly veers from the inside of the track directly across the course at an extreme angle. The rider manages to check his mount before it goes through the fence. However, he ends up facing the wrong direction and loses his third-place position.

Six horses compete in the next race. A white man wearing number 88 on his back wins. Then African American riders promenade their mules on the track in a loose circle near the starting position. One rider wears a red and white satin shirt and a red satin cap. The other men wear light-colored shirts, trousers, and caps. Spectators line both sides of the track, judging the merits of mules and riders before laying their bets. This is the third and penultimate mule race.

Six men, two African Americans and four whites, ride in the third and final horse race. Three men carrying the curve-handled canes help the riders get their mounts into position at the starting post. It is a sunny, hot Delta day, and sweat soaks through the back of one man's shirt. The crowd presses against the white rope fence separating them from the track. HM2 shows the start and finish of this race, won by a white rider. It is not clear whether this final horse race was a sweepstakes.

Six riders compete in the last recorded mule race, a sweepstakes. The fair-skinned man and the man in the red cap are among the riders. In HM2, the line-up and beginning of the races are filmed as well as the winning gray mule as it gallops down the track and over the finish line, carrying the red-capped man to victory. Neither camera filmed the awards ceremony; the victor appears in the next shot riding his mule to the stands for the crowd's inspection and acclaim. The gray mule sports a wreath of cotton bolls and flowers around its neck. The winner smiles as young white boys and a small, enthusiastic African American boy run toward him. He continues smiling as he saunters out of the frame.

Immediately the camera cuts to a shot of two white men standing on the back of the public-address system truck in the middle of the infield. One tips

his hat with his left hand while holding the sweepstakes trophy in his right. The announcer, standing next to him, microphone in hand, might be saluting the prizewinning plantation owner and the town for a successful event or reminding the crowd that the day's festivities are not over.[1]

This home movie footage, inscribed by the perspectives of the filmmakers, provides information about mule races that is unavailable elsewhere. The pre-race footage of the grounds shows an elaborately staged setting that required time, money, and effort to arrange. Speaker platforms, concession booths, bleachers, tents, costumes, a public-address system, and the racetrack itself had to be built, erected, sewn, and organized. The footage establishes the medieval theme of the races, reminiscent of the southern tradition of ring tournaments. A parking lot full of cars during the Depression year of 1940 and small planes saluting the track indicate the wealth of the spectators. The filmmakers' concentration on the races suggests that they might have had animals participating in the competition. It is possible to infer the seriousness with which the planters approached the mule races by the very fact that they were documented on film.

Aside from the riders, the 1940 Rosedale film contains very little footage of the African American presence at the track. The initial panorama shot includes a glimpse of a small group of black spectators, and one of the final shots shows a young African American child running into the frame. The footage does not show the separate viewing sections for African Americans near the holding area of the mules. Jimmy Love, an African American farmer who lived with his family in Rosedale and attended the races before World War II, arrived at the track early one year and described watching the animals in the holding area as he waited to enter the black viewing section of the track: "One time I went before the race and . . . kept me waiting. They'd bring a truck there with the mules. Mule be bucking and pawing . . . couldn't hold a mule, you know, they was just really wild, some of them mules wild."[2]

## The Crowd

Emma Lytle (HM4) filmed the first postwar mule race in Rosedale in 1946, training her 8mm camera on the people at the races as well as the action on the track. In HM4, the footage opens with mounted African American men in an open, parklike setting riding their mules toward the starting line. An animal balks; the rider pulls its head up with the bridle and holds it in check. The large mules have dark, glossy coats. A long shot of the starting line shows the riders crouched over the necks of their animals. The camera follows the

galloping mules around the track until they pass behind a public-address system truck parked in the middle of the infield. Then it films a young man thundering down the track, sitting upright on his mule. He gallops over the finish line, off the track, and into the trees. The second- and third-place mules finish far behind the winner.

People surround the betting booth. A woman's hands tear a perforated ticket from a booklet. A man turns from the booth, smiles at the camera, and fans out a handful of tickets. The camera weaves through the crowd, casually engaging friends in conversations, filming them in close-up while filming everything else as a wide shot. The camera turns to the track for a brief shot of men and mules coming around a curve.

Now the camera follows two white men as they walk through the crowd in the African American section of the track. Two riders wearing numbers on their backs, one leading a mule, walk in front of the white men. Suddenly, three riders enter the scene from the left and ride across the frame through the African American spectators' section. The camera traces their movement to the right, panning over the backs of the enthusiasts facing the track.

People are everywhere. Older men sit on benches in front of a booth where a band is playing. A heavyset planter chats with the bench sitters from astride a light-colored horse. Young men in white shirts wearing ties carry plates of food into the clubhouse. Young women in large hats and white gloves smile and talk to the filmmaker. A quick shot of the scoreboard reads "RACE NO. 5." Riders form a group at the starting line of two or three abreast. About six men take off as two white men in hats back away from them. A rider on a white mule, wearing a soft snap-brimmed cap backward, canters easily across the finish line. A man jumps up and down in the judges' booth.

Groups socialize in the parking lot. People sit on folding chairs and talk. Women huddle over other people's children. The camera lingers on a banner that reads "ANNUAL MULE RACES ROSEDALE JULY 5" stretched across a car grill. The crowd moves constantly—from the track to the betting booth to the clubhouse to the parking lot to the grandstand.

At the track, a group of spectators enthusiastically cheers on their favorites. Once again, the camera picks out the same two white men and follows them through the crowd. One turns, smiles at the filmmaker, and waves to her to follow them into the African American section of the track. For three seconds a small group of African American men and women in light-colored summer clothing fill the screen. They do not pay attention to the white men or to the camera operator.

The filmmaker returns to the parking lot for more shots of talking people. Then she moves back onto the grounds to catch the young man in

the snap-brimmed cap struggling with his mount. Coverage ends with a shot of the stocky older planter, still on horseback, lifting a child up onto his saddle.[3]

This raw footage defines the mule races from the point of view of the planters and their children: a good time, lots of betting, a white community event. The only African Americans among the strolling crowd are on mule-back. Not counting the riders, African Americans appear twice, both times as a stationary group positioned along the track. These brief glimpses of African American spectators in HM4 establish a segregated section at the track, which supports firsthand accounts of African American attendance from the oral history interviews, including those of Jimmy Love, Joe Pope, Frank Duncan, and Freddie Anderson.

## Racing and the South

In most of the South the mule dealer was the "biggest man in town," according to Robert Byron Lamb, "and his mule barn was the center of trading activity."[4] Ray Lum's mule and horse barn was a key trading institution in Vicksburg, Mississippi, from the early 1900s through the 1950s. Lum recalled: "The Delta was a booming place for mules in the thirties. If you didn't have mules, you wasn't in the farming business. Those farmers bought them by the hundreds. Some good farmers had a barn that would hold fifteen hundred mules."[5]

Wherever men worked mules, they found time to race them. The earliest citation is the 1835 Maury County Fair in Tennessee. On the last day of the fair, planters often organized a mule race using their slaves as jockeys. Part of the ritual required spectators to do everything they could to "retard the progress of the steeds and make them fly the track."[6]

Racing provided the entertainment at many get-togethers in the South, from agricultural fairs during the antebellum period to informal barbecues at the turn of the century. Mules frequently shared the racing program at these events along with ponies, harness horses, and native running horses. Tom Wilburn, from east central Mississippi, remembers attending races as early as 1928: "It'd be little social gatherings around here. And they'd have these impromptus, just on a straightaway, mule race [sic]. And then different plantations would bring in their mules and some of the black riders, and [it's] competitive; local competition among local places . . . always betting on the side."[7]

Planters regularly matched their stock in performance against each

other. Mule races occurred so frequently that, according to Wilburn, some planters kept mules that did nothing but compete on the track: "Runnin' mules, they were not very big, they were streamlined and medium sized. And . . . they were kept by different places strictly to run. They were never worked. . . . Keep in mind, a mule that size is kind of like a goat. It doesn't cost anything to keep it."[8]

When promoted as draft animals in this country after the Revolutionary War, mules were scarce, highly esteemed animals. As they became more common, their status changed. The mule came to symbolize the endless drudgery and manual labor of farm work. With the development and expansion of the slave economy in the antebellum period, the lives of mules and slaves intertwined until one came to symbolize the other, and wealthy people strived to distance themselves from the working animal just as they physically separated themselves from the enslaved population.

The mule races in Rosedale and Greenwood, Mississippi, began toward the end of the Depression, a few years after the Delta plantation owners started receiving federal agricultural subsidies. Planters used the government assistance to buy tractors, actively reducing their reliance on the labor of tenants and sharecroppers to farm their land. Hard times combined with agricultural mechanization displaced many sharecropper families. The situation was so grave that the federal government interceded and began distributing relief payments to sharecroppers, slightly lessening their financial dependency on the plantation owners. Outside attention, the growing number of unemployed farm workers, and federal relief payments to sharecroppers threatened the planters' viselike hold on African American labor in the Delta.

In this grim economic atmosphere, the dominant society asserted its control over the status of African Americans in the social order by pairing them with plow mules in the annual races. Modeled on thoroughbred racing, the mule races were viewed by whites as an inherently comical Sambo-type spectacle, designed "to make the black male into an object of laughter . . . to render the black male powerless as a potential warrior, as a sexual competitor, as an economic adversary."[9]

Eleanor Fiore, a white resident of Greenwood, described the attraction of the races: "Oh, it was a delight; I never had so much fun. . . . You never [knew] whether they were gonna sit down, those mules would just sit down all of a sudden, they get so confused . . . and they might could run backwards, run in the opposite direction."[10]

Mary Hamilton, a white member of the Greenwood Junior Auxiliary, also believed the unpredictability of the mule was the main attraction of the

races: "They were mules, you never know what they're going to do . . . they'd have them all lined up, and they'd start out and maybe one of them, all of a sudden, changes his mind, turn[s] around and go[es] back, jump[s] the fence and go[es] out. So, nobody knew what they were going to do, and I think that was one thing that made it so much fun."[11]

Conversely, African American spectators stressed the skill of the riders as the main attraction of the races. Paralleling the lure of the rodeo for those in the livestock business, African American farmers went to watch the best hostlers perform. Joe Pope sharecropped with his family on a local plantation and saw his first mule race in Rosedale: "Oh, I think it was great because I had never been to the mule race and I enjoyed them riding mules."[12] Jimmy Love recalls: "It was a great big event, and we all look forward to it all the time. And we be at home wondering who's going to ride and who's going to win."[13]

Normally, one man rode for each farm. Some planters held competitions to determine the best rider. Men wanted to ride and vied for the chance to participate in the races. Competing in the races was public acknowledgment of one's skill as a hostler and provided a rare opportunity to earn cash. Officially, riders received $2.50 to $5.00 for each race. If they won, they also collected the prize money. Unofficially, stories circulated about bets between riders, special incentives to riders from owners and bettors, and hats being passed around the crowd to sweeten the prize money. For farmhands making $1.00 to $1.50 a day, the mule races offered a significant source of money.

Competitive planters wanted skilled hostlers to ride their animals to the winner's circle. They did not want their mules or the men, who represented their plantations and thus themselves, to be publicly ridiculed. Two of the four riders interviewed worked as hostlers, not farmhands, on the plantations. They broke and trained the plantations' mules, workhorses, and show horses. Freddie Anderson worked as a hostler on Will Ghourly's plantation and rode Ghourly's mules in the races. Anderson spoke highly of a rider named Sparkplug: "This boy from Pace, called him Sparkplug. . . . If he was there and they had mules that needed a rider, he rode them."[14] Besides riding competitively, Sparkplug broke wild mules between events. Nearly every Rosedale informant, white or African American, mentioned his name in connection with a legendary race story. As one of the first stories people recalled, it provides a good example of the difference between African American and white perceptions of the mule races.

Whites recalled the story with humor, using it as an example of the crazy things that can happen at mule races. African Americans told the story straight-faced, with admiration for Sparkplug's riding skills. People related

many versions of the story: some called the rider Sparks, others called him Sparkplug; some described an out-of-control mule race, others described a runaway wild mule. Despite these differences, everyone told the same story about the mule that ran over the levee. Sparkplug's friend Freddie Anderson confirmed that the stories were about the same man.

When asked why Rosedale hosted mule races, Clyde Aycock, a white man, described the unpredictability of the animals through the story of Sparkplug:

> CA: Well, it was a lot of fun. Though you can't ever tell when you get on a mule and start him to running where he's going to go. He may stay in the race or he may wind up over on the levee, and that's what happened some time.
>
> KAREN GLYNN (KG): People ended up over the levee?
>
> CA: Yeah.
>
> KG: Can you tell me the story?
>
> CA: Well, they just start the race, you know, shoot the gun and start the race, and here they go around there, and the track ain't nothing but a little old roped-off area, and a mule's hard to turn once you get him started. And they just run right on through that rope and up on the levee. It's down at the country club, which is right by the levee.
>
> KG: Who did this?
>
> CA: I don't remember who did it. But it happened. I saw it happen.[15]

Asterina Carter, a white Rosedale resident, heard about the event and used the story to describe the attraction of the races: "One of the jockeys, the black jockey's riding and . . . the mule just went wild. And instead of stopping at the end, they said he went across the levee. The golf course, the levee sits right behind the golf course. That mule just went wild, just went, just headed on out."[16]

Frank Duncan, a retired African American chauffeur from Rosedale, remembered Sparkplug's name and reputation, though he did not mention the levee story: "There was one called Sparks, Sparks. He was, yeah, he was riding them bad mules, what didn't want you to ride them, Spark would ride them. He wasn't in the race, though, he wasn't riding around. He just come there to meet different people [who] bring mules . . . you can't ride at all, bad mules."[17]

Jimmy Love, the former farmworker, saw Sparkplug ride over the levee:

> JL: They bring mules in for the Negro man to ride. We had a fellow there we used to call Sparks, he could do that . . . ride mules that ain't never been rode before.

KG: Do you remember any stories, or did you see this guy Sparks?

JL: Yeah, I seen him ride.

KG: Can you describe it?

JL: Yeah, I can describe it, 'cause he had one mule the man said could nobody ride him. He got on him and he took off, but now he didn't go round no circle, no race[track]. The last time you see Sparks, he and the mule was over the levee. Just kept on crossing the levee. Sparks had a sister, used to be with him all the time. She rode a horse. She followed him. And he was gone so long we were wondering about him.

KG: What happened?

JL: When Sparks come back, that mule was trotting just as gentle as [could be].[18]

While other people recounted fragments of the levee story either through direct observation or hearsay, Freddie Anderson recounted it as both a witness and an appreciative fellow rider:

Mr. Malone had some mules had never been rode. Had nobody never sit on their back. Had nobody never put a bridle on them. They caught them mules and brought them to that track. And this boy went up there and got that mule, put a line on him, hooked him to that [his] horse, and brought him down there.

It's one thing that horse will do, if he caught, throwed a line over a mule or cow, he had to drag that horse . . . that boy had double girths on that horse, breastplates, leather breastplate, and that strip come around his tail, come down his back, that means you couldn't pull that saddle off. He had him dressed to kill, but he would hold whatever you throwed that line over, and it tighten up against the horn of that saddle, hey, only way he'd get away, he'd break every girth that was on it. 'Cause he wouldn't give up to them, he'd hold them . . . when you bring them [wild mules] out to the park, they would sometimes have to put a twister on it. That's a [clasp] handle and a rope, and put it on his lip and twist him down so they can get on it. Then they'd throw a rope over him, just like you do on them bulls. And when you twist that twister on his lip, he give. You draw that rope around his waist, twist over on that twister, he give. Draw that rope around his waist and get that rope good and tight, only thing you can do then, you jump up on him. You jump up on him, and Sparkplug, he was a rodeo rider, he had them big quarter-inch spurs. You know he could stop a mule or horse dead still with them spurs. He was tall and he was bowlegged. He'd reach around and hook him in the chest when he bucking, and you could see him giving. He'd set back. He wouldn't buck coming down no more. He'd set back. . . . This boy rode a mule there one day. That mule went through the wire fence and broke about four strands of wire. And that mule went over the levee with him. You know when he was running, he [Sparkplug] whistled [makes whistling

sound]. When he left, running that race, he made his bridle ring up on his saddle. That horse was standing out there . . . like he's at attention. And all Sparkplug had to do was whistle, that horse was coming to him. When he whistled, he went to him. That horse cleared that . . . jumped that fence and went over out [the levee]. And Sparkplug had got off the mule and . . . that horse come up, he jumped on that horse, and he'd taken that line off his saddle and roped that mule and brought him back. Yeah, he was a rodeo rider, no doubt about that.[19]

The story of Sparkplug riding over the levee symbolizes the ritual of the mule races for the black and white communities, each group interpreting the story to suit its distinctive social/political/cultural needs. These interpretations reflect the tensions between African American Southerners and white Southerners as they constantly negotiated and redefined the racial code. White informants depicted Sparkplug as a buffoon, a Sambo without a name, present only to provide comic entertainment. They appeared driven to rein in the liminality of the mule races that showcased the talents of individual African Americans and to restore the temporarily inverted social order. By declining to name Sparkplug or to recognize his skill, the white community effectively denied his existence. By abandoning Sparkplug over the levee, the tale warned African Americans of what happens to people who challenge the social order.

The African American community rejected the racial stereotypes and defined Sparkplug as a talented, competent man who beat the system by successfully completing what he set out to do against all odds. African American versions of the story named him, noted his horse, cited his reputation, returned him to his community, and recorded his story in group folklore. In *Black Culture and Black Consciousness*, Lawrence Levine describes this type of character as a "moral hard man."

> They won their victories within the confines of the legal system in which they lived. They defeated white society on its own territory and by its own rules. They triumphed not by breaking the laws of the larger society but by smashing its expectations and stereotypes, by insisting that their lives transcend the traditional models and roles established for them and their people by the white majority. They were moral figures, too, in the sense that their lives provided more than vehicles for momentary escape; they provided models of action and emulation for other black people.[20]

The mule race ritual graphically depicts the complexity of racial relations and racialized memory in the American South. The home movie footage of 1940 opens with a typical political campaign scene of the era—white men on a platform draped in patriotic bunting addressing a crowd of white voters.

Disenfranchised African Americans are not in the frame. They appear later, filmed performing competitively on a makeshift racecourse. These images, neatly juxtaposed, contained by the same event, express the diverse political will present in Delta society. This extraordinary home movie footage transgresses the boundaries of the annual racing ritual and survives it. Extracted from its sociocultural context, the footage does not convey the stereotypical images remembered by members of white Southern society, but it does support the African American memory of the mule races as a demonstration of manly prowess and reveals a continuity of Southern male cultural values, from the Virginia frontier to the Mississippi Delta of the 1940s.

## Notes

An earlier version of this essay was previously published as "Running Mules: Mule Racing in the Mississippi Delta," *Mississippi Folklife* 28, no. 2 (summer/fall 1995): 20–31.

1. HM1 and HM2, Bro. Wilson tape, Dixon Dossett tape, Southern Media Archive, University of Mississippi Library. HM3, Gary Collection, Southern Media Archive, University of Mississippi Library, Oxford, Mississippi.

2. In this and the following interview transcriptions, gaps in the interviews are noted in the text with ellipses. Jimmy Love, personal interview, Rosedale, MS, October 29, 1993.

3. HM4, Lytle Collection, Southern Media Archive, University of Mississippi Library.

4. Robert Byron Lamb, *The Mule in Southern Agriculture* (Berkeley: University of California Press, 1963), 19.

5. Quoted in William Ferris, *You Live and Learn, Then You Die and Forget It All: Ray Lum's Tales of Horses, Mules, and Men* (New York: Anchor-Doubleday, 1992), 73.

6. John Trotwood Moore, *Songs and Stories from Tennessee* (Freeport, NY: Books for Libraries Press, 1902), 98.

7. Tom Wilburn, personal interview, Artesia, MS, October 7, 1994.

8. Ibid.

9. Joseph Boskin, *Sambo: The Rise and Demise of an American Jester* (New York: Oxford University Press, 1986), 14.

10. Eleanor Fiore, telephone interview, Greenwood, MS, March 8, 1994.

11. Mary Hamilton, personal interview, Greenwood, MS, February 25, 1994.

12. Joe Pope, personal interview, Rosedale, MS, October 16, 1993.

13. Love, personal interview, Rosedale, MS, October 29, 1993.

14. Freddie Anderson, telephone interview, Chicago, IL, November 28, 1993.

15. Clyde Aycock, telephone interview, Rosedale, MS, November 29, 1993.

16. Asterina Carter, personal interview, Rosedale, MS, October 16, 1993.

17. Frank Duncan, personal interview, Duncan, MS, October 16, 1993.

18. Love, personal interview, Rosedale, MS, October 29, 1993.

19. Anderson, telephone interview, Chicago, IL, November 28, 1993.

20. Lawrence Levine, *Black Culture and Black Consciousness: Afro-American Folk Thought from Slavery to Freedom* (New York: Oxford University Press, 1977), 420.

# 20  The Academy Film Archive

*Los Angeles, California*

LYNNE KIRSTE

The Academy Film Archive's holdings are composed of over eighty thousand elements, with an emphasis on American feature films, films that have won or been nominated for Academy Awards, footage of Oscar ceremonies, and materials that relate to the Hollywood film industry, such as behind-the-scenes footage, special-effects reels, and screen tests. We have extensive collections of home movies, documentaries, and experimental films. The archive also features collections of material from specific filmmakers, including directors Alfred Hitchcock, Satyajit Ray, and George Stevens; animator John Whitney; and documentarian Robert Drew.

The archive currently holds over one thousand reels of home movies. About half of these films were donated by people who worked in the motion picture industry, including directors, actors and actresses, cinematographers, and screenwriters. The other half of these films were contributed by people with no connection to the film industry. Amateur films are an important part of the Academy Film Archive's collection. They offer uniquely intimate glimpses into the lives of public figures and ordinary people alike. Home movies document everything from off-camera moments on film sets to the experiences of underrepresented groups of people—usually from an insider's point of view.

One 16mm silent, black-and-white and color home movie in the archive's Richard Brooks Collection is made up of four noteworthy sequences spliced together on one reel. The first three sequences are camera originals and were almost certainly filmed by writer-director Brooks. Due to space constraints, I will focus on the first sequence, color footage of a baseball game in Los Angeles, which I will describe in more detail in a moment. Second on the reel is a black and white segment featuring the Del Mar racetrack in California, circa August 1948. Diverse people arrive at the track, look at racing forms,

place bets, and watch races. A woman circles the name of the horse Lady Bruce—who was owned by actress Virginia Bruce and director John Huston, a friend of Brooks's—on her racing form. The third segment, also black and white, depicts a visit to Hoover Dam circa 1948. The final sequence on the reel, which was apparently given to Brooks, is a print of footage shot by composer Harold Arlen, circa 1936–37. This color segment was filmed at George and Ira Gershwin's home in Beverly Hills, California. George Gershwin, actress Simone Simon, and director Rouben Mamoulian play tennis on the backyard court. The Gershwins write together. Arlen, songwriter E. Y. "Yip" Harburg, and the others lounge in the backyard. We do not know if the camera original of this sequence survives.

The color baseball sequence was filmed at Wrigley Field, Los Angeles, on November 7, 1948. Footage of fans, vendors, the stadium, and the Goodyear blimp are interspersed with shots of ballplayers and the game. The filmmaker focuses most of his attention on the spectators, in particular MGM studio head Louis B. Mayer and his companions. Mayer, talking and laughing, sits in a box with his son-in-law, producer William Goetz, MGM music producer Arthur Freed, actor Rory Calhoun, and others. Two women in dressy attire watch the game. Several African American fans can be seen in the background of some shots. On the field, the Negro Leagues' famed Kansas City Monarchs, barnstorming as the Royals, play the major league Gene Bearden–Bob Lemon All-Stars. The legendary Satchel Paige, wearing a Cleveland Indians uniform, pitches for the Royals. Paige throws a warm-up toss and a few serious pitches. Rookie phenomenon Gene Bearden pitches for the All-Stars. In one shot, the scoreboard can be seen; it is the bottom of the sixth inning, with the Royals ahead 5–0.

The Academy Film Archive selected this film (with no knowledge of its content) because Brooks is a major figure in the American film industry. During a career that spanned four decades, he wrote and directed such well-known films as *Blackboard Jungle, Cat on a Hot Tin Roof, The Professionals, In Cold Blood,* and *Looking for Mr. Goodbar,* and was an eight-time Academy Award nominee. After Brooks died, his estate donated his personal film and video collection to the Academy Film Archive and his personal papers to the academy's Margaret Herrick Library. Many of the archive's home movie holdings have come to us in a similar way, as part of a larger donation of someone's personal film collection.

Film and video materials in the Richard Brooks Collection include numerous production-related reels: screen tests, outtakes, and research footage for *In Cold Blood;* behind-the-scenes material and outtakes of *The Professionals;* and bloopers from several of Brooks's films. There are also episodes

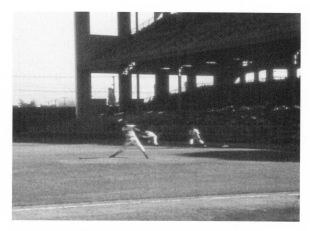

**Figure 70** Satchel Paige pitching at Wrigley Field, probably filmed by Richard Brooks, 16mm, Los Angeles, California, circa 1948. Courtesy of Academy Film Archive, Richard Brooks Collection.

of *Why We Fight* and *Screen Snapshots,* newsreel footage, footage of the *Lord Jim* premiere, commercials, and four reels of remarkable home movies, including the one under discussion here.

Amateur films are a rich source of images of people who have been marginalized in mainstream cinema. The Brooks baseball sequence adds to both the number and the scope of moving images of African Americans. The footage shows a major African American sport and cultural figure, Satchel Paige, and records an important part of African American life, Negro Leagues baseball, both of which were neglected by mainstream theatrical, documentary, and newsreel film. In addition, the baseball sequence documents an aspect of racism in the United States. Because African Americans were barred from playing in the major leagues, Negro Leagues baseball thrived from the 1920s through the 1940s. In 1947, Jackie Robinson joined the Brooklyn Dodgers, beginning the process of integrating the major leagues while marking the beginning of the end of the Negro Leagues as their fan base turned to the majors. This home movie captures a bittersweet time in the history of African Americans in baseball. A few months before the footage was shot, the final Negro Leagues World Series took place, after which the Negro National League disbanded and the Negro League teams that continued to play fell into decline. However, the major leagues were slow to integrate. In 1948, only three of the sixteen major league teams fielded African American players. Satchel Paige was one of

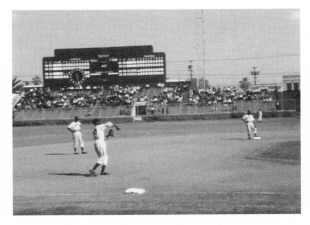

**Figure 71** Barnstorming Negro League players warming up at Wrigley Field, probably filmed by Richard Brooks, 16mm, Los Angeles, California, circa 1948. Courtesy of Academy Film Archive, Richard Brooks Collection.

these players. Paige, signed by the Cleveland Indians in the summer of 1948, helped his new team win the American League pennant. It was not until 1959 that every major league team had signed at least one African American player.

The baseball sequence also serves as an example of a home movie whose images must be examined carefully by an archivist or other viewer in order to discern their value. Running less than three minutes, the sequence is a minor part of the entire Brooks reel. The filmmaker shows more interest in the spectators and stadium than in the ballgame itself. Unless a viewer is paying close attention and has knowledge of baseball history, he or she would probably overlook the fact that one of the ballclubs is a Negro Leagues team. At face value, the noteworthy images in this sequence are those of Louis B. Mayer and the other fans who capture the attention of the filmmaker. Recognizing the Negro Leagues content requires that the viewer look beyond the cinematic interests of the filmmaker.

This footage also demonstrates how a viewer's interests and knowledge determine what he or she will find in a reel of home movies. I am attuned to looking for images of marginalized groups of people and have some background in baseball and the Negro Leagues. Another viewer might miss the Negro Leagues material, but might recognize value in images that I have overlooked. Educating archivists to look for images of underrepresented groups (and to look for film shot from the point of view of mem-

bers of these groups) is important. It is also valuable to have people with different backgrounds and areas of expertise view a home movie to enrich documentation of its content.

Finally, the Brooks reel illustrates how documentation and contextualization increase the usefulness of home movie images. The archive received the original film with no documentation. Through research, and with the help of generous colleagues, I was able to precisely date the Negro Leagues footage; identify the teams, players, stadium, and several of the spectators; and obtain a newspaper account of the game. This information situated the footage in its historical context and was the basis for detailed cataloging that increases the material's accessibility. The same holds true for the other sequences in the film.

The Brooks home movie has historical, regional, national, and international significance. It shows aspects of Negro Leagues history and the integration of major league baseball. Satchel Paige was and still is the best-known Negro Leagues ballplayer. He is a member of the National Baseball Hall of Fame and is regarded as one of the best pitchers to ever play the game. Motion picture footage of the Negro Leagues, especially color footage, is extremely rare. There is also very little known film footage of Paige, and I have not found any other footage of him pitching in a game. Louis B. Mayer and his associates are part of Hollywood history. The ballpark, Wrigley Field in South Central Los Angeles, was home to the Pacific Coast League's Los Angeles Angels from 1925 to 1957 and the Hollywood Stars from 1926 to 1935. The stadium was demolished in 1966. The other sequences on the Brooks reel are also significant, depicting the landmarks Hoover Dam and the Del Mar racetrack, the experience of going to the track in 1948, and private moments in the lives of several important figures in film and music.

Preservation of the original Brooks home movie was completed by the Academy Film Archive in 2007. The footage had previously been transferred to Digital Betacam videotape. The color of the Kodachrome stock on which the baseball sequence was shot is excellent. The Ansco color stock on which the Gershwin footage was printed is somewhat faded. Video copies of the baseball sequence were sent to the National Baseball Hall of Fame in Cooperstown, New York, and to the Negro Leagues Baseball Museum in Kansas City, Missouri.

Home movies are a treasury of culturally diverse images. Like the Negro Leagues ballplayers in the Brooks film, many of these images can be discovered only by thoughtful viewing, and require contextualization to reveal their full worth. The Academy Film Archive is committed to collecting, caring for, and providing access to these unique cultural documents.

**"As If by Magic"**

Authority, Aesthetics, and Visions of the Workplace
in Home Movies, circa 1931–1949

HEATHER NORRIS NICHOLSON

In the early and middle decades of the twentieth century, interest in industrial endeavor fueled an urge for storytelling that was not only a part of constructing national narratives about economic and technological might. From the very early days of home moviemaking in the United Kingdom, industry, along with family, holidays, and animals, was promoted as legitimate subject matter for cine enthusiasts.[1] These resultant unofficial moving histories of working people constitute an important record of past economic activities during decades of profound change. Many of the material traces of those industrial memories have now been erased from the landscape. Oral recollections about working in industries that may no longer exist are also fast disappearing unless deliberately sought out and recorded by younger generations. Global technological and economic changes, newer educational opportunities, and modern lifestyle aspirations are severing direct contact with the increasingly unfamiliar worlds of heavy and manufacturing industry. Industrial Britain, some critics might argue, might now be more familiar through televised costume dramas and brown signposts to tourist heritage attractions.[2] Against this background of societal transformation and the constant redefining of working processes in response to global market forces, it is timely to take stock of the visual stories about earlier working lives and regional social histories captured—and often forgotten—in moving imagery.

This chapter explores some of the meanings that may be found within the footage of home moviemakers who went out and about in the industrial northern counties of England in the 1930s and '40s. Attention focuses upon film footage and associated written materials deposited at the Yorkshire Film Archive in North Yorkshire. Eastman Kodak's promotion after 1923 of portable cine equipment meant that home movie enthusiasts from

middle-class backgrounds could make scenes on 16mm film stock, featuring people at work, and present them to family, friends, and wider audiences. These industrial projects provided filmic encounters with other environments and experiences that often had an exoticism and unfamiliarity not dissimilar to the contemporary quest for scenic and cultural otherness found in travelogues and ethnographic expeditions.[3] These cinematic forays into other working lives crossed social rather than physical distance and were able to occur during times of more widespread economic austerity in the 1930s and during the early years of postwar Britain.

Technical and industrial subjects gained popularity among amateur enthusiasts for varied reasons. An expanding specialist literature and the promotion of increasingly adaptable camera equipment fostered consumerism and the search for cinematic subject matter.[4] Possibly, documentary filmmakers' interests in industry, science, and technology also encouraged hobbyists to tackle similar subjects.[5] Early film enthusiasts, like their professional counterparts, were motivated by a wide range of objectives.[6] Some left-wing amateur filmmakers recognized that industrial footage could be a tool in wider class struggles given that 16mm offered an important outlet for political expression unfettered by laws of censorship.[7] Scenes of strikes and union-led rallies were more typical than the uneventful routine patterns of monotonous daily work.[8] Less polemical depictions of working-class life made about, by, and for working-class people remained rare until social access to cine equipment widened.[9]

In contrast, middle-class enthusiasts saw industrial or technical topics as a means to combine filmmaking with philanthropic or local commercial interests. Gaining permission or being invited to film on an industrial site might fulfill a local civic or social as well as a personal interest. Sometimes, hobbyists were able to justify or support—at times both—their costly pastime by producing industrial footage that might "instruct, inspire and entertain" or simply advertise local business activity.[10] Films could thus combine various objectives: as long as footage was acceptable to the enthusiastic local sponsor or amenable company, there was also scope for simple visual experimentation and for communicating different kinds of messages.

Inevitably, ideological differences are reflected in how subject matter was treated. The films discussed in this chapter yield fascinating footage of working people and settings, but what we see is filtered through the eyes of those with access to camera equipment. Their ways of seeing determine how they understand themselves and how they showed particular social groups on the screen. Thus, the industrial footage found in home movies may offer visions of everyday work experience that are underrepresented in other

forms of moving imagery even though the cinematic intervention may now also seem to be an intrusion into other people's lives.

The three films considered here portray manual workers through middle-class eyes. Observed processes are shown as straightforward, accurate representations of factory and foundry life. Virtually nothing is known about the making of the CEAG film (circa 1931) on light bulb manufacture although the film stock and vehicles seen in the film help to date the footage.[11] Indeed, as discussed later, the film's overt commercial message might exclude it from the home movie category, but, as nothing is known about its producer, even this uncertainty cannot be verified. In contrast, much contextual material exists for *Hands of the Potter* (1948)[12] and *Men of Steel* (1949),[13] which show greater technical competence and more sophistication in how industrial scenes are used. Both of the latter films form part of the prolific output of Charles Joseph Chislett (1904–90), a Yorkshire filmmaker, bank manager, and active Christian who, for over forty years, presented home movies to thousands of audiences in church halls, schools, clubs, and community centers across England. His film projects spanned travelogues; social, educational, and industrial films; and domestic subjects. His industrial imagery was produced primarily between 1947 and 1953, although he continued to edit a number of different versions of *Men of Steel* later into the 1950s.[14]

The CEAG film was made to promote a light bulb and miners' safety lamp factory in Barnsley, South Yorkshire. In contrast, *Hands of the Potter* and *Men of Steel* were made for the London-based Church Pastoral Aid Society (the filmmaker's connection with the church is discussed in more depth below). All three films record working practices that once determined the residential, social, and economic character of entire communities and regions. Their footage offers social, technical, and environmental histories as it captures some of the visual and physical realities of past living and working conditions. Although details may be either consciously or unwittingly included, these visual histories complement other sources in their illustration of continuities and changes.

All three films contain evidence of ideas on social identities, industrialization, and work experiences at a time when far-reaching changes were occurring in and beyond Britain. Their imagery discloses attitudes and meanings just as the certainties of belonging to region and community were in flux and ideas of industrial and technological progress could no longer be taken for granted. They are testimony to transitional phases in the histories of work and of leisure: the ways of knowing created by the triangular relation among spectator, subject, and filmmaker intersect with changing patterns of recreation and nonwork time, mobility, material affluence, and education.

Home movies, like other forms of historical evidence, have functions, contexts, and layers of meanings that have changed over time. A consideration of how a producer might handle industrial material, represent visual meanings, and compress time and space into a convincing filmic reality also unlocks a broader cultural discursive context. Once we consider *how* as well as *what* we see in these visions of working people, other interpretative possibilities emerge. Unlike other sources of evidence that have been underused in historical analysis, we cannot justify the study, storage, and interpretation of early British home movies as a means to simply reclaim marginalized memories and past experiences. The films may consist of moving imagery of underrepresented aspects of life, but this footage does not offer obvious counternarratives to those views found in more mainstream cinematic practice, much as we might try to ascribe meaning to the sometimes impassive faces or the silenced moving lips. On the contrary, it offers visions of working people framed by the perspectives of individuals who had economic, ideological, and social dominance. These glimpses into Britain's industrial past not only reveal midcentury attitudes toward industrial, social, and labor relations and notions of authority; they also help to illustrate both the significance and potential of home movies to wider historical analysis and their importance in film historiography.

## Working People and Processes

Industrial scenes disclose much about attitudes as well as prevailing employment conditions. For instance, the CEAG film offers a view of factory life in which labor relations seem relaxed and cooperative.[15] It portrays the CEAG Company Ltd., which produced lighting, as a source of specialized high-quality products made by a team of highly skilled efficient workers. The family-owned company was a major local employer that, for over thirty years, had an essentially female workforce of 400 to 500 staff members. Its reputation and existence were linked primarily to the mining industry that once dominated the regional economy and way of life. The owner of CEAG, seen at the start and end of the film, was respected locally both as a boss and for his civic duties. Working at CEAG meant more than just contributing to safety in the mines. Being a company employee offered households a level of economic security unattainable in the mining industry, where the threats of accidents, illness, and hazards were everpresent. Filmed during years of severe economic depression, the CEAG film's intertitle, "happy workers," resonates with various meanings.

**Figure 72** Factory owner with miner's lamp, filmmaker unknown, 35mm, Barnsley, South Yorkshire, United Kingdom, circa 1931. Courtesy of Yorkshire Film Archive (1179), courtesy M. W. Caldileugh on behalf of CEAG Centre, Barnsley, UK.

Commercial imperatives ensure that the CEAG factory is portrayed in a positive and highly selective way. Until its final frames, we only see people at work—no canteen, washrooms, or midshift break. Members of the CEAG staff scarcely allows the camera's presence to disrupt the rhythm of their work. Some employees seem oblivious to the cinematic gaze while others—generally women—exchange a friendly smile with the filmmaker. Being framed by the camera prompts amusement and some deference, as in the opening scene of the miners who briefly pose and then file past. The concluding images also suggest that the realities of going home tired after work outweigh any novelty of being captured on film. Factory workers do not share the privilege of being able to stand and stare back at the camera.

The CEAG footage shows how people occupy and move through specifically gendered and socially defined spaces. These industrial scenes are microcosms of wider power relations and spatial delineations in society. They reveal the microgeographies of everyday life both inside and beyond the factory gates. Entire working lives were spent on specialized tasks from apprenticeship to retirement in what have become increasingly unfamiliar patterns and places of employment. Unlike holidays and domestic scenes captured on film as special times for future recollection, hobbyists' industrial films often depict routine situations, processes, and experiences and thus offer important testimony to past work practice.

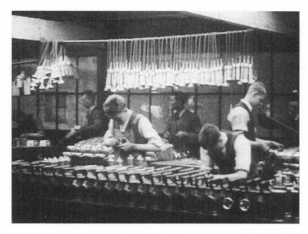

**Figure 73** Factory workers making light bulbs, filmmaker unknown, 35mm, Barnsley, South Yorkshire, United Kingdom, circa 1931. Courtesy of Yorkshire Film Archive (1179), courtesy M. W. Caldileugh on behalf of CEAG Centre, Barnsley, UK.

The unknown filmmaker of the CEAG footage captures the dress codes of a differentiated occupational hierarchy: male supervisors, laboratory analysts, and engineers in ties and jackets as well as female workers clad in aprons as they make, fit, and test lamp filaments. Women brought speed, dexterity, and painstaking precision to highly repetitive tasks that were—and interestingly, still are—unautomated. They provided a new, cheap, and flexible labor force for manufacturing during the interwar period, although attitudes and customary practice confined them to particular kinds of work.[16]

More male and female workers share similar tasks in *Hands of the Potter*, although the wedger who kneads her clay as if it were dough and the close-ups of women engaged in handpainting intricate designs onto crockery suggest that postwar opportunities continued to reflect traditional gender roles. The CEAG footage portrays an earlier transitional phase in employment history as women and men—of different ages—work together on the factory floor and share typing and other clerical tasks. The change in office work from predominantly male clerk to female secretary had yet to occur. The camerawork offers other clues about the relationship between CEAG's filmmaker and the subject matter. Unlike the owner who *faces* the camera, most of the employees are filmed from behind or sideways and often from above. The gaze is over their shoulders: as viewers, our own encounter resembles an inspection tour and what the filmmaker perhaps as an

outsider to the process was shown. An employee's perspective literally has no place in advertising material.

Chislett offers very detailed coverage of working situations. His imagery also discloses his detachment, even if he films sometimes at very close quarters. Repeatedly, he focuses attention on the process rather than the individual. The synchronized actions of people and machines recur through *Hands of the Potter* as levers, gadgets, and hands convert clay into cups and plates. Manual tasks assume the tempo and rhythm of automation as shown in a plate-breaking sequence and again, elsewhere, when footage portrays the impassive faces of men as they form a human conveyor belt to unload a kiln. In *Men of Steel,* Chislett captures the awesome majesty of heat and fire. The foundry workers are little more than shadowy figures or silhouettes against the blazing furnaces and streams of molten metal. Tilting crucibles and giant pincers seem to transform white-hot substance into recognizable forms independent of any human intervention. Occasionally, we may look over a crane driver's shoulder or follow an employer's gaze over the crisscross of high rails, girders, and gantries. Such details reinforce the massive scale and illustrate Chislett's wish to "capture something of the drama and grim beauty of a great iron and steel works" but, as in the CEAG footage, reveal nothing from the employee's perspective.[17]

Little detailed attention is directed toward individual workers in any of these films. Close-ups frame employees differently. The CEAG footage uses smiling faces to denote good staff relations as it strives to impress clients and agents elsewhere. Chislett's decisions to include occasional close-ups in his films are more complex: the elderly men in the pottery and the inclusion of his children in the journey to the pottery are, by his own admission, for "human interest." Chislett's use of people, animals, and humorous intertitles reveals his care over narrative form and his viewers' needs. No distraction is allowed, even at the risk of showing incomplete faces. Chislett's sense of purpose and visual awareness result in cinematic effects being as important as unobtrusive filming. His social distance from the physical process of production results in sequences that verge on abstract form.

These films visually endorse the transformative power of manufacturing. Prevailing conventions of factual recording cannot mask a lively responsiveness to the metamorphosis of inert substances into products. The footage is often playful and creative in its response to the power, rhythms, and forms of industry. The CEAG film is much less sophisticated than Chislett's work, but nonetheless its obvious enjoyment of capturing the magical process of creating something that lights up in the dark parallels the later filmmaker's fascination with malleable clay on the potter's wheel and

white-hot molten metal in the foundry. Here are hints of an aesthetic response that constructs industry as a kind of alchemy where products, in Chislett's words, are made "as if by magic."

In the CEAG film, the sudden contrasts produced by light bulb testing combined quality assurance with visual interest. They illuminate the company's commercial philosophy, "Spreading light around the world!"[18] The magical effect was good for advertising, but it also endorsed a belief in manufacturing as social progress. Mass production meant efficiency, precision, and opportunity. Notwithstanding the economic difficulties of the early 1930s, the cinematic gaze over CEAG's employees exudes confidence. Eighteen years later, optimism is more cautious. Chislett's wartime experiences, in Malaysia and as one of the first photographers to document the Bergen-Belsen Concentration Camp, made him unequivocal about the potential destructive power of industry.[19] Chislett's camerawork acknowledges the dehumanizing effects of industry repeatedly in *Men of Steel,* and his beliefs are explicit in his concluding intertitles and imagery: foundry workers' houses dwarfed by the parish church that, for Chislett, represents the ultimate source of power.

## Authority and Image-Making

Cinematic space encodes wider socio-spatial relations and these scenes of skilled manual work, as seen by outsiders, illustrate the politicized nature of framing others. An image-maker's control of who and what is shown also shapes how viewers subsequently understand the scenes captured on camera. The capacity to show may also readily convert into a presumed right to know. As the filmmaker assumes the voice and vision of authority, employees' experience and expertise are displaced. When we examine these views of working people, what we learn most about them is not the people in question but the social group that depicted them. These representations of industrial life thus reveal facets of class relations during years of significant social change.

The CEAG footage equates quality of product with a contented work force. Nothing alludes to the wider social or labor unrest that was rife in the early 1930s.[20] Stable labor relationships were a product of secure economic prospects as well as local respect and reputation. Where an employer's business acumen sustained local livelihoods as well as company viability, the visit by a filmmaker was another expression of the owner's managerial style. Being on film was accepted by the employees with seeming good humor as were the annual outings to Blackpool, the works parties, and regular exhortations to

purposeful recreation in the company newsletters.[21] The CEAG footage gives visual expression to the legacy of benevolent paternalism that once characterized many family-owned enterprises in the industrial north. Self-assurance and shrewd selling technique combine as CEAG's owner, seen first with a lamp and then with what might be an order or checkbook, provide the framing device for this film.

Chislett's material resembles the CEAG footage in being essentially managerial in outlook. His voice and vision frame our understanding. Chislett's knowledgeable perspective is evidenced by his detailed scenes and intertitles. His sense of authority derives from status, respectability, and responsibility associated with his social position and also his extensive background research prior to making any film. He would plan meticulously and revise his proposed intertitles, often in consultation with onsite contacts at the supervisory level.[22] Chislett also believed in his own ability to bring an unfamiliar topic to an audience. Although he was an onlooker, he privileged his knowledge over that of the people he shows at work. As his intertitles and images occupy the same cinematic time and space, viewers can imagine themselves *onsite* listening to him as their guide.

In *Hands of the Potter,* Chislett shows workers talking, but, as viewers, we are dependent upon his intertitles. The visual effect of Chislett's silenced talkers possibly seems stranger now than for audiences more accustomed to silent motion pictures. Probably, voices would have been inaudible over sounds of machinery in much of the foundry and pottery footage. It also seems quite likely that unfamiliarity with cine equipment might prompt people to talk to the camera, which then seems to make their moving lips more noticeable than when they are speaking in front of a still camera. So it might appear that the exclusion of voice is largely a consequence of location and the technology in use. Contextual understanding must acknowledge practical constraints, but might there be ideological implications too? Chislett's silent speakers also include his host, the parish priest, on the top of the church tower, so the lost words are not simply an expression of power relations between filmmaker and subject. Could the absence of local people's voices disclose middle-class attitudes toward the ownership of knowledge and indeed the nature of knowledge itself? Cine equipment, like earlier camera technology, encoded authoritative ways of seeing but also reinforced a belief in observable truth as a route to understanding even as filmmakers became more competent in image manipulation.

Chislett's planning notes include both rough jottings and carefully reworked typewritten sheets. His itineraries, contact lists, outline film sequences, and draft scripts reveal that *Hands of the Potter* was filmed over

several visits and in two different potteries. He subsumes distinct settings and entire workforces into one filmic reality for narrative purposes: entire working lives become symbolic hands and faces. His titles embody all the heroism and other qualities of generations of craft and foundry workers into an archetype—"The Potter"—or in an undifferentiated mass, as in *Men of Steel*. Chislett's film focuses upon the general situation rather than the individuality of workers' lives. Interestingly, correspondence related to this film reveals how his own suggestions for a more personalized narrative were changed by the fundraising body that supported the project.[23]

Silent home movies privilege eye over ear as an aide-memoire and a means to knowing the world. Although Chislett's projects span over forty years during which amateur sound film and television gained widespread use, he continued to use silent film stock. However, he also left extensive records of the scripted live commentaries that accompanied his film presentations. Nowhere is there any hint of a perspective other than his own.[24] People are included as narrative devices for Chislett, but not because viewers might learn something directly from them. Both his scripts and his intertitles also emphasize image rather than sound. Even when the blast furnace is likened to a bonfire on November 5 (Guy Fawkes Day), the text evokes a word picture rather than a cacophony of sound.[25]

Although the commentaries represent a nonvisual form of Chislett's authority, the effect of the *side voice* from the platform should not be forgotten: lecture presentations were part of evolving film practice, and their spoken commentaries helped to link spectator to cinematic time and space. Chislett's voiceover was both a legacy of a pre-talkie era and also very recognizable as one of numerous vocal strategies that filmmakers tried out as they adapted old ways to new technologies in the '30s and '40s. His belief in the importance of live over recorded sound perhaps also reflects a prewar controversy among some of the professional documentary filmmakers and the belief that "sound was just a flash in the pan [that] was interfering with the real art of filmmaking which was cutting and silence."[26]

Chislett's talking commentaries offered a regional perspective at a time when television was edited by outsiders. Scenes of familiar places and people validated aspects of local life in the modern democracy of postwar Britain, and their regional tone—distinctive from the voice of the BBC—perhaps helps to explain their enduring popularity among hundreds of northern audiences at a time when televisions were becoming more commonplace. During the uncertain years of postwar reconstruction, Chislett's home movies seemed to maintain an earlier middle-class sense of social responsibility: like the cinematic gaze of the prewar documentary movement,

his films reveal an unquestioning belief in the ability to portray regional experience with dignity and thus enable local people to see themselves onscreen.

Chislett's filmmaking also encodes the Christian beliefs that guided many aspects of his life. Text and image testify to his faith and social conscience and his belief that the visual representation of other people's lives offer insights into their inner spiritual state. Such moral certainties are, of course, not limited to time and place and remain influential among those with evangelizing or missionary commitments. Chislett made many of his films on behalf of the London-based Church Pastoral Aid Society. A personally close yet professional relationship developed as the society came to commission, advise on, and finance many projects. His films were used in various ways: to show at fundraising events, to inform people about specific pastoral projects, including summer camps for disadvantaged children from urban slums, and as a part of social outreach work in different parishes.[27] Specific films, including *Hands of the Potter* and *Men of Steel,* were made to assist in religious training and ministry within particular communities and to illustrate how Chislett's moral authority might be expressed in different ways.

The symbolic role of the church at the heart of the community combines, at least in *Hands of the Potter,* with offering an elevated vantage point for filming. From correspondence, we learn of how Chislett hopes that the parish priest's inclusion in the film will give him "a cinematic presence" and thus help him to seem less unfamiliar when the film is shown locally. Both priest and church are guiding landmarks for Chislett in the featureless and monotonous sprawl of industrial housing. The church building on higher land is literally a point to look up to above the steel plant and workers' homes, as in the final sequence of *Men of Steel,* while the views available to both priest and filmmaker from the tower in *Hands of the Potter* seem to imply the all-seeing nature of spiritual perspectives. From this height, it seems as if Chislett's gaze over rooftops and streets is to render the preoccupations of everyday living insignificant within a wider vision.

The religious message seems rather clumsily stitched onto the end of *Men of Steel.* Up until this point, the camerawork gives little indication that Chislett's interests extend beyond visual effects. The italicized final intertitles are a signal that perhaps this inferno-like world of fire and darkness also has symbolic significance as a site of human alienation. The artistic representation of industrial subjects captured midcentury middle-class imaginations and social consciences just as it had in earlier times. Apocalyptic visions of industrial society found frequent cinematic expression in the twentieth century as confidence in technology gave way to doubt. Home moviemakers

were no more shielded from such concerns about modernity than others who expressed their responses about the times in which they lived.

Contextual evidence suggests that *Men of Steel* is not merely an exploration of industrial aesthetics and that this high-contrast visual drama between light and shade has more metaphorical meanings in postwar Britain. Chislett's preparatory notes support such an interpretation: he writes of his wish "to underline the effect of a man's daily work . . . upon his outlook towards outside problems." This allusion to the film conveying a religious message is strengthened further by Chislett describing *Men of Steel* as a social problem film. Chislett's intentions for *Men of Steel* as a piece with a spiritual significance are also supported by his exploration of light and dark in allegorical terms in other films. For instance, *The Power House* (1948) compares the energy and light supplied to vast areas by a modern generating station and the "Power" of a different kind spread by newly ordained priests after leaving theological college.[28] It is tempting to link the inspiration for both films to the opening of a much-lauded new municipal electricity power station in the steel town where Chislett lived, but it cannot be proven. What is clear, however, is that Chislett's visions of work can be approached in different ways.

## Concluding Remarks and Implications

Home moviemaking offers a valuable means to tap into and explore how people gave meaning to everyday aspects of their lives. While it is important to acknowledge that these films may illuminate aspects of people's private worlds and unofficial versions of past times, clearly these visions are both socially selective and not as unconnected to mainstream practice as their description as amateur work might suggest. Indeed, the films considered in this discussion demonstrate that there may be as much variety within home moviemaking as between the hobbyists and their more professional counterparts.

A recurring theme in the emerging literature on home moviemaking is the problematic distinction between amateur and professional filmmaker. Indeed, the term "amateur" tended to polarize the hobbyist from the professional at a time when filmmaking was still in its relative infancy. Yet by their own admission, pioneer members of Britain's documentary movement considered their own work quite amateurish during the 1920s and 1930s.[29] At least retrospectively, these times of innovation were recognized as a period of learning by trial and error. Considerations of technology, consumerism, finance,

and aesthetics affected all practitioners in varying ways. Despite the sometimes disparaging contemporary use of the term *amateur*, it is evident that many early experiments in documentary filmmaking—as well as in fiction film—were often naive and basic in concept, storyline, and camera technique.

Similarly, it is evident that some home movie enthusiasts were very professional. Indeed, the promotion of the home cine industry depended upon its very ability to persuade hobbyists that they too could become professionals provided they bought the appropriate equipment. Chislett's material and, for that matter, the CEAG footage should not be seen in total isolation from developments within the professional film industry. Chislett's work illustrates how the nonprofessional might tackle moviemaking with rigor, organization, and social awareness: his own notes reveal an awareness of the contradictions set up by Grierson's "creative treatment of actuality."

Chislett rehearsed, revised, refilmed, and recut his material with painstaking attention to detail, visual interest, and narrative structure. His use of devices to focus, sustain, and shift audience attention reveal considerable awareness of cinematic practice. He was familiar with both current terminology and procedures, as shown by his correspondence on how his films were to be financed, publicized, and shown. He recognized the commercial and propagandist potential of moviemaking at home and abroad, and his work encodes a sense of social engagement not dissimilar to the values of the filmmaking intelligentsia that came to dominate the early British documentary movement. In short, Chislett shared many of the same values and, thanks to a career in banking, was able, in many ways, to be a professional in all but name.

What blurs some of the difference between amateur and professional in Chislett's case is a combination of social outlook and competence. Although Chislett never achieved the quality or reputation of the prewar documentary makers, there are unmistakable similarities in his choice of topics, titles, and relationship with subject matter during the 1940s. Thus these home movies may be seen as a part of film's wider ideological role in shaping and reproducing social meanings. Middle-class male hobbyists, like many of their male professional counterparts, encoded the beliefs and values of conservative liberalism and the preservation of an existing social order. Their gaze upon working-class lives remains an expression of social dominance, traditional power relations, and exclusivity even as transformative processes were leading to major changes within British society after World War II.

Home movies become a means to reclaim visions and voices underrepresented and marginalized in other historical sources only as access to cine equipment permits broader social participation in filmmaking. In London and many of Britain's large industrial cities, various early initiatives strove

to involve working-class people in both the watching and making of films. Trade unions and workers' film societies became increasingly active through the 1920s and 1930s, particularly as cine equipment became comparatively cheaper and easier to handle. However, opportunities for working-class people to make films about their personal lives and interests remained infrequent until well into the 1960s. Postwar affluence may have brought new patterns of leisure, but changing expectations, education, and disposable income only gradually brought about wider access to home moviemaking.

Alongside class barriers, other determinants of unequal power relations have also circumscribed access to cine cameras. Within Britain, during the formative years of cine photography's development into a popular pastime, it seems likely that amateur filmmakers were typically male, white, and middle class, yet rare exceptions are bound to exist.[30] Home moviemaking provides striking testimony of social relations in a variety of direct and indirect ways but, as shown by other chapters in this collection, only sometimes does it reinstate experiences neglected or omitted from other historical sources. Those rarities are all the more significant for being so unique.

Industrial footage that documents changes in the workplace during the early years of immigration as part of Britain's postwar reconstruction would shed fascinating and significant light upon still-neglected aspects of recent ethnic settlement, adaptation, and community formation. Did the filmic forays across social space cease as demographic change transformed manual work in areas of heavy industry? Were the jobs that white workers no longer wanted to do also shunned and was it perhaps less easy for nonprofessional filmmakers to gain access to film in the 1950s and early 1960s? Is the apparent absence of such material indicative of industrial confidence ebbing in the face of wider economic restructuring?

If such moving imagery does not exist, its absence is telling evidence about the character of home moviemaking in an era of wider geographical travel and changing notions of social responsibility in postwar Britain. Alternatively, perhaps such footage of working people may exist, but its wider recognition will only come about through greater contact among archivists, researchers, and ethnic groups. Changes in geographical and social mobility mean that international links are also significant in the retrieval and reinstatement of these underrepresented aspects of industrial, technological, and sociocultural change.

The politics of gender, class, culture, race, and locality determine who did the framing and how people framed others in cinematic space during the last century. Although this discussion has focused upon nonprofessionals, changing access to professional filmmaking was determined by similar

variables. Perhaps the possibilities for reclaiming aspects of underrepresented social groups now come as much from professional as from nonprofessional sources. Today's professional filmmakers have the potential to let others speak from their own experience about where and how they work, live, and socialize. Meanwhile, it is the modern-day equivalent of the camera-touting hobbyist that can now travel through geographical as well as social space and frame other working lives in their search for difference. Undoubtedly, moving imagery by nonprofessionals has produced and continues to produce evidence of both remarkable and unremarkable lives. Mining this rich seam of visual memory is timely as we move into another century of moving imagery. It is certainly a source of historical narratives, but the stories being told are both on and off the screen.

## Notes

1. Charles Chislett Collection, Yorkshire Film Archive. Film notes, File 99. The archive now occupies purpose-built facilities at York St. John University in York. Cataloging activities, including online access, have evolved greatly since the attic-and-cellar phase when this research was undertaken.

2. See Raphael Samuel, *Theatres of Memory* (London: Verso, 1994), 242–56, for a discussion of the heritage debate that took place between two of the key British commentators during the 1980s and early 1990s, namely Robert Hewison, *The Heritage Industry: Britain in a Climate of Decline* (London: Methuen, 1987); and Patrick Wright, *On Living in an Old Country* (London: Verso, 1985).

3. Heather Norris Nicholson, "Telling Travellers' Tales: The World through Home Movies, 1935–1967," in *Engaging Film: Travel, Mobility and Identity*, T. Cresswell and D. Dixon, eds. (Lanham, MA: Rowman and Littlefield, 2002), 47–68.

4. Amateur Cinema League (ACL), *The Amateur Cinema League Movie Book: A Guide to Making Better Movies* (New York: ACL, 1940); Alex Strasser, *Amateur Films: Planning, Directing, Cutting,* trans. from German by P. C. Smethurst (London: Link House Publications, n.d.); Patricia R. Zimmermann, *Reel Families: A Social History of Amateur Film* (Bloomington and Indianapolis: Indiana University Press, 1995).

5. Rachel Low, *Films of Comment and Persuasion of the 1930s* (London: George Allen and Unwin, 1979); Paul Swann, *The British Documentary Film Movement, 1926–1946* (Cambridge: Cambridge University Press, 1989).

6. A. P. Hollis, "Movies at Home," *Amateur Movie Makers* 2, no. 4 (April 1926): 24, cited in Zimmermann, *Reel Families.*

7. Strasser, *Amateur Films,* 34; Brian Winston, *Claiming the Reel: The Griersonian Documentary and Its Legitimations* (London: British Film Institute, 1995).

8. Bert Hogenkamp, *Deadly Parallels: Film and the Left, 1929–1939* (London: Lawrence and Wishart, 1986).

9. Maryann Gomes, former director of the North West Film Archive, Manchester

Metropolitan University, Manchester, England, drew my attention to a remarkable collection of films made by Ralph Brookes, a former dock laborer who filmed people and events in the terraced neighborhood of Ordsall, Salford, where he lived and ran a newspaper shop until he was moved as a part of slum clearance and urban renewal in the early 1970s. See Heather Norris Nicholson, "Seeing How It Was?: Childhood, Memory and Identity in Home Movies," *Area* 33, no. 2 (2001): 128–40.

10. Publicity leaflet, Charles Chislett Collection, Yorkshire Film Archive, File 99; see also Heather Norris Nicholson, "In Amateur Hands: Framing Time and Space in Home Movies," *History Workshop Journal* 43 (1997): 198–212.

11. Yorkshire Film Archive. CEAG film (ca. 1931; black and white, 5 min.).

12. Charles Chislett Collection, Yorkshire Film Archive, film no. 344 (1948; 650 feet, black and white).

13. Charles Chislett Collection, Yorkshire Film Archive, film no. 345 (1949; 2,000 feet, color, 16mm). *Men of Steel* was edited with additional footage on a number of occasions and used extensively as a company training film between circa 1951 and 1966. By the time Park Gate Iron and Steel Works withdrew it from use, it had been seen by over fifteen thousand people in schools, colleges, and universities and also had been used by the British Iron and Steel Federation.

14. See Norris Nicholson, "In Amateur Hands," 198.

15. The author's visit to the CEAG factory in Barnsley, South Yorkshire, in connection with this research in October 1998 prompted considerable interest, collection of archive material, and plans for showing the film locally to tap into memories of former employees.

16. Jane Lewis, *Women in England, 1870–1950: Sexual Divisions and Social Change* (London: Wheatsheaf Books, 1984).

17. Charles Chislett Collection, Yorkshire Film Archive. File 99 (1948).

18. Early advertising material (undated), general office, CEAG factory, Barnsley, South Yorkshire.

19. Biographical details based upon transcript of interview with archive staff in 1990 with Rachel Williams, at the time when her father's film collection was entrusted to the Yorkshire Film Archive. Transcript available from the Yorkshire Film Archive, York St. John University, York, North Yorkshire.

20. Stephen Constantine, *Social Conditions in Britain, 1918–1939* (London: Methuen, 1983).

21. Company newsletters made available during the author's visit to CEAG in October 1998.

22. Charles Chislett Collection, Yorkshire Film Archive. Film File 99.

23. Ibid.

24. Chislett's narrative voice had its professional equivalent long after sound was introduced. See, for instance, Charles Wolfe, "Historicising the 'Voice of God': The Place of Vocal Narration in Classical Documentary," *Film History* 9 (1997): 149–67.

25. Chislett's work often sustains audience attention by using references to popular experience. Bonfire Night or Guy Fawkes Day is generally linked to the so-called Gunpowder Plot, when Guy Fawkes and collaborators were arrested and accused of

attempting to blow up the Houses of Parliament during King James I's state opening of Parliament in 1605.

26. Elizabeth Sussex, *The Rise and Fall of British Documentary* (Berkeley: University of California Press, 1975).

27. Norris Nicholson, "Seeing How It Was?," 2001; Heather Norris Nicholson, "Moving Memories: Image and Identity in Home Movies," in *The Jubilee Book: Essays on Amateur Film*, ed. N. Kapstein (Charleroi: Association Européene Inédits [Inédits], 1997), 35–44.

28. Charles Chislett Collection, Yorkshire Film Archive, film nos. 312 and 314 (1948; 250 feet and 380 feet in black and white and color, 16mm). This two-part film may also be linked to another religious film project also produced by Chislett in 1948, *Speeding the Gospel through the Century, Parts One and Two*. This material questions the relationships among technology, social well-being, and faith through extensive footage of industry, housing, transportation scenes, and traditional rural life (Charles Chislett Collection, Yorkshire Film Archive, nos. 350 and 351).

29. Sussex, *The Rise and Fall of British Documentary.*

30. For instance, an extensive collection of travel films made during the 1950s by a woman filmmaker from the northeast coast port of Hull, East Yorkshire, was given to the Yorkshire Film Archive in 1998. (Personal communication with Sue Howard, director of Yorkshire Film Archive, November 1998.)

## 22 The New Zealand Film Archive/ Nga Kaitiaki o Nga Taonga Whitiahua

*Auckland, New Zealand*

VIRGINIA CALLANAN

The New Zealand Film Archive "collects, protects and projects" the country's moving image history, giving equal emphasis to the processes of acquisition, preservation, and access. It has a broad-based collection, ranging from commercials and training films to features and television drama, from documentaries and newsreels to music videos and home movies. Our earliest New Zealand film (showing soldiers departing for the Boer War) is from 1900. In addition, the archive holds a large collection of associated support material—books, photographs, posters, periodicals, and ephemera—that document the story of film in New Zealand.

Of our fifty thousand film and video titles, there is a much higher proportion of nonfiction and amateur films than feature-length dramatic narratives. Home movies, vividly recorded by ordinary New Zealanders, and the amateur output of cine club enthusiasts are now well represented, after an active countrywide film search conducted over a number of years.

In 1989, we received a deposit of ten cans of untitled 16mm black and white and color silent prints from the Auckland Museum. Their combined running time was ninety minutes. They were shot by two Aucklanders—Lou Robertson, a trade union official, and Rude Sunde, a young left-wing activist—over the period 1949 to 1952. They are a record of trade union marches, meetings, protests, and celebrations.

We had no hesitation in accepting this deposit into the archive. The period it covers was a volatile one in our country's labor history. Footage of this period had been requested by news producers and documentary filmmakers for years, and we had had nothing to show them.

The year 1951 is remembered politically for one overwhelming event—the nationwide waterfront lockout and other supporting strikes, which remained unresolved for five months. Over twenty thousand workers either

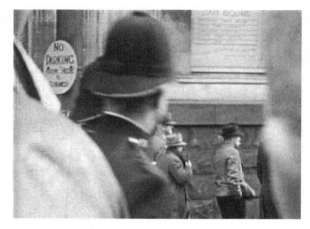

**Figure 74** "Scab" laborers protected by the police, filmed by Rudy Sunde (whose presence was hidden by fellow unionists), 16mm, Auckland, New Zealand, April 28, 1951. Courtesy of New Zealand Council of Trade Unions and the New Zealand Film Archive.

were locked out of their jobs on the wharf or, like the coal miners and railway men, were on strike in support of the waterside workers (dockworkers). A hundred thousand people, from a population of little more than one and a half million, were directly impacted by repressive legislation and police harassment under the government's Emergency Regulations. The struggle lasted 151 days and left a bitterness that lasted for decades.

As primary historical source material, this collection of films is very valuable. It provides coverage, albeit silent, of marginalized groups, strike actions, anticonscription marches, and protests prior to 1951 that no official agency would cover. During the events of 1951, emergency legislation prohibited any media coverage of activity supporting the strike. Official film agencies and private concerns managed to avoid any reference to dockworkers and the lockout for the duration of the struggle, apart from the occasional praise for the Armed Forces members pressed into service portside and comments about the importance of getting New Zealand's primary produce exports to Northern Hemisphere destinations. In the face of such official silence, the illegal footage taken during the period is, in effect, the only moving image record of the lockout. The only other possible source would be police surveillance footage, which has been sought to no avail.

The amateur films of Robertson and Sunde express their personal political motivations. They recorded, as participant observers, a succession of

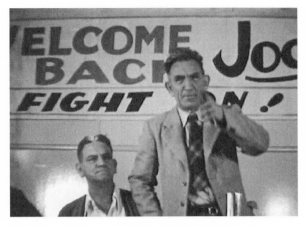

**Figure 75** Unionist Alec Drennan welcoming back jailed union leader Jock Barnes at the Auckland Trades Hall, filmed by L. D. Robertson, 16mm, Auckland, New Zealand, November 10, 1951. Courtesy of New Zealand Council of Trade Unions and the New Zealand Film Archive.

marches, rallies, and meetings that were the public face of the workers' struggle in those Cold War years.

There are interior shots capturing the mood of meetings at the Trades Hall in Auckland and close-ups of Jock Barnes, the Trade Union Congress leader. There are details of passing placards and banners highlighting the many causes within a cause, such as women's pay equity, the high cost of living, the need for increase in old-age pensions, and antiwar statements. There are wide shots of huge crowds at outdoor rallies, plus more identifiable shots of individual men and women. Even the children of workers are filmed playing on the swings while their parents attend to the serious business of their future welfare.

The illegal 1951 footage in particular suffers somewhat from subterfuge—some blurred sections were caused by the filmmakers' need to evade the constabulary, and there are shots obviously taken over the shoulders of a protecting crowd. These jerky, urgent sequences evoke the mounting tension on the street and ultimate confrontations.

The Robertson and Sunde footage had been shown to gatherings after 1951, but by the late 1980s no one knew of its whereabouts. Dean Parker, an independent journalist and playwright, tried to track it down when he was planning a fortieth-anniversary documentary of the 1951 events. Lou Robertson was now dead, and the matter was pursued with his family. A letter to

Parker from Japan, from a Robertson family member, said there had been loads of cans of film "in a shed somewhere" around the family house. The film, Parker was told, was largely family home movies and footage shot at the Auckland Zoo. To quote Parker:

> At this point I gave up on the case but suddenly, out of the blue, in 1987–88 some bloke moved into a house—in Point Chevalier, I think—and found under the house some cans of film. The house was the Robertson family house. The new owner handed the film cans to the Auckland Museum. The museum looked at the contents and rang Bill Andersen at the Auckland District Council of the Federation of Labour. Bill, unionist Johnny Mitchell, and labor historian Bert Roth then identified the sequences . . . the film was subsequently deposited with the Film Archive and was used in the documentary *Shattered Dreams* [1990].

The original ten rolls from the Auckland Museum were transferred to one-inch tape in 1989. Screening tapes were also produced. In the late 1980s, our preservation budget was focused on early New Zealand nitrate film. By the mid-1990s, 16mm safety stock became a preservation priority; this collection, with incipient vinegar syndrome, had duplicate negatives and new prints struck.

The year 2001 marked the fiftieth anniversary of the waterfront dispute. A prime-time television documentary, *1951*, was able to supplement historical reenactments, talking heads, and library stills with excerpts from the restored films. The New Zealand Film Archive also curated a commemorative exhibition, "1951 Lockout, Strikes, Confrontation," which relied extensively on these important amateur artifacts. Both of these projects demonstrate that the archival process involves not only acquisition of material chronicling histories from below, but also their recirculation in various cultural contexts and practices.

# 23 **Working People, Topical Films, and Home Movies**

The Case of the North West Film Archive

*Manchester, England*

MARYANN GOMES

## The Origins of the North West Film Archive

The North West Film Archive (NWFA) is a public film collection housed at the Manchester Metropolitan University in Manchester, England. Over the years, the NWFA has garnered professional recognition as the home of the North West's filmed heritage. Currently, it contains Britain's largest regional film source.

The archive originated from a research project designed to salvage films about local people's lives before they were lost forever through chemical deterioration, neglect, or destruction. This search and rescue initiative was part of a research effort by a team of historians united by their interest in recovering the story of the region's working people during the nineteenth and twentieth centuries. Discovering that this history could not be constructed from the traditional records held in official repositories, the team refocused their efforts to identify and collect alternative forms of primary historical evidence. This work generated significant and extensive collections of taped interviews conducted with elders as firsthand oral history recordings and photographs were systematically copied from local family albums. Specific research topics included the Jewish community in Manchester, the textile workers of Lancashire's mill towns, volunteers joining the International Brigade during the Spanish Civil War, and the role of women in working families' economies. These painstakingly accumulated collections were deposited in public archives to redress the imbalance within the extant official record with the personal experiences of contributors to the research project.

Because cinema-going represented the most popular working-class leisure pursuit during the first half of this century, an investigation into the role of the region's cinemas was launched. This project traced relevant

original material. The quantity of regional films recovered and their special preservation needs encouraged the development of a more ambitious proposal: the creation of a dedicated custodial operation to ensure that these moving images remained in the region. The North West Film Archive was established to provide public access to this filmic heritage for current and future generations of North West people. This mission continues to inform our work. The publicly funded National Film Archive based in London typically accepted only about 5 percent of the titles rescued by the Manchester-based team. The national archive only selected examples of North West life that informed British national history. Without the efforts of the NWFA to reclaim this visual record, less than one-tenth of the current collection would survive today. Committed to the understanding that the nation's history is vitally composed of the experiences of people from many distinct regions within Great Britain, the NWFA has actively encouraged other regions to adopt similar systematic search programs.

## The Collection of the North West Film Archive

The NWFA locates, acquires, preserves, catalogues, stores, and makes accessible moving images produced by and representing the inhabitants of the North West of England. This region was the home of Britain's industrial revolution during the nineteenth century. Its geographical territory, which spans Greater Manchester, Lancashire, Cheshire, and Merseyside counties, includes the major cities of Manchester and Liverpool. The film collection evidences the area's strong industrial and urban characteristics.

Both amateur and the professional films have been acquired. The collection extends from the late nineteenth century to the present. It consists exclusively of nonfiction material: newsreels, documentaries, advertising and promotional material, educational and travel films, home movies, amateur productions by groups/organizations, corporate videos, and regional television programs. Feature films are redirected to the national archive while films relating to other parts of Britain are forwarded to the appropriate local archive.

The accessioned film collection currently totals 3,541 titles, excluding the deposits of almost 14,000 cans of television material. Seven hundred additional reels of film will be added to the holdings. In 1995, major new funding doubled the attainment levels for film inspection, assessment, acquisition, cataloguing, and digitizing records. This infusion of funds enabled more accurate identification of the strengths and weaknesses of the collection by

subject, period, place, and producer. Work and local industry, leisure, sport, entertainment, community activities, civic events, healthcare, transport, holiday-making, housing, middle-class family life, and wartime experiences are strongly represented. In contrast, political and organized labor activities, domestic routines, working-class family life, the contribution of ethnic minority communities (especially from the late 1940s and the 1950s, when heavy waves of immigration from Commonwealth countries occurred), and all socially excluded groups are underrepresented.

This statistical evidence and database informs a proactive acquisition strategy. As a result, we have attracted more diverse footage reflecting the postwar cultural diversity of the region's society, documenting the experiences of disabled people, and illustrating the viewpoint of young people.

Amateur films comprise approximately two-thirds of the titles in the accessioned collection; the remaining third of the collection consists of professional productions. All film from the mid-1890s to the mid-1920s is professionally filmed on 35mm, with a large amount of nitrate-based stock. In Britain, amateur filming was introduced in the early 1920s. Pathé's 9.5mm gauge became commercially available in 1922. Eastman Kodak's 16mm gauge appeared the following year, in 1923. Eastman Kodak's standard 8mm gauge was launched in 1932 and its Super 8mm version in 1965.

## The Representation of Working-Class People in Local Topicals and Home Movies

An analysis of the representation of working people in the NWFA films requires careful examination of films produced by both professional and amateur filmmakers. It is somewhat ironic, on the one hand, that the local topicals that relate to local working people actually fall within a mainstream cinema tradition. On the other hand, the vast majority of home movie collections celebrate the lives and concerns of the middle and upper classes. While not oversimplifying this apparent contradiction, financial resources and class constitute major determining factors. Independent cinemas needed to attract audiences. Confronting escalating competition during the 1910s and 1920s, filming local events served as a marketing ploy to entice paying customers.

The tactics were simple but effective. Arrange for a cameraman to record a local event. Ensure that the camera recorded as many participants and spectators as possible, even if it detoured from recording the event of the day. Advertise the film by announcing, "Come and See Yourself on the Screen."

Wait for ticket sales to soar. However, this barebones description of the process falls short of justifying the historical significance of local topical films.

While amateur film technology was available from the early 1920s, the costs of the equipment and processing exceeded a working person's budget. As a result, the earliest authenticated home movie shot by a member of the working class in the NWFA collection dates from the early 1950s. During the 1920s, 1930s, and 1940s, home moviemaking appears to have been the exclusive preserve of professional people and inheritors of titles and wealth.

## Local Topicals

The NWFA's mission is to preserve all the region's moving images. However, the archive has a strong interest in finding footage that illuminates the lives of working people. Consequently, local topicals attracted particular attention. Because many were shot on decaying 35mm nitrate film stock between 1896 and 1951, the search for local topicals accrued great urgency. Because of its inflammability, Great Britain banned nitrate film stock in 1951. Although local topicals represent a subset of the newsreel genre, they differed dramatically from the national newsreels produced by Pathé, Gaumont, Universal News, and Movietone. These major newsreel companies recorded the key events and high-profile figures of Britain's political, social, and economic life during the first half of this century. Local topicals, conversely, reflect early cinema's origins in fairgrounds and music halls heavily patronized by working people. As popular mass entertainment, cinemagoing was a working-class leisure time activity. The middle class did not participate in cinema in Great Britain until the advent of sound systems in the late 1920s. The era of art deco picture palaces in the 1930s heralded the gentrification of cinema.

Local topicals were filmed primarily during the silent period of cinema until 1929, although production continued until the onslaught of World War II. These films were always "exclusives." Only one print was struck. The film screened over several nights to maximize its earning potential. Normally, local topicals were programmed between the official newsreel and a feature film. While the film would be instigated by the owner or manager of the cinema, it is difficult to ascertain who actually shot the film. Occasionally, cameramen who worked for the national newsreel companies would be employed, most likely in an unofficial freelance capacity, or theaters would commission local film production companies. Owners or managers also hired cameras and filmed events themselves. Sometimes they

delegated this responsibility to their most technically competent staff, usually the projectionist.

The NWFA collection includes 132 local topical films, representing about 11 percent of our professionally produced material. Our collection includes topicals produced from the 1910s through the 1930s, representing ninety-three different exhibition venues. Cinemas adopted glorious names such as the Art Picture Hall (Bury) and the Peoples Hall (Denton). Local topicals covered a range of subject matter; carnivals, festivals, and processions dominated, but military and war-related images, newsworthy sporting events, civic occasions, whit walk (an annual religious procession), and healthcare imagery to promote hospital funds also appear. Less salient areas include daily life, sport, cinema promotions, holidays, and weddings.

These films function as the collective camera of working people. In the family photograph collection in Manchester, I observed the infrequent, almost ritualistic visits working people made to the studio portrait photographer to record births, weddings, joining the military during wartime, and the annual whit walk. The photograph was a luxury. Group photographs were taken on holiday and at school. The cinema provided animated family albums that extended beyond still photography in their range of subject matter and celebration of community spirit. The actuality footage in local topicals is largely unrehearsed and uncut. The subjects filmed are also the targeted customers.

During the nineteenth and early twentieth centuries, the textile industry was the dominant employer in Lancashire. Wealth generated by the cotton mills funded the expansion of Britain's Empire and reinforced a rigidly demarcated class structure. The development of the factory system during Queen Victoria's reign in the nineteenth century propelled several significant social changes: working people congregated in new towns built around the workplace. This change left a legacy of crowded streets where thousands of people lived in close communities.

Dependent on particular local employers for their livelihood, working people were also very susceptible to downturns in the economy. Recession could force whole families into unemployment. In Lancashire, it was very common for generations to follow each other into a particular textile mill, with young people receiving training and apprenticeships from their relatives. Working practices in textile mills were strictly organized, often by gender, to ensure high productivity. Health and safety standards were almost absent. At the beginning of the twentieth century, thirteen-hour working shifts six days a week were standard. Children began laboring in the textile industry around the age of twelve as "half-timers": they spent

the morning at school and the afternoon at the mill. I have spoken with several people born around 1900 who can describe vividly the exact routine of their working day. While working conditions were harsh, these workers affectionately recall the mill and its camaraderie.

With their dense populations of working people, mill towns provided fertile ground for the mass entertainment of cinema, emulating the popular but seasonal attraction of touring fairs where itinerant showmen presented early films. The introduction of the Cinematography Act in 1909 heralded an era of buildings designed specifically for the cinema, logically located in areas with good-paying audiences.

In 1913, Ernest Greenwood opened a cinema in Milnrow. At the time, no fewer than fourteen cotton manufacturers operated in that area.[1] His contribution to the recording of working people's lives survives because of a chance telephone call in 1983.

While I was working as director of the North West Film Archive, an appointment was rescheduled at the last minute, so I was in the office. I was asked if I was willing to accept a rubbish bag full of rusty old film cans that had been left at the headquarters of a local television company. My contact suspected the films were nitrate. Due to their inflammability, the films would invalidate the company's insurance policy if brought into the building. He had dumped the consignment in the car park until he could speak either to the archive to arrange for preservation or the fire service to arrange for incineration.

I got there first. The 35mm cans were very rusty, with no identification. It was difficult to open the lids. The first reel was large and dirty: the initial footage consisted of color stock that was, regrettably, part of a feature film. But my hopes soon revived when the stock changed to early black and white footage. I began to discern the first signs that this was a prized local topical film.

The reel suffered from chemical deterioration. However, the opening title ("Milnrow and Newhey Gazette") was followed by scenes of people outside a building (which later proved to be the Empire Cinema, Milnrow, and its staff), a street procession, and, most precious of all, sequences showing textile workers working inside various mills, leaving work, and setting off for an outing. The reel ended with a shot of children outside the cinema, presumably gathered for the start of the Saturday matinee. The archive already housed images of the textile industry, with the earliest title made in 1919. However, this reel of film could be dated to 1913 and therefore was the only known pre–World War I coverage of the textile mills. It remains the earliest known textile footage in Europe.

The footage shows people leaving William Clegg's mill, evoking actualités from the early twentieth century, and a Doffers and Gaiters trip. The closing shots are taken outside the Empire Cinema. Curiously, the reel had titles in two different styles. Original title sequences could be dated to 1913, while new, bolder titles showed a 1935 stockmark.

Upon viewing these films, I suspected that several original reels of local topical films had been compiled in the mid-1930s to rescreen the material for later generations. During his early days as a cinema owner, Ernest Greenwood had commissioned films of local events to show to his local audience before and during World War I. Four generations of the Greenwood family visited the archive for a special screening of this collection, supplying valuable information on its provenance and content.

*Milnrow and Newhey Gazette 1913* was produced in 35mm by the Empire Cinema, Milnrow. Four other titles illustrate how the Milnrow and Newhey communities worked and played between 1913 and 1917. One reel features a shot of the cinema exterior; a large billboard placed in front exhorts, "COME AND SEE YOURSELF." This film also shows the local chemist shop. We can conjecture that its owner shot these films, a practice not unknown in the days of early cinema. For a particularly poignant film entitled *Milnrow and Newhey Roll of Honour* (1917), Ernest Greenwood requested that his now predominantly female audience bring in photographs of their husbands, sons, fathers, and brothers who had died during the war. Consisting entirely of studio portraits rephotographed on motion picture film, this moving record shows 125 men sacrificed from that community alone by the third year of the war, only a small proportion of the real loss. Older residents still recall the impact of the film on them during its first exhibition. I have located only two similar examples within this region. All three films have been copied and deposited in the Imperial War Museum's national collection in London. These films chronicle the war's devastation of working communities. These images of lost loved ones contrast sharply with official British war films.

In 1923 the Health Committee of St. Helens near Liverpool decided to promote healthcare, especially child welfare, by creating a "health week." The committee's chairman, Alderman Dr. H. R. Bates, and the town's medical officer, Dr. Hausewell, enlisted the support of teachers, clergy, and health workers to draw attention to this important issue. A tuberculosis epidemic may have prompted this public health campaign.

"Health week" was widely covered in the *St. Helens Newspaper and Advertiser* and the *St. Helens Reporter*. These local newspapers extensively covered "health week" before, during, and after the event. A "bonny babies

competition," a publicity stunt, encouraged mothers to learn more about the health care services provided by the town's children's clinics. To raise awareness of health and to reach a wider audience, the local cinemas were enlisted. The local press encouraged readers: "Take your baby to one of the clinics. You may get one of the valuable prizes and the honour of possessing the bonniest baby. Films of St Helens babies and their mothers will be shown at all the local picture halls on Saturday next, October 6th and during the week. . . . Healthy parents, of course mean healthy children, and perhaps the most interesting part of the health week campaign has to do with baby welfare."[2]

The *Kinematograph Year Book* (1923) shows that St. Helens had a population of 102,675. It boasted ten cinemas. However, the newspaper accounts do not provide the details about the efforts of the participating cinemas. Although the films lack identification, it is believed that several cinemas contributed toward the costs of this production—an expense recouped from admission tickets.

Three local topicals show the opening of hospitals and tours of their facilities. Two publicize healthcare. *St. Helen's Health Week 7–13 October 1923* was produced by St. Helens Cinemas/St. Helens Health Committee in 35mm. Several films appealing for funding or subscriptions for hospitals and medical treatment centers evidence how resources were sustained for health care prior to 1948, when the institution of the National Health Service ensured free services for working people. Interestingly, NWFA amateur films from the 1920s and 1930s chronicle hospitals and healthcare, celebrating the philanthropic and charitable works of the wealthy classes who possessed the cameras.

Wakes Week was a strong tradition in the North of England. Mills and factories closed each year in order for essential maintenance and overhaul of equipment. Working people were obligated to take their holiday during this week, scheduled between early June and late September.

The seaside resort of Blackpool was the most popular destination for the region's holidaymakers. The development of railway transport opened up Blackpool to the working class. Because factories in different northern towns staggered Wakes Weeks, Blackpool hosted a large number of holidaymakers almost continuously throughout the summer months. Boarding houses offered lodging to Wakes Weekers, with the best prices based on one-week occupancy. Working people could reduce costs by supplying their own food and bed linen. Many people fondly recall their holiday exploits in Blackpool: it provided an excellent opportunity to meet members of the opposite sex.

The NWFA archive holds extensive collections of home movies shot by the more affluent families of the region in 9.5 mm, 16mm, and 8mm. An example is *A Record of Stalybridge Wakes 1927*, produced by New Prince's Cinema, Stalybridge, in 35mm. These reels evidence that the middle class also patronized Blackpool's beaches, fairground rides, dance halls, and circus. During the 1920s and 1930s, private hotels sprang up in certain areas of the town to accommodate their needs. However, the cost of home moviemaking was beyond the economic reach of working-class people. Consequently, our collection contains no working-class-produced personal records of holiday experiences. Advertising films, often commissioned by railway companies, promote the delights awaiting visitors to Blackpool. *Stalybridge Wakes* represents an exceptional record of the start of the holiday journey for the town's working people.

At first viewing, this film appears to record a non-event. Yet it is one of the most powerful documents recording how working people lived before World War II. It is the preeminent local topical film in our collection. Public screenings always provoke audiences to recall their own experiences of the now largely defunct Wakes Week holidaymaking ritual.

The town of Stalybridge was inhabited by 25,233 people in 1927. Nine cinemas fiercely competed for this audience, according to the *Kinematograph Year Book* (1927). The manager of the New Prince's Cinema realized that his potential customers would assemble at the local railway station to board the special trains to transport them to Blackpool at the start of the Wakes Week. He arranged for a cameraman to film the holidaymakers, panning slowly across the six-hundred-foot platform, cramming in as many people as possible. The film was screened on their return home, thus ensuring good attendance that week. The intertitle references "our friends," reinforcing the close, personal relationship between the holidaymakers filmed and the intended audience.

Mrs. Elsie Wootan, who worked as a cashier at the New Prince's at that time, remembers that the film had to be shown repeatedly so that the noisy audience could enjoy seeing themselves and their friends, relatives, and neighbors. She also recalled that the cinema manager offered a basket of fruit as a prize to the first person who recognized himself or herself in this film. Although cinemagoers claiming prizes for self-recognition was a regular practice, the interview with Mrs. Wootan confirmed its operation. During the time this film was produced, the cost of admission for the children's Saturday matinee was three pence. It was common for children to redeem clean jam jars at the local grocer's shop for the price of the ticket, an early example of recycling. The film ends with a shot of the cinema and its staff, including my informant, Mrs. Wootan.

## Home Movies Made by Middle-Class People

While the work of amateur filmmakers outnumbers professional producers by two to one in the NWFA's collection, the archive contains no home movies shot by working people during the decades of the 1920s, 1930s, and 1940s. The 1930s and 1960s were the decades when amateur filmmakers appear to have been the most prolific in our region. The archive acquired approximately 800 films made by the aristocracy and the wealthy middle class during the 1920s and 1930s. Such films primarily feature family-related footage. Sometimes they reveal particular interests such as transport innovations or charitable deeds. On rare occasions, the camera has been taken into the workplace, often owned by the filmmaker, to record a significant commercial development such as the installation of a new and costly piece of machinery.

The Birtwistle collection is the earliest amateur film in the archive, dating from 1925. The Lancashire cotton mills at Blackburn generated the Birtwistle family fortune. Their home, Billinge Scar, hosted many society parties. The family opened the grounds for fetes and for local groups such as Girl Guides, cricket teams, and cine clubs. The five Birtwistle titles were actually shot between 1925 and 1939 on the professional format of 35mm film, an exceptional case among our amateur material.

Among our 110 collections from the 1920s and 1930s, two deposits dominate: the 137-reel Sir Leonard Behrens collection and the 139-reel Preston family collection. After several years of negotiation, the archive acquired a collection of 16mm film shot by twin brothers, Sidney and Harold Preston, from the late 1920s throughout the 1930s. The twins' father, Joshua Preston, served as mayor of Stockport in 1927, 1928, and 1929. His sons filmed his official duties with their Bell and Howell Filmo 70 and Cine Kodak Model BF3.5 cameras. Joshua started work as a tailor, eventually building a large clothing business called Joshua Preston and Sons Wholesale Clothier that employed hundreds of people. He had seven children; his eldest daughter, Gertie, accompanied him on official mayoral functions. The family lived in an impressive Victorian villa named Glengarry in the prosperous suburb of Bramhall, Cheshire. Joshua Preston's wealth was self-made. According to his grandchildren, he took his civic responsibilities very seriously.

All the films are black and white 16mm reversal stock camera originals. Despite shrinkage, warpage, and emulsion cracking, the films show high technical standards in cinematography. The collection strongly reflects the twin brothers' fascination with land, sea, and air transport. Harold and Sidney screened some of the twenty-four compilation reels entitled *Glengarry Topical New 1927–1929* at their home and at local public venues.

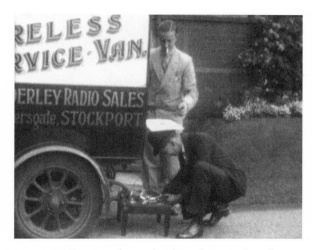

**Figure 76** Two men from a local wireless supplier play-ing gramophone records on a windup machine to provide entertainment for a nurses' outing, filmed by Sidney and Harold Preston, 16mm, Stockport, England, 1929. Courtesy of North West Film Archive, Manchester Metropolitan University.

*Nurses Outing: North Western Buses and Stockport Street Scene 1928–29,* by the Preston family, shot in 16mm, shows the 1929 outing of nurses from Stockport Infirmary. Joshua was heavily involved in fundraising for this hospital. He invited the nurses to Glengarry for an annual hospitality event.

## Home Movies Made by Working-Class People

The NWFA's first acquisition of home movies by a working-class person were the 1950s films of Arthur Townsend, a prolific working-class film-maker whose films spanned the 1950s, 1960s, and 1970s.

Townsend was born February 9, 1924, in Ashton under Lyne, close to Stalybridge. An apprentice joiner before the outbreak of World War II in 1939, he continued this trade when he was "demobbed," a British slang term for demobilization from the armed forces. Townsend shot eighteen films during the 1950s using a standard 8mm camera. They represent the first substantiated example of working-class-produced home movies in our collection. A friend who had received training in filmmaking while in the army sparked Townsend's interest. Townsend retired as a chartered builder in 1995.

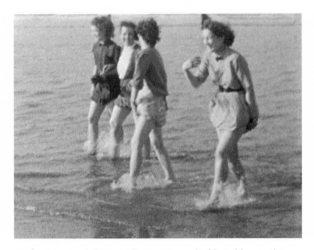

**Figure 77** *Holiday at Pleasure Beach,* filmed by Arthur Townsend, 8mm, Blackpool, England, 1949. Courtesy of North West Film Archive, Manchester Metropolitan University.

The Townsend collection features scenes of family life, including holidays and weddings. He also filmed local events, particularly transport developments and celebrations. This collection includes extremely rare footage of domestic interiors and routines; food preparation and mealtimes are frequently absent in home movies. In *Blackpool Football, Illuminations* and *Pleasure Beach 1950s,* Townsend films his holiday to Blackpool, accompanied by his wife, his daughter Kathleen, and their friends. The reel also includes a soccer match.

Ralph Brookes (1900–96) was one of the most prolific working-class amateur filmmakers. He was a well-known and respected figure in the North West of England. Born in Ordsall, a dense area of working-class housing close by the docks, he started work as a dock laborer at the age of fourteen. In 1917 he joined the navy. After the war, he did dock work from 1921 through 1935. In his mid-thirties he began operating his parents' newspaper shop on New Park Road, Ordsall. Like his parents, Brookes spent his life within the terraced streets of Ordsall. Brookes's two enthusiasms were photography and motorcycling. He made a still photography record of his neighborhood. In 1957, he adopted the cine camera, producing ninety-three films on the standard 8mm gauge until 1974. Approximately 86 percent of the collection features family footage. Fourteen percent of the images record Ordsall life, including the complete redevelopment of the area in the late 1960s

and early 1970s, when high-rise tower blocks replaced the demolished terrace houses. His most prolific period was the 1960s, when he shot sixty-four titles. Neighbors, especially children, cooperated easily with Mr. Brookes's filming activities. He is fondly recalled as "the man with the camera." For example, he filmed a customer frequenting his shop, the butcher next door, and a horse-drawn ice-cream cart.

Made in 1963, the standard 8mm film *Ordsall Scenes: Children and Docks 1963*, for example, opens with shots of children dressed up and practicing for the annual May Day procession. The next sequence shows girls dressed up in their mothers' clothes. The film ends with shots of street repair. The park in the film was located opposite Brookes's shop. The children who regularly appear in these films would play in this recreational space, the only open space in the neighborhood. Brookes and his wife Elizabeth did not have any children but raised his nephew as their own son.

*Croal at Christmas, Santa's Grotto and Bonfire at Ordsall 1968–69*, also photographed by Brookes in the standard 8mm format, was shot when demolition work had begun around his home in November 1968. It chronicles children's preparations for Bonfire Night. A later sequence shows the bonfire alight at night. Brookes recorded interior and exterior scenes of housing under demolition in Ordsall, a striking counterpoint to the documentary footage shot by professional television cameramen at the time.

## Final Comment

As filmic artifacts operating far outside the domain of British national or commercial cinemas, local topicals and home movies trace the microhistory of a region and a class, even though they present quite different production, distribution, and exhibition contexts. These films demonstrate the importance of regional film history in mapping the representations of working-class people—often excised from feature film cinematic imagery—and in recovering the lost histories of this frequently invisible population. These films also suggest the importance for archivists and film historians alike of aggressively mining and uncovering material documenting the working class. Although local topicals utilize mainstream cinematic visual and editing conventions, and home movies are photographed in a more primitive style, both function as a collective camera of working people, imaging work, leisure, and daily life virtually absent from narrative feature films. The local topicals and home movies vividly mark how working people of the North West were represented, both outside and inside the culture, and from different class perspectives.

However, North West Film Archive's research and reclamation efforts into this working-class material do not remain dormant, but are mobilized in a series of outreach programs to activate historical thinking outside the domains of the archive. Educators, ranging from primary school to university-level, recognize the teaching and research potential of these films. Television and media producers benefit from a comprehensive access service at competitive rates. The NWFA is committed to developing audiences: we produce screenings of this material in railway stations, hospitals, shopping precincts, bingo halls, residential homes, and remand centers. These various practices of public outreach mobilize these reclaimed images to reconnect the present with the region's rich past.

## Notes

1. James Clegg, *Clegg's Commercial Directory of Rochdale* (Rochdale, UK: Lanchashire Press, 1913), 100–13.
2. "Bonny Babies Competition," *St. Helens Reporter,* October 1, 1923, 12.

## 24 The Oregon State Historical Society's Moving Image Archives

*Portland, Oregon*

MICHELE KRIBS

The Oregon State Historical Society's Moving Image Archives contain over 15,000 titles, a total of approximately 8.5 million feet of film. The archives' holdings include early newsreels, family movies, commercial/industrial films, travel and nature films, and a host of fragments and outtakes produced by professional and amateur cameramen and -women from 1902 through 1992. The diverse subjects include logging, fishing, family life, trolleys, aviation, and business and industry.

The television news collections comprise the largest portion of the archives. Depicting daily Portland and Oregon news events from 1966 through 1984, extensive collections of film generated by KOIN and KPTV are complemented by smaller samples from KATU and KGW. The archives preserve many unique examples of Oregon's early film industries, including newsreels such as the *Oregon Journal Webfoot Weekly,* the *Oregon Pictorial,* and *Screenland News.* The archives also hold copies of the few existing silent theatrical films produced by Oregon's American Lifeograph and Beaverton Studios and house the noted exploration/wildlife collections of Amos Burg and William L. Finley. A variety of industrial and educational subjects and home movies illustrate work and life in the Pacific Northwest.

The Oregon State Historical Society has been actively collecting amateur movies since the mid-1970s. At that time, few film archives or historical societies collected these family treasures. The society's first film archivist, Lewis Clark Cook, a former filmmaker, knew the value of these collections and saved many from the landfills. We are fortunate to have so many wonderful amateur collections on our shelves. Some highlights of the archives are described below.

## The William Cheney Collection

*16mm color and black and white footage on mixed reels; silent; 23,890 feet;*
*circa 1929–64*
*Archive numbers 01457–01483, cataloging completed*
*Film elements: original 16mm camera positives*

This collection is exceptional for its diversity, for the forethought and skill with which the footage was shot, and for the intelligent editing of subjects. These are not your typical home movies. William Cheney had an eye for the life around him, and it is evident in the material he shot. He filmed things most amateurs ignored, such as a scene of a scone booth at a fair showing the entire process of making the scones. There is no doubt of the regional importance of this collection; the subjects are so diverse, and the material is so wonderfully filmed, that it is hard to express its significance. Every subject Cheney chose to place onto his reels is a complete vignette within a bigger frame. His larger reels encompass years of dedicated work to this hobby.

William Cheney was born in Oregon City, Oregon, early in the twentieth century. He was a machine shop operator and manufacturer who lived in Seattle, Washington, during his adult life. His hobbies included making telescopes and camera lenses. He enjoyed shooting both motion picture film and still photographic images. He was known by his friends to be a quiet, philosophical genius.

The images in this collection cover an amazing range of topics beginning in 1929. At first, Cheney filmed various jobs that he worked on. Then he moved onto scenes of everyday events around him. On automobile trips to the Olympic Peninsula, he filmed children picking berries, clamdigging on the Washington coast, and smelt fishing. He filmed ferry rides in Seattle's busy harbor, waterfront industries, and early passenger aviation. Also included are scenes of the Depression, local World War II activities such as scrap metal drives, women working on airplane electronics in store windows, fishing derbies, and boat races. He was a member of the Mazamas Mountaineering Club, and he filmed club climbs on Mount Rainier and visits into ice caves. He took vacations to the 1939–40 San Francisco World's Fair and toured around Oregon and Nevada, filming everything along the way. He filmed everything in great detail: a film archivist's dream.

These reels are still in good shape, though some of the color scenes are fading. Thankfully, no vinegar syndrome has been found as yet. The preservation challenge is that he filmed in both color and black and white, intercutting

the film stocks within a scene to create his vignettes. Many questions come to mind regarding the preservation of this unique collection:

> Does one create a color internegative of the entire reel, attempting to match the color stock to the black and white images?

> Does one painstakingly separate the color from the black and white, keeping accurate notes so that each format is preserved in its proper stock?

> Does one have separate negatives made, then have separate prints made?

> Does one again cut these images back into order as Cheney once did?

> Or does one transfer these images separately onto video and marry them once more in sequence on videotape?

## The Enio Koskela Collection

*16mm black and white; silent; 3,320 feet; circa 1950s (8mm described below)*
*Archive numbers 02248–02253 (for 16mm), cataloging completed*
*Film elements: preservation negatives and positive prints*

Enio Koskela was raised in Astoria, Oregon. In his adult life he worked for and was a member of the Union Fishery Co-operative. One of his hobbies was shooting motion picture film. The 16mm portion of this collection features images of Oregon's coastal fishing industry and the Union Fishery Co-operative of Astoria, Oregon. Scenes include men repairing fishing nets on the docks, construction of barges used for oyster seeding and fish recovery scows, and transporting of salmon caught by horse seining to the cannery for processing. There is a complete walk-through of the Union Fishery Cannery, from the head office to the assembly line, including film of the canning and cooking of the fish. This documentation of one of Oregon's major industries toward the end of its heyday gives the viewer/researcher a look into what seemed at the time to be never-ending runs of local wild salmon, and of another era gone by.

The Oregon Historical Society was allowed to make black and white internegatives and prints from the original camera positives. The Koskela family retained the original 16mm films.

*Regular 8mm color; silent; 2,400 feet; late 1940s through the early 1960s*

These films have had only basic inventory work completed. They are the Koskela family's home movies, and include images of holiday festivities,

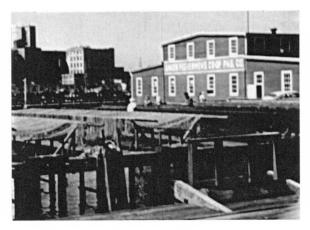

**Figure 78** Union Fishery Co-operative, filmed by Enio Koskela, 16mm, Astoria, Oregon, circa 1950s. Courtesy of Oregon Historical Society, Koskela Collection (02453).

trips to Portland, the children at school and play, picnics on the beach, and other such domestic activities.

This collection was selected for its content as well as the quality of the filming and editing done both in the camera and on the bench.

## The John Capern Collection

*17.5mm nitrate negative with safety positives; black and white; silent; 600 feet; 1908–15*
*Archive number 03797, cataloging completed*
*Film elements: 17.5mm positives, 16mm optical reduction negatives and positive prints*

The Capern films were donated in the early 1980s, with negative nitrate stock, positive safety stock, and a 17.5mm amateur projector. The images in this collection are more of what I would deem typical home movies. There are shots of the Capern family at home and with their new car. Scenes of a favorite swimming area called Columbia Beach, now an industrial park, show a lifeguard contest, a boxing match set up on the beach, and, of course, the bathers. The earliest known images of Portland's Rose Festival Fleet coming up the Willamette River and the Rose Parade itself are found in this small collection.

This collection was chosen as the earliest example of home/amateur movies in our holdings. The images are grainy and the scenes choppy due to the short wind of the camera. Nevertheless, they are important examples of early amateur filmmaking in the Pacific Northwest.

In 1985, the Oregon Historical Society received a grant from the American Film Institute for the preservation of this unique collection of home movies. The films and an original 17.5mm projector were sent to a specialty film lab to have the 17.5mm film clips optically reduced to 16mm preservation negatives; answer prints were also made.

### The Senator Charles McNary Collection

*16mm; color and black and white; silent; 876 feet; circa 1938–40*
*Archive numbers 02391–02393, cataloging completed*
*Film elements: preservation negatives and positive prints*

These are home movies from the country estate of Senator Charles McNary of Oregon. This small collection was chosen for its depiction of lifestyle. Scenes include a maid serving afternoon tea on the patio and the senator catching fish in his own private trout pond. Included are scenes of his daughter learning to ride her pony and images of the small farm that was a part of the family's estate. Also included are scenes of Senator McNary's acceptance speech in 1940 as presidential candidate Wendell Willkie's running mate.

### The Herbert G. Miller Collection

*16mm color and black and white; silent; 8,215 feet; circa 1930–41*
*Archive numbers 01874–01900, cataloging completed*
*Film elements: original camera positives*

Herbert Miller's family founded the Miller Paint Company and owned a large chain of paint stores in the Pacific Northwest. Miller also was a member of the Amateur Cinema League of Oregon. Interestingly, Miller's grandson followed in his grandfather's footsteps and became a television news cameraman and is now an independent producer. It was through his grandson that we received this wonderful, whimsical collection.

This collection is a "typical" home movie collection with images of family vacations in Alaska, Victoria, B.C., California, and Yellowstone, and it

documents favorite recreational activities such as skiing and sledding, fishing and hunting, and soapbox derbies. Miller also covered many Northwest events such as the Portland Rose Festival, a 1938 Oregon Trail reenactment, and the construction of the Golden Gate Bridge. Included are whimsical images of Miller and his son in Seaside, Oregon, trying out in-camera effects, and a silly piece about a gym where Miller was a member.

The Oregon Historical Society amateur film holdings represent significant representations of daily life in the Northwest region of the United States. These films demonstrate that although the home movie has some tropes that repeat, such as family events, travel, and leisure, the specificities of place and geography infuse them with important regional resonances and details.

## 25 Reflections on the Family Home Movie as Document

A Semio-Pragmatic Approach

ROGER ODIN

This essay uses the semio-pragmatic model I have developed over the last two decades.[1] In France, the semiological approach to cinema[2] was developed in the tradition of Ferdinand de Saussure on a basis of immanence: film semiology focuses on the *filmic text*. When semiology accounts for the spectator, the spectator is constructed by the film.[3] When semiology investigates enunciation, it examines its traces in the text. This textual approach yielded positive results in cinema research.[4] However, semiology completely underestimates the determining role of context in textual construction.

My semio-pragmatic model maintains the benefits of the semiological textual approach and clarifies its presuppositions. It views the construction of the text from a pragmatic perspective. The modalities of textual construction change in relation to context. Meaning is not everything: affect and the interactions during production and reception must be analyzed.

The semio-pragmatic model involves two levels. The first level concerns the *modes* of producing meaning and affect. What types of spaces will this text permit the spectator to build? Which discursive impositions will it accept? Which affective relationships are established with the spectator? Which enunciative structure will it authorize the spectator to produce? The model describes nine different modes:[5] the spectacular mode (the film as spectacle); the fictionalizing mode (a film as the thrill of fictively recounted events); the fabulizing mode (the film's story demonstrates an intended lesson); the documentarist mode (the film informs about realities in the world); the argumentative/persuasive mode (to analyze a discourse); the artistic mode (the film as the work of an author); the energetic mode (the rhythm of images and sounds stirs the spectator); and the private mode (the film relives a past experience of the self or a group).

The second level is the *contextual*. The semio-pragmatic model empha-
sizes the institutional frame, pointing out the main *determinations* ruling
the production of meaning and affect. When do we use the aesthetic mode?
The fictional mode? The fabulizing mode? How are these modes articu-
lated? How are they put into a hierarchy? Why do we use these modes in
a particular context?

This study focuses on the documentarist mode. This mode puts at stake
three processes:

1. The construction of a real enunciator (as opposed to a fictive one): an
   enunciator constructed as belonging to the same space as myself and
   to whom I am authorized to ask questions.

2. The questioning of this enunciator in terms of truth. The question,
   not the answer, defines the documentary mode. If the enunciator
   does not tell the truth, it does not imply the fictionalizing mode; on
   the contrary, lies, errors, and erroneous hypotheses belong with the
   documentarist mode.

3. The evaluation of acquired knowledge and its informational value:
   What have I learned about the world, people, and their relationships?

## The Home Movie: A Document?

A home movie is made by one member for other members of the same fam-
ily, filming events, things, people, and places linked to the family. Merilee Ben-
nett's 1987 film, *A Song of Air*,[6] which I will use here as a kind of film-
laboratory, is a compilation film[7] composed of home movies shot by Merilee's
father, Reverend Arnold Lucas Bennett, who regularly filmed his family with
a Paillard Bolex 16mm camera between 1956 and 1983. This film invites two
levels of reading: first, the level of the home movies made by the father; sec-
ond, the analysis made by Merilee of her father's home movies through her
own reediting of the images and her omnipresent commentary in the form of
a letter addressed to her father, who at the time of its writing is deceased.

## To Film versus to Make a Film

In family cinema, the production of the film is not a primary goal. The
filmmaker films to play with the camera and its various gadgets.[8] He/she
films for the pleasure of gathering the members of the family. *A Song of Air*

shows images of the father surrounded by his wife and children, hugging them, organizing them into a portrait-style family photo, asking them to look at the camera. To look at the camera together testifies to the unity of the familial unit. No other types of films evidence as much direct address as the home movie. The family filmmaker's camera functions first as a *go-between* and only secondly as a recording instrument.

In a film I bought at a flea market, a sequence demonstrates this function. During a somewhat uninteresting three-minute silent sequence, a familial fanfare plays out in front of a shop window with a sign that reads "R. Pallu." However, this sequence was not produced to be viewed. It is evident that during its production, the greatest pleasure was in the participants finding themselves together in front of a camera. The film produced an effect *before* its exhibition. Each family member's individual performance is spotlighted. The youngest son knocks on a large cash register and laughs; an older son blows his trumpet right in front of the camera's operator. A French horn player executes a few dance steps. To film is to take part in a *collective game* in the family domain.

However, these familial interactions are not always peaceful. In a personal letter, Merilee Bennett recounts one of these conflicts. "The shot of him [my father] talking directly into the camera with a tree and blue sky behind him was shot by me when I was 12 years old and he is actually telling me to stop, that it was enough now. I remember holding my finger on that button knowing that he couldn't get really mad at me because I would have it on film, so he had to keep smiling even though he was getting cross."

*A Song of Air* shows that shooting the family can have much more serious consequences. In this film, Merilee sheds the influence of her father's films, which required her to play the role of the well-behaved daughter, dispossessing her. She reclaims her identity through editing, imposing her own order on her father's films. The first and last image of the film is a shot of Merilee at the editing table. The film visualizes how the father used cinema to rule over his family: he occupies the center of the image, organizing the shooting and ordering people to perform in front of the camera. The father, "like an omnipotent God," uses cinema to mold his family. "We have to give our own life for the sake of his movies. But the important thing was to be together and feel the same way about the world."[9] Through *A Song of Air*, Merilee rebels against both family order and the films that were its reflection and its agent. Merilee describes how she embarked on a life opposite to what her father had planned. The violence of her statement testifies to her aggressive oppression: "Out of love you tried to prevent my pain, but your safety is like suffocation. I did not tell you that I had bit a piece of a

man's tongue in a fight to stop him from raping me. Nor did I tell you that I heard the clear high song of air through the feathers of a condor. . . . When I was just ready to face you again all grown up, you died."[10]

Home movie productions are a festival of Oedipal relations: the person behind the camera is not just any operator but, in general, the father. In her autobiography *The Words to Say It*,[11] Marie Cardinal explains to her psychoanalyst that after clinical treatment she had the strength to undertake a search for the origin of her trauma. After many detours, she finally remembers her father filmed her pissing in the forest. Confused by a tapping noise, she turns around and sees her father "holding a funny black thing in front of one of his eyes, a sort of metal animal which has an eye at the end of the tube." Conscious that her urination has not only been watched, but also filmed, she felt traumatized and thought, "I want to hurt him. I want to kill him!" Shooting a home movie does not always have such dramatic consequences, but it always carries a risk for the subjects filmed, especially children. Parents are not aware of the psychic consequences of a seemingly harmless act.

Even before existing as a film, the family film has already produced collective and individual effects. What happens during shooting is often more important than the film itself. Indeed, the family filmmaker does not always develop the film. In *Sur la plage de Belfast* (On the Beach at Belfast, France, 1996), Henri-François Imbert recounts his discovery of an 8mm camera with an undeveloped reel inside. After a long search, he found the family to whom this camera belonged. The director of the movie had died. The mother remembered her husband regularly making films that he rarely developed. This practice is not exceptional at all.

## To Film versus to Do Cinema

Merilee's father's movies are fearful precisely because they are well made. The images are shot on a tripod, well framed, and carefully directed. Sometimes, the father would even make his family act out little scenarios. Merilee notes that "all had the theme of a family alone facing an outside threat."[12] Form strictly corresponds to the content. Images are regulated, policed and policing. These images represent the family moral order that the Methodist father mandates.

In *A Song of Air*, Merilee radically deconstructs and appropriates her father's films. She destroys her father's storylines and reedits the images to illustrate the letter she reads to her father in voiceover. She attacks the images' materiality, breaking them up and manipulating them (as Godard does

in some films) to bestow specific symbolic meaning. For example, a shot of the father lifting his eyes to the sky is shown three times. First, it symbolizes the trust in God that the father communicates ("united, we can laugh at the ghosts, at the dark corner of life, at pain, even at death"). Second, when Merilee discusses her father's death, the shot appears as flashback. Third, when Merilee explains her life to her father, who claims misfortune, the shot illustrates discontent. Another shot assumes a symbolic force as an undoing-in-motion. One of Merilee's brothers, hatchet in hand, chops a block of wood whose form evokes a head. The father's long hands order the hatchet be handed over. Her brother smashes the head into many pieces— a startlingly violent effect. The beautiful and remarkable waterfall sequence (a succession of pauses visualizes the trickle of falling water) shows the young girl's will to escape the force that submerges her. Merilee swims underwater in a movement abruptly stopped. Merilee adds her own image, a close-up screaming toward the sky in contrast to the direction of her father. In her personal letter referenced above, Merilee explains she used video to oppose her father's overpolished images: a dirty image.

At the end of this filming process, Merilee will be able to say, "I love you" to her deceased father. Family movies that are too "well made" exert violence on the family. Only another violence might break off the process: the violence that comes with artistic reprocessing, as exemplified in *A Song of Air.*

## Documentarist Readings versus Private Reading Practices

In the home movie, those addressed by the film have lived the events depicted. Reading a home movie does not summon the documentarist mode of reading but the *private one.* If I construct a real enunciator (the Family), I do not ask the truth question nor expect information. Home movie images function less as representations than as *index* inviting the family to *return to a past already lived.* The home movie does not communicate. Instead, it invites us to use a double process of *remembering.*

*Collective remembering.* Unlike fictional film screenings, interaction infuses the projection of a family film. Each family member reconstitutes a common past. A viewer might intervene to stop the screening (behavior prohibited while watching a fictional film) to develop the memory of an important scene. The story is certainly triggered by the screen, but it does not necessarily relate to the images. Unlike traditional cinematographic projection, to watch a home movie is to be involved in a "performance." The home

movie resembles "expanded cinema":[13] what transpires at the time of the showing forms an integral part of the text. To watch a home movie with the family is to collaborate in the reconstruction of a (mythical) family history. Remembering builds toward *celebration*. Merilee Bennett's father clearly understood the home movie's ideological role: Merilee explains that "almost every Sunday evening, after tea, we watched movies, we saw ourselves growing up."

*Individual remembering.* The story of the individual parallels the collective story. Boris Eikhenbaum proposed the notion of "interior language": "The process of interior discourse resides in the mind of the spectator."[14] This interior language can be understood without referring to a context because it is located in the Subject. With the home movie, the context resides in the experience of the Subject. Consequently, home movies seem boring for those outside the family because outsiders lack the contextual frame that positions the disjointed images. This model also explains how completely banal images can refer to representations far removed from what is represented. Contrary to the generally euphoric collective experience, this process of returning to the self often conjures painful memories. Merilee is driven to remember she had once dreamed of poisoning her father and ruminates on how leaving his house to live her life caused his death.

In *Muriel* (France, 1963), Alain Resnais demonstrates this internal functioning of the family film. Bernard shows the elder Jean images taken during his Algerian military service. Scenes from the life of Algerian military camp life during the war are rendered with the fuzzy, shaky, and overexposed visual rhetoric of the family film. This film, however, bears no resemblance to a document: it teaches nothing about Algeria, the Algerian War, or soldiers. Its importance is elsewhere. In response to the question posed by his girlfriend, Marie, who queries, "Is this a documentary?" Bernard unhesitatingly replies, "Worse." This film evokes a terrible and unforgettable scene: the torture session he and other soldiers forced Muriel to endure. The film does not show any torture images, but Bernard describes the event that changed his life in detail: "There were five of us around her. . . . We were discussing that she had to talk before nightfall. . . . Robert lights a cigarette. . . . He comes close to her. . . . She screams."

Jerky, broken, the voice is monotonous, neutral, and expressionless, like a sleepwalker who speaks. Alain Resnais demands we assume Bernard's drama. By showing banal images, he privileges Bernard's oral story, pushing us to fantasize the scenes he describes. The story of Muriel's torture involves us; we produce the images. It is our film. With several minutes of bad-quality images, this fragment serves as a moment of torture for the spectator, operating as

what I call a "mise-en-phase,"[15] simultaneous with the story of Muriel's torture and with the torture that memory of this session enacts in Bernard.

In the family domain, a home movie does not function as documentation. The family film is, in fact, a *counter-document*. The collective interactions at the moment of their shooting or viewing or in the individual interior discourses aroused are more important than the images. To read a home movie as a document is to *"use"*[16] it for something that is not its own function.

## Reading the Home Movie as a Document

Reading a home movie as a document, I employ the three processes of the documentarist mode.[17] What are the specific problems raised by the home movie as a document? What does using the home movie as a document— as opposed to other existing documentary resources, such as professional televised reports—bring to documentary production? The difficulties encountered in the usage of home movies as a document are the most interesting points of analysis.

The first difficulty emerges from the stereotypical character of the home movie. Nothing resembles a home movie as much as another one. The home movie perpetuates and reinforces a familialist ideology that subjects it to various pressures. Pierre Bourdieu, discussing family photography, argued that nothing can be filmed outside of what *must* be filmed.[18] The same ritual ceremonies (marriage, birth, family meals, gift-giving), the same daily scenes (a baby in his mother's arms, a baby having a bath), the same vacation sequences (playtime on the beach, walks in the forest) appear across most home movies. With such repetitions, discouragement and lassitude sometimes overtake spectators, weakening informational value.

Looking at home movies differently, these stereotypes also constitute a remarkable trump card, attesting to their formidable *representability*.[19] As a specimen from an entire ensemble of images, a home movie image possesses an extraordinary force. Each image condenses and *crystallizes* thousands of analog images. No news reports hold such psychic force. Discussing "common things," Georges Perec contended the difficulty is "to free these images from the straitjacket in which they are trapped, to make them produce meaning and speak about what they are and what we are."[20] Home movies are precisely "common things."

Frequently, commentary imbues images with meaning. The result depends on the writer's skill. The storyteller of *La vie filmée* (1975), a series of films done for television from amateur films, enchants us,[21] but not everyone is

Georges Perec. Another strategy consists of serialization. In *Les vacances à la mer de 1840 à nos jours*[22] (Belgium, 1986), another series, various representations confront the same theme across different periods, from aristocratic vacations to the advent of mass tourism, through the war years, illuminating the differences between the stereotypes of each period. Lastly, another route consists in cultivating what Erving Goffman terms the process of "shifting of frame."[23] A film of minor importance can suddenly become a fabulous document when the historical context of reading changes. André Huet recounts how stock travel films shot in the former Yugoslavia, initially considered insignificant, suddenly accrued more importance after the war. Every old home movie that operates within a different spatial, cultural, ethnic, or social framework will benefit from de-framed readings. Even if these images were not documents and were stereotypical home movies, they become precious because they look new. Shifting from the familial to the cultural frame, Merilee's father's films reveal themselves to be less stereotypical. Methodist family characteristics emerge: the number of children, the force of religion, the written rules, the frugality of meals, the insistence on outdoor games.

The second difficulty resides in the familial institution's prohibitions and impositions on representation. The home movie refuses to represent anything shocking and embarrassing (the intimate), to reveal a pessimistic view of family life (illness, suffering, misery), or too threatening to the image of the ideal family (household scenes, parent-child conflicts, familial dramas). The home movie constructs a euphoric vision of family life. No other genres of cinema consist of so much laughter and so many smiles.[24] If the truth question is posed, these images are deceptive. Merilee's family is not the happy family documented in her father's films. Instead of providing information about society, home movies function as filters masking reality. Patrick Jeudy constructed his film *Les yeux d'Eva Braun* (France, 1991) on this opposition. The film parallels Hitler's typical home movies presenting happy, charming images with the terrifying reality of archival documents of the Third Reich. Hitler smiles, surrounded by two babies. Eva kisses a small rabbit. Hitler, seated in an armchair, strokes Eva's hair. Hitler strolls with Eva's sisters along the Koningsee. Eva does gymnastics. She wears a Bavarian costume on the terrace of Berghof. Hitler walks, cane in hand, reminiscent of "Charlot" (the affectionate French name for Charlie Chaplin). Home movies are deceptive documentaries (*"documenteurs,"* to quote the title of one of Agnès Varda's films).

One can turn Jeudy's film demonstration upside down: Eva's home movies show that Hitler was a man like us. This discovery is more informational and perhaps more frightening than the images of war. It is possible

to assert the documentary specificity of the home movie and its contribution to the informational level as opposed to the framework of professional reporting, which is as incomplete and deceptive as the home movie. On the one hand, a report documents historical upheavals, social conflicts, political rivalries, the scandalous, minor bedroom happenings of stars and politicians, foul or passionate crime—everything excised from the home movie. On the other hand, it tells us nothing about what Georges Perec has described as what happens when nothing happens, "everyday happenings, that which comes back every day, the banal, the daily, the obvious, the ordinary, the background noise, the habitual." In another passage of the same article, Perec adds: "The news covers everything except the everyday humdrum of our lives" and begins to dream about an endotic anthropology (versus "exotic").[25] Family filmmakers are involuntary endotic anthropologists: they film those moments of life that professionals ignore. Official reports fail to document entire aspects of society. Home movies are sometimes the only records of some racial, ethnic, cultural, social communities marginalized by the official version of history. Even if these films do not recount the entire history and often show what the community sanctions, these films represent important documents. As Karen L. Ishizuka insists, "Within home movies . . . lie hidden histories of the world."[26]

The third difficulty is the absence of background on some of these films. Confronting a home movie found at the flea market, I undertake a superficial reading of only the image. This limitation precludes an understanding of particular shots and actions (for example, I am unable to know the status of two men who hold a woman by the waist), but this lack of background information can also have positive consequences. Unconstrained by demands of a familial reading that positions the construction of the family as a real enunciator, I can construct other enunciators. These different reading areas offer "specifications"[27] of the exemplary value of the images.

I can, for example, assume the camera as a real enunciator. In this perspective, everything placed in front of the camera becomes a possible object for a reading. I can focus on things that are not the topic of the shot itself: the habitat in the decor, the cars on the street, the outfits worn by the characters, the details of their haircuts, the secondary actions in the corner of an image. I can also position the cameraman as enunciator and observe that he shoots better than most family cameramen. The film then becomes a documentary on the filmmaker. Lastly, I can take the film text itself as a real enunciator. The image is beautiful and well focused, the colors have stood the test of time, but there is a stripe down the center, a sign the film was made in the 9.5mm format with a center frame perforation. The film, then,

documents technological evolution. The documentarist reading expands into a *palimpsest* of readings.[28]

One might wonder if photography isn't a more appropriate object of study for this type of multilayered reading than cinema. Because of its constantly moving images, cinema does not lend itself to a detailed analysis of each image. Films that allow such a reading, as *La vie filmée,* freeze the images to focus on a background element, or reduplicate the same sequence to enable different readings.

The fourth difficulty is linked to the particular emotional relation that home movie images weave with their spectator: an ordinary man like myself filmed them, thus these images are a little like me and they speak to me of people like me. The result is that when I see a document that I know to be excerpted from a home movie, I have a tendency not to ask the truth question, which characterizes the documentarist mode of reading. Reading in terms of authenticity perverts the documentarist mode of reading: it rests on the construction of a real enunciator, yet it prevents one from questioning it, impeding a critical reading and a true historical approach.[29] At the same time, it is evident that this emotional relation is what gives home movie images their specific power. Their ability to seduce and to attract creates a magic that radically distinguishes home movies from news-reported images and from traditional documentaries.

## Magic against Truth

It is interesting to point out some of the various strategies adopted by directors to face these contradictions.

The first solution consists of ignoring the problem in using the authenticity effect in a matter-of-fact way, a typical television strategy. If television explicitly indicates the provenance of these documents in the commentary or in a subtitle ("amateur images"), it is not only to excuse their poor quality in comparison to other televisual images but, mostly, to recuperate the emotional effect for profit.

A second solution—radically opposite of the first—reinforces the discourse of the historian: the images follow the voiceover that delivers the historical discourse. The beginning of the fourth part of *La guerre filmée au quotidien,* "The Vision of the Soldier" (Germany, 1995), a documentary by Michael Kubal,[30] functions according to this construction: images from several amateur films are reedited to create a continuous narrative illustrating the commentary. Using the voice of the master, we are in what Bill Nichols

calls the "expository mode."[31] The enunciator of the film is not constituted by the authors of the images (the amateur filmmakers), but by the one in charge of the discourse (the historian). Such a treatment certainly allows us to perform a documentarist reading (to ask the truth question), but results in the effacement of the home movie's affective power by reducing its function to documentation.

A third solution consists in telling a story and doing everything to ensure believability. An excellent example of this treatment is *Le rêve de Gabriel* (Belgium, 1996) by Anne Lévy-Morelle. The film recounts the story of an engineer from Brussels, Gabriel de Halleux, who one day decides to leave for Patagonia with his wife and nine children to exploit a territory offered by the Chilean government. The film reedits numerous reels of 9.5mm and 8mm film shot by the engineer. Interviews and landscape shots are added later. The story is unquestionably captivating, but its force leads to the loss of specificity of home movies and to the flattening of historical discourse. The cinematographic work (montage, sound, music, mise-en-phase) pushes toward a fictionalizing reading. In place of a real enunciator, we construct a fictive one: we watch the film without asking any questions, stirred by the rhythm of the narrated events.

A fourth solution would give voice to those who took images and/or to the participants of the filmed event. The program *Inédits,* created by André Huet for Belgian TV R.T.B.F. (1980), made its mark with this sort of treatment. *Inédits* is the first daily program entirely done from amateur films. But this formula is not without some negative consequences: it encourages one to retain only scraps of history and to insist on picturesque or anecdotal events. For example, in one of the broadcasts two brothers comment on a film, discussing the evolution of a revolutionary motorcycle that they built at Châtelet in 1925. In another example, in a suitcase sold at an auction or at a flea market in Brussels, an amateur discovers photos of two acrobats who worked for the famous Barnum and Bailey circus. In 1967, a truck transporting 10,400 gallons of gas explodes in the heart of Martelange, setting an entire neighborhood on fire. What the discussants say is often very disappointing: they simply describe the images or vaguely situate them in their context, while others share their impressions or talk about their lives. However, on some occasions the narrative can be moving and even poignant, but in this case, the result is to fall directly back into the schema of authenticity.

The most interesting films are produced by directors who understand that the most productive strategy is to wrestle with the contradictions of the family-movie-as-document. The series *La vie filmée* chose to articulate

syntagmatically all the readings and modes of reference that a home movie allows: historical, fictional, private readings, testimonies, nostalgia, moments of pure emotion. Other riskier readings have focused on placing the contradiction in the center of the film, banking on the aesthetic force of the images. Hungarian filmmaker Péter Forgács undertakes this position in *Wittgenstein Tractatus* (1998). Closer to experimental cinema than to the document, this film constitutes a masterful reflection on the notion of the document itself: why one makes films; the language of the images and language itself; and the possibilities that the image holds for cognition.[32]

## Conclusion

The amateur film movement is often associated with democracy: "One thing is certain," notes Peter MacNamara in an issue of *Journal of Film Preservation* devoted to the amateur film, "amateur films are wonderful documents for a democratic history."[33] Circulating home movies is "to fight for the sharing of experiences and knowledge that have been drawn from all areas concerning traces of collective memory."[34] These writers argue amateur films give voice to the politically, ethnically, and socially excluded, revive the productive capacities swallowed up by globalization and consumerism, and restore creativity and freedom. In short, they contribute to "remaking the world."[35] Although I would like to share these euphoric positions, I advance a somewhat different discourse. I wonder why this kind of film is in fashion today? What is this fashion symptomatic of? What does it hide or stand in for?

First, this interest in amateur film obviously derives from the logic of media economy and increases the risk of exploiting amateurs. The Association Inédits is the only institution truly concerned with this question: it produced a "charte des inédits" (charter for the amateur productions).[36] Unfortunately, such a charter does not resolve every problem. First, amateurs are eager to be exploited to see their work on television. Second, even if the amateur is properly remunerated, amateur production is cheaper than professional production for a television channel. Third, the turn to the amateur resolves all problems of flexible crews. It is no longer necessary to send a team to an event because hundreds of amateurs will spontaneously rush there. Finally, because the quality of amateur productions has significantly improved, the route to television no longer entails as many technical problems. One can conjecture that television channels will utilize more and more

of these productions. An entire sector of the profession will be threatened. Mass use of amateur productions on European television appears to be an important agent of deregulation.

Secondly, it is not an accident that film archives specializing in amateur productions appear in regions where the question of identity seemed urgent: Brittany, Belgium, Holland, Wales, border regions. Family productions are deployed for a local or identity claim context. The rising interest in amateur productions is one symptom of micromovements fighting for identity and the dissolution of a structured public space. Although these movements can be read as a reaction against globalization, there exists a dangerous corollary in the rise of tribal identifications and mobilizations.

Finally, the use of family films as documents, testimonies, and first-person productions is especially troubling. These productions empty out the truth question, which benefits authenticity and affective emotion. This movement constitutes a massive exploitation of productions in what Umberto Eco called "neo-television" or what Dominique Mehl calls "television of intimacy."[37] This movement has trickled down to movie houses where first-person productions are increasingly shown; for example, *Intime* (Italy, 1996) and *Aprile* (Italy, 1998) by Nanni Moretti, *La Rencontre* (France, 1997) by Alain Cavalier, *Omelette* (1998) by Remy Lange, or *Demain et encore demain* (1998) by Dominique Cabrera. Increasingly, fictional films also function in this mode: pseudo-confessions, such as *Blackout* (United States/Italy, 1997) by Abel Ferrara; pseudo-news programs, such as *The Blair Witch Project*; productions by Dogma. "Whatever has happened, that's what we see," notes the director of *Festen* (Denmark, 1998), Thomas Vinterberg, who claims a surveillance-video aesthetic.[38] On the Web, with its incredible outpouring of the intimate displayed in myriad forms, this phenomenon is even more evident.

This wave of amateur productions participates in a larger social context strengthening individualism. As Renaud Dulong wrote: testimony does not subject a mind to a statement but an individual to another individual.[39] It also propels the emergence of the uncivil man (Richard Sennett), the weakening of public institutions (Jürgen Habermas), the masking of conflicts by affect, and the replacement of communication by communion or fusion.[40]

Relations between democracy and amateur documents are neither always simple nor always positive. We must resist mystifying these productions as much as we formerly scorned them. We must realize not only their public usage, but also their economic, social, and ideological influence. In every case, the stakes are high.

## Notes

The essay was translated by Grace An.

1. The first article that I explicitly devoted to this approach was "Pour une sémio-pragmatique du cinéma," *Iris* 1, no. 1 (1983): 67–82, translated in *Film and Theory: An Anthology*, ed. Robert Stam and Toby Miller (Malden, MA: Blackwell Publishers, 2000), 54–67. To follow the development of this model, read my "Sémio-pragmatique du cinéma et de l'audiovisuel: modes et institutions," *Toward a Pragmatics of the Audiovisual* (Münster: NODUS, 1994), 33–47; and my *De la fiction* (Brussels: De Boeck, 2000).

2. For a systematic presentation of this approach, see Roger Odin, *Cinéma et production de sens* (Paris: A. Colin, 1990).

3. For an approach in this perspective, see Daniel Dayan, *Western Graffiti: Jeux d'images et programmation du spectateur dans la chevauchée fantastique de John Ford* (Paris: Clancier-Guenaud, 1983); and Francesco Casetti, *Dentro lo sguardo: il filme il suo spettatore* (Milan: Bompiani, 1986). Regarding enunciation, see J. P. Simon and M. Vernet, eds., "Enonciation et cinéma," *Communications* 38 (1983).

4. Christian Metz claims this approach in his *L'énonciation impersonnelle ou le site du film* (Paris: Méridiens-Klincksieck, 1991). For Raymond Bellour, this new attention to the filmic text is the essential contribution of semiology to film studies: *The Analysis of Film*, ed. Constance Penley (Bloomington: Indiana University Press, 2000).

5. I characterize them from the reader's perspective, but this characterization also applies to the space of direction; one would just have to replace "seeing" with "directing" and modify the necessary details that are indispensable to the definition.

6. Merilee Bennett was born in Brisbane in 1957. She was trained in photography and cinema at the Philip Institute of Technology. *A Song of Air* (1987) was shot in 16mm. Production: Jane Karslake, with a grant from the Women's Film Fund and from the Australian Film Commission. Script and editing: Merilee Bennett. Photography: Maria Rita Barbagallo. Music: Douglas Knehans. Sound: Duncan Smith.

7. Jay Leda, *Films Beget Films: A Study of the Compilation Film* (New York: Hill and Wang, 1971).

8. In "Experience of an Amateur Filmmaker," Norman MacLaren explains the pleasure he had in being promoted from his ordinary Ciné Kodak camera to the Special Kodak camera: "It was as playing on an electric organ after fooling on a tin whistle; . . . our first impulse was to press all the stops and use all the gadgets. I was so enamored with the possibilities of the Ciné Kodak Special that I designed a film specially to exploit all the possibilities of such a camera." *Journal of Film Preservation* 25, no. 53 (1996): 33.

9. I quote the film commentary.

10. It was this sentence that provided the film with its title. In a personal letter, Merilee explains this title:

When I was 20 years old I went to Peru and on my 21st birthday, I was camping with friends high in the Andes and as we set up our little tent a condor

flew down to have a look at us. It hovered above us for a long time, this huge bird, wing span of around 6 feet across and the tips of the wings were open like fingers and it was so close I could hear the sound of air through those wing tips. It was a flutelike sound, a song of air. It was one of those moments in life when I felt blessed. It was the most exquisite surprise for my birthday. It became a personal emblem of life's ecstasy. I had a lot of trouble trying to work out how to name the film. I read through the script and that phrase "song of air" jumped out at me, so to speak. It felt right also because I was making a film that was in a sense a love letter, a love song to my father and he was dead so I was speaking to the air.

11. Marie Cardinal, *The Words to Say It,* trans. Pat Goodheart (Cambridge, MA: Van Vactor and Goodheart, 1983), 152.

12. Here is the summary of one of these scenarios as communicated by Merilee in a personal letter. The scenario is titled "Family Ghost": "It's the story of a family, at home, hearing a strange sound one night when father is away. My sister lies down for a rest and has a dream where she sees an ancestor killing someone; she wakes up in fright as if the sound is coming from the ghost of this murdered butler; the family rush in when they hear her screams. Outside in the light of the moon they see it: the Ghost. Next shot a possum (small friendly marsupial)."

13. The term "expanded cinema" designates a trend in experimental cinema that plays on the transformation of conditions around traditional projections of film, especially in regard to the involvement of spectators themselves in the show. Expanded cinema is one aspect of "performance art." On this kind of cinema, see G. Youngblood, *Expanded Cinema* (London: Studio Vista, 1970); D. Noguez, *Éloge du cinéma expérimental* (Paris: Centre Georges Pompidou, 1979); and *Une renaissance du cinéma: le cinéma underground américain* (Paris: Méridiens Klincksieck, 1985).

14. Boris Eikhenbaum, "Problemes de ciné-stylistique," *Cahiers du cinéma* 220–221 (May–June 1970): 70–78, trans. Sylvianne Mossé and André Robel. This question of interior language was taken up again by Emilio Garroni in *Progretto di semiotica. Messaggi artistici et linguaggi non-verbali. Problemi teorici e applicativi* (Bari: Editoria Laterza, 1972).

15. For a definition of my notion of "mise-en-phase," see *Film and Theory,* ed. Robert Stam and Toby Miller: "By mise-en-phase, we mean the following: at every major stage in the story being told, the film produces a relationship between itself and the spectator (an affective positioning of the latter) which is homologous with the relationships occurring in the diegesis" (60); and Robert Stam, *Film Theory: An Introduction* (Malden, MA: Blackwell Publishers, 2000): "Mise en phase (literally the 'placing-in-phase' or 'phasing in' of the spectator), the operation which enlists all the filmic instances in the service of the narration, mobilizing the rhythmic and musical work, the play of looks and framing, to make the spectator vibrate to the rhythm of the filmic events" (255). See also R. Odin, "Mise en phase, déphasage et performativité dans *Le Tempestaire* de Jean Epstein," *Communications* 38 (1983): 213–38, and chapter 3 in my book *De la fiction*.

16. Here I am borrowing Umberto Eco's distinction between "to use" and "to interpret" a text. See *The Limits of Representation* (Bloomington: Indiana University Press, 1990).

17. It is to be noted that all films (even fictional films) may be read as documents.

18. P. Bourdieu, *Photography: A Middle-Brow Art* (Stanford, CA: Stanford University Press, 1990), 31–36.

19. On this notion, see Nelson Goodman, *Languages of Art* (Indianapolis and New York: Bobbs-Merrill, 1968), chapter 3.

20. Georges Perec, "Approche de quoi," in *Le pourrissement des sociétés*, 10/18 (Paris: UGE, 1975), 251–55.

21. The series was directed by Jean Pierre Alessandri and Jean Baronnet and narrated by Georges Perec, 1975.

22. A series directed by André Huet, Inédits series, 1986.

23. On this notion, see Erving Goffman, *Frame Analysis: An Essay on the Organization of Experience* (Cambridge, MA: Harvard University Press, 1974).

24. See my article "Rire et film de famille," in *Le genre comique*, R. Rolot and F. Ramirez, eds. (Montpellier: Centre d'Étude du XX siécle, Université Paul Valery, 1997), 133–52.

25. Perec, "Approche de quoi."

26. Karen L. Ishizuka, "The Home Movie: A Veil of Poetry," in *Jubilee Book: Essays on Amateur Film* (collective publication, Association Européene Inédits) (1977): 45–50.

27. See Goodman, *Languages of Art,* chapter 3.

28. See my article "Lecture documentarisante, film documentaire," *Cinémas et Réalités* (St. Etienne: C.I.E.R.E.C., Université de Saint-Etienne, 1984), 263–78; and my *De la fiction,* chapter 12.

29. I borrow this distinction from Jürgen Habermas, *The Theory of Communicative Action,* trans. Thomas McCarthy (Bloomington: Indiana University Press, 1973).

30. Michael Kubal is also the author of *Familien Kino, Geschicte des Amateurfilms in Deutschland,* 2 vols. (Reinbek bei Hamburg: Rowolt, 1980).

31. Bill Nichols, *Representing Reality* (Bloomington: Indiana University Press, 1991), 34–38.

32. On this theme, other than Gilles Deleuze, one can consult Jacques Aumont, *A quoi pensent les films* (Paris: Séguier, 1996).

33. Peter MacNamara, "Amateur Film as Historical Record: A Democratic History?" *Journal of Film Preservation*, no. 25 (1996): 53.

34. André Huet, "Approche de l'univers des Inédits," *Jubilee Book: Essays on Amateur Film* (collective publication, Association Européene Inédits) (1977): 28.

35. Patricia R. Zimmermann, "Cinéma amateur et démocratie," *Communications* 68 (1999): 281–92.

36. Suzanne Capau, "L'inédit et le droit: Ébauche d'un contrat," *Jubilee Book: Essays on Amateur Film* (collective publication, Association Européene Inédits) (1977): 117–22.

37. Umberto Eco, "TV: La transparence perdue," in *La Guerre du faux* (Paris:

Livre de Poche, 1988), 196–220 (the article was originally written in 1983). On this notion, also see Francesco Casetti and Roger Odin, "De la paléo- à la néo-télévision. Approche sémio-pragmatique," *Communications* 51, "Télévisions/mutations" (1990): 9–26. Dominique Mehl, *La télévision de l'intimité* (Paris: Seuil, 1996).

    38. Interview with Thomas Vinterberg, *Repérages* 4 (winter 1998–99): 13.

    39. Renaud Dulong, *Le Témoine ocupaire* (Paris: EHESS, 1998), 160.

    40. Richard Sennett, *The Fall of Public Man* (New York and London: W. W. Norton, 1974); Jürgen Habermas, *Strukturwandel der Öffentlichkeit* (Berlin: Neuwied/Rhin, 1962); Jean Baudrillard, *In the Shadow of the Silent Majorities, or The End of the Social and Other Essays.* trans. Paul Foss, Paul Patton, and John Johnston (New York: Semiotext(e), 1983).

# 26 The Stephen Lighthill Collection at the UCLA Film & Television Archive

*Los Angeles, California*

ROSS LIPMAN

The UCLA Film & Television Archive's collection has historically focused on professional film productions; its core consists of Hollywood studio features and Hearst newsreel footage. Over the years, however, a number of excellent examples of alternative film forms have made their way into the archive's vaults. Prominent among these is a growing collection of American independent cinema. By its very nature independent film crosses the boundaries between "professional" and "amateur" quite freely, often exhibiting characteristics of both within the same production. An illuminating instance of this dynamic is the Stephen Lighthill Collection at UCLA.

Stephen Lighthill, now a professional cinematographer, began his career in the Bay Area in the 1960s by documenting the antiwar and civil rights movements, both locally and nationally. He filmed scores of protests, demonstrations, and rallies, and also documented key cultural moments such as the first Human Be-In in Golden Gate Park in 1967. Lighthill was a journalism student with no professional production training, who was drawn into filmmaking through his own social activism.

His first major project as a cinematographer was *Sons and Daughters*, a documentary centering on the antiwar movement in Berkeley, by filmmaker Jerry Stoll. Out of this experience a number of the crew's members, who, like Lighthill, were primarily activists, formed American Documentary Films, a collective devoted to radical filmmaking. Lighthill later went on to become a stringer for CBS news, but maintained his involvement with activist cinema at the same time. He helped film the Rolling Stones' 1969 Altamont concert for the Maysles brothers' *Gimme Shelter*, and contributed to such documentaries as *Seeing Red, The Good Fight,* and *The Day after Trinity*. Not only did he serve as director of photography on Mark

Kitchell's *Berkeley in the Sixties,* but the film also included clips of both his activist footage and his CBS work.

The Stephen Lighthill Collection at the UCLA Film & Television Archive contains all the outtakes from *Sons and Daughters,* as well as a substantial amount of footage shot by Lighthill and others from the American Documentary collective. Together it comprises a treasure trove of moments from the turbulent era it documents. While it is heavily splattered with coverage of key figures of the era, ranging from Allen Ginsberg and Jerry Rubin to Huey Newton and Bobby Seale, it also documents the unseen faces in the crowd, the untold women and men who formed a generation. Their counterparts the police are documented too, in both clinical detail and occasional intimacy. Even bystanders play a part through their observations of the events around them. These glimpses are perhaps ultimately the most revealing, as we see in these faces a country trying to understand the drastic changes it's undergoing; in their confusion we feel both the political urgency of the times and the human sensibility behind them.

Lighthill himself admits that he was, at the time, somewhere in the gray area between professional and amateur. Technically the quality of the footage is that of a pro, but the proximity of the camera to the events it documents speaks of an involvement in the moment that is decidedly radical. The footage is thus both highly partisan and strangely neutral. Looking for the contemplative moment amid the flurry of activity, Lighthill lets his viewpoint be known while ultimately allowing the images to speak for themselves.

The footage is for the most part 16mm reversal, and encompasses both color and black and white and silent and sound footage. Large portions of the collection consist of Lighthill's original 400-foot camera rolls. It spans the period from the mid-1960s to the early 1970s, and includes Lighthill's work as both an amateur and professional. The rolls inspected thus far have not exhibited excessive deterioration, and UCLA is currently in the midst of transferring much of the footage to video to create viewing access copies. In this process, Lighthill's original footage logs, which are part of the collection, have served as an invaluable guide. Due to the collection's size, there is a great quantity that remains to be inspected and no doubt many gems await discovery.

Encompassing both professional and amateur filmmaking as it does, the Stephen Lighthill Collection is an excellent example of how independent cinema can infiltrate the mainstream and help to shape our cultural perceptions. Here at UCLA we are trying to expand notions of what comprises

our national cinema. In the heart of Hollywood, the well-composed images of Stephen Lighthill help disarm conventional critiques of amateur footage. As collections like this are recognized and utilized, the path is paved for a deeper understanding of the vast "nonprofessional" cinema that is the greatest record of so much of our culture.

## 27 Morphing History into Histories

From Amateur Film to the Archive of the Future

PATRICIA R. ZIMMERMANN

### I. Theory/Theories

A historiographic theory of amateur film must map localized microhistories rather than nationalized, phantasmatic representations. These microhistories hybridize the local with the global, the psychic with the political. Amateur films do not simply absorb history. Instead, they mobilize an active historical process of reimaging and reinvention.

If cinematic practices, technologies, sites, and histories are pluralized, how does historiography change? What models explain the endlessly mobile, contradictory histories of amateur film? This reconceptualization of amateur film as an active historical process transforms history into histories.[1] This historiography must move beyond the binary of the accomplished professional versus the deficient, privatized amateur. Shifting from artifactual evidence and static objects toward writing-of-histories, amateur cinema can be redefined as a plurality of practices: home movies, surveillance, narratives, experimental works, travelogues, documentaries, industrials, hobbies, sites for emergent subjectivities.

The archival, defined by Jacques Derrida as a psychoanalytic construct of memory and its creation, would no longer repress the trauma of the amateur as deviant.[2] The archival—continually rewriting to end repetition—would emerge as a plurality of practices working beyond the repression of difference and heterogeneity. The film archive and film history then shift from the collection of artifacts toward the multiplication of practices, technologies, discourses, and representations that refuse this traumatic absence.

Amateur film disrupts historiographic explanatory models of linearity, causality, and deductive evidentiary claims. Amateur film is more than a democratic technology reclaiming marginalized identities. Beyond cinematic

reparation, its images challenge nationalist representations of sameness. Amateur film historiography extends beyond artifacts produced and representations recovered.

This historiography requires engaging a performative practice of producing visualities.[3] Amateur film expands and complicates film history through its social, historical, and aesthetic flows, interventions, mergings. This new historiography suggests a more activist model of culture as a continual process of contention and debate over who speaks, from what position, and within what relationships of power.[4]

Many film scholars have noted how narrative, commercial cinemas function as national allegories. They invoke a mythologized and stabilized past for national identity formation. The difference between the national and the foreign is defined through separation.[5] In amateur films from a range of national, regional, and local archives, these national allegories and separations collapse into a range of differences, eruptions, discontinuities. These films suggest that microhistories are pluralized and discordant. Amateur film inscribes family life, minoritized cultural practices, fantasies, the quotidian. Amateur film contains the history of self-representation, an auto-ethnography. The amateur camera mediates between self and fantasy, between self and others.[6]

Amateur film marks both social and psychic relations. It is an open text in a dialectic with historical context. It writes the body into representation. Amateur film imagery functions as a nodal point where history, memory, the nation, the local, power, and fantasy condense. As visual texts, amateur films operate as traces rather than as evidence. They visualize historical contradictions. Rather than inert and mythologized national imaginaries, amateur film is always forming.[7]

Although colonized by Hollywood, trivialized as a toy, and imprisoned within the nuclear family, amateur films insist on the importance of everyday people within different communities and nations. Amateur film represents psychic tracings of diaries and dreams. The anthropological, the social, and the political press into these films, etching the ideological contradictions between the subjective and the public. In amateur film, the family, dreams, nightmares, and elsewheres create new hybrids to define the nation differently.[8]

Amateur films do not deploy any systematic cinematic language.[9] They reverse the relationship between text and context. Facts reveal fantasies, and fantasies expose facts. They present psychic imaginaries of real things, and figure material objects as psychic imaginaries. As a result, it is necessary to cross-section the sedimentary layers of historical context to deconstruct what is repressed and absent.

Amateur films are often viewed as cinematic failures infused by an innocent naivety and innocence, a primitive cinema without semiotic density.[10] Amateur films appear to lack visual coherence because they occupy unresolved phantasmatics. These lacks and insufficiencies create collisions between the political and the psychic, between invisibility and visibility.[11]

Amateur film's alterity requires analysis of active relationships between maker and subject, the international and the local, evidence and the imaginary. These works record marginal practices, but they also register complex social, historical, national, and psychic discourses.[12] Ultimately, home movies deconstruct the empiricism of the visual artifact.

## II. History/Histories

Most amateur films problematize oppositions between professional and amateur, dominant and emergent, national/international and local. Amateur films push questions of artistry—if defined as authorial genius and intervention into visual codes—to the sidelines. Analysis requires situating these films as historical formations rather than reified objects. How can historiography account for shifting relations between aesthetic, discursive, social, political, economic, and technological formations?

French historian Michel Foucault's historical project uncovered the power relations and knowledges in the marginal. Foucault argued history is always incomplete, filled with gaps, fissures, and ruptures. His method offers a way to position amateur film not as a text, but as a series of power relations and negotiations between dominant film practices and marginal ones, between privileged knowledges and delinquent ones, between grand schematics and more local, specific knowledges. Shifts and redistributions between discourses create new objects and new formations.[13]

Cultural production legitimated by capitalist exchange is privileged, shadowing other filmic artifacts produced within families, political collectivities, or marginalized identities. Amateur film poses a threat to more dominant visualities—it is heteroglossic, multiple; and it forms a significant site of cultural struggle over who has power to create media and to enter into representation.

Feminist scholars have argued that the private sphere of family, home, sexuality, reproduction, childrearing, celebrations, and mourning are significant micropolitical social struggles.[14] Cinema expresses a gendered division of labor: professional film is masculine, while amateur film is feminine. The regimented visual iconographies of the professional chart its psychoanalytic

identification with phallic power. Conversely, hysteria, chaos, excess mark the amateur. Early Kodak and Bell and Howell amateur movie cameras were often advertised with women operators, suggesting the camera was so simple, even a woman could operate it. Linking amateur cameras with the feminine, advertisements and how-to manuals aligned amateur film with consumption rather than production, a familial memory machine rather than a political history-making machine.

Amateur films map the private sphere from the point of view of the participants, collapsing the borders between subject and object. These films trace the melodrama of personal life and the idealized projections of family. They graph the contradictions between the realities of family life bounded by class, race, and gender expectations and the fantasies of the nuclear family, and they also reveal the nation's unfinished production of obedient subjects and histories.

The term "amateur" is rooted in nineteenth-century capitalism.[15] As entrepreneurial capitalism evolved into corporate capitalism, the term "professional" described desirable attributes of intellectual workers and corporate managers. As corporate bureaucracies engulfed engineers, designers, artists, and other entrepreneurs, the standardized professional as only a part of an organizational chain replaced the artisanal model of autonomy and control.

The professional was controlled, committed to an institution rather than the self, possessed reproducible skills, and functioned as an interchangeable part. The concept of the amateur, on the other hand, evolved as an antidote to the enervation of the professional, bureaucratized cog. The word *amateur* derives from the Latin word *amare*—to love. In the nineteenth century, amateurism of all forms—bicycling, painting, drama—emerged as a zone for all that corporate capitalism expelled from the workplace: passion, autonomy, creativity, imagination, the private sphere, family life. Professionalism was linked with rationalized work, the public sphere, and exchange relations. Amateurism was located within leisure, the private sphere, and hobbies. Corporate capital exiled the ragged remains of bourgeois individualism into amateurism.

Amateur technologies parallel the emergence of cinema in the late nineteenth century. From 1895 until 1923, different formats and technologies promoted by European inventors vied for—but never penetrated—the consumer market. Two versions of amateur film prevailed. Thirty-five-millimeter films shot by professionals chronicled the familial life of presidents, kings, czars, and corporate executives. Family films and actualities on formats ranging from 9.5mm to circular film to glass plates were shot by

less elite clientele. Amateur film was defined in technological terms. It was an experimental arena for entrepreneurs—a dying breed in an era of corporate capitalism and the middle-management engineer—outside of the monopoly control of the Motion Picture Patents Company that controlled all access to 35mm production.

A major shift occurred in the definition of amateur film in 1923. Bell and Howell and Eastman Kodak colluded to standardize the amateur film gauge as 16mm, ensuring an oligopoly over cinema technologies for the consumer. With the standardization of 16mm, amateur film transformed from an entrepreneurial battleground for competing patents into a consumer commodity aimed at families and copying Hollywood narrative forms.

From the 1920s until World War II, the aesthetic domain defined amateur film. A plethora of magazines geared to amateur filmmakers appeared, hawking Hollywood style as the pinnacle of cinematic perfection. Amateur film served as a training ground to create a new aesthetic consciousness about the perfection of classical Hollywood style. Women's magazines, family magazines, and arts magazines heralded amateur film as a new art form.

For the most part, amateur filmmaking was ideologically dominated by Hollywood: articles emphasized the harmony and beauty of Hollywood-style pictorial composition as well as control over narrative continuity. Professional editors and cinematographers who wrote for these amateur magazines imparted Hollywood narrative style. Some writers even supplied narrative scenarios of family life. They emphasized a reactionary stability into the visual register through a focus on nineteenth-century photographic pictorialism, an antiquated aesthetic by the 1920s.

These articles harbored a fear of constructivism, which would move image-making out of the home and into public life. Advocating discordant and jarring angles, constructivism disrupted ideas about harmony. Harry Alan Potamkin, a politically radical theorist, debunked Hollywood narrative style. His articles urged amateurs to employ constructivist principles by shooting factories, cities, and public life. Some writers hailed Soviet director Sergei Eisenstein as the greatest amateur of all time because he used real people and shot on location. Other writers, particularly in the magazine *Amateur Movie Maker,* adopted amateurism to enliven film as an art form, considered destroyed by the coming of sound in 1927.

By World War II, amateur cameras went to war along with B-52s and guns. The United States military drafted all 16mm equipment into the war effort. Amateur cameras were used for surveillance, for chronicling battles, and for training. For the first time, Hollywood cinematographers launched training sessions of cameramen for the military. Signal Corps cameramen

were told to shoot with cameras and guns, thereby equating the camera eye with the barrel of a gun. World War II substantially legitimated amateur film. It standardized 16mm as a semiprofessional medium, increasing the number of professionally trained operators. It standardized equipment by augmenting its interchangeability, and initiated a new standard of participatory, handheld camerawork, derived from shooting in the trenches, as a more phenomenological realism.

By the 1950s, amateur film was almost completely isolated within the bourgeois nuclear family. As 16mm became standardized and as the semiprofessional market for educational, news, and industrial film expanded, the democratic potential of amateur film was contained. During this period, amateur film collapsed into home movies. It was redefined as a social relation between families, rather than as an art form or a public intervention. New formats like 8mm that could not be publicly exhibited proliferated, creating an amateur class hierarchy based on manipulation of cameras.

Endless articles appeared in women's magazines that directed amateurs toward shooting their families. The nuclear family's greatest form of recreation was itself, and its endless reproduction in imagery. Reproduction here traversed two practices: actual physical reproduction of babies, and then their visual reproduction in home movies. Home movie equipment sales boomed, with camera gear seen as important as barbecue grills for family togetherness. In the United States, the do-it-yourself movement, dedicated to family occupations such as fixing up one's own home and a variety of hobbies, engulfed amateur filmmaking. Filmmaking became the visual equivalent of gardening: an activity in the family home rather than on the streets.

As the nuclear family became increasingly isolated in suburbia, cut off from the differences erupting in urban life, cameras emerged as the tools that etched out the privileging of the family and patriarchal power. Fathers took more pictures than mothers, and children were photographed more than almost anything else, according to a marketing study conducted by Bell and Howell in the mid-1950s. During this period of increasing isolation and enervation of amateurism within the bourgeois home, several strains of resistance did emerge, among them the development of an experimental film movement in the United States based on 16mm, and the use of cameras within community groups to document the civil rights struggles in the South.

The history of amateur film technology progressed toward smaller equipment, simpler usage, and an increased emphasis on family. The democratic potential of amateur film was gradually stripped away in a series of redefinitions, first technological, then aesthetic, then social and political. The

history of amateur film betrays how dominant cultural practices like Hollywood narrative style and familialism truncated its emergent radical possibilities. Aesthetic standards imported from Hollywood style colonized amateurism. Social relations inserted amateur film into the bourgeois nuclear family, exiling it from the public sphere.

## III. Imagery/Imaginaries

This section elaborates three different stages of amateur film history and technological formats. It analyzes works from three different specialized archives. Produced by women, these works illustrate the gendering and racialization processes inscribed into amateur practices and formations.

The amateur films of Miriam Bennet, daughter of a well-known Wisconsin photographer, which are housed in the Wisconsin State Historical Society, exemplify amateur filmmaking that moved away from the nuclear family into the realm of narrative. The Amateur Cinema League, the largest organization for amateur film aficionados in the United States, sought to reinvigorate cinema as an art form rather than as a corporate enterprise ensconced in Hollywood. Although the league championed antirealist formal approaches, it advocated a rededication to the art of cinema as the "seventh art" more than as an antinarrative visual experimentation. The league ran yearly contests, circulated amateur films, and held exhibitions, functioning as an Americanized, hobbyist version of the more avant-garde and politically oriented cine clubs.

A Study in Reds (1927) creates an imaginary narrative where Wisconsin middle-class women are suddenly catapulted into Soviet society, a culture without men, without leisure, without capitalism. Produced before the stock market crash of 1929 and ten years after the Bolshevik revolution, the film is suspended between a series of global reorderings. It also evokes the long tradition of social activity in the Midwest. The film suggests cinema as a collective, leisure-time, club enterprise. It also refutes the idea that all amateur film be collapsed into the universalizing rubric of the family-centered home movies.

This film invokes a performative narrative: the women in the film play at communism as they drop their children off at daycare, work in the fields, saw down trees, labor in the factories, participate in a firing squad. The film operates more as a record of fantasy than as a record of history. It presents history, instead, as an inflection of fantasy to restructure women's lives.

This performativity displays identity as that which can be remade differently on celluloid than in life, a malleable rather than an inert state. In *A Study in Reds,* the snowy, barren landscapes of Wisconsin are refigured as the stark landscapes of the Soviets, a reimagining of space and place suspended between the ideological and the fantastic. What was Wisconsin is now Russia, what was middle class is now the worker, what was family life is now daycare.

Although the film could easily be read as an anticommunist diatribe, showing the horrors of the life of a woman who is controlled by the party and forced to labor outside the home, the visual structure of the film circumvents its overt political ideology. Scenes inside a middle-class drawing room, with finely dressed ladies gathered in a circle for a club meeting, bookend the narrative. Some embroider, some apply makeup, others are bored. The middle of the film, where the ladies are transformed into Bolsheviks, occupies the most screen space.

The film assigns more screen space to the Soviet fantasy section than to the more realist narrative inside the home. While the middle-class Wisconsin women sit on chairs inside the home, in the Soviet fantasy sequences they do physical labor outside, work on the farms, and operate heavy machinery. The film spatializes women's bodies differently within capitalism and communism. Although it mocks communist death squads as a reaction to insufficient egg production by hens, the film presents women as active producers.

*A Study in Reds* demonstrates how classical realist narrative and avant-garde tropes blur together in amateur film. The film employs realist cinematic forms, with long takes and minimal editing. It focuses on group activities, a visual trope in many amateur films that frequently recorded church, school, and country club performances. The camera is distanced from the subjects. *A Study in Reds* is shot mostly in medium and medium long shot, with very few close-ups and shots of individuals, a nascent cinema of collective identity. The Soviet section of the film evidences more plot development than the bracketing story: the day progresses, deviations are noted, a woman is slated for execution.

The film borrows visual tropes from surrealism, with a framing sequence spurring dreams. The first transition into the Soviet section is marked by blurred imagery, suggesting transformation. The second transition back to the middle-class parlor entails a close-up of clapping hands abstracted from space. Further, resonating with *Entr'acte,* the film works with actors who perform as a group, ostensibly engaging in absurd activities like running machines and working the fields. Babushkas, groups of women, snow, aprons, fur hats, and stars sewn into coats signify communism.

*A Study in Reds* highlights the conceptual difficulties in reading amateur films as only histories from below. As the narrative mixes in fantasy, the question as to what history these images are actually documenting arises. This film transfigures historical facts and representations. The immobilization of the women in the bracketing story evokes the enervation of middle-class women. Conversely, the fantasy story entails action through imaging different economic and social structures. *A Study in Reds* shows daycare, women's work, collective activity, images virtually absent from commercial films. While it can be read as an anticommunist warning about the horrors of communism for women, it can equally be read as the making-legible of fantasies beyond men and family.

This historiographic question of how to read the slippery, unstable, sexual, national, international, and colonial politics and fantasies in home movies also emerges in footage shot in Africa. For example, a jittery color medium shot of a rural village in the Belgian Congo surveys circular thatched huts. A large, huddled mass of Pygmies engulfs a middle-aged white woman in a belted pink dress and heels, a still camera draped around her neck. She remains physically distant from them. They whisper into one another's ears.

The white woman frantically motions to her camera, pantomiming a request for the Pygmies to perform a traditional tribal dance for the camera. Fifty-one short, choppy, canted medium shots of partially clothed Pygmies unfold. They dance in a circle. Some blow reed pipes. They gingerly peep at the camera. Unedited, visually congested, shaky close-ups of Pygmies unspool in rapid-fire succession. The dancers swarm around the filmmaker. A black man in Western khaki stands next to a Pygmy man who reaches his hip. He pats the Pygmy on the head, then smiles at the camera.

Ethel Cutler Freeman shot these 16mm color images, housed in the Human Studies Film Archive of the Smithsonian Institution, during the winter of 1949–50. Freeman, a wealthy East Coast woman, mother of three grown children, and grandmother, embarked on a grand tour of Africa from South Africa through Kenya, the Congo, and Egypt with her invalid husband, Leon. Freeman occupies multiple subject positions: wife, nurse, anthropologist, tourist, collector, filmmaker, socialite, civil rights advocate. Influenced by her teacher Margaret Mead, Freeman kept meticulous diaries and field notes. The footage doubles as travelogue and amateur anthropological research. In Freeman's footage, productive leisure, science, technology, travel, the developing world, race, class, and gender constitute the contradictions of the eyes of the white empire before decolonization.

Freeman's African travel films enunciate a mobile panopticon, a gaze endowing the amateur camera with mobility in and out of difference—a

privilege enjoyed by the white majority. Figuring the African continent as a seething cauldron of ethnic multiplicity requiring categorization and cataloguing, the films merged a residual imperialist nineteenth-century anthropological discourse with 1950s economic imperialism. In Freeman's footage, Africa represents a disorganized multiplicity that the filmmaker will order, control, verify, and specify through science.

This struggle between the perception of chaotic collectivities and the ordering logic of representation establishes first world authority, an epistemological maneuver embedded in traditional ethnography. Freeman's footage performs an act of negation, creating an Africa of the unconscious. In visualizing scientific tropes of categorization, it represses the larger political and social processes of rural destabilization, agricultural decline, and hunger; movement from rural areas to urban areas; and decolonization and national liberation movements that characterize this period of African history.

In her diaries, Freeman abhors apartheid. Returning to the United States, she agitated against it. Her footage maps bodies under apartheid's pass laws—the white female body travels with a camera while the black immobilized body is displayed. In Freeman's films, apartheid visually orders all of Africa. Africa's multiplicities of nations, ethnicities, identities, and regions are simplified to a universalized blackness, regulating racialized bodies as a single controllable mass. Freeman's imagery traverses cruise ships with white people, estates, villages, the poverty of shantytowns. The rapidity and incoherency of these images suggest an inventory of hystericized otherness. Freeman slips in and out of various social and racial structures. Her documentation of tribes concludes with lovely continental dinners at the finest hotels—served by black Africans.

The Freeman footage does more than fragment racialized bodies from time and space through the jump cuts. Ethel Cutler Freeman's diaries describe her trip as escape from the enervation of her ailing husband, Leon, who limited her more scholarly aspirations. She collected clippings on apartheid from around the world. She corresponded with liberal white South Africans who opposed apartheid. In the early 1950s during the U.S. Civil Rights Movement, Freeman lectured in churches and garden clubs, screening her films to decry apartheid. The antiracist circulation of these images exceeds—and complicates—their own visual inscriptions of a racialized gaze.

Home movies can also serve as ethnographies of feminized and maternalized spaces. Gladys Steputis's reel *Doing the Twist* (1961, 8mm) is housed in the collections of Northeast Historic Film in Bucksport, Maine. As a visual record, it chronicles the deep snow of Maine winters and one family's attempts

to clear it away for the Christmas holidays. As a social imaginary, it sketches a snowstorm in the suburbs, a middle-class surreal world without people.

Its lack of editing, its medium shots strung in a sequence of jagged jump cuts, and its cockeyed horizon lines indicate an incoherent congestion of images. These aesthetic structures also privilege the manufacture of facticity over the consumption and circulation of images. As characters perform for the camera and gaze with full frontal views, the proto-Brechtian elements of the shooting foreground the relationships between Gladys Steputis and her daughters and husband, rather than control over the technological and aesthetic apparatus. This film traces tributaries of familial relations, showing how parenting flows into the visualities of the cinema machine through performance, embraces, machines, bodies.

Beyond the surface characteristics of familialism and the maternalization of the cinematic apparatus, *Doing the Twist* both condenses and problematizes maternity, nation, and geography. These moves displace the familial as natural. Instead, they refigure it as performative, an endless shuttle among fantasy, fiction, and documentation.

*Doing the Twist*'s two-part structure migrates from public space to private space. The reel begins with long shots of a suburban home, surrounded by snow piled high. A man shovels. The next several medium shots show young women jumping into snow banks, shoveling, tossing snow. They look at the camera. In many shots, the image is obscured by a finger over the corner of the lens. This obstruction imprints the film as something that is handmade, a nascent self-reflexivity.

These cinematic mistakes where Gladys's gloved finger intrudes suggest a breakage in the text: they speak the trauma of cold, of snow, of holding a small camera without direct contact to the skin. The image is not simply an image of Gladys's daughter, but of the intimacy between mother and daughter.

The second half of the film moves inside into the family living room, decorated for the holidays with the words "Merry Christmas" strung over the window. The first shot shows two young women doing the twist, their circular, labyrinthine body movements intertwining in sync. The parents awkwardly imitate the dance; a young girl twists alone. In the last shot, the family reunites, twisting together in front of the Christmas tree.

*Doing the Twist* braids together the psychic and the popular, the regional and the national. The film travels from the streets to the living room, from cold to warm. It moves from fragmenting the family into separate shots to the familialist fantasy of togetherness in the final shot, repairing the trauma of separation. It shifts from snow as a regional index of difference of

extreme weather into a larger, more idealized conflation of winter into Christmas.

*Doing the Twist* marks the body as a site for historical inscription. In the first half of the film, the body is outside, overpowered by place, stilled by snow, shoveling. Inside, the bodies shed their jackets and dance, translating the larger youth subcultures of rock and roll into the home. The young women ecstatically dance together, signifying that these bodies are not yet maternalized. The adult dancers are physically inept. *Doing the Twist* shows how amateur film performativity functions as a node for the overlapping discourses of the family, youth subcultures, weather, domestic space, and region.

## IV. Endings/Beginnings

Amateur films graph visual, discursive, and psychic vectors. The visualities of amateur films figure as a continual enfolding of text into context and bodies into text. The film archive, as a result, is infinite. It is constantly beginning rather than ending, opening up rather than closing.[16] Amateur film imagery makes legible the invisible history of psychic fantasies and reconnects the local to the global. In amateur film, various regional identities and practices pluralize and specify places as they problematize unified national imaginaries.

Amateur films urge us all—scholars, filmmakers, archivists, curators—to reimagine the archive and film historiography. They suggest the impossibility of separating the visual from the historical and the amateur from the professional. Our collective film archive of the future demands a new historiography that embraces multiple cinematic forms. Rather than ending, we need new beginnings: we need to imagine the archive as an engine of difference and plurality, always expanding, always open.

## Notes

A different and longer version of the arguments developed in this essay was previously published in "Morphing History into Histories: From Amateur Film to the Archive of the Future," *The Moving Image: The Journal of the Association of Moving Image Archivists* 1, no. 1 (spring 2001): 109–30.

I would like to acknowledge the collegiality and intense intellectual exchanges with Karen Ishizuka, Jan-Christopher Horak, Karan Sheldon, and Anna Siomopoulos that have contributed to the development of the arguments in this essay.

1. For a discussion of microhistories, see Ewa Domanska, *Encounters: Philosophy of History after Postmodernism* (Charlottesville: University of Virginia Press,

1998); and Robert Berkhofer Jr., *Beyond the Great Story: History as Text and Discourse* (Cambridge, MA: Harvard University Press, 1995).

2. For a discussion of the archive as the repression of trauma, see Jacques Derrida, *Archive Fever* (Chicago: University of Chicago Press, 1998), 11–23.

3. See Patricia R. Zimmermann, *States of Emergency: Documentaries, Wars, Democracies* (Minneapolis: University of Minnesota Press, 2000). For explication of the necessity of analyzing the historical in variegated and multiple practices, see Andrea Liss, *Trespassing through Shadows: Memory, Photography and the Holocaust* (Minneapolis: University of Minnesota Press, 1998); and Marita Sturken, *Tangled Memories: The Vietnam War, the AIDS Epidemic, and the Politics of Remembering* (Berkeley: University of California Press, 1997).

4. For explication of Michel Foucault's historical methodology, see his *The Archaeology of Knowledge* (New York: Pantheon, 1972); and Donald F. Bouchard, ed., *Language, Counter-Memory, Practice: Selected Essays and Interviews* (Ithaca, NY: Cornell University Press, 1977).

5. See Slavoj Zizek, *The Plaque of Fantasies* (London: Verso, 1977). For an explication of the relationship between history and nationalism, see Homi K. Bhabha, "DissemiNation: Time, Narrative, and the Margins of the Modern Nation," in Homi K. Bhabha, ed., *Nation and Narration* (New York: Routledge, 1990), 184–222.

6. For an analysis of how trauma and memory require mediation, see Cathy Caruth, ed., *Trauma: Explorations in Memory* (Baltimore: Johns Hopkins University Press, 1995); and Shoshana Felman and Dori Laub, *Testimony: Crises of Witnessing in Literature, Psychoanalysis and History* (New York and London: Routledge, 1991).

7. Various scholars have mined how the nation and the national imaginary are constantly rewritten, including Zillah R. Eisenstein, *Hatreds: Racialized and Sexualized Conflicts in the 21st Century* (New York: Routledge, 1995); Frederick Buell, *National Culture and the New Global System* (Baltimore: Johns Hopkins University Press, 1994); and Andrew Parker, Mary Russo, Doris Sommer, and Patricia Yaeger, eds., *Nationalisms and Sexualities* (New York: Routledge, 1992).

8. The issue of psychic imaginaries and their relationships to border issues and the nation as more hybrid than unified are discussed in Vivian Sobchak, ed., *The Persistence of History: Cinema, Television, and the Modern Event* (New York: Routledge, 1996); and Jim Pines and Paul Willemen, eds., *Questions of Third Cinema* (London: British Film Institute, 1989).

9. For detailed analysis of the formal textual system of classical Hollywood film, see David Bordwell, Janet Staiger, and Kristin Thompson, *The Classical Hollywood Cinema: Film Style and Mode of Production to 1960* (New York: Columbia University Press, 1985). For more contextual analysis of the relationship between visual styles and historical contexts, see David E. James, *Allegories of Cinema: American Film in the Sixties* (Princeton, NJ: Princeton University Press, 1989); and Jan-Christopher Horak, ed., *Lovers of Cinema: The First American Film Avant-Garde, 1919–1945* (Madison: University of Wisconsin Press, 1995).

10. This configuration of amateur film as quaint, naive, pure, and uncorrupted, as well as semiotically primitive, is most frequently found in remediations of amateur

film in commercials, music videos, commercial television documentaries, and commercial narrative films that emphasize its nostalgic qualities, as a fragment of time frozen outside of historical relations and social contexts.

11. The question of the ideological fault lines between visibility and invisibility can be found across a variety of disciplines. For an example of this issue in film studies, see Chris Holmlund and Cynthia Fuchs, eds., *Between the Sheets, in the Streets: Queer, Lesbian and Gay Documentary* (Minneapolis: University of Minnesota Press, 1997). For a discussion of this issue of postcolonial studies, see Angelika Bammer, ed., *Displacements: Cultural Identities in Question* (Bloomington: Indiana University Press, 1994).

12. For an analysis of how this issue of discourse has revolutionized historiography, see Keith Jenkins, ed., *The Postmodern History Reader* (London and New York: Routledge, 1997), 239–386.

13. See Michel Foucault, *Power/Knowledge: Selected Interviews and Other Writings, 1972–1977* (New York: Pantheon, 1980).

14. Marianne Hirsch, *Family Frames: Photography, Narrative, and Postmemory* (Cambridge, MA: Harvard University Press, 1997), 41–112.

15. The historical arguments in this section of the essay are derived from my previous research on amateur film history and technology, *Reel Families: A Social History of Amateur Film* (Bloomington and Indianapolis: Indiana University Press, 1995).

16. For one of the few histories of the international movement to create film archives for the preservation of film, see Penelope Houston, *Keepers of the Frame: The Film Archives* (London: British Film Institute, 1994).

# Selected Filmography and Videography

COMPILED BY LIZ CZACH

By its very nature, any filmography/videography necessitates making difficult selections and ultimately excludes many important films and videos. Thus, the works selected for inclusion in this filmography/videography are meant to be illustrative, rather than exhaustive, of the kinds of films and videos that engage with the home movie. Many of the works discussed in the essays of this volume were selected for inclusion. However, the myriad amateur film reels housed in the various national and international archives discussed in this volume are not included because they are noncirculating archival materials. Researchers interested in these works should contact the archives directly to inquire about research copies and permission to screen. The remaining films and videos were chosen to reflect the multiple ways that the home movie image has been reprocessed and the various strategies for its recontextualization. These films span a vast array of genres, from experimental films and documentaries to narrative fiction films, and reflect a myriad of strategies employed in working with the home movie image. I have attempted to select films from both established practitioners and emerging artists that illustrate different modes of intervention in working with amateur footage. These films employ strategies of rereading, reprocessing, and remaking the home movie to bring forth a multiplicity of possible meanings, among them the home movie as document, testimony, and evidence. They also reveal the potential trace of psychic trauma in what the home movie image has long repressed.

The films included here attest to the growing interest and engagement with home movies apparent among filmmakers, scholars, and archivists. These films make evident how much we can learn from the home movie. In light of the prevalence of home moviemaking in the West, productions from the United States, Canada, and Europe predominate. It should be made clear

that these films explicitly engage with home movie imagery, that is, moving images produced initially for private consumption in the private sphere that have been made public through their repurposing. Not selected for inclusion are those films that exhibit a homemade aesthetic of "rawness" (among other codes) common to the avant-garde and increasingly evident in commercial filmmaking.

This filmography is intended to function on multiple levels. At its simplest, it provides information for those films in distribution that the reader may wish to seek out. Furthermore, it is hoped that this filmography will provide a valuable tool for research and education on the home movie image, thus furnishing a reference guide for those wanting to pursue specific areas of interest, such as courses on amateur filmmaking, home movies, or documentary. Additionally, this filmography need not be confined to use within film studies, as many of the films elucidate debates and discussions in other disciplines such as history, labor studies, queer studies, Asian American studies, African American studies, women's studies, and Latin American studies. Home movies provide a rare glimpse into the private world of the everyday, and so these films offer a peek into private histories that have remained buried for too long.

*Adria: Holiday Films 1954–1968 (School of Seeing)*, Gustav Deutsch, Austria, 1990, 35:00, 16mm (Canyon, sixpackfilm). A collection of countless holiday films filled with clichés. The material dates from the '50s and '60s; Deutsch orders the clichés systematically and edits them into small series.

*Angelo's Film*, Péter Forgács, the Netherlands, 1999, 60:00, video (Lumenfilm). Constructed entirely from the amateur films shot by Greek aristocrat, entrepreneur, and former naval officer Angelo Papanastassiou. Although filming was forbidden by the Nazis, Angelo used a hidden camera, shooting the devastation caused by the Nazis during their occupation of Greece.

*Back in the Saddle Again*, Scott Stark, USA, 1997, 10:00, 16mm (Canyon). A found-footage film in which a family sings along as a group with Gene Autrey's title song. The film features Western fantasy, American kitsch, gender posturing, and the deterioration of the film's surface.

*Balkan Inventory*, Yervant Gianikian and Angela Ricci Lucchi, Italy, 2000, 62:00, 35mm (MOMA). An experimental documentary that examines the history of Yugoslavia and the Danube River through fragments of old newsreels and amateur footage.

*Blue Movie*, Mark Street, USA, 1994, 5:00, 16mm (Canyon). Constructed from old porno films that have been handpainted, this film questions the emotion behind the mechanized performances.

*Bontoc Eulogy*, Marlon E. Fuentes, USA, 1995, 56:00, video (California, Cinema Guild). Part truth, part fantasy, *Bontoc Eulogy* combines archival photos and

footage with contemporary live-action scenes, exploring the complex psychology behind the 1904 Saint Louis World's Fair, where race, science, and politics intertwined.

*Covert Action*, Child Abigail, USA, 1984, 10:00, 16mm (CFMDC, FMC, Canyon). This film examines the seduction behind social interaction, remaking these gestures into a dance through the use of looped home movies.

*The Danube Exodus*, Péter Forgács, Hungary, 1998, 60:00, video (Lumenfilm). The film is comprised of footage shot from 1938 to 1945 by a riverboat captain on board a ship cruising the Danube. The film chronicles the transformation of his elegant boat into a refugee liner for escaping Jews, who were fleeing on the Black Sea to reach Palestine.

*Daughter Rite*, Michelle Citron, USA, 1979, 53:00, 16mm (WMM). Combining home movies, a dreamlike voiceover, and scripted cinema vérité sequences, the film extends the language of feminist documentary.

*Destroying Angel*, Philip Hoffman and Wayne Salazar, USA, 1998, 32:00, 16mm (CFMDC). An experimental documentary that relates two stories of illness and weaves them into a filmic tapestry of family history, memory, and loss. A moving portrait of the struggles involved in dealing with AIDS, cancer, memory, and intimate relationships.

*The Devil Never Sleeps (El Diablo nunca duerme)*, Lourdes Portillo, USA/Mexico, 1994, 82:00, video, 16mm (WMM). Using clips from television soap operas, 8mm home movies, archival footage, family photographs, and stylized visual reminiscences, Portillo exposes the loves and hatreds of a Mexican family shaken by the death of one of its members.

*Don't Fence Me In*, Nandini Sikand, India, 1998, 55:00, video (WMM). Set against the broader backdrop of modern India's political and social history, this documentary examines the life of the filmmaker's mother from childhood to maturity, incorporating black-and-white photos as well as clips from home movies.

*É Minha Cara (That's My Face)*, Thomas Allen Harris, USA, 2001, 56:00, digital betacam. An autobiographical documentary, shot entirely in Super 8mm, exploring black identity in the United States, Brazil, and Africa. The video is available through amazon.com or Chimpanzee Productions (www.chimpanzeeproductions.com).

*Everything's for You*, Abraham Ravett, USA, 1989, 58:00, 16mm (Canyon). A meditation on filial relationships featuring the filmmaker's deceased father, a man who survived both the Lodz Ghetto and Auschwitz. The film utilizes a combination of family photographs, archival footage, optically printed footage, animation, and computer graphics.

*The Exquisite Hour*, Phil Solomon, USA, 1989 (revised 1994), 14:00, Super 8mm and 16mm (Canyon). In a montage of painfully vivid home movies from the '20s, death is evident in the slack mouth of an aged patient who's spied through a window, a young girl's plaintive Hebrew song, and shots of charging lions. A melancholic lament for the dying.

*Eyes on the Prize: America's Civil Rights Years, 1954–1965*, Henry Hampton (producer), USA, 1987, 6 hours, video (Blackside). A six-part documentary series that

focuses on individual stories of the movement for social change in the words of both famous and lesser well known participants.

*Eyes on the Prize II: America at the Racial Crossroads, 1965–mid-1980s,* Henry Hampton (producer), USA, 1990, 8 hours, video (Blackside). Through historical footage and contemporary interviews, the films examine the triumphs and failures of individuals and communities eager to realize the Civil Rights Movement's hard-won gains.

*Family Album,* Alan Berliner, USA, 1986, 60:00, 16mm (MOMA, FMC, Milestone). An experimental documentary utilizing a vast collection of rare 16mm home movies from the 1920s through the 1950s. It explores traditional home movie idioms, including mixed racial, ethnic, economic, and geographic sources.

*Family Viewing,* Atom Egoyan, Canada, 1987, 86:00, 35mm (Zeitgeist). A young man discovers that his childhood home videos have been erased to make room for his father's homemade sex tapes.

*Father and His Three Sons—The Bartos Family (Private Hungary 1),* Péter Forgács, Hungary, 1988, 60:00, video (EAI). This film is constructed from the diary films of Zoltan Bartos, amateur filmmaker and composer of popular dance music. Shot from the 1920s through the middle of the 1950s, the film reflects both private and official history.

*Final Cut,* Matthias Müller, Germany, 1986, 12:00, Super 8mm (Canyon). Super 8mm as the medium of individual memory is used to express the essence of personal relationships; the filmmaker literally has the "final cut" with regard to his father's home movies.

*First Person Plural.* Deann Borshay Liem, USA, 2000, 56:00, video (NAATA). This personal documentary chronicles the filmmaker's struggle to reconcile two families, her adoptive white American family and her Korean birth family.

*Frank's Cock,* Mike Hoolboom, Canada, 1993, 8:00, 16mm (CFMDC). Employing a split screen, this film juxtaposes a variety of images—from gay porn, sex ed films, and home movies—constructing an extremely explicit assault on love and AIDS.

*The Great Depression,* Henry Hampton (producer), USA, 1993, 7 hours, video (Blackside). This series portrays Depression America at its most vulnerable and most courageous. People are the center of this story of the era—not just the well-known heroes and politicians, but the unsung women and men who were the agents of change.

*Happy End,* Peter Tscherkassky, Austria, 1996, 12:00, 16mm (Canyon, sixpackfilm). A found-footage film incorporating the home movies of a festive Viennese couple who filmed themselves over the 1960s and '70s.

*History and Memory,* Rea Tajiri, USA, 1991, 30:00, video (EAI, WMM). An exploration of personal and cultural memory that juxtaposes Hollywood images of Japanese Americans and World War II propaganda with stories from the videomaker's family during the Japanese internment.

*The House of Science: A Museum of False Facts,* Lynne Sachs, USA, 1991, 30:00, 16mm (Canyon). This film explores society's representation and conceptualization of women through home movies, personal reminiscences, staged scenes, found footage, and voice.

*Human Remains,* Jay Rosenblatt, USA, 1998, 16mm (Canyon). The banality of evil is illustrated by creating intimate portraits, including home movie footage, of five infamous dictators: Adolf Hitler, Benito Mussolini, Joseph Stalin, Francisco Franco, and Mao Tse-tung.

*In Memory,* Abraham Ravett, USA, 1993, 13:00, 16mm (Canyon). A projected memorial to members of Ravett's family and all those who died under the Nazi occupation.

*Intimate Stranger,* Alan Berliner, USA, 1991, 16mm (Milestone, Facets, Canyon). An engaging portrait of the filmmaker's maternal grandfather, Joseph Cassuto, a Palestinian Jew who was a cotton buyer for the Japanese in Egypt prior to World War II. The film is constructed from archival material and home movie footage.

*Iota,* Carolyn Faber, USA, 1998, 6:00, 16mm (Internet Archive [www.archive.org]). An optically printed found-footage film in which a four-second segment of an anonymous Super 8 amateur film is blown up, slowed down, and repeatedly rephotographed, suggesting a way of looking at ephemeral artifacts of time, place, and celluloid.

*Karagoez,* Yervant Gianikian and Angela Ricci Lucchi, Italy, 1979–81, 54:00. A compilation made from 1920s home movies shot with a 9.5mm camera in Europe and Russia.

*L'amateur (Camera Buff),* Krysztof Kieslowski, Poland, 1979, 112:00, video (Facets). In Communist Poland, a young father with a home movie camera intends to film his newborn daughter but is suddenly filming everything in sight, including things the authorities would rather not have exposed.

*La rêve de Gabriel,* Anne Lévy-Morelle, Belgium, 1996, 52:00 and 83:00, 35mm (Sokan). In 1948, four large, wealthy Belgian families sell all their belongings and embark on a voyage to Patagonia. Slowly most of them return, but Gabriel, one of the fathers, stays until his death in 1988.

*Last Night in Cuba,* various, USA, 2001, video (University of Miami). Narrated by a young woman who left Cuba in the 1980s, the documentary features interviews with ten Cubans of different economic status and ethnic backgrounds who left their island country during the first wave of exodus between 1959 and 1963.

*Laurent et Stephane,* Alexandre Valenti, France, 1991, 26:00, video (Le Journal de la Santé). This documentary follows two hemophiliac children, infected with AIDS after a transfusion, who are filmed by their father for the duration of their illness.

*Les yeux d'Eva Braun,* Patrick Jeudy and Gérard Miller, France, 1991, 52:00, video (TF1). The events that Eva Braun, Hitler's mistress, refused to see for ten years, 1935–45.

*A Letter without Words,* Lisa Lewenz, USA, 1997, 62:00, video (Lisa Lewenz). The filmmaker uncovers a forgotten personal history when she finds her grandmother's home movies, made during a period when the Nazis prohibited independent filmmaking.

*Letters from Home,* Mike Hoolboom, Canada, 1996, 15:00, 16mm (CFMDC). Beginning with a speech by Vito Russo, *Letters* enjoins a chorus of speakers to sound off on AIDS, love, and death. A series of mini-portraits generously

furbished with found footage extracts, hand-processed dilemmas, home movies, Super 8 psychodramas, and pixilated phantasms.

*Lumumba: Death of a Prophet (Lumumba: la mort du Prophète)*, Raoul Peck, France/Germany/Switzerland, 1992, 69:00, video (California Newsreel). Haitian filmmaker Raoul Peck examines home movies, photographs, old newsreels, and contemporary interviews with Belgian journalists and Lumumba's own daughter to try to piece together the tragic events and betrayals of Lumumba's 1960 overthrow.

*The Maelstrom: A Family Chronicle*, Péter Forgács, the Netherlands, 1998, 60:00, video (Lumenfilm). The film chronicles the lives of the Dutch Jewish Peereboom family during the period 1933 to 1942, using the family's own home movies, along with segments filmed by the Reich Commissioner of Holland.

*Malcolm X: Make It Plain*, Henry Hampton (producer), USA, 1994, 138:00, video (Blackside). Malcolm X's story is told through the memories of people who had close personal and working relationships with him. Also included is extensive archival footage of Malcolm X speaking in his own words, at meetings and rallies and in media interviews.

*Mein Krieg (My Private War)*, Harriet Eder and Thomas Kufus, Germany, 1991, 90:00, video (Facets). A compilation of home movies and oral histories of six Wehrmacht soldiers who were involved in the Nazi invasion of Russia.

*Moeder Dao, de Schildpadgelijkende (Mother Dao, The Turtle-like)*, Vincent Monnikendam, the Netherlands, 1995, 90:00, video (Zeitgeist). A spare and elegant film constructed entirely from archival footage shot between 1912 and 1932 in the former Dutch East Indies.

*Moving Memories*, Karen L. Ishizuka (producer) and Robert A. Nakamura (creator and editor), USA, 1993, 31:00, video (JANN, Facets). *Moving Memories* is a journey into the 1920s and 1930s featuring restored and edited home movies taken by Japanese American immigrant pioneers.

*My Father's Camera*, Karen Shopsowitz, Canada, 2000, 59:28, video (NFB). The director weaves the history of home movies together with footage shot by her father and traces the history of home movies from the 1920s through the amateur explosion of the '30s and '40s and beyond.

*My Mother's Place*, Richard Fung, Canada, 1990, 49:00, video (Vtape). Using home movies and documentary footage, the director weaves together interviews with his mother and four women thinkers to explore the formation of consciousness of race, class, and gender under colonialism.

*90 Miles*, Juan Carlos Zaldívar, USA, 2001, 79:00, video (90 Miles). A personal documentary about a Cuban family caught in the clash between the United States and Cuba.

*Nobody's Business*, Alan Berliner, USA, 1996, video and 16mm (video only available, Milestone, Facets). Berliner takes on his reclusive father as the reluctant subject of this poignant and graceful study of family history and memory.

*Nursing History*, Marian McMahon, Canada, 1989, 10:00, 16mm (CFMDC). Having worked as a nurse for ten years, the filmmaker locates her inquiry historically, within her own past, as represented in the home movies made by her father.

*Obsessive Becoming*, Daniel Reeves, USA/Scotland, 1995, 55:00, video (Video Data Bank). Drawing upon a wealth of images created since the 1940s in his family's enthusiasm for capturing time through Polaroids and 16mm film, this free-form and surreal autobiography is concerned with childhood and adult rituals and the longing for meaning and connection during the often wildly absurd events of early life.

*Omelette*, Rémi Lange, France, 1998, 75:00, video (Re:Voir) A young man tired of writing and rewriting a screenplay decides to begin a Super 8mm film diary. He films his parents and those close to him and determines to tell them about his homosexuality.

*The Passage of the Bride*, Phil Solomon, USA, 1979–80, 6:00, 16mm (Canyon). Composed entirely from a 100-foot roll of footage of a wedding and what appears to be a honeymoon, this is a dreamy and hypnotic film in which Solomon compulsively repeats recognizable images until they melt like distilled essences of the originals.

*Positiv*, Mike Hoolboom, Canada, 1997, 10:00, video (CFMDC). A meditative examination of the issues of being HIV-positive, mixing sampled video footage from mass media, home movies, and original sources.

*Private Chronicles, Monologue (Tchastnye Khroniki. Monolog)*, Vitalij Manskij, Russia, 1999, 91:00, 35mm (d-net). Taken from over 5,000 hours of film material and 20,000 still pictures, these images made for home use—black and white, out-of-focus, coarse-grained, blurred—form a fictional biography of the collective life of a generation.

*Remains to Be Seen*, Phil Solomon, USA, 1989 (revised 1994), 17:30, Super 8mm, 16mm (Canyon). Dedicated to the memory of his mother, the film charts the passage from life to death. A series of fugitive images—pans of an operating room, an old home movie of a picnic, a bicyclist in vague outline—seem stolen from a family album of collective memory.

*Remembrance*, Jerry Tartaglia, USA, 1990, 5:00, 16mm (Canyon). An exploration of the filmmaker's obsession with strong female characters in Italian opera and in Hollywood movies, combining glimpses of an 8mm home movie and images of Bette Davis.

*Sea in the Blood*, Richard Fung, Canada, 2000, 26:00, video (Vtape). A contemplative and heartfelt personal essay about living in the shadow of illness. Multiple layers of images, including home movies and text, are used to reflect on personal history.

*Sermons and Sacred Pictures*, Lynne Sachs, USA, 1989, 29:00, 16mm (Canyon). Filmmaker Sachs returns to Memphis, her hometown, to listen to eleven people as they explore their almost forgotten pool of memories of a unique, religiously inspired filmmaker from the 1930s.

*She/Va*, Marjorie Keller, USA, 1973, 3:00, 16mm (Canyon). A young dancer re-choreographed through film editing. This film was originally made in standard 8mm, using home movie footage (from a neighbor) as source material and made on standard 8mm.

*Shifting Positions*, Kathy High, USA, 1999, 27:00, video (Video Data Bank). A semi-autobiographical/fictional trilogy exploring the topics of becoming queer later in

life, paternal dementia, and life crises. The relationship between father and daughter is looked at through home movies and documented intimate moments of private life.

*Silent Movie (Film Muet)*, Freda Guttman, Canada, 1994, 9:27, video (Vtape). A reworking of the filmmaker's 8mm home movie footage from the 1940s in which she is framed with her father and brother in a family narrative. The episode is retold three times to uncover the cultural constructs of patriarchy, male privilege. and female exclusion.

*Sink or Swim*, Su Friedrich, USA, 1990, 48:00, 16mm, video (Canyon, WMM). Through a series of twenty-six short stories, a teenage girl describes the childhood events that shaped her ideas about fatherhood, family relations, work, and play.

*Something Strong Within*, Karen L. Ishizuka (writer, producer) and Robert A. Nakamura (director), USA, 1995, 40:00, video (JANN, Facets). A haunting compilation of never-before-seen home movies of the forced removal and incarceration of Japanese Americans during World War II, including footage from within the internment camps.

*A Song of Air*, Merilee Bennett, Australia, 1987, 10:00 (Australian Film Commission). The filmmaker uses amateur films taken by her father of her and her family as the backdrop to the story of her family life.

*Sur la plage de Belfast (On the Beach at Belfast)*, Henri-François Imbert, France, 1996, 39:00, video (ADAV). An unfinished roll of Super 8 film from Belfast finds its way into the hands of a French filmmaker. The filmmaker decides to travel to Belfast to find the family in the home movie.

*The Ties That Bind*, Su Friedrich, USA, 1984, 55:00, 16mm, video (Canyon, WMM). An experimental documentary about the filmmaker's mother's life in Nazi Germany and her eventual marriage to an American soldier, mixing images of her current life in Chicago with archival footage of her life in Germany to create a dialogue between past and present, mother and daughter.

*Toyo Miyatake: Infinite Shades of Gray*, Robert A. Nakamura (director) and Karen L. Ishizuka (producer), USA, 2001, 28:00, video and 16mm (Japanese American National Museum). This documentary on the Japanese American photographer features his 16mm home movies of Los Angeles from the 1930s through the '60s. The film is also notable for employing rare 16mm footage of the Manzanar concentration camp months after its closing at the end of World War II.

*Treasures from the American Film Archives*, various, USA, 2000, 642:00, DVD (NFPF). This is a compilation of fifty preserved films from eighteen American archives spanning the years 1893 to 1985, encompassing everything from documentaries and home movies to experimental films and animation.

*The Way to My Father's Village*, Richard Fung, Canada, 1988, 38:00, video (Vtape). This experimental documentary examines the way that children of immigrants relate to the land of their parents. It is about the construction of history and memory, the experience of colonialism, and Westerners looking at China.

*Wittgenstein Tractatus*, Péter Forgács, Hungary, 1992, 32:00, video (EAI). Forgács's *Wittgenstein Tractatus* is composed of seven short video essays that refer to one

of Wittgenstein's most influential works, *Tractatus Logico Philosophicus*. Black-and-white home movies from the early twentieth century are accompanied by voiceovers and written texts from the *Tractatus*.

*Zyklon Portrait*, Schogt Elida, Canada, 1999, 13:00, 16mm (CFMDC). *Zyklon Portrait* is a Holocaust film without Holocaust imagery: family photographs, underwater photography, and home movie imagery draw a personal story out of historical minutiae.

# Selected Bibliography

## COMPILED BY LIZ CZACH

This bibliography provides an overview of a wide range of books on amateur film and home movies, film history, film theory, and critical historiography. It is organized to be a useful compendium of writing on home movies for future researchers, students, programmers, and curators. It is not compiled as a definitive, all-encompassing survey of all writing in the area of amateur film, the new film history, or critical historiography; rather, it features works that are seminal in this area and that have contributed to the theorization and historical analysis of amateur film/home movies.

### Home Movies

Beauvais, Yann, and Jean-Michel Bouhours, eds. *Le je filmé.* Paris: Centre Georges Pompidou, 1995.

Becker, Snowden. "Family in a Can: The Presentation and Preservation of Home Movies in Museums." *The Moving Image* 1, no. 2 (fall 2001): 99–106.

Bird, Lance. "A Letter to the Editor: Cinema Clubs and 'The World of Tomorrow.' " *The Journal of Film and Video* 38, nos. 3–4 (summer–fall 1986): 39–46.

Camper, Fred. "Some Notes on the Home Movie." *The Journal of Film and Video* 38, nos. 3–4 (summer–fall 1986): 9–14.

Chalfen, Richard. "Home Movies as Cultural Documents." In Sari Thomas, ed., *Film/Culture: Explorations of Cinema in Its Social Context.* Metuchen, NJ, and London: Scarecrow Press, 1982.

———. "The Home Movie in a World of Reports: An Anthropological Appreciation." *The Journal of Film and Video* 38, nos. 3–4 (summer–fall 1986): 102–10.

———. "Media Myopia and Genre-Centrism: The Case of Home Movies." *The Journal of Film and Video* 38, nos. 3–4 (summer–fall 1986): 58–62.

———. *Snapshot Versions of Life.* Bowling Green, OH: Bowling Green State University Popular Press, 1987.

Citron, Michelle. *Home Movie and Other Necessary Fictions*. Minneapolis and London: University of Minnesota Press, 1999.

Eastman Kodak. *How to Make Good Movies*. Rochester, NY: Eastman Kodak, circa 1950.

Erens, Patricia, ed. "The Galler Home Movies: A Case Study." *The Journal of Film and Video* 38, nos. 3–4 (summer–fall 1986): 15–24.

————. "Home Movies and Amateur Filmmaking." Special monograph issue of *The Journal of Film and Video* 38, nos. 3–4 (summer–fall 1986).

————. "Home Movies in Commercial Narrative Film." *The Journal of Film and Video* 38, nos. 3–4 (summer–fall 1986): 99–101.

Hale, Grace Elizabeth, and Beth Loffreda. "Clock for Seeing: Technologies of Memory, Popular Aesthetics, and the Home Movie." *Radical History Review*, no. 66 (winter 1997): 163–71.

Hoberman, J. "Homemade Movies: Towards a Natural History of Narrow Gauge Avant-Garde Film-Making in America." In J. Hoberman, ed., *Home Made Movies: 20 Years of American 8mm and Super-8 Films*. New York: Anthology Film Archives, 1981.

Inédits. *Images, Mémoire de L'Europe*. Proceedings of the European Colloquium of Inédits, March 7–10, 1989, Belgium.

Ishizuka, Karen. "Artifacts of Culture." *Journal of Film Preservation* 25, no. 52 (April 1996): 15–19.

Kattelle, Alan. "The Evolution of Amateur Motion Picture Equipment 1895–1965." *The Journal of Film and Video* 38, nos. 3–4 (summer–fall 1986): 47–57.

————. *Home Movies: A History of the American Industry, 1897–1979*. Nashua, NH: Transition Publishing, 2000.

Kleinhans, Chuck. "My Aunt Alice's Home Movies." *The Journal of Film and Video* 38, nos. 3–4 (summer–fall 1986): 25–36.

Klinger, Barbara. "The New Media Aristocrats: Home Theater and the Domestic Film Experience." *The Velvet Light Trap*, no. 42 (fall 1998): 4–19.

Luckett, Moya. " 'Filming the Family': Home Movie Systems and the Domestication of Spectatorship." *The Velvet Light Trap*, no. 36 (fall 1995): 21–32.

Morrisset, Micheline. "Home Movies." *The Archivist: Magazine of the National Archives of Canada*, no. 108 (1995): 28–29.

Neumann, Mark. "Home Movies on Freud's Couch." *The Moving Image* 2, no. 1 (spring 2002): 24–46.

Odin, Roger. "Rhétorique du film de famille." *Rhétoriques, Sémiotiques, Revue d'Esthétique*, nos. 1–2 U.G.É., 10/18 (1979): 340–73.

————, ed. *Le film de famille: usage privé, usage public*. Paris: Éditions Méridiens Klincksieck et Cie, 1995.

————. "Le Film de Famille dans l'Institution Familiale." In Robert Odin, ed., *Le film de famille: usage privé, usage public*. Paris: Éditions Méridiens Klincksieck et Cie, 1995, 27–41.

————, ed. "Le cinéma en amateur." Special monograph issue of *Communications*, no. 68. Editions Seuil, 1999.

Ouellette, Laurie. "Camcorders Dos and Don'ts: Popular Discourses on Amateur and Participatory Television." *The Velvet Light Trap*, no. 36 (fall 1995): 33–44.

Parrell, Marnie. "Repression or How to Make Good Home Movies." *CineAction*, no. 30 (winter 1992): 22–23.

"The Past as Present: The Home Movie as a Cinema of Record." Proceedings. Getty Research Center, Los Angeles, California, December 4–5, 1998.

Schneider, Alexandra. "Homemade Travelogues: *Autosonntag*—A Film Safari in the Swiss Alps." In Jeffrey Ruoff, ed., *Virtual Voyages: Cinema and Travel*. Durham, NC, and London: Duke University Press, 2006.

Schultz, Ed, and Dodi Schultz. *How to Make Exciting Home Movies and Stop Boring Your Friends and Relatives*. Garden City, NY: Doubleday, 1972.

Schwartz, Eric. "Intellectual Property Law and Rights of Privacy in Relation to Home Movies." Talk delivered at Northeast Historic Film Symposium, July 25, 2001. Online: www.oldfilm.org. Accessed February 8, 2007.

Slater, Don. "Consuming Kodak." In Jo Spence and Patricia Holland, eds., *Family Snaps: The Meaning of Domestic Photography*. London: Virago Press, 1991.

Sobchack, Vivian. "Towards a Phenomenology of Nonfictional Film Experience." In Jane M. Gaines and Michael Renov, eds., *Collecting Visible Evidence*. Minneapolis and London: University of Minnesota Press, 1999.

Spence, Jo, and Patricia Holland, eds. *Family Snaps: The Meanings of Domestic Photography*. London: Virago, 1991.

Stern, Christopher. "National Registry Taps 25 Pix." *Variety*, December 4, 1996, 2, 32.

Stone, Melinda, and Dan Streible, eds. Special issue on small-gauge and amateur filmmaking, *Film History: An International Journal* 15, no. 2 (2003).

Ury, Tanya. "Surely Everybody Makes Their Own Home Pornos?" Home Movies: Super 8 site. Online: www.tanyaury.com. Accessed January 3, 2000.

Williamson, Judith. *Consuming Passions: The Dynamics of Popular Culture*. New York: Marion Boyars, 1986.

Zimmermann, Patricia R. "The Amateur, the Avant-Garde, and Ideologies of Art." *The Journal of Film and Video* 38, nos. 3–4 (summer–fall 1986): 63–85.

———. "Professional Results with Amateur Ease: The Formation of Amateur Filmmaking Aesthetics 1923–1940." *Film History* 2 (1988): 267–81.

———. "Trading Down: Amateur Film Technology in Fifties America." *Screen* 29 (spring 1988): 40–51.

———. *Reel Families: A Social History of Amateur Film*. Bloomington and Indianapolis: Indiana University Press, 1995.

———. "Startling Angles: Amateur Film and the Early Avant-Garde." In Jan-Christopher Horak, ed., *Lovers of Cinema: The First American Film Avant-Garde, 1919–1945*. Madison: University of Wisconsin Press, 1995.

———. "Geographies of Desire: Cartographies of Gender, Race, Nation and Empire in Amateur Film." *Film History* 8 (1996): 85–98.

———. "Morphing History into Histories: From Amateur Film to the Archive of the Future." *The Moving Image* 1, no. 1 (spring 2001): 109–30.

## Film History/Historiography

Allen, Robert C., and Douglas Gomery. *Film History: Theory and Practice.* New York: Alfred A. Knopf, 1985.

Andrew, Dudley. "Film and History." In John Hill and Pamela Church Gibson, eds., *The Oxford Guide to Film Studies.* Oxford: Oxford University Press, 1998.

Belton, John. *Widescreen Cinema.* Cambridge, MA: Harvard University Press, 1992.

Bordwell, David, Janet Staiger, and Kristin Thompson. *The Classical Hollywood Cinema: Film Style and Mode of Production to 1960.* New York: Columbia University Press, 1985.

Cartwright, Lisa. *Screening the Body: Tracing Medicine's Visual Culture.* Minneapolis: University of Minnesota Press, 1995.

Eberwein, Robert. *Sex Ed: Film, Video and the Framework of Desire.* New Brunswick, NJ: Rutgers University Press, 1999.

Fregoso, Rosa Linda. *The Bronze Screen: Chicano Images in Film.* Minneapolis: University of Minnesota Press, 1994.

Klinger, Barbara. "Film History Terminable and Interminable: Recovering the Past in Reception Studies." *Screen* 38, no. 2 (1997): 107–28.

Landy, Marcia. *Cinematic Uses of the Past.* Minneapolis: University of Minnesota Press, 1996.

Loshitzky, Yosefa. *Spielberg's Holocaust: Critical Perspectives on* Schindler's List. Bloomington: Indiana University Press, 1997.

Martin, Michael T., ed. *New Latin American Cinema.* Vol. 1, *Theory, Practices, and Transcontinental Articulations.* Detroit: Wayne State University Press, 1997.

———. *New Latin American Cinema.* Vol. 2, *Studies of National Cinemas.* Detroit: Wayne State University Press, 1997.

Musser, Charles. *The Emergence of Cinema: The American Screen to 1907.* Berkeley: University of California Press, 1994.

Naficy, Hamid, ed. *Home, Exile, Homeland: Film, Media and the Politics of Place.* New York: Routledge, 1999.

Pick, Zuzana. *The New Latin American Cinema: A Continental Project.* Austin: University of Texas Press, 1993.

Rosen, Philip. *Change Mummified: Cinema, Historicity, Theory.* Minneapolis: University of Minnesota Press, 2001.

Schaefer, Eric. *Bold! Daring! Shocking! True! A History of Exploitation Films, 1919–1959.* Durham, NC, and London: Duke University Press, 1999.

Thompson, Kristin, and David Bordwell. *Film History: An Introduction.* New York: McGraw-Hill, 1994.

Wollen, Peter. "Cinema and Technology: An Historical Overview." In Stephen Heath and Teresa de Lauretis, eds., *The Cinematic Apparatus.* London: Macmillan, 1980.

## Home Movies and Nonnarrative Filmmaking

Bordwell, David. *Narration in the Fiction Film.* Madison: University of Wisconsin Press, 1985.

Brakhage, Stan. "8mm Seeing." In Robert A. Haller, ed., *Brakhage Scrapbook. Collected Writings: 1964–1980*. New York: Documentext, 1982.

———. "In Defense of Amateur." In Robert A. Haller, ed., *Brakhage Scrapbook. Collected Writings: 1964–1980*. New York: Documentext, 1982.

Buzzi, Stella. *New Documentary: A Critical Introduction*. London: Routledge, 2000.

Dixon, Winston Wheeler. *The Exploding Eye: A Re-Visionary History of 1960's American Experimental Cinema*. Albany: State University of New York Press, 1997.

Holmlund, Chris, and Cynthia Fuchs, eds. *Between the Sheets, in the Streets: Queer, Lesbian and Gay Documentary*. Minneapolis: University of Minnesota Press, 1997.

Horak, Jan-Christopher, ed. *Lovers of Cinema: The First American Film Avant-Garde, 1919–1945*. Madison: University of Wisconsin Press, 1995.

James, David. *Allegories of Cinema: American Film in the Sixties*. Princeton, NJ: Princeton University Press, 1989.

Leyda, Jay. *Films Beget Films*. New York: Hill and Wang, 1964.

MacDonald, Scott. *The Garden in the Machine: A Field Guide to Independent Films about Place*. Berkeley: University of California Press, 2001.

Mekas, Jonas. *Movie Journal: The Rise of a New American Cinema, 1959–1971*. New York: Collier Books, 1972.

Nichols, Bill. *Ideology and the Image: Social Representation in the Cinema and Other Media*. Bloomington: Indiana University Press, 1981.

———. *Blurred Boundaries: Questions of Meaning in Contemporary Culture*. Bloomington: Indiana University Press, 1991.

———. *Representing Reality: Issues and Concepts in Documentary*. Bloomington: Indiana University Press, 1994.

———. *Introduction to Documentary*. Bloomington: Indiana University Press, 2001.

———. *Maya Deren and the American Avant-Garde*. Berkeley: University of California Press, 2001.

Rabinowitz, Paula. *They Must Be Represented: The Politics of Documentary*. London: Verso, 1994.

Rees, A. L. *A History of Experimental Film and Video*. London: British Film Institute Publishing, 1999.

Renov, Michael. "Domestic Ethnography and the Construction of the 'Other' Self." In Jane M. Gaines and Michael Renov, eds., *Collecting Visible Evidence*. Minneapolis: University of Minnesota Press, 1999.

———, ed. *Theorizing Documentary*. New York and London: Routledge, 1993.

Rosenthal, Alan, ed. *New Challenges for Documentary*. Berkeley: University of California Press, 1988.

Ruby, Jay. *Picturing Culture: Explorations of Film and Anthropology*. Chicago: University of Chicago Press, 2000.

Russell, Catherine. *Experimental Ethnography: The Work of Film in the Age of Video*. Durham, NC: Duke University Press, 1999.

Sherman, Sharon R. *Documenting Ourselves*. Lexington: University Press of Kentucky, 1998.

Sitney, P. Adams, ed. *The Avant-Garde Film: A Reader of Theory and Criticism.* New York: New York University Press, 1978.

———. *Visionary Film: The American Avant-Garde, 1943–1978,* 2d ed. New York: Oxford University Press, 1979.

Wees, William. *Recycled Images: The Art and Politics of Found Footage Films.* New York: Anthology Film Archives, 1993.

———. "The Ambiguous Aura of Hollywood Stars in Avant-Garde Found-Footage Films." *Cinema Journal* 41, no. 2 (winter 2002): 3–18.

Zimmermann, Patricia R. *States of Emergency: Documentaries, Wars, Democracies.* Minneapolis: University of Minnesota Press, 2000.

## From Home Movies to Home Video

Handhart, John, ed. *Video Culture: A Critical Investigation.* Rochester, NY: Visual Studies Workshop Press, 1986.

Moran, James. *There's No Place Like Home Video.* Minneapolis: University of Minnesota Press, 2002.

Renov, Michael, and Erika Suderberg, eds. *Resolutions: Contemporary Video Practices.* Minneapolis: University of Minnesota Press, 1996.

## Film/Media Theory

Baudry, Jean-Louis. "Ideological Effects of the Basic Apparatus." In Philip Rosen, ed., *Narrative, Apparatus, Ideology.* New York: Columbia University Press, 1986.

Bazin, André. "The Ontology of the Photographic Image." In Alan Trachtenberg, ed., *Classic Essays in Photography.* New Haven, CT: Leete's Island Books, 1980.

Benjamin, Walter. "The Work of Art in the Age of Mechanical Reproduction" (1936). In Hannah Arendt, ed., *Illuminations.* New York: Schocken, 1969.

Comolli, Jean-Louis. "Technique and Ideology: Camera, Perspective, Depth of Field." In Philip Rosen, ed., *Narrative, Apparatus, Ideology.* New York: Columbia University Press, 1986.

Cook, Pam, and Mieke Bernink, eds. *The Cinema Book,* 2d ed. London: British Film Institute Publishing, 1999.

Enzenberger, Hans Magnus. "Constituents for a Theory of the Media." In John Hanhardt, ed., *Video Culture.* New York: Peregrine Smith Books, 1986.

Hansen, Miriam. "Benjamin, Cinema and Experience: 'The Blue Flower in the Land of Technology.'" *New German Critique* 40 (winter 1987): 179–224.

———. *Babel and Babylon: Spectatorship in American Silent Film.* Cambridge, MA: Harvard University Press, 1991.

Hoberman, J. "The Super-80's." In J. Hoberman, ed., *Vulgar Modernism: Writings on Movies and Other Media.* Philadelphia: Temple University Press, 1991.

Kracauer, Siegfried. *Theory of Film: The Redemption of Physical Reality* (1960). Princeton, NJ: Princeton University Press, 1997.

Lapsley, Robert, and Michael Westlake. *Film Theory: An Introduction.* Manchester, UK: Manchester University Press, 1988.

Marks, Laura U. *The Skin of the Film: Intercultural Cinema, Embodiment, and the Senses.* Durham, NC, and London: Duke University Press, 2000.

Michelson, Annette, ed. *Kino-Eye: The Writings of Dziga Vertov.* Berkeley: University of California Press, 1984.

Musser, Charles. "The Travel Genre in 1903–1904." In Thomas Elsaesser, ed., *Early Cinema: Space, Frame, Narrative.* London: British Film Institute Publishing, 1990.

Schafer, Eric. "Plain Brown Wrapper: Adult Films for the Home Market, 1930–1970." In Eric Smoodin and Jon Lewis, eds., *In the Absence of Films: Towards a New Historiographic Practice.* Durham, NC: Duke University Press, forthcoming.

Shohat, Ella, and Robert Stam. *Unthinking Eurocentrism: Multiculturalism and the Media.* London and New York: Routledge, 1994.

Sobchack, Vivian, ed. *The Persistence of History: Cinema, Television and the Modern Event.* New York and London: Routledge, 1996.

Stewart, Garrett. *Between Film and Screen: Modernism's Photo Synthesis.* Chicago: University of Chicago Press, 1999.

Turim, Maureen. *Flashbacks in Film, Memory and History.* New York and London: Routledge, 1989.

———. "The Trauma of History: Flashbacks upon Flashbacks." *Screen* 42 (summer 2001): 205–10.

Walker, Janet. "The Traumatic Paradox: Documentary Films, Historical Fictions, and Cataclysmic Past Events." *Signs* 22, no. 4 (1997): 803–25.

———. "Trauma Cinema: False Memories and True Experience." *Screen* 42 (summer 2001): 211–16.

Zizek, Slavoj. "Pornography, Nostalgia, Montage: A Triad of the Gaze." In Slavoj Zizek, ed., *Looking Awry: An Introduction to Jacques Lacan through Popular Culture.* Cambridge, MA: MIT Press, 1991.

## Critical Theory

Antze, Paul, and Michael Lambek, eds. *Tense Past: Cultural Essays in Trauma and Memory.* New York and London: Routledge, 1996.

Barthes, Roland. "The Photographic Message" (1961). In Roland Barthes, ed., *Image, Music, Text.* London: Fontana, 1977.

———. "The Rhetoric of the Image." In Roland Barthes, ed., *Image, Music, Text.* London: Fontana Press, 1977.

———. "The Third Meaning." In Roland Barthes, ed., *Image, Music, Text.* London: Fontana Press, 1977.

———. *Camera Lucida.* New York: Hill and Wang, 1981.

Bourdieu, Pierre. *Distinction: A Social Critique of the Judgement of Taste.* Trans. Richard Nice. Cambridge, MA: Harvard University Press, 1984.

———. *Photography: A Middle-Brow Art* (1965). Trans. Shaun Whiteside. Stanford: Stanford University Press, 1990.

Brecht, Bertolt. "The Radio as a Means of Communication: A Talk on the Function of Radio." Trans. Stuart Hood. *Screen* 20, nos. 3–4 (winter 1979–80): 24–25.

———. "The Radio as an Apparatus of Communication." In John Handhardt, ed., *Video Culture: A Critical Investigation.* Rochester, NY: Visual Studies Workshop, 1986.

Halbwachs, Maurice. *On Collective Memory.* Trans. Lewis A. Coser. Chicago and London: University of Chicago Press, 1992.

Jameson, Frederic. "Nostalgia for the Present." *Postmodernism or the Cultural Logic of Late Capitalism.* Durham, NC: Duke University Press, 1991.

Kuhn, Annette. *Family Secrets: Acts of Memory and Imagination.* London: Verso, 1995.

Lefevbre, Henri. *Critique of Everyday Life* (1947). Vol. 1. Trans. John Moore. London: Verso, 1991.

Petro, Patrice. "After Shock/Between Boredom and History." In Patrice Petro, *Fugitive Images: From Photography to Video.* Bloomington and Indianapolis: Indiana University Press, 1995.

Stewart, Susan. *On Longing: Narrative of the Miniature, the Gigantic, the Souvenir, the Collection.* Durham, NC, and London: Duke University Press, 1993.

## Critical Historiography

Agamben, Georgio. *Remnants of Auschwitz: The Witness and the Archive.* New York: Zone Books, 1999.

Bammer, Angelika, ed. *Displacements: Cultural Identities in Question.* Bloomington: Indiana University Press, 1994.

Berkhofer, Robert E., Jr. *Beyond the Great Story: History as Text and Discourse.* Cambridge, MA: Harvard University Press, 1995.

Bhabha, Homi K., ed. *Nation and Narration.* New York: Routledge, 1990.

———. *The Location of Culture.* New York: Routledge, 1994.

Burke, Peter, ed. *New Perspectives on Historical Writing.* University Park: Pennsylvania State University Press, 2001.

Caruth, Cathy, ed. *Trauma: Explorations in Memory.* Baltimore: Johns Hopkins University Press, 1995.

———. *Unclaimed Experience: Trauma, Narrative and History.* Baltimore: Johns Hopkins University Press, 1996.

Chow, Rey. *Writing Diaspora Tactics of Intervention in Contemporary Cultural Studies.* Bloomington: Indiana University Press, 1993.

de Certeau, Michel. *The Practice of Everyday Life.* Berkeley: University of California Press, 1988.

Derrida, Jacques. *Specters of Marx: The State of Debt, the Work of Mourning, and the New International.* New York: Routledge, 1994.

———. *Archive Fever.* Chicago: University of Chicago Press, 1998.

Felman, Shoshana, and Dori Laub, M.D. *Testimony: Crises of Witnessing in Literature, Psychoanalysis, and History.* New York: Routledge, 1991.

Foner, Eric. *Who Owns History? Rethinking the Past in a Changing World.* New York: Hill and Wang, 2002.

Foucault, Michel. *The Archaeology of Knowledge.* Trans. A. M. Sheridan Smith. New York: Pantheon, 1972.

———. *Language, Counter-Memory, Practice: Selected Essays and Interviews,* ed. Donald F. Bouchard. Ithaca, NY: Cornell University Press, 1977.

———. *Discipline and Punish: The Birth of the Prison.* Trans. Alan Sheridan. New York: Vintage, 1979.

———. *Power/Knowledge: Selected Interviews and Other Writings, 1972–1977.* New York: Pantheon, 1980.

Jenkins, Keith, ed. *The Postmodern History Reader.* New York: Routledge, 1997.

Liss, Andrea. *Trespassing through Shadows: Memory, Photography and the Holocaust.* Minneapolis: University of Minnesota Press, 1998.

Marchitello, Howard, ed. *What Happens to History: The Renewal of Ethics in Contemporary Thought.* New York: Routledge, 2001.

Morris, Meaghan. *Too Soon Too Late: History in Popular Culture.* Bloomington: Indiana University Press, 1998.

Munslow, Alun. *Deconstructing History.* New York: Routledge, 1997.

Roediger, David R. *Colored White: Transcending the Racial Past.* Berkeley: University of California Press, 2002.

Steedman, Carolyn. *Dust: The Archive and Cultural History.* New Brunswick, NJ: Rutgers University Press, 2002.

Sturken, Marita. *Tangled Memories: The Vietnam War, the AIDS Epidemic, and the Politics of Remembering.* Berkeley: University of California Press, 1997.

Trinh T. Minh-ha. *When the Moon Waxes Red: Representation, Gender and Cultural Politics.* New York: Routledge, 1991.

White, Hayden. *The Content of the Form.* Baltimore: Johns Hopkins University Press, 1987.

Wyschogrod, Edith. *An Ethics of Remembering: History, Heterology and the Nameless Others.* Chicago: University of Chicago Press, 1998.

# Contributors

**AYISHA ABRAHAM** is a freelance visual artist who received a BFA at the Faculty of Fine Arts, Baroda, India, in 1987 and an MFA from Rutgers University in 1995. She lived and worked in New York City from 1989–95 and in 1991 participated in the Whitney Independent Study Program. She is currently based in Bangalore, where she practices as an artist and teaches part-time at the Shrishti School of Art and Design. In 2006 she was awarded a one-year fellowship from the Majlis Foundation, Bombay, to research amateur film in India.

**GRACE AN** is assistant professor of French and cinema studies at Oberlin College. Specializing in twentieth-century French literature and cinema, she wrote a dissertation, "Par-asian Visualities," which explores French representations of China and Japan and reconstructions of East Asia in Paris.

**VIRGINIA CALLANAN** is the registrar at the New Zealand Film Archive/Nga Kaitiaki o Nga Taonga Whitiahua (www.filmarchive.org.nz). Both have curated national touring exhibitions featuring amateur films from the collection.

**LIZ CZACH** was a programmer of Canadian and Québecois cinema at the Toronto International Film Festival from 1995 to 2005. She is currently completing her PhD thesis on home movies in the visual and cultural studies program at the University of Rochester.

**STEVEN DAVIDSON** was the founding director of the Florida Moving Image Archive from its establishment in 1987 through 2005. He is currently an independent consultant in the moving image archive and library field working on a variety of projects, including Jewish educational media. He is coeditor of *The Administration of Television Newsfilm and Video Tape Collections: A Curatorial Manual* (American Film Institute and Wolfson Media History Center, 1997), the first publication of its kind. Davidson has frequently appeared on local television and radio discussing issues relating to archives and preservation, and he has been a consultant for numerous film and video productions. Davidson has written extensively on film and television preservation and has curated several exhibitions on home movies and local television.

**CAROLYN FABER** is an independent moving image archivist and filmmaker. She recently cofounded the Midwest Media Archives Alliance, a nonprofit dedicated to building an active network of Midwestern archives, institutions, organizations, and individuals to preserve, promote, and provide access to the region's dynamic media history. Previously, she was the archivist for the WPA Film Library, a commercial stock footage resource, where she managed over fifty collections. She has been awarded multiple grants from the National Film Preservation Foundation to preserve and screen the work of local independent filmmakers.

**PÉTER FORGÁCS** is a media artist and independent filmmaker based in Budapest whose works have been exhibited worldwide. Since 1978 he has made more than forty films and installations, including one of his best-known works, *The Danube Exodus*. He is also known for his "Private Hungary" series of award-winning films based on home movies from the 1930s and 1960s, which document ordinary lives that were soon to be ruptured by an extraordinary historical trauma that occurs off-screen. His international debut came with *The Bartos Family* (1988); since then he has received several international festival awards, including the Prix Europe for *Free Fall*.

**RICHARD FUNG** is a Toronto-based videomaker and writer whose tapes have been widely screened and collected internationally and whose essays have been published in many journals and anthologies. Among other distinctions, he has received the 2000 Bell Canada Award, the national career prize for outstanding achievement in video art. He teaches in the Integrated Media program of the Ontario College of Art and Design.

**KAY GLADSTONE,** born in Sydney, has a BA in history and an MSc in information science from the University of London. After joining the Imperial War Museum as a film cataloguer in 1972, he researched the history of British combat filming during World War II by recording interviews with veteran cameramen, publishing on this topic in *Film History* (2002) and in *Holocaust and the Moving Image* (Wallflower Press, 2005). As curator of acquisitions and documentation of the Imperial War Museum Film and Video Archive since 1990, he has extended the collecting of amateur film, pioneering the recording of commentaries and historical interviews to contextualize these personal images.

**KAREN GLYNN** began her career in 1979 as the film coordinator at the School for International Training in Brattleboro, Vermont. Since then, she has worked in production, as a news editor, and as a film researcher. In 1993, Glynn enrolled in a master's program in history at the University of Mississippi and began collecting and preserving film in the Southern Media Archive. Currently, Glynn is the visual materials archivist in the Special Collections Library at Duke University.

**MARYANN GOMES** was devoted to widening public access to visual collections, higher education, and galleries before her appointment to lead the North West Film Archive (NWFA) research project in 1982. Her teaching, writing, and presentations focused on the value of moving images as social and regional testimony. She was regularly invited to share her experience of establishing, managing, housing, and

resourcing a regional film archive at national and international conferences. Gomes was elected as the first chair of the Association of Moving Image Archivists' Regional Audio Visual Archivists Interest Group and presented at International Federation of Film Archives (FIAF) conferences. She died in 2001.

**JOHN HOMIAK** is director of the Anthropology Collections and Archives Program at the National Museum of Natural History, Smithsonian Institution, Washington, D.C. He works in the field of visual anthropology and has done extensive fieldwork in the Caribbean and Circum-Caribbean since 1980. He is currently working on an exhibition about the globalization of the Rastafari Movement that is scheduled to open in Washington, D.C., in November 2007.

**KAREN L. ISHIZUKA** is an independent writer and documentary producer. She has written and produced over twenty videos and films that have garnered over sixty awards. Many, such as *Pilgrimage* (2006), *Toyo Miyatake: Infinite Shades of Gray* (2001), *Something Strong Within* (1994), and *Moving Memories* (1992), feature home movies and home videos. Her most recent book was *Lost and Found: Reclaiming the Japanese American Incarceration* (University of Illinois Press, 2006). She is on the editorial board of *The Moving Image: The Journal of the Association of Moving Image Archivists* and was appointed to the National Film Preservation Board from 1997 to 2005.

**LYNNE KIRSTE** is special collections curator at the Academy Film Archive in Los Angeles, California, where she works with the archive's extensive home movie holdings. She has spoken to a variety of audiences about caring for their amateur films and videotapes and appreciating the cultural value of their materials. Kirste helped organize Queer Home Movie Night in Los Angeles in 2005, and she serves on the advisory board of the Legacy Project for LGBT Film Preservation.

**NICO DE KLERK** is the staff member responsible for research at the Nederlands Archive/Museum Institute in Amsterdam. He coedited *Nonfiction from the Teens; "Disorderly Order": Colours in Silent Film; Uncharted Territory: Essays on Early Nonfiction Film; The Eye of the Beholder: Colonial and Exotic Imaging;* and *"Het gaat om de film!": een nieuwe en geschiedenis van de Nederlandsche Filmliga 1927–1933*, all published by the Archive/Museum Institute. He has also contributed articles to various national and international film publications.

**MICHELE KRIBS** has been film preservationist at the Oregon Historical Society since 1978. In this role, she is responsible for all aspects of the Moving Image Archives, including collection development, preservation of all film and video, and providing public access through inventories and transfers to videotape. Kribs has been a speaker on film collection, access, and preservation issues at the local, regional, and national levels. She was a founding member of the Film Archives Advisory Committee (FAAC) and the Television Archives Advisory Committee (TAAC) and has been an active member of the Association of Moving Image Archivists (AMIA) since its inception in 1989, when she hosted the association's first annual meeting that created AMIA, and she also hosted the AMIA 2001 meeting. Michele received AMIA's "Silver Light" career recognition award at the 2001 meeting.

**ROSS LIPMAN** is an independent filmmaker whose work has screened throughout the world, at venues ranging from the London International Film Festival to the Chinese Taipei Film Archive. In his role as film preservationist at the UCLA Film & Television Archive, he has restored works dating from the dawn of cinema to the present era. Recent restorations include works by John Cassavetes, Shirley Clarke, Emile de Antonio, Sid Laverents, Kenneth Anger, and others. His writings on film history, technology, and aesthetics have appeared in numerous publications internationally.

**ROBERT A. NAKAMURA** is the director of the Center for EthnoCommunications and the associate director of the Asian American Studies Center at the University of California, Los Angeles. Nakamura pioneered the field of Asian Pacific American media in the 1970s and founded Visual Communications, the oldest continuing community media center in the United States. He was the first recipient of the annual Steven Tatsukawa Memorial Award for contributions to Asian American media. He also holds the endowed chair in Japanese American studies at UCLA.

**HEATHER NORRIS NICHOLSON** is a research fellow at the Center for Regional History, Department of History and Economic History, Manchester Metropolitan University. She writes on sociocultural and landscape-related change in relation to the interpretation of visual evidence and the politics of representation within British and international contexts. She is currently working on a sociocultural history of Britain's amateur film movement for Manchester University Press. Publications include *Screening Culture: Constructing Image and Identity* (Rowman and Littlefield, 2003), various chapters, and also articles in *The Moving Image, Film History, Geo Journal, Landscapes, Tourist Studies,* and the *Journal of Intercultural Studies.*

**ROGER ODIN** is professor emeritus of communication and was the head of the Institute of Film and Audiovisual Research (IRCAV) at the Université de Paris III–Sorbonne Nouvelle from 1983 to 2003. A film theorist, he is the author of numerous works that focus on a semio-pragmatic approach to films and audiovisual productions, including two books: *Cinéma et production de sens* (Armand Colin, 1990) and *De la fiction* (De Boeck, 2000). For five years, he has directed a research group on documentaries and published *L'âge d'or du cinéma documentaire: Europe années 50.* He also has written about home movies and amateur productions (*Le film de famille: usage privé, usage public* [Éditions Méridiens Klincksieck et Cie, 1995]; "Le cinéma en amateur," special monograph issue of *Communications,* no. 68 [Éditions Seuil, 1999]).

**ROBERT ROSEN** is professor and dean of the UCLA School of Theater, Film and Television. He has published widely in the field of media preservation and has guided the growth of the UCLA Film & Television Archive from a small study collection to the world's largest university-based holding of original film and television materials. As a preservationist and historian, he has occupied many leadership positions: he was founding director of the National Center for Film and Video Preservation at the American Film Institute, served on the Executive Committee of the International Federation of Film Archives, was a member of the National Film Preservation Board of the Library of Congress, and was a board member of the Stanford Theater Foundation and the Geffen Playhouse. With Martin Scorsese, he was the organizer of the

Film Foundation, on which he currently serves as the founding chair of the Archivists Council.

**MICHAEL S. ROTH** is president of the California College of Arts and Crafts, a visual arts college with campuses in Oakland and San Francisco. His publications include the books *Psycho-Analysis as History: Negation and Freedom in Freud* (Cornell University Press, 1987 and 1995), *Knowing and History: Appropriations of Hegel in Twentieth-Century France* (Cornell University Press, 1988), *The Ironist's Cage: Memory, Trauma, and the Construction of History* (Columbia University Press, 1995), and *Irresistible Decay: Ruins Reclaimed*, with Claire Lyons and Charles Merewether (Getty Research Institute, 1997). He is the editor of several volumes, including *Disturbing Remains: Memory, History and Crisis in the Twentieth Century* (Getty Research Institute, 2001) and *Freud: Conflict and Culture* (Knopf, 1998), the companion volume to the 1998 Library of Congress exhibition of the same name, for which Roth was the curator.

**KARAN SHELDON** is cofounder and board member of Northeast Historic Film, which began in 1986. A founding board member of the Association of Moving Image Archivists (AMIA), she cochaired the first Committee on the U.S. National Moving Image Preservation Plans, organized the inaugural AMIA plenary on home movies and amateur film in 1991, and chaired the Small Gauge Film Preservation Task Force. Sheldon helps organize the annual Summer Film Symposium at Northeast Historic Film (www.oldfilm.org). She has curated museum screenings, including "You Work, We'll Watch" and "Exceptional Amateur Film"; other presentations include annual Regional and Nontraditional Moving Image Archiving Preservation for the L. Jeffrey Selznick School of Film Preservation.

**DWIGHT SWANSON** has an MA in American Studies from the University of Maryland and a Certificate in Film Preservation from the L. Jeffrey Selznick School of Film Preservation. He has been an archivist at the Alaska Moving Image Preservation Association, Northeast Historic Film, and Appalshop. He is a cofounder of Home Movie Day and the Center for Home Movies.

**BRIAN TAVES** (PhD, University of Southern California) is a film archivist with the Library of Congress in Washington, D.C. In addition to some one hundred articles and fifteen chapters in anthologies, he is author of *Robert Florey, the French Expressionist* (Scarecrow, 1987), *The Romance of Adventure: The Genre of Historical Adventure Movies* (University Press of Mississippi, 1993), *The Jules Verne Encyclopedia* (Scarecrow, 1996), *Talbot Mundy, Philosopher of Adventure* (McFarland, 2005), and *P. G. Wodehouse and Hollywood* (McFarland, 2005). Taves is completing *Thomas Ince, Pioneer Independent*, and his next book is on the more than three hundred film and television adaptations of the works of Jules Verne made worldwide.

**IVÁN TRUJILLO** studied biology and filmmaking at the National University of México (UNAM), where he now teaches courses in the history of documentary film. Since 1989, he has served as the director of Filmoteca UNAM, one of the largest film archives in Latin America. He was the president of the International Federation of Film Archives (FIAF) from 1999 to 2003.

**AMY VILLAREJO** teaches film history and theory at Cornell University, where she also is director of the Feminist, Gender, and Sexuality Studies Program. Her book *Lesbian Rule: Cultural Criticism and the Value of Desire* (Duke University Press, 2003) won the 2005 Katherine Singer Kovacs book award from the Society for Cinema and Media Studies. Her articles on the politics of representation have appeared in *New German Critique, Social Text,* and other journals. She is coeditor of *Keyframes: Popular Film and Cultural Studies* (Routledge, 2001) and is author most recently of *Film Studies: The Basics* (Routledge, 2007).

**PAMELA WINTLE** began her career in moving image archiving in 1969 at the American Film Institute, Washington, D.C. In 1976, she joined the Smithsonian Institution's National Anthropological Film Center. In 1981, with a change in the Center's program and focus, Wintle developed a new program, which was renamed the Human Studies Film Archives. She is a founding board member of Northeast Historic Film, a regional archives based in Maine; former board member of the Archives of Factual Film, University of Iowa at Ames; founding chair of the Association of Moving Image Archivists' (AMIA) amateur film interest group (now assumed under the Small Gauge Interest Group); and she has served as the AMIA's alternate representative to the Library of Congress's National Film Preservation Board from 2001 to the present.

**PATRICIA R. ZIMMERMANN** is professor of cinema, photography, and media arts at Ithaca College. Her books include *Reel Families: A Social History of Amateur Film* (Indiana University Press, 1995) and *States of Emergency: Documentaries, Wars, Democracies* (University of Minnesota Press, 2000). With the late Erik Barnouw, Ruth Bradley, and Scott MacDonald, she edits the Wide Angle Books series for Temple University Press. She is on the editorial boards of *The Moving Image: The Journal of the Association of Moving Image Archivists, The Journal of Film and Video,* and *Wide Angle.* She also serves as codirector of the Finger Lakes Environmental Film Festival.

# Index

Page references given in italics refer to illustrations or material contained in their captions.

Text: 10/13 Aldus
Display: Franklin Gothic, Aldus
Compositor: Binghamton Valley Composition, LLC
Printer and Binder: Thomson-Shore, Inc.